THE GENUS
AGAPANTHUS

HYACINTHUS AFRIC: TUBEROSUS, FLORE CÆRULEO UMBELLATO.

Fig. 67

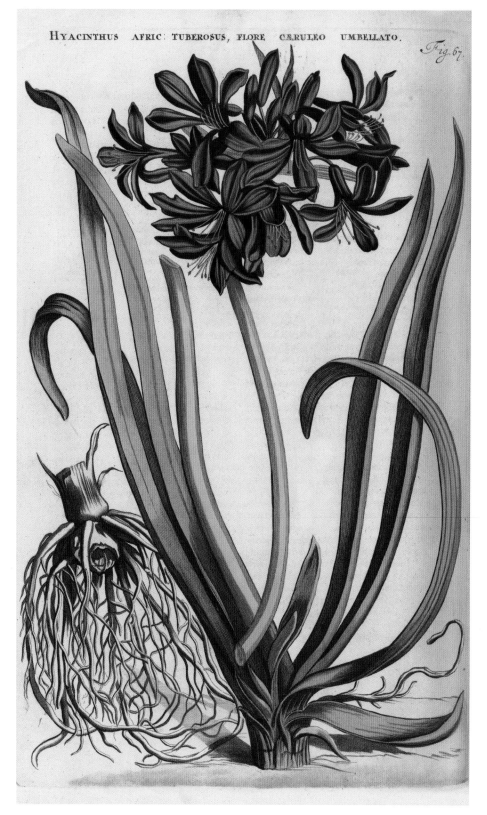

Agapanthus africanus, probably by Sibylla Merian, figure 67 in Caspar Commelin's *Horti Medici Amstelodamensis Rariorum*, vol. 2 (1701).

A BOTANICAL MAGAZINE MONOGRAPH

THE GENUS
AGAPANTHUS

Graham Duncan

WATERCOLOURS BY
Elbe Joubert

FOREWORD BY
Brian Mathew

GENERAL EDITOR
Martyn Rix

Kew Publishing
Royal Botanic Gardens, Kew

First published in 2021 by
Royal Botanic Gardens, Kew,
Richmond, Surrey, TW9 3AB, UK
www.kew.org

ISBN 978-1-84246-723-7
eISBN 978-1-84246-724-4

Distributed on behalf of the Royal Botanic Gardens, Kew in North America
by the University of Chicago Press, 1427 East 60th St, Chicago, IL 60637, USA

British Library Cataloguing in Publication Data
A catalogue record for this book is available from the British Library

Production management: Georgie Hills, Jo Pillai
Copy-editing: Ruth Linklater
Design, typesetting and page layout: Christine Beard

Jacket illustrations: *Agapanthus walshii*, plate 504 from *Curtis's Botanical Magazine* vol. 21 (2004) by Elbe Joubert (front); *Agapanthus africanus* by Elbe Joubert (back).

The production of this book has been generously supported by Dr Shirley Sherwood, OBE.

Printed in the United Kingdom by Short Run Press Ltd

For information or to purchase all Kew titles please visit
shop.kew.org/kewbooksonline or email publishing@kew.org

Kew's mission is to understand and protect plants and fungi, for the wellbeing of people and the future of all life on Earth.

Kew receives approximately one third of its funding from Government through the Department for Environment, Food and Rural Affairs (Defra). All other funding needed to support Kew's vital work comes from members, foundations, donors and commercial activities, including book sales.

CONTENTS

LIST OF PAINTINGS . vii

NEW SPECIES PUBLISHED IN THIS WORK . viii

FOREWORD .ix

ACKNOWLEDGEMENTS .xi

PREFACE . xii

1. HISTORY . 1

2. AGAPANTHUS CULTIVARS . 13
 Brief history . 13
 Cultivars
 Deciduous cultivars . 24
 Evergreen cultivars . 57

3. CULTIVATION AND PROPAGATION . 87
 Cultivation . 87
 Propagation . 99
 Pests and diseases . 101

4. AGAPANTHUS AND THE ENVIRONMENT 107
 Conservation . 107
 Phytogeography . 108
 Ecology, habitat and adaptive strategies . 111
 Phenology . 119

5. AGAPANTHUS BIOLOGY . 121
 Morphology . 121
 Pollination biology . 133
 Seed dispersal . 140
 Karyology . 141
 Phytochemistry and medicinal use . 142

6. SPECIES RELATIONSHIPS . 145

7. TAXONOMIC TREATMENT . 149

 Species Concepts . 150

 Key to the taxa . 152

 The species . 154

 Insufficiently known names . 231

 Excluded taxa . 231

REFERENCES . 233

GLOSSARY . 239

INDEX OF SCIENTIFIC NAMES . 240

INDEX OF CULTIVAR NAMES . 242

INDEX OF COMMON NAMES . 244

LIST OF PAINTINGS

Plate 1. *Agapanthus praecox* 'Albiflorus' (p. 14)

Plate 2. *Agapanthus* 'Lydenburg' (p. 18)

Plate 3. *Agapanthus africanus* (p. 156)

Plate 4. *Agapanthus walshii* (p. 163)

Plate 5. *Agapanthus praecox* 'Adelaide' (p. 173)

Plate 6. *Agapanthus praecox* 'Storms River' (p. 175)

Plate 7. *Agapanthus caulescens* 'Politique' (p. 184)

Plate 8. *Agapanthus pondoensis* (p. 194)

Plate 9. *Agapanthus coddii* (p. 200)

Plate 10. *Agapanthus campanulatus* 'Wolkberg' (p. 205)

Plate 11. *Agapanthus inapertus* subsp. *inapertus* 'White', and blue form (p. 212)

Plate 12. *Agapanthus inapertus* subsp. *pendulus* 'Graskop' (p. 217)

NEW SPECIES PUBLISHED IN THIS WORK

Agapanthus pondoensis F.M.Leight. ex G.D.Duncan, sp. nov.

FOREWORD

As a botanist and keen gardener the very word monograph gives me a frisson of anticipation that this will be what we've been waiting for: the last word, although of course it will never be the last! So what are the expectations? Monograph is just what its name implies: a written work about one particular subject and in the plant world often refers to a single genus. The focus in this case is on a currently popular group of South African plants so a definitive book devoted to the species of *Agapanthus* and their selections and hybrids is timely and very welcome. Particularly well timed as it follows on from an impressive horticultural trial at the RHS Garden Wisley just two years ago in which 185 cultivars were displayed and assessed. To augment its appeal, the book has been written by Graham Duncan, the bulbous plant specialist at Kirstenbosch Botanical Garden. Graham is well qualified to prepare monographs of horticulturally important genera such as this, for his skills are not restricted to their cultivation: he has knowledge of them in their wild habitats and an in-depth interest in their biology and taxonomy. This holistic approach is unusual but becomes very apparent when referring to his work. It contains all the information expected of a botanical treatise and much horticultural detail concerning cultivation and hybridisation in this striking group of garden plants. His previously published monograph *The Genus Lachenalia* (2012) is outstanding and this new work follows with the same degree of scholarship and presentation.

Apart from the personal studies that have gone into the preparation of the account Duncan has consulted the work of many specialist horticulturists, botanists and hybridisers. The detailed history of *Agapanthus* makes for fascinating reading and on a personal note it was pleasing to find the work of the Hon. Lewis Palmer acknowledged. I remember visits to the garden in Hampshire when his Headbourne Hybrids were stimulating an interest in them as hardy garden plants in Britain; now there are hundreds of selections and the section devoted to cultivars will be of great value to gardeners. On the botanical side the taxonomic history from early opinions through to today's molecular studies is also of interest: after much shuffling between families and even having a family of its own the genus now resides in Amaryllidaceae. There seems little doubt that they form a neat and clearly defined group with no close relatives and are instantly recognisable by gardeners and botanists alike.

It is good to see the book illustrated with a mix of photographs and botanical artwork as the two complement each other: the photographs show the plants as they occur in the wild while the latter encompass an artist's eye for detail. The illustrator in this case is Elbe Joubert who joins a long tradition of superb botanical artists in South Africa. Included among these, in the context of *Agapanthus*, is the botanist/artist Winsome F. Barker who illustrated the 1965 monograph of the genus by Frances Leighton, which was the classic reference work for many years. There is an elegant connection here in that some of the new paintings by Elbe were prepared from plants accumulated at Kirstenbosch all those years ago by Frances Leighton. Two of Elbe's paintings also appeared in Graham's *The Genus Lachenalia*.

Agapanthus are superb summer flowering perennials and valuable for their blue flowers, a colour that is particularly appreciated in gardens. Coupled with this the umbellate form of the inflorescence makes them useful subjects for providing a contrasting shape in mixed plantings. They are also, and

particularly the larger ones, excellent container plants. We have long enjoyed a substantial plant, presumably a form of *A. praecox*, which flowers freely year after year with almost no attention, tightly jammed in its large earthenware pot. Looking at the excellent photographs in this new work explains all, for they are shown often growing wedged in their rocky habitats and the author describes this species as inhabiting niches between boulders and in crevices. Little wonder ours appears to thrive on nothing at all!

Since its founding in 1787 several species have been illustrated in *Curtis's Botanical Magazine*, most recently *A. walshii* painted by Elbe Joubert with text by Graham Duncan in 2004. Thankfully their collaboration has continued to complete this fine comprehensive account of the whole genus. It is good to see this important monograph appearing under the banner of Kew's *Botanical Magazine Monographs*.

Brian Mathew

ACKNOWLEDGEMENTS

I am most grateful to the South African National Biodiversity Institute, and to Dr Martyn Rix, Editor of *Curtis's Botanical Magazine*, for his constant support, and to Dr Shirley Sherwood for her kind contribution towards costs of printing. Dick Fulcher, doyen of agapanthus breeding and selection in the UK, assisted me in many ways, generously providing historical detail of the many fine cultivars he has developed, and numerous photographs taken at his agapanthus nursery at Pine Cottage Plants, and I thank him and his wife Lorna for their hospitality during my stay in Devon. Patrick Fairweather, Director of Fairweather's Garden Centre in Beaulieu, Hampshire, was a great source of support and information regarding the many cultivars he grows so successfully. Likewise, Cape Town horticulturist Richard Jamieson was unstinting in his help with historical information regarding agapanthus in the wild, and the many cultivars he has raised.

I wish to record my sincere thanks to Elbe Joubert, South African botanical artist extraordinaire, for her masterful execution of 12 new agapanthus paintings made especially for this book, over a period of many years. Peter and Barbara Knox-Shaw of Freshwoods, Elgin, greatly assisted me in locating and studying populations of *Agapanthus walshii* in the Elgin Valley, as did Prof. Neil Crouch in numerous ways, including photographing species of *Agapanthus* for this book in the Eastern Cape and KwaZulu-Natal. I thank Assoc. Prof. Peter Bruyns, Rafaël Govaerts and Dr John Rourke for advice on taxonomic and nomenclatural matters, and Dr Annalie Melin, Dr Jonathan Colville, Prof. Mike Picker and Dr Hayley Jones for identification of insect pollinators. Wildlife artist Leigh Voigt kindly provided two line drawing studies, and several fine photographs of agapanthus from the wilds of Mpumalanga, and Steven Hickman, owner of the Hoyland Plant Centre in South Yorkshire, ably answered my numerous enquiries.

The Curators of herbaria (BOL, G, K, NBG, NH, NU, PRE and SAM) generously allowed me to study their collections on site, or sent photographs of type material, and I especially thank the Herbier Boissier at the Conservatoire et Jardin Botaniques de la Ville de Genève, Switzerland.

I am most grateful to Lord Charles Howick, owner and manager of Howick Hall Gardens and Arboretum, Northumberland, for permission to reproduce a rare, early photograph of his great nephew, The Hon. Lewis Palmer, that great selector of agapanthus cultivars and promoter of outdoor agapanthus cultivation in the United Kingdom, and to the Royal Horticultural Society (RHS) and Crestina Forcina of the RHS Lindley Library for permission to publish an image of Palmer in later life, in the greenhouse at Headbourne Worthy, Hampshire, where he conducted his agapanthus work.

I also thank the following people who kindly assisted me in one way or another: Fanie Avenant, John Burrows, Welland Cowley, Murray Dawson, Nicholas de Rothschild, Mary Duncan, Mpendulo Gabayi, Dr Graham Grieve, Andy Hackland, Adam Harrower, Steven Hickman, Dr Nicholas Hind, Anthony Hitchcock, Jonathan Hutchinson, Hanneke Jamieson, Heiner Lutzeyer, Andrew Morton, Geoff Nichols, Roger Oliver, Sean Privett, Trevor James, Michèle Karamanof, Keith Kirsten, Sylvie Kremer-Köhne, Bennie Kruger, Richard Loader, Jeanette Loedolff, Duncan McKenzie, Cameron and Rhoda McMaster, Rose Ncube, Mashudu Ndanduleni, Dr Elsa Pooley, Les Powrie, Ben Serage, Malcolm Shennan, Dr Brian Schrire, Prof. Stefan Siebert, Lady Christine Skelmersdale, Wessel Stoltz, David Styles, Anthony Tesselaar, Terry Trinder-Smith, Dennis Tsang, Guy Upfold, Judy van Warmelo, Sisanda Velembo, Mike Whitehead, Sarah Wilks and Neville Wylie.

Finally, I am most grateful to Gina Fullerlove, Lydia White, Georgie Hills, Ruth Linklater and Christine Beard at Kew Publishing for their advice and support throughout the project.

PREFACE

Frances Leighton's monograph *The Genus* Agapanthus appeared more than 50 years ago as supplementary volume number 4 of the *Journal of South African Botany*, in 1965. Though far from perfect, the work was an admirable attempt at classification of a notoriously difficult group, and, as the only full revision of the genus published up until then, it laid the foundation upon which subsequent researchers could build. Unfortunately, some of the traits used by Leighton to distinguish the 10 species (20 taxa) she recognised, were ambiguous, making identification difficult.

The present monograph provides a new classification, with a reduction to eight in the number of species (11 taxa), including a new species, *A. pondoensis* from the Eastern Cape. It is based on the results of fieldwork, an in-depth morphological study of living material, examination of pressed material, and my experience with the plants in cultivation over four decades. These data have been used in conjunction with a previously published analysis (Zonneveld & Duncan, 2003), in which genome size and pollen colour and vitality were employed as novel criteria in distinguishing the species. The present work provides a simplified approach to the taxonomy of *Agapanthus*, while simultaneously showcasing the morphological variation which exists within all the species. It aids in identification by means of a detailed key and descriptions, to be used in conjunction with distributional data and photographs of the plants in habitat and in cultivation. In addition, it focuses on the extraordinary development of agapanthus in ornamental horticulture, providing a selection of 155 of some of the best cultivars in the nursery trade, developed by leading agapanthus breeders and gardeners alike. It contains detailed advice on cultivation, both as container subjects and in landscape plantings, in cold and temperate climates, and includes hardiness ratings. New developments in propagation technique, and disease and pest management are discussed, such as the impact of recent invasions of agapanthus borer in South Africa, and gall midge in the United Kingdom. The multi-faceted use of agapanthus in traditional medicine in southern Africa is covered, as well as the potential certain species hold in treating serious disease like cancer and tuberculosis.

The monograph is illustrated with a selection of historical artworks, and 12 new watercolours by the South African botanical artist Elbe Joubert, painted mostly from material assembled by Frances Leighton, and still in cultivation at Kirstenbosch, and from recent collections from the wild. Photographs of the plants in their varied natural environments, illustrating their remarkable adaptation to local conditions, are accompanied by those depicting pollinator interactions, as well as by 12 distribution maps.

Cultivars of both evergreen and deciduous agapanthus enjoy increasing global appeal as dependable landscape subjects in temperate climates, and as rewarding perennials for borders and containers under protection in colder parts, and selected cultivars are becoming increasingly popular in the cut flower trade. Evidence of this has been the proliferation of cultivars from the major agapanthus-growing parts of the world, none more so than in the United Kingdom and The Netherlands, the two epicentres of agapanthus cultivation and selection. The publication of the present monograph seems opportune, following-on from a highly successful Royal Horticultural Society Agapanthus trial of 185 new cultivars, completed in 2018.

Graham Duncan
Cape Town, October 2020

1. HISTORY

Following the establishment of a Dutch colony at the Cape in 1652, many newly discovered plants were despatched to The Netherlands by botanical collectors and travellers who sojourned off Table Bay. One of the earliest of these introductions was a blue, summer-flowering perennial now known as *Agapanthus africanus*, which grew plentifully on Table Mountain and is still to be found there in abundance. It was first described by Jakob Breyne (1637–1697), the prominent Polish-born merchant, naturalist and artist from Gdańsk (formerly Danzig), using the phrase name *Hyacinthus Africanus Tuberosus, Flore caeruleo umbellato*, or, 'The tuberous African Hyacinth with umbels of sky blue flowers' (Breyne, 1680). Breyne, who considered the plant to resemble the eastern Mediterranean genus *Hyacinthus*, did not personally collect at the Cape, but included the agapanthus in his *Prodromus Fasciculi Rariorum Plantarum*, a published list of descriptions of plants he had viewed in various Dutch gardens in 1679. The agapanthus had been cultivated from seed collected by the German-born botanist Paul Hermann, later Director of the *Hortus Botanicus* in Leiden, while on a short stay at the Cape, and had flowered in 1678 in the garden of the prominent Dutch plant collector, Hiëronymus van Beverningh. It was listed in the Catalogue of the *Hortus Botanicus* in Leiden in 1687, and flowered in Amsterdam in the *Hortus Medicus*, one of the most important collections of exotic plants in Europe (Wijnands, 1983). Numerous 'varieties' of *A. africanus* were eventually described, many of which were ultimately referred to other species, mainly to *A. praecox*.

The earliest published illustration of an agapanthus is that of the English botanist Leonard Plukenet (1642–1706), Royal Professor of Botany and gardener to Queen Mary, whose monochrome engraving of *A. africanus* appeared in 1692 as figure 1 of a composite plate (t. 195) in part 3 of his *Phytographia*. It was accompanied by the phrase name *Hyacintho affinis, tuberosa radice, Africana, umbella caerulea inodora*, or 'The African plant allied to *Hyacinthus*, with a basal tuber and sky blue scentless umbels' (Plukenet, 1691–1692) (Figure 1). The depicted plant had been cultivated at Hampton Court Palace, and there is a reference to an elegant illustration of it in the *Codex Bentingiana*, a collection of illustrations compiled from rare plants and insects in the garden in Holland of the Dutch and English nobleman, Hans Willem Bentinck (1649–1709), Ist Earl of Portland. Unfortunately, the current whereabouts of this codex is unknown.

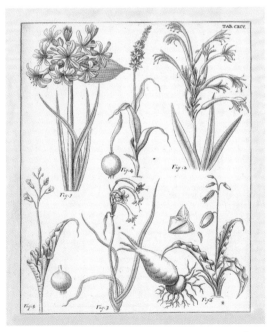

Figure 1. Engraving of *Agapanthus africanus* in part 3 of Leonard Plukenet's *Phytographia*, plate 195, figure 1 (upper left corner) (1692).

Claude Aubriet (1665–1742), the Frenchman who later became royal painter to the Sun King Louis XIV, illustrated the 'African Hyacinth' growing in the Jardin du Roi in Paris in 1700. His watercolour on vellum, set against a landscaped background, was included as plate 12 in volume 10 of his Collection des vélins du Muséum national d'histoire naturelle, and depicts a flowering plant with the cut inflorescence placed alongside it, and, unusually, with the leaves extending beyond the demarcated painted area of the work. It is complemented by dissections of the flowers, a ripe capsule and seeds. The first published watercolour of *A. africanus* was by the Dutch botanical artist Jan Moninckx, and appeared in 1698 on plate 15 in volume 4 of the *Moninckx Atlas*, from material grown in the *Hortus Medicus* in Amsterdam. In 1701, a masterful engraving of the plant, probably by the German-born illustrator Maria Sibylla Merian, appeared as figure 67 in volume 2 of the Dutch botanist Caspar Commelin's *Horti Medici Amstelodamensis Rariorum* (see frontispiece). More than three decades later, Caspar Commelin's compatriot, the naturalist Albertus Seba, included a stylised but unmistakeable inflorescence of the 'Afrikaansche Hyacinth' on plate 19 in volume 1 of his *Locupletissimi rerum naturalium…*, published in Amsterdam, the coloured engraving depicting a flowerhead of many buds, and ten open flowers showing prominent brown anthers (Seba, 1734).

In 1737, Carolus Linnaeus published two works on the private garden of the wealthy Dutch banker George Clifford III, located at Hartekamp south of Haarlem: these were his *Hortus Cliffortianus*, a catalogue of the plants, and *Viridarium Cliffortianum*, with descriptions of the plant holdings. In both publications he described the agapanthus using the phrase name *Polianthes floribus umbellatis*, comparing it with *Polianthes tuberosa* from Mexico, with its vaguely similarly-shaped flowers. Two years later, a second edition of Jakob Breyne's work, *Prodromi fasciculi rariorum plantarum primus et secundus*, was published, this time illustrated with engravings by his artist son Johann Philipp Breyne (1680–1764) from his folio of Cape plants, including an excellent portrayal of the agapanthus in figure 1 on plate 10, depicting an inflorescence and leafing plant (Breyne, 1739) (Figure 2).

The 'African Hyacinth' received its first binomial, *Crinum africanum*, in 1753, described by Carolus Linnaeus in the first volume of his *Species Plantarum*, in which he made reference to its 'sublanceolate, flat leaves and obtuse corolla'. Other than the words 'Habitat in Aethiopia', no detail

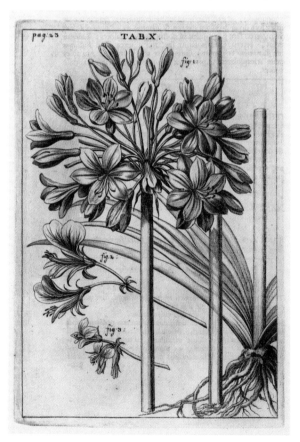

Figure 2. Engraving of *Agapanthus africanus* by Johann Philipp Breyne in his father Jakob Breyne's *Prodromi fasciculi rariorum plantarum primus et secundus*, from his folio of Cape plants, plate 10, figure 1 (1739).

exists of precisely where it was collected, and a sheet (415.6) in the Linnaean Herbarium comprising two flowering stems, was designated as the type by Frances Leighton (1965) in her monograph *The Genus* Agapanthus *L'Héritier*, and confirmed as the lectotype by Jarvis (2007). In 1755, the German botanist Lorenz Heister linked the phrase name *Hyacinthus Africanus Tuberosus* with the description of his genus *Tulbaghia* Heist., but ultimately the generic name *Agapanthus* was conserved over *Tulbaghia* at the seventh International Botanical Congress held in Stockholm in 1905. In 1760 the English botanist Philip Miller published a coloured engraving of a robust form of *A. africanus* on plate 210 in volume 2 of his *The Gardeners Dictionary,* but instead of recognising the published binomial (*Crinum africanum*) for it, he used Linnaeus's earlier phrase name *Polianthes floribus umbellatis,* but later reverted to *Crinum africanum* in the eighth edition of his work (Miller, 1768).

The Frenchman Charles-Louis L'Héritier de Brutelle (1746–1800) established the genus *Agapanthus* in his *Sertum Anglicum,* a book in French comprising 36 text pages and 35 plates, published in stages in Paris between 1789 and 1792 (although 1788 is given on the title page, the starting year of publication is 1789). His description of the genus was based on specimens of *A. africanus* he had seen in London while visiting the eminent naturalist and scientist Sir Joseph Banks, in Soho Square, accompanied by the young flower painter, Pierre-Joseph Redouté. The book contains a collection of 125 plants mostly seen by L'Héritier in gardens around Paris and London (especially at Kew), during 1786 and 1787, some of which were illustrated (excluding *Agapanthus*), mostly by Redouté and James Sowerby. A facsimile edition of this work, with an English translation, and introductory essays on L'Héritier (by F.A. Stafleu), the plants (by J.S. Gilmour, C.J. King and L.H. Williams) and the illustrators (by Wilfrid Blunt) was published as the first number in the *Hunt Facsimile Series* by The Hunt Botanical Library, Pittsburgh, Pennsylvania (Lawrence, 1963) (Figure 3). L'Héritier, a keen amateur botanist and prolific author of new genera and species, was a magistrate and state tax lawyer both under the old regime and in post-revolutionary France, and, born into an aristocratic family, was imprisoned and narrowly escaped execution during the Reign of Terror in 1792. No illustrations of him exist, since he steadfastly refused any portraits, and at the age of 54, lost his life near his Paris home to an unknown assassin (Stafleu, 1963). The derivation of *Agapanthus* is from the Greek *agapé* (love) and *anthos*

Figure 3. Page 17 of Charles-Louis L'Héritier de Brutelle's *Sertum Anglicum,* in which the genus *Agapanthus* first appeared (1789).

(flower), the 'flower of love'. Alternatively, the Greek *agapeo*, meaning 'to be well contented with', and *agapetos*, meaning 'beloved' or 'desirable', are possible other derivations. The rationale behind the name *Agapanthus* has been lost, as it is not precisely known what inspired L'Héritier to name his genus, however, Sir Joseph Paxton in his *A Pocket Botanical Dictionary* considered the name an 'allusion to the lovely and showy flowers' (Paxton, 1840). In describing the first species under the genus *Agapanthus*, L'Héritier erred in naming it *A. umbellatus*, since it had already been afforded the specific epithet *africanus* by Linnaeus (1753) in his *Species Plantarum*. This mistake led to untold confusion, which has prevailed for more than two centuries among gardeners, nurserymen, horticulturists, taxonomists and researchers, a lamentable situation which largely continues to the present. Following L'Héritier's publication of *A. umbellatus*, the confusion was initially unwittingly carried forward by William Curtis in his text on *A. umbellatus* (*A. africanus*) in volume 14 of *The Botanical Magazine* (Curtis, 1800) (Figure 4), in which he stated that only one species of *Agapanthus* was known at that time, however the flowering specimen in the accompanying colour plate (t. 500) by Sydenham Edwards, is clearly a

different species, *A. praecox,* confirmed by its broad, glaucous leaf. The two species have superficially similar flowers, but *A. africanus* has thick-textured tepals and *A. praecox* relatively thin-textured ones, and they are at once distinguished by their leaves, *A. africanus* producing fans of leathery, erect or suberect leaves, and *A. praecox* having mostly arching, relatively soft-textured and usually broader ones. Consequently, *A. africanus* and *A. praecox* whose distribution ranges do not overlap in the wild, both came to be known in cultivation as *A. umbellatus,* a name which was strictly inapplicable to either of them. Following Curtis's publication, the mistake was perpetuated by prominent authors and artists alike, including Redouté on plate 4 of *Les Liliacées* (volume 1) in 1803, and plate 403 of *Les Liliacées* (volume 7) in 1813, in which both were identified as *A. umbellatus* (*A. africanus*) but depict *A. praecox,* and continues to the present, particularly by researchers, for example González *et al.* (1975), Mori & Sakanishi (1989) and Reis *et al.* (2014) whose research material was identified as *A. africanus*, but almost certainly was *A. praecox*. The mistake was formally rectified by the German botanist Count Johann Centurius von Hoffmannsegg, who proposed the new

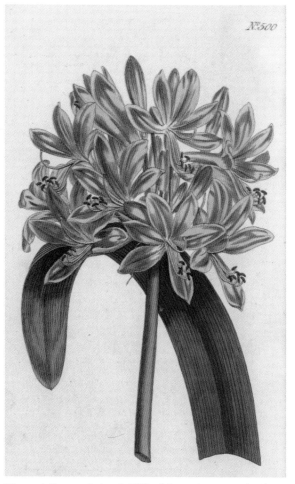

Nº500

Figure 4. Engraved plate (t. 500) of *Agapanthus praecox* (as *A. umbellatus*) in volume 14 of *The Botanical Magazine* by Sydenham Edwards (1800).

combination *Agapanthus africanus* (L.) Hoffmanns. in his book *Verzeichniss der Pflanzenkulturen in den Gräfl. Hoffmannseggischen Gärten zu Dresden und Rammenau*, published in Dresden, and *A. africanus* thus became the type species of the genus (Hoffmannsegg, 1824). However, the change was not taken note of for more than a century thereafter. With the introduction into cultivation in the early and late 19th century of plants later to become known as *A. campanulatus* and *A. patens*, respectively, the confusion was compounded, with both regarded as varieties of *A. umbellatus*.

The second *Agapanthus* species to be discovered was the evergreen *A. praecox*, and its popularity in cultivation quickly displaced the much less easily grown *A. africanus*. It was described in the early 19th century by Carl Ludwig von Willdenow, the German botanist and Director of the Botanical Gardens in Berlin. The publication appeared in his *Enumeratio plantarum Horti Regii Berolinensis,* from material he collected at an unspecified locality at the Cape, and the type specimen, comprising a single inflorescence and leaf, resides in the Berlin Herbarium (Willdenow, 1809). In 1823 the English botanist J. B. Ker Gawler described *Agapanthus umbellatus* var. *minimus* on plate 699 of *The Botanical Register*, from material said to have been imported from an unrecorded location at the Cape, which flowered in the nursery of Mr Colvill of King's Road in Chelsea, London. Previously, John Lindley was erroneously assumed to be the author of *A. umbellatus* var. *minimus* (rectified in Duncan, 2005) and it later became *A. praecox* subsp. *minimus*. The plant had much smaller, light blue flowers and narrower leaves than other forms of *A. praecox* already in cultivation in England, and the accompanying painting by M. Hart compares well with forms of the plant known from Knysna in the southern Cape. Subsequently, Leighton described a different form of this plant from Adelaide in the Eastern Cape as *A. longispathus* (Leighton, 1934), and later re-assessed it, along with Ker Gawler's plant and other small-flowered forms, as *A. praecox* subsp. *minimus*, with plate 699 in *The Botanical Register* as the type (Leighton, 1965). For much of the 19th century, all agapanthus were regarded as varieties of *A. umbellatus*, and in the text accompanying his new variety *Agapanthus umbellatus* var. *maximus*, John Lindley (1843) expounded upon the confusion surrounding the identity of agapanthus species then known, as follows:

> 'With regard to the species, these are so little understood that, although this (*A. umbellatus* var. *maximus*) may well be distinct from *A. umbellatus* (*A. africanus*), we have no materials for defining it, and therefore we leave it to our successors; possibly it may be the *A. multiflorus* of Willdenow. Mr Harvey says there are several species in the Cape Colony; it would be well worth anyone's while to collect and compare them, so as to settle the distinctions that exist'.

In 1843, Lindley described *A. umbellatus* var. *maximus* on plate 7 in volume 29 of *Edwards's Botanical Register*. The plant was of unknown wild origin, grown in the nursery of Mr Groom of Clapham Rise, London, and the accompanying colour illustration by Sarah Drake shows a dense, rounded inflorescence of large blue flowers, a broad leaf, and a reduced version of the whole plant (see Figure 195 on page 171). A plant comparable with this one was later described as *A. orientalis* by Frances Leighton in the *Journal of South African Botany* (Leighton, 1939a) and subsequently re-assessed by her as *A. praecox* subsp. *orientalis* (Leighton, 1965). Even relatively recently in South Africa, uncertainty surrounded the name *A. umbellatus*, as seen in plate 1 in volume 1 of *The Flowering Plants of South Africa*, which clearly depicted *A. praecox* (subsp. *orientalis*) but was misidentified as *A. umbellatus* (Phillips, 1920). Although an elucidatory paper dealing with the true *A. africanus* appeared in *The New Plantsman* (Andrews & Brickell, 1999), the name frequently continues to be incorrectly applied. In his treatment of *Agapanthus* in *Flora Capensis*, J.G. Baker recognised *A. umbellatus* as the only species, with four varieties, var. *multiflorus* (*A. praecox*), var. *praecox*, var. *minor* (= *A. africanus*) and var. *leichtlinii* (= *A.*

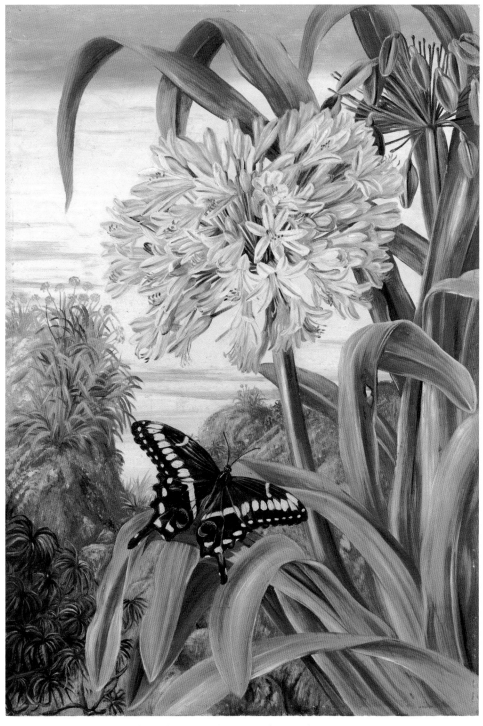

Figure 5. 'Blue Lily and large butterfly, Natal', oil painting of *Agapanthus praecox* by Marianne North, painted in South Africa between 1882–1883, plate 357 in the Marianne North Gallery at Kew.

africanus), and stated that these varieties 'are connected by gradual intermediates' (Baker, 1897). One of the most familiar depictions of *A. praecox* is the English botanical artist Marianne North's oil painting titled 'Blue Lily and large butterfly, Natal', painted between 1882–1883 in South Africa, which hangs as plate 357 in the Marianne North Gallery at Kew (Figure 5). Another well-known rendition of *A. praecox* is Claude Monet's early 20th century impressionist work, showing the agapanthus flowering beside waterlilies in his garden at Giverny in northern France.

The third *Agapanthus* species, *A. caulescens*, a striking, deciduous, summer-growing plant, was described in 1901 by the German botanist and horticulturist Carl Sprenger in volume 50 of the gardening periodical, *Gartenflora*. It was accompanied by a chromolithograph by Emil Laue on plate 1487, showing a stylised flower head and single obtuse-tipped leaf, and a reduced version of the whole plant in monochrome, illustrating the distinctive robust, caulescent pseudostem, with characteristic basal sheathing leaves. It had been cultivated at Sprenger's nursery in the neighbourhood of Vomero in Naples, Italy, where he lived, from seed collected in about 1898 at an unrecorded locality in the Drakensberg by a friend named Dietrich, and which had taken three years to flower (Sprenger, 1901). Although Sprenger lost many of his plants as a result of an eruption of Mt Vesuvius in 1906, it is thought that material of his *A. caulescens* was passed to Glasnevin Botanic Garden in Dublin, and from there to Kew and Kirstenbosch (Leighton, 1965).

The Swiss botanist Gustave Beauverd (1867–1942) described the fourth *Agapanthus* species, the deciduous, usually tubular-flowered *A. inapertus,* in volume 2 of the *Bulletin de la Société Botanique de Genève* (Beauverd, 1910). Prior to his formal description, the plant had already been introduced into cultivation in The Netherlands under the name *A. weillighii* by the nurseryman C.G. van Tubergen, from plants collected at an unrecorded location, probably along the Eswatini (formerly Swaziland)-Mozambique border in about 1898, by the South African surveyor and amateur botanist of German descent, Gideon R. von Wielligh (1859–1932). Von Wielligh sent material to the German horticulturist Max Leichtlin at Baden-Baden, where he established a private botanical garden, and it was published as *A. weilligii* (species name incorrectly spelt, should have been *wiellighii*) in *The Gardeners Chronicle* (May, 1913), but being a later name, the earlier-published *A. inapertus* took precedence. The type plant was collected by Swiss-born South African missionary Henri-Alexandre Junod near Shiluvane southeast of Tzaneen in east-central Limpopo (South Africa's most northerly province) in 1903. Junod sent it to L'Herbier Boissier (the Boissier Herbarium) in Geneva, where it was cultivated and flowered for the first time in September 1910. Beauverd illustrated the species by means of his own composite line drawing, showing a reduced version of the whole plant in flower, with enlarged floral dissections. He considered his *A. inapertus* to be the third species of the genus and provided updated text on *A. africanus* and *A. caulescens*, but mistakenly regarded *A. praecox* and several of its forms as varieties of *A. africanus* (Beauverd, 1910). The first illustration of *A. inapertus* (subsp. *inapertus*) to be published in colour was a lithograph by the British botanical artist Lilian Snelling, showing blue and white forms originally distributed by Max Leichtlin, and cultivated in the Glasnevin Botanic Garden, Dublin, which appeared on plate 9621 in *Curtis's Botanical Magazine* (Sealy, 1940–1942) (Figure 6).

Agapanthus walshii, endemic to the south-western Cape and the only evergreen species with tubular or trumpet-shaped flowers, was first recorded by Albert Walsh (1853–1930), an English pharmaceutical chemist, in January 1918. He found it in the vicinity of Steenbras Railway Station, at the southern foot of Sir Lowry's Pass east of Cape Town, a short distance from the road that provides access over the Hottentots Holland Mountains. Known as Hottentot's-Holland 'kloof' in the eighteenth and early nineteenth centuries, this road provided one of the most important routes from Cape Town to the interior, traversed by many prominent botanists and plant collectors of the time, who, remarkably, had

not detected the plant. It was described by Louisa Bolus in volume 3 of the *Annals of the Bolus Herbarium*, along with another species, *A. pendulus* from Lydenburg, Mpumalanga, later to become *A. inapertus* subsp. *pendulus*. Both plants were minimally illustrated with monochrome sketches by Mary Page showing the apex of a scape with a solitary flower (Bolus, 1923). In the early 1940s, a second collection of *A. walshii* was made in the same area at Steenbras, and in March 1969 John Rourke came across a small colony of plants on the eastern foothills of the Kogelberg Mountain range above Steenbras Dam, at an altitude of about 730 m. Flowering material of the typical blue forms was later collected from this population and illustrated in watercolour by Fay Anderson in volume 42 of *The Flowering Plants of Africa* (Rourke, 1973). A rare white form of this species was subsequently collected by G. Gerber in 1977 near the same locality and cultivated in the bulb nursery at Kirstenbosch, where it flowered for the first time in November 1981 (Duncan, 1983).

The year 1934 saw the publication of three more *Agapanthus* taxa in the

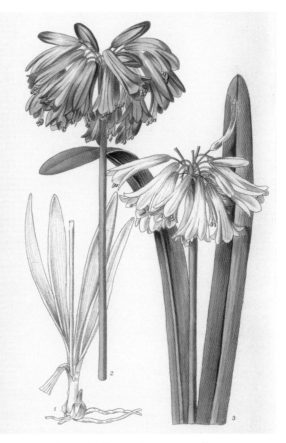

Figure 6. Lithograph of *Agapanthus inapertus* subsp. *inapertus* by Lilian Snelling, plate 9621 from *Curtis's Botanical Magazine* (1940–1942).

periodical *South African Gardening and Country Life*: the widespread and deciduous *A. campanulatus*, mainly from KwaZulu-Natal; the tall, deciduous, tubular-flowered *A. hollandii* from Mpumalanga (later to become *A. inapertus* subsp. *hollandii*) and *A. longispathus* from Adelaide in the central Eastern Cape (later to be incorporated into *A. praecox* subsp. *minimus*) (Leighton, 1934). More than half a century prior to its formal publication, *A. campanulatus* had already been in cultivation at the Durban Botanic Gardens, from plants collected by the Curator Wilhelm Keit in the early 1870s. In 1939, Leighton described the evergreen *A. orientalis* (after to become *A. praecox* subsp. *orientalis*) in the *Journal of South African Botany*, from type material collected in 1932 at Port St Johns, Pondoland in the Eastern Cape by the South African botanist Neville Pillans (Leighton, 1939a). Forms of this plant are by far the most commonly cultivated of all agapanthus, ubiquitous in gardens over much of South Africa, and intraspecific hybrids have become naturalised in temperate parts around the world including Australia, California (USA), Canary Islands, Cornwall and the Isles of Scilly (UK), Ethiopia, Jamaica, Madeira, Mexico, New Zealand, St Helena and Tasmania, and have even gained a foothold in humid forests of Brazil (Duncan, 2003). Leighton also published a brief review of the genus *Agapanthus* in volume 6 of *Herbertia* and stressed the need, for purposes of taxonomy, to work with material collected in the field, rather than from cultivation, due to its tendency to become gross, and hybridise (Leighton, 1939b). Six

years later, she described two more deciduous taxa, *A. patens,* a high altitude plant with widely flared tepals, later to become *A. campanulatus* subsp. *patens*, and *A. gracilis* (later *A. caulescens* subsp. *gracilis*) mainly from KwaZulu-Natal (Leighton, 1945).

The Hon. Lewis 'Luly' Palmer (1894–1971), the English plantsman and a former Vice President of the Royal Horticultural Society, began selecting hardy agapanthus in the south of England at his home at Headbourne Worthy near Winchester, Hampshire, in the mid-1940s, and published authoritative articles on the species and cultivars in the *Journal of the Royal Horticultural Society* (Palmer, 1954; 1956; 1967) (Figure 7). On a visit to Kirstenbosch directly after WW2, he viewed the extensive collection of wild-collected evergreen and deciduous agapanthus cultivated by Frances Leighton, flowering in the nursery beds, and was subsequently given a range of open-pollinated seed harvested from the best forms, by the Director, R. H. Compton. Palmer raised some 300 seedlings from these, and when they began flowering in their third season, he became aware that all were hybrids, some of which combined the hardiness of the deciduous species with the larger flower heads of the evergreens (Palmer, 1967). He greatly promoted the cultivation of agapanthus in the United Kingdom in the 1940s and 1950s, and found that in the relatively mild Hampshire climate, and subsequently in various other parts of the U.K., including the Royal Botanic Garden Edinburgh, the hybrids could be grown outdoors with ease, provided they were sufficiently well mulched in winter. Palmer made selections from these hybrids, which must have included the deciduous *A. campanulatus* and *A. inapertus*, and the evergreen *A. praecox*, which ultimately became known as 'Headbourne Hybrids', a strain of deciduous, blue-flowered plants, from which selections were made. Some of these are still in cultivation at Howick Hall Gardens and Arboretum in Northumberland, home of Lord Charles Howick, Lewis Palmer's great nephew, where they have been growing across a terrace since the 1950s (Lord Charles Howick, pers. comm.).

Prior to the present account, Frances Margaret Leighton (1909–2006, married surname Isaac) produced the only comprehensive taxonomic revision of the genus *Agapanthus*, published in 1965. Born in King William's Town in South Africa's Eastern Cape, she was the daughter of James Leighton, Scottish horticulturist from Aberdeenshire who worked at Kew from 1878 to 1880, and settled in King William's Town, where he was Curator of the local botanical garden from 1881 to 1887. Frances Leighton attended Rhodes University in Grahamstown (now Makhanda), graduating with a B.Sc., and

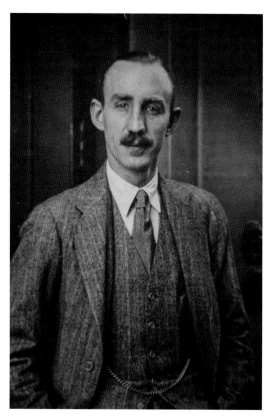

Figure 7. The Hon. Lewis Palmer (1894–1971), breeder of the 'Headbourne Agapanthus Hybrids', *circa* early 1920s. Image: courtesy of Howick Hall Gardens and Arboretum, Northumberland.

joined the staff of the Bolus Herbarium as a Botanical Assistant at the University of Cape Town from 1931 to 1947 (Gunn & Codd, 1981) (Figure 8). With the financial help of the Smuts Memorial Scholarship Fund, she explored the genus *Agapanthus* in great detail in the wild and in cultivation, studied dried material from major herbaria, and greatly augmented the collection of preserved material at the Bolus Herbarium. In addition, she assembled the most comprehensive living collection of habitat accessions ever made, at Kirstenbosch, many of which continue to be grown there (Duncan, 1985; Dyer, 1966a, b).

Leighton researched the genus *Agapanthus* for more than 30 years, and the typescript of her work was completed shortly before she left South Africa in 1961 for Nairobi, Kenya with her husband, William Isaac, a specialist in marine algae and Professor of Botany at Nairobi University College, and they eventually settled in Victoria, Australia. Following her departure, the task of publication fell to three individuals at Kirstenbosch, Gwendoline Lewis (Botanical Research Officer), Winsome Barker (Curator of the Compton Herbarium) and C.E. Hugo (proof reader). The work was published as supplementary volume number 4 of the *Journal of South African Botany*, illustrated with nine

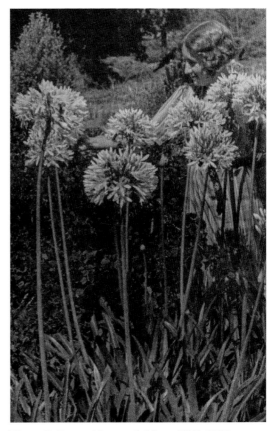

Figure 8. Frances Margaret Leighton (1909–2006), admiring *Agapanthus praecox* in the nursery at Kirstenbosch during the 1930s (reproduced from *Herbertia* vol. 6, 1939).

superb watercolours by W.F. Barker, and numerous line drawings showing the variation in floral and capsule morphology, together with monochrome photographs, maps and a diagram of relationships of the species and subspecies (Leighton, 1965). She recognised six previously published species (*A. africanus, A. campanulatus, A. caulescens, A. inapertus, A. praecox* and *A. walshii*) and described four new ones (*A. coddii, A. comptonii, A. dyeri* and *A. nutans*) as well as numerous subspecies. Considering the difficulty in classification of this genus, she did remarkably well in laying the foundation upon which subsequent researchers could build. She said:

> 'I have explored every avenue for (morphological) characters on which to base the species of *Agapanthus* and have found very few which are reasonably constant. The genus could be broken down into innumerable species or subspecies. The differences between species of *Agapanthus* are very real to the worker in the field and the horticulturist who is growing them. They lie in texture (of) the leaf and flower, in the set of the perianth, obvious in the living plant but lost in the herbarium specimen. For this reason it has been virtually impossible to draw up a key on the older taxonomic basis. As I conceive it, other techniques will have to be employed. Cytology may help to solve the problem, and I put forward my data in the hope that they may be used as a basis for further work' (Leighton, 1965).'

Leighton sent seeds of most of her species to the cytologist H.P. Riley at the University of Kentucky, USA, however only a few germinated, and no general phylogenetic conclusions could be made (Riley & Mukerjee, 1962). Unfortunately, some of the traits upon which Leighton based her species and subspecies were ambiguous, resulting in difficulty in identification.

In 1979 I began work at Kirstenbosch as a trainee horticulturist, and *Agapanthus* was included within my area of responsibility. Of great assistance to me in gaining an initial understanding of the species and subspecies of *Agapanthus* was access to the Leighton living collection being grown in open beds in the nursery, most of which were planted into the garden during the 1980s. The publication *Grow Agapanthus, a guide to the species, cultivation and propagation of the genus* Agapanthus was one of the first titles in the Kirstenbosch Gardening Series (Duncan, 1998). It comprised colour photographs of most of the taxa recognised at the time, with details of natural distribution and identification notes, accompanied by brief text on history, cultivation and propagation, and pests and diseases. Several years later, the Association Nationale des Structures D'Expérimentation et de Démonstration en Horticule, in collaboration with the Institut National de la Recherche Agronomique, produced the French publication *L'agapanthe*, a guide to its physiology and commercial production, including forcing procedures and pest- and disease management, accompanied by an extensive table of cultivars (Allemand *et al.*, 2001).

In 2003 I collaborated on a research paper with Ben Zonneveld, then a researcher of the Institute of Biology at Leiden University, in which genome size, and pollen colour and vitality, were evaluated as novel criteria in establishing relationships within *Agapanthus*. The study showed that the species could be divided into two main groups, one with lilac pollen and a relatively low nuclear DNA content, comprising *A. campanulatus*, *A. caulescens* and *A. coddii*, the other with yellow or brownish-yellow pollen and a higher nuclear DNA content, comprising *A. africanus*, *A. inapertus* and *A. praecox*. The DNA results, in conjunction with morpohological considerations, led us to conclude that three of the species (*A. comptonii*, *A. dyeri* and *A. nutans*) were respectively synonymous with *A. praecox*, *A. inapertus* subsp. *intermedius* and *A. caulescens* subsp. *gracilis*, and *A. walshii* was regarded as a subspecies of *A. africanus* (Zonneveld & Duncan, 2003; Duncan, 2004, 2005).

Two books on *Agapanthus* were published simultaneously by Timber Press during 2004. *Agapanthus for Gardeners*, by Hanneke van Dijk, a practical guide to their cultivation and propagation, included notes on a selection of 80 of the most rewarding cultivars to grow, illustrated with colour photographs. *Agapanthus*, 'A revision of the Genus' by Wim Snoeijer, a Dutch plant breeder and nurseryman, was published in association with the Royal Boskoop Horticultural Society and provided a full account of *Agapanthus* in cultivation, with a classification and extensive listing of 625 accepted cultivars, based on four flower shapes. It included details of history, morphology and synonymy, and a chapter on genome size of the species and cultivars by Ben Zonneveld, accompanied by colour photographs and a selection of historical paintings.

In 2005 I became aware that Frances Leighton, then 96 years of age, was still alive and living in Australia. I sent her a typed letter, with a copy of the *Apapanthus* paper (Zonneveld & Duncan, 2003), thanking her for her revision of the genus *Agapanthus*, and reported that several of the assumptions she had made in her monograph had turned out to be correct. Within two weeks, I received a handwritten reply, in which she conveyed best wishes for my future research, adding that she would not have been surprised if I had 'torn her work to shreds'. She had intended to send me an account of an 'hair-raising and hilarious' agapanthus collecting trip she had undertaken from Haenertsburg, Limpopo to Eswatini with the well-known Limpopo nurserywoman Sheila Thompson, during her agapanthus collecting days in the 1950s, but she died in early 2006.

2. AGAPANTHUS CULTIVARS

BRIEF HISTORY

Variously known as 'African Agapanthus', 'African Blue Lily', 'African Lily', 'Blue Agapanthus', 'Blue Lily' and 'Lily of the Nile', and in Afrikaans as 'Afrikaanse Lelie', 'Agapant', 'Bloulelie' and 'Kaapse Lelie', *Agapanthus* is one of the oldest South African plants in western-style gardens. Most of the early selections were made in England, The Netherlands, France and Germany, with many recent introductions emanating from England, The Netherlands, South Africa, New Zealand, Belgium, Australia, Northern Ireland, the USA (California) and Japan. One of the earliest known cultivars was a blue-flowered plant with variegated leaves, described by G. Sinclair in Philip Miller's *Dictionary of Gardening* as *A. umbellatus* var. *variegatus* (Miller, 1834), now a synonym of *Agapanthus praecox*. A white-flowered form of the deciduous, often high altitude and hardy, summer-growing *A. campanulatus* was also known in cultivation in the UK during the mid-1830s, but only listed for the first time much later, as *Agapanthus umbellatus* var. *albidus* in volume 1 of *Flora and Sylva* by J.W. Besant in 1903, and it has since occasionally been recorded in the wild. By 1864, a white-flowered form of the evergreen *A. praecox*, with large, full-sized heads, now known as *A. praecox* 'Albiflorus', was established in cultivation in the UK (Plate 1). It was first listed in *Paxton's Botanical Dictionary* as *A. umbellatus* var. *albiflorus* (Paxton, 1868), and has become one of the most widely grown cultivars (see page 74). In 1865 the deciduous cultivar 'Beth Chatto', a violet-blue form of *A. campanulatus* with variegated leaves, was raised at Beth Chatto Gardens in Essex, and during the same year the evergreen, white-and-glaucous-leafed, bright blue-flowered, variegated plant named 'Argenteus Vittatus' (Figure 9), a cultivar of *A. praecox*, had been introduced elsewhere in England, both of which are still often cultivated (Snoeijer, 2004). Another variegated cultivar, *A.* 'Aureovittatus', which has relatively broad leaves with yellow margins and green longitudinal median stripes, was recorded in The Netherlands in 1875 and is still in cultivation, yet several other early Dutch cultivars, including *A.* 'Albo-lilacinus', introduced in 1888, are no longer extant (Snoeijer, 2004). The evergreen cultivar 'Flore Pleno', a dwarf cultivar of *A. praecox* with light violet-blue, double-tepal blooms, was known since 1878 in France and reported several years later by the French botanist E.-A. Carrière, who illustrated it in monochrome (Carrière, 1882), and is still in cultivation. During the early 1870s, Wilhelm Keit, Curator of the Durban Botanic Gardens, discovered a very hardy form of *A. campanulatus* with widely funnel-shaped flowers and sent it to Sir Frederick Moore, Keeper of the Royal Botanic Garden at Glasnevin, Dublin in 1879. It was thought to have been collected in the eastern Free State, known for its very cold winters, and Keit gave it the manuscript name *A. mooreanus*, for David Moore, Sir Frederick's father (Nelson, 2016). It later appeared in print as *A. umbellatus* var. *mooreanus*, along with seven other varieties of *A. umbellatus* in *The Illustrated Dictionary of Gardening* (Nicholson, 1884), where it was described as being of dwarf stature, with dark blue flowers, and perfectly hardy. It has undoubtedly been the cardinal deciduous parent in the development of the hardy cultivars. Other key parents are the many forms of the evergreen *A. praecox,* and certain subspecies of the deciduous *A. inapertus*, however the precise parentage of most cultivars is unknown, due to incomplete or absent records. In L.H. Bailey's *Standard Cyclopedia of Horticulture*, 18 varieties of *A. umbellatus* were

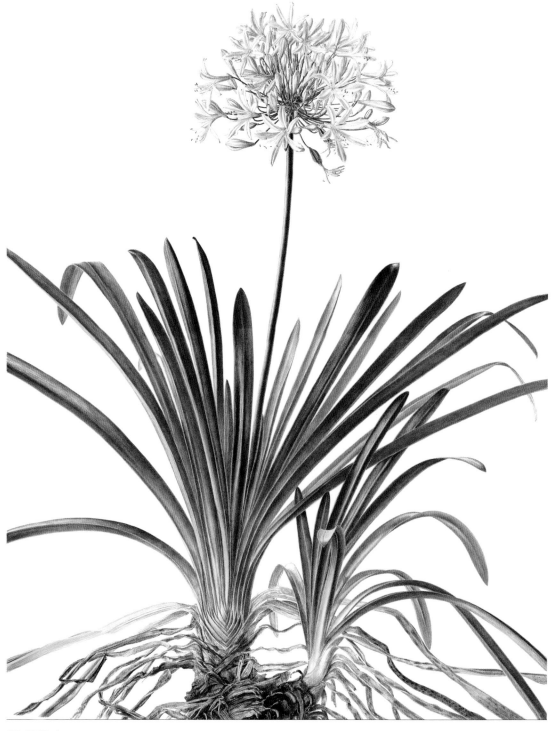

PLATE 1 Artist: Elbe Joubert

Watercolour painting of *Agapanthus praecox* 'Albiflorus' (*ex hort* Kirstenbosch, NBG 1316/83).

Figure 9. *Agapanthus praecox* 'Argenteus Vittatus', in cultivation at Kirstenbosch, from plants obtained in the Canary Islands. Image: Graham Duncan.

listed, among which it is evident that at least four species (*A. campanulatus*, *A. caulescens*, *A. inapertus* and *A. praecox*) were already well established in cultivation (Bailey, 1914), and by the mid-1920s, a number of these varieties were being offered for sale by the New Zealand nursery Duncan & Davies, Ltd. (Duncan & Davies, 1925).

Following The Hon. Lewis Palmer's agapanthus selection work during the 1940s, the Royal Horticultural Society (RHS) Wisley Garden trialled 60 of the hardy *Agapanthus* hybrids (Headbourne Hybrids) he had raised, some of which are still in cultivation in RHS gardens, such as at Rosemoor (Figure 10). These included *A.* 'Lady Grey', named for his sister, a violet-blue-flowered plant with widely funnel-shaped blooms, which received an Award of Merit in 1951, and in 1954 the tall-growing cultivar *A.* 'Lewis Palmer', with large, rounded heads of greenish-blue, nodding, funnel-shaped blooms was introduced by the RHS and received an Award of Merit that year. A subsequent five-year Wisley Agapanthus Trial comprising a total of 71 accessions was held from 1972 to 1977, of which 60 emanated from Palmer's plants (Figure 11) (Bond, 1978). The celebrated name 'Headbourne Hybrids' is, unfortunately, often misapplied to an assortment of seed-propagated plants in the nursery trade, which are not necessarily derived from Palmer's plants. In 1978, an agapanthus trial was established in The Netherlands at the Experimental Station for Floristry at Aalsmeer, in which 58 cultivars were included, classified into five groups based on five different perianth shapes (tubular, trumpet, funnel, salver and intermediate)(Gillissen, 1980). In the most recent RHS trial of agapanthus, the deciduous, tall-growing cultivar with dense, rounded heads of violet-blue, funnel-shaped flowers, *A.* 'Luly' (Palmer's nick-name and originally raised by him), received a First Class Certificate in 1977, and an Award of Garden Merit in 2018 (Skelmersdale, 2019).

Figure 10. *Agapanthus* 'Headbourne Hybrid' in Lady Anne's garden at the Royal Horticultural Society Garden, Rosemoor, Devon.
Image: Graham Duncan.

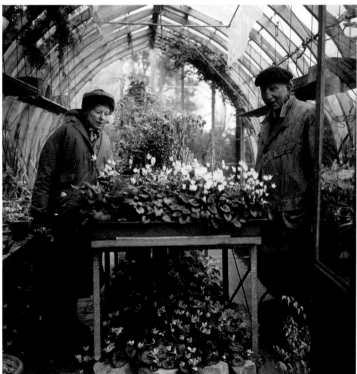

Figure 11. The Hon. Lewis Palmer in the greenhouse at Headbourne Worthy, Hampshire, with Mrs C. Saunders, *circa* 1960s.
Image: Valerie Finnis (1924–2006), courtesy of the Royal Horticultural Society Lindley Collections.

Dick Fulcher, formerly Head Gardener at Inverewe Gardens, Scotland, established the first National Collection of *Agapanthus* in the UK during the 1980s. In 1994, while Head Gardener at Bicton College in Devon, he began selecting new cultivars from large batches of seedlings from this collection. Following his departure from Bicton in 1996, he began his own nursery business with his wife Lorna at Pine Cottage Plants in Devon, and continued his agapanthus work, adding cultivars to his collection from within the UK and The Netherlands, as well as some from Kirstenbosch. His main objectives in breeding were to expand the colour range, and extend the flowering season, using both evergreen and deciduous species, and he made several visits to observe agapanthus in their natural habitats (Fulcher, 2000; 2018). He has bred dozens of outstanding cultivars, many of which have received an Award of Garden Merit. These include 'Northern Star', a deep blue-flowered plant with widely flared blooms produced in well-rounded flower heads, the tall-growing 'Eggesford Sky' with striking light blue flowers produced in large, rounded heads, and the recently introduced 'Flower of Love', an early-blooming and fully hardy, deciduous, deep blue-flowered plant with a compact growth habit. In 2003 he obtained European Union plant breeder's rights for 'Northern Star', one of his best productions, which, along with many of his other cultivars, has since been distributed by Patrick Fairweather of Fairweather's Hilltop Nursery in Hampshire, Europe's leading grower of agapanthus. Fulcher was made a Royal Horticultural Society Associate of Honour for his contribution to horticulture in 2012, and Pine Cottage Plants was holder of one of the Plant Heritage National Collections of Agapanthus for 20 years until 2017. Now in retirement, he and his wife continue to grow a collection of Pine Cottage named agapanthus cultivars for the National Council for the Conservation of Plants and Gardens (NCCPG), which are on display to the public in summer (Figure 12).

During the early 1980s I began selecting some of the better forms of wild-collected material assembled by Frances Leighton at Kirstenbosch, and published an article on the horticultural potential of *Agapanthus* species, introducing ten cultivars from the Kirstenbosch collection (Duncan, 1985). These included the bright blue, dwarf evergreen *A. praecox* 'Adelaide', the deep violet-blue, deciduous *A. inapertus* subsp. *pendulus* 'Graskop', and the semi-deciduous *A.* 'Lydenburg', at that time regarded as a form of *A. inapertus* (subsp. *hollandii*), but subsequently thought to be a probable hybrid between a wild form of *A. inapertus* and a locally cultivated form of *A. praecox* (Zonneveld & Duncan, 2003) (Plate 2).

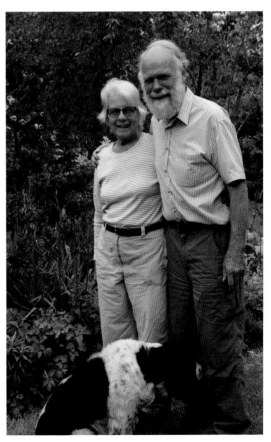

Figure 12. Dick and Lorna Fulcher in the garden, Pine Cottage Plants, Devon. Image: Graham Duncan.

PLATE 2

Artist: Elbe Joubert

Watercolour painting of *Agapanthus* 'Lydenburg' from Alkmaar, Mpumalanga (*Beetge s.n.*, NBG 461/44).

The Cape Town horticulturist Richard Jamieson began breeding agapanthus in 1985 by initially sowing several thousand seeds harvested from open-pollinated flowers of *A.* 'Selma Bock', a striking bicoloured, evergreen plant with white tepals and blue perianth tubes (Figure 13). Seedlings were established in seed trays and planted out into open fields. When they flowered, a very low percentage were considered to have any value in breeding, and selections were made for strong colour (blue, lilac, mauve, purple) and a dwarf, evergreen growth habit. He found that results obtained from deliberate hand-pollinated crosses of forms with desirable traits to be not nearly as successful as compared with those obtained from open-pollination. Clones were initially increased vegetatively and multiplied on large scale in tissue culture. Within about ten years, he was able to start marketing named cultivars, among which some of the most striking are 'Blue Flare' with upright, light blue flowers, 'Full Moon', with large, light blue flowers in a compact, rounded head, and 'Croft's Pearl' with long-lasting metallic blue flowers which do not open, but remain in bud stage.

In his classification of the cultivars of *Agapanthus*, Wim Snoeijer (2004) provided an alphabetical listing of 625 cultivars known up until 2004, with synonyms, and details of origin, etymology, plant description, references to illustrations in literature, awards of merit, and included colour photographs of 97 cultivars. He largely followed Gillissen (1980; 1982) in his interpretation of perianth shape (tubular, funnel, trumpet and salver), but dispensed with Gillissen's 'intermediate' perianth shape. Both authors referred to flowers with widely spreading tepals as 'salver-shaped', however Stearn (1992) defines 'salver-shaped' (hypocrateriform) as flowers in which the tube is long and slender,

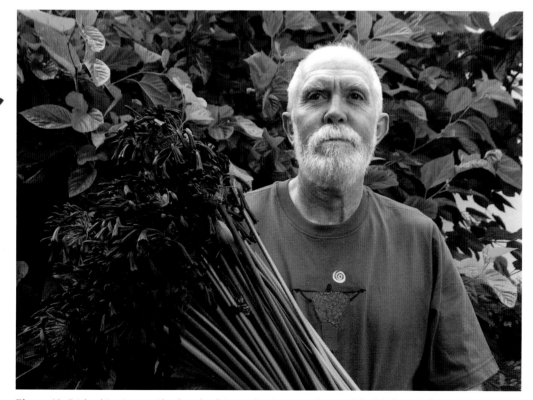

Figure 13. Richard Jamieson with a bunch of *Agapanthus inapertus* subsp. *pendulus* 'Black Magic'.
Image: Hanneke Jamieson.

and abruptly expanded into shorter, flat limbs (tepals). The tepals in agapanthus are never abruptly expanded into flat orientation, and the term 'widely funnel-shaped' is preferred in the present work, replacing 'salver-shaped' (see page 128). Similarly, the interpretation of 'trumpet-shaped' in the present work differs from that used by Gillissen (1980, 1982) and Snoeijer (2004) in that it refers only to perianths which are slightly recurved at the very tips. In his chapter on genome size in *Agapanthus* species and cultivars in Snoeijer (2004), Zonneveld (2004) found that, based on nuclear DNA content and perianth shape, four groups could be distinguished among the 130 artificial cultivars measured: deciduous plants with a 'salver'-shaped perianth ranged from 21.9–22.8 pg, suggesting they were derived from *A. campanulatus*, or were the result of repeated back-crosses and selection for 'salver'-shaped flowers; plants with mostly evergreen leaves and funnel-shaped perianths, but sometimes with trumpet-shaped perianths, ranged from 24.4–25.4 pg, suggesting they were mostly derived from *A. praecox*; 'intermediate' plants ranged from 22.9–24.4 pg and were mostly deciduous, with trumpet-shaped perianths, and fell between the 'salver'- and funnel-shaped groups; and the fourth group was assumed to comprise plants derived from *A. inapertus* with tubular perianths, but nuclear DNA amounts were not provided.

Patrick Fairweather's initial interest in agapanthus was sparked when his father returned from New Zealand in 1990 with two varieties, 'Fragrant Glen' and 'Fragrant Snow', which were allegedly fragrant. When they flowered, their scent was not easily detectable, but Patrick and his father were impressed with the plants anyway, and launched them as 'Glen Avon' and 'Snow Cloud' respectively, at Fairweather's Wholesale Nursery in Hampshire, and both remain in the Fairweather's range as reliable evergreen cultivars (Figure 14). When Dick Fulcher bred 'Northern Star', Fairweather's was chosen to launch the plant to the wholesale trade, and the size of its flower, and its hardiness, subsequently attracted much attention. Fairweather's sells 500,000 agapanthus each year which are produced at their nursery in Beaulieu, with sales throughout Europe. Most plants are grown from tissue culture, and LED lights are used during the winter months to enable year-round production. The wholesale range of 50 cultivars is supplied in 3 cm and 6 cm plugs and 9 cm pots, and the nursery holds a National Collection of 550 *Agapanthus* species and cultivars, which are grown in reference beds and pots.

Among the National Plant Collections administered by Plant Heritage in the United Kingdom, six are dedicated to *Agapanthus*. These include two collections of Pine Cottage cultivars, one held by Dick and Lorna Fulcher at Pine Cottage Plants in Devon, the other by Ruth Penrose at Bowdens Hosta Nursery in Devon; the Nursery Trials Collection is held by Patrick Fairweather in Hampshire; the pre-2005 Collection of cultivars is held by Mike Grimshaw at Cam, Gloucestershire; the collection of Hoyland hybrids, variegated and special interest agapanthus is held by Steven Hickman in South Yorkshire; and the Bali-Hai Collection is held by Ian Scroggy in Carnlough, Northern Ireland. During 2018, *Success with Agapanthus*, a guide to the cultivation and propagation of agapanthus cultivars in the UK was authored by the father and son team Steven and Colin Hickman of the Hoyland Plant Centre in Yorkshire (Hickman & Hickman, 2018).

A recent RHS Agapanthus trial comprising entries submitted by nurseries in the UK and Europe, took place from 2015–2018, run by an Agapanthus Trials Assessment Forum, chaired by Patrick Fairweather. It comprised a total of 185 entries, of which 152 were hardy and mostly deciduous, as well as hardy evergreen selections, planted in open ground in the Trials Field at Wisley. In 2016, a further 33 less hardy, mainly evergreen cultivars were planted in containers at Fairweather's Nursery, where they were over-wintered in tunnels and moved out into the open in spring. The objectives of the trial were to assess a wide range of cultivars grown in open ground and in containers, according to flowering time and length of flowering, colour of the flower and shape and fullness of the flowerhead,

Figure 14. Patrick Fairweather among the agapanthus, Fairweather's Nursery, Hampshire. Image: FhF GreenMedia.

as well as the balance between flowerhead and leaves, the manner in which the flowerhead fades, the robustness of the scape, leaf quality and infructescence appeal. The plants were viewed at each site up to three times per year in each year, and the aims were to recommend the Award of Garden Merit (AGM) to outstanding cultivars for garden use; to demonstrate cultivation practices to garden visitors; and to provide an opportunity to obtain plant descriptions for the RHS Herbarium. The forum recommended the Society's Award of Garden Merit to 55 entries (18 evergreen cultivars and 37 deciduous or semi-deciduous ones); some of which were recommended subject to availability, and reconfirmed the award for the deciduous cultivar 'Loch Hope'. Reports on the trial were published in *The Garden* (Skelmersdale, 2019) and *The Plant Review* (Fulcher, 2019), and a guide to the cultivars included in this RHS Agapanthus Trial is currently in progress.

The past several decades has seen an increasing worldwide advance in interest in agapanthus cultivation and in the development of new cultivars, as long-lived, showy dwarf container subjects and bedding plants, and as impressive medium- to tall-growing landscape perennials, both for cold and temperate climates, as well as for their long-lasting cut flowers, a trend which shows no sign of abating. The many hundreds of cultivars now available in the trade offer the enthusiast and commercial grower a wide choice in flower shape, colour, size, flowering time, thickness and colour of stem, leaf width, length and colour, and growth habit (deciduous or evergreen). With the rise in temperature as a result of global climate change, especially within large cities, it may soon be possible to grow an increasing number of evergreen agapanthus outdoors in cold climates. Some of the older cultivars have been superseded by modern ones, and breeding work and selection continues apace

by numerous private individuals and companies worldwide, with much still to be achieved in the development of good pinks and strongly scented cultivars. In such a rapidly advancing industry, it is unfortunate that, in the absence of an international registration authority for *Agapanthus*, confusion often arises when the same cultivar is sold under different cultivar names.

CULTIVARS

The cultivars listed below are a selection of 155 of some of the better old and recent cultivars recommended for cultivation, and for which a reasonably good chance exists of their being obtained in the nursery trade from at least one outlet (Figure 15). They are placed in two categories according to growth cycle: deciduous and evergreen. It is important to bear in mind that certain normally deciduous cultivars grown in cold climates may be semi-deciduous in mild parts, and certain normally evergreen cultivars may be semi-evergreen in colder climates. In accordance with Article 21.2 of the *International Code of Nomenclature for Cultivated Plants* (9th edition) (Brickell *et al.*, 2016), cultivar names listed below are linked to the species or subspecies name, where pertinent, in order to convey further information about the plant. Where appropriate, meanings of cultivar names are given, and major synonyms are included. The subheading 'Origin' refers to the individual and/or place, country and year (where known) in which the cultivar was first selected, named, published, registered or introduced into cultivation, as the case may be. Since 'Flowering Height' and 'Leaf Width' are dependent upon local growing conditions, these classes are of necessity a rough guide only. For an extensive listing and classification of cultivars up until 2004, see *Agapanthus* by Wim Snoeijer (2004). For further listings, see the *RHS Plantfinder* by Janet Cubey (2020), *Agapanthus for Gardeners* by Hanneke van Dijk (2004), and *Success with Agapanthus* by Steven and Colin Hickman (2018).

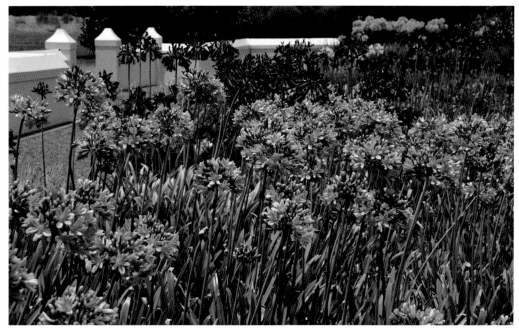

Figure 15. *Agapanthus* 'Full Moon' (foreground) and *A.* 'Black Pantha' (at rear), Vergelegen, Somerset West. Image: Graham Duncan.

KEYS TO TERMS AND ABBREVIATIONS:

AGM: Award of Garden Merit
AM: Award of Merit
FCC: First Class Certificate

APPROXIMATE FLOWERING HEIGHT CLASSES:

Short = 20–60 cm
Medium = 65–120 cm
Tall = 130–200 cm

APPROXIMATE LEAF WIDTH CLASSES:

Narrow = 0.5–2.5 cm
Medium = 3.0–5.0 cm
Broad = 5.5–8.0 cm

APPROXIMATE FLOWERING TIMES:

Early season = late June to mid-July (northern hemisphere); late October to mid-December (southern hemisphere).

Mid-season = mid-July to late August (northern hemisphere); late December to late January (southern hemisphere).

Late season = early September to early November (northern hemisphere), early February to early April (southern hemisphere).

HARDINESS RATINGS:

Hardiness ratings (UK) with equivalent United States Department of Agriculture (USDA) zone ratings, are according to the Royal Horticultural Society Hardiness Ratings (RHS, 2012), and are absolute minimum winter temperatures in °C. As these serve as a guide only, and weather patterns vary, ratings err on the side of caution.

H3: USDA 9b/10a. Category: **Half-hardy**. Suitable for the unheated greenhouse in areas with mild winters; temperature range: -5 to +1°C. Hardy in coastal and mild parts of the UK, except in severe winters and at risk of sudden, early frosts. May be hardy elsewhere with wall shelter or good microclimate. Likely to be damaged or killed in cold winters, particularly with no snow cover or if pot-grown. Can often survive with some artificial protection in winter.

H4: USDA 8b/9a. Category: **Hardy** (average winter); temperature range: -10 to -5°C. Hardy through most of the UK, apart from inland valleys, at altitude and central/northerly locations. May suffer foliage damage and stem dieback in harsh winters in cold gardens. Some normally hardy plants may not survive long, wet winters in heavy or poorly drained soil. Plants in pots are more vulnerable to harsh winters, particularly evergreens.

H5: USDA 7b/8a. Category: **Hardy** (cold winter); temperature range: -15 to -10°C. Hardy in most places throughout the UK, even in severe winters. May not withstand open/exposed sites or central/northern locations. Evergreens will suffer foliage damage, and plants in pots will be at increased risk.

DECIDUOUS CULTIVARS

Agapanthus 'Alan Street' AGM 2018 (Figure 16)

Cultivar name: in tribute to Alan Street, longtime horticulturist at Avon Bulbs, Somerset, UK.
Height: medium (105–115 cm).
Description: striking, very dark violet, nodding, narrowly funnel-shaped flowers on strong, erect or slanting scapes; leaves narrow, yellowish-green, arching.
Flowering: mid-season.
Hardiness: H4/USDA 8b/9a.
Uses: wall-side borders; centre of mixed borders.
Origin: Avon Bulbs, Somerset, UK, introduced 2013.

Agapanthus 'Amsterdam'

Cultivar name: after the capital city of The Netherlands.
Height: short to medium (50–75 cm).
Description: open, rounded heads of deep blue, narrowly funnel-shaped flowers, with violet-blue buds, on strong, erect, green scapes; leaves narrow, dark green with purplish base, arching.
Flowering: early season.
Hardiness: H4/USDA 8b/9a.
Uses: front borders; patio pots.
Origin: Kees Duivenvoorde, Beverwijk, The Netherlands; introduced 1999 (Snoeijer, 2004).

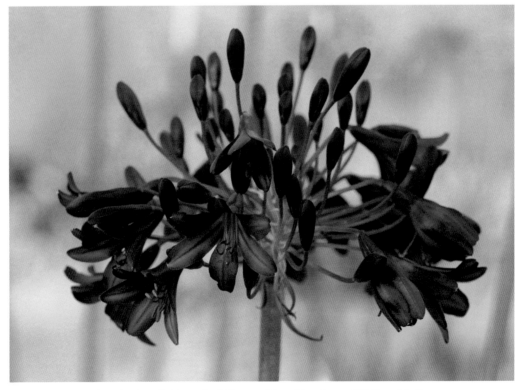

Figure 16. *Agapanthus* 'Alan Street', Fairweather's Nursery, Hampshire. Image: FhF GreenMedia.

Agapanthus 'Angela'

Cultivar name: in tribute to the youngest daughter of Dick and Lorna Fulcher.
Height: medium (120 cm).
Description: striking light blue, narrowly funnel-shaped, semi-pendent flowers; leaves narrow to medium width, arching, strap-shaped, mid-green; a vigorous plant with strong, slanting scapes.
Flowering: late season.
Hardiness: H4/USDA 8b/9a.
Uses: wall-side borders; centre of mixed borders.
Origin: Dick Fulcher, Pine Cottage Plants, Devon, UK; selected and named 2000 (Dick Fulcher, pers. comm.).

Agapanthus 'Aquamarine'

Height: short to medium (60–80 cm).
Description: compact, small rounded heads of bright blue, widely funnel-shaped blooms with upwardly flared, broad tepals, carried on suberect green pedicels and upright or slanting green scapes; leaves suberect, mid-green, medium-width.
Flowering: early to mid-season.
Hardiness: H4/USDA 8b/9a.
Uses: front borders; patio pots.
Origin: Thought to have been introduced from the UK *circa* 1998 (Snoeijer, 2004).

Agapanthus 'Arctic Star' AGM 2018

Height: medium (70–80 cm).
Description: striking, large dense heads of white, narrowly funnel-shaped flower on strong, slanting or upright green scapes; leaves broad, grey-green, arching; a vigorous plant which is often semi-deciduous or evergreen in mild climates, only dying back fully in the coldest parts.
Flowering: early to late season.
Hardiness: H4/USDA 8b/9a.
Uses: front borders; patio pots; rockeries; good cut flower.
Origin: Lady Bacon, Raveningham Hall, Norfolk, UK; known since 2000 (Snoeijer, 2004).

Agapanthus 'Ardernei' (Figure 17)

Synonym: *Agapanthus* 'Ardernei Hybrid'.
Height: medium (85–120 cm).
Description: elegant, hemispherical heads of white, narrowly funnel-shaped flowers, with tepal outer surface tips flushed light purple or rose-pink, pedicels purplish-brown, scapes slanting; leaves medium width, erect or suberect, mid-green; pseudostem flushed reddish-purple; a cross between *A. praecox* and *A. campanulatus*.
Flowering: mid- to late season.
Hardiness: H4/USDA 8b/9a.
Uses: front or centre of mixed borders; patio pots; good cut flower.
Origin: unknown, exhibited at a Royal Horticultural Society show, 1966 (Snoeijer, 2004). Known in cultivation at least by the early 1950s, since Palmer (1954) referred to it as a plant 'sometimes applied to hybrids of *A. orientalis*'.

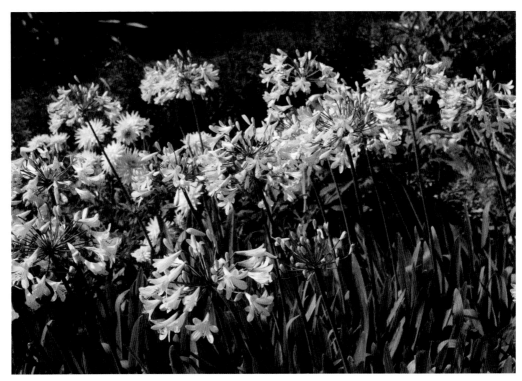

Figure 17. *Agapanthus* 'Ardernei', Exbury Gardens, Hampshire. Image: Graham Duncan.

Agapanthus 'Back in Black'

Height: medium (65–70 cm).

Description: elegant hemispherical heads of deep purplish-blue, spreading or slightly nodding, narrowly funnel-shaped blooms, carried on purplish-black, radiating pedicels and upright, rigid, deep green scapes which age to almost black; leaves arching, medium-width, bright green, sometimes semi-evergreen; unusual black ripening capsules.

Flowering: mid- to late season.

Hardiness: H5/USDA 7b/8a.

Uses: front borders; patio pots; good cut flower.

Origin: Piet Zonneveld, The Netherlands; introduced 2005.

Agapanthus 'Balmoral' AGM 2018 (subject to availability)

Cultivar name: after Balmoral Castle, north-eastern Scotland, UK.

Height: medium (70–75 cm).

Description: elegant, dense, hemispherical heads of deep violet-blue, slightly nodding, widely funnel-shaped blooms, carried on slanting, yellowish-green scapes; leaves narrow, suberect, bright green, sometimes semi-evergreen in mild climates.

Flowering: mid-season.

Hardiness: H5/USDA 7b/8a.

Uses: front or centre of mixed borders; patio pots.

Origin: Crown Estate, Windsor, UK; introduced 1975 (Snoeijer, 2004).

Agapanthus **'Ben Hope'** FCC 1977
Cultivar name: after Ben Hope Mountain, northern Scotland, UK.
Height: medium (90–120 cm).
Description: hemispherical heads of widely funnel-shaped, mid-blue flowers, carried on light green pedicels and upright or slanting, glossy, light green scapes; leaves narrow, suberect or arching, glossy, deep green, pseudostem purple-flushed.
Flowering: early to mid-season.
Hardiness: H3/USDA 9b/10a.
Uses: centre of mixed borders; good cut flower.
Origin: The Crown Estate, Windsor, UK; introduced 1972 (Snoeijer, 2004).

Agapanthus **'Black Buddhist'**
Height: short to medium (60–90 cm).
Description: large rounded heads of nodding or pendent, deep blue, trumpet-shaped blooms with deepest blue buds, carried on purplish-green pedicels and robust, erect or slanting green or purple-flushed scapes; leaves medium width, arching, yellowish-green, broad, with pointed tips.
Flowering: mid- to late season.
Hardiness: H5/USDA 7b/8a.
Uses: front or centre of mixed borders; patio pots.
Origin: Unknown.

Agapanthus **'Blue Magic'** AGM 2018
Height: medium (80 cm).
Description: hemispherical heads of intense deep blue, spreading, narrowly funnel-shaped flowers with deeper blue, erect buds, carried on purplish-green pedicels and strong, upright or slanting green scapes; leaves medium width, arching, bright green; very free-flowering, strongly clump-forming.
Flowering: mid- to late season.
Hardiness: H5/USDA 7b/8a.
Uses: front or centre of mixed borders; patio pots.
Origin: Rijnbeek en Zoon, The Netherlands.

Agapanthus **'Blue Velvet'**
Height: medium (85–120 cm).
Description: dense, rounded heads of deep violet-blue, spreading or slightly nodding, widely funnel-shaped flowers, carried on slender, upright green scapes; leaves narrow, suberect, bright green.
Flowering: mid-season.
Hardiness: H4/USDA 8b/9a.
Uses: centre of borders; patio pots.
Origin: Dick Fulcher, Pine Cottage Plants, Devon, UK; named 1993 (Fulcher & Fulcher, 2010).

Agapanthus **'Bray Valley'** AGM (2018) (subject to availability) (Figure 18)
Cultivar name: after Bray River Valley in Devon, UK.
Height: medium (80–90 cm).
Description: magnificent dense, rounded heads of dark violet-blue, widely funnel-shaped blooms, carried on long, slanting scapes; leaves medium-width, erect, dense, yellowish-green.
Flowering: mid-season.

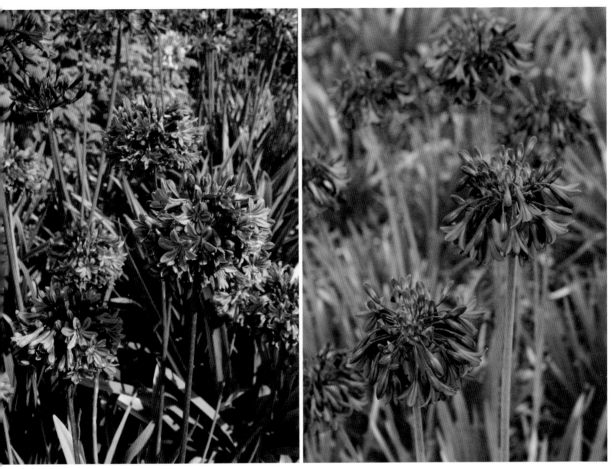

Figure 18 (left). *Agapanthus* 'Bray Valley', Pine Cottage Plants, Devon. Image: Graham Duncan.
Figure 19 (right). *Agapanthus* 'Bressingham Blue', Evolution Plants, Wiltshire. Image: Graham Duncan.

Hardiness: H4/USDA 8b/9a.
Uses: front or centre of mixed borders; patio pots.
Origin: Dick Fulcher, Pine Cottage Plants, Devon, UK; selected and named, 2000 (Fulcher & Fulcher, 2010).

Agapanthus **'Bressingham Blue'** (Figure 19)

Synonyms: *Agapanthus campanulatus* 'Bressingham Blue'; *Agapanthus umbellatus* 'Bressingham Blue'.
Cultivar name: after Bressingham Gardens, Norfolk, UK.
Height: medium (80–90 cm).
Description: striking rounded heads of violet-blue, nodding, widely funnel-shaped flowers on erect, green scapes; leaves narrow, arching, mid-green.
Flowering: mid-season.
Hardiness: H4/USDA 8b/9a.
Uses: centre of mixed borders; patio pots; good cut flower.
Origin: Alan Bloom, Bressingham Gardens, Norfolk, UK; selected 1967; named 1972 (Snoeijer, 2004).

Agapanthus **'Bressingham White'**

Synonym: *Agapanthus campanulatus* 'Bressingham White'.
Cultivar name: after Bressingham Gardens, Norfolk, UK.
Height: medium (80–100 cm).
Description: rounded heads of white, widely funnel-shaped blooms, outer tepal lower surface tips flushed pink, carried on purplish-green pedicels and somewhat flimsy, slanting green scapes; leaves narrow, arching, mid-green, shading to purple at base.
Flowering: mid- to late season.
Hardiness: H4/USDA 8b/9a.
Uses: centre of mixed borders; patio pots; good cut flower.
Origin: Alan Bloom, Bressingham Gardens, Norfolk, UK; named 1972 (Snoeijer, 2004).

Agapanthus **'Brody'** (Figure 20)

Cultivar name: in tribute to a grandson of Dick and Lorna Fulcher.
Height: medium (90–110 cm).
Description: large, hemispherical heads of deep blue, widely funnel-shaped, slightly nodding flowers on strong, dark scapes; leaves narrow, suberect, yellowish-green.
Flowering: mid-season.
Hardiness: H4/USDA 8b/9a.
Uses: centre of mixed borders.
Origin: Dick Fulcher, Pine Cottage Plants, Devon, UK; named 1995 (Fulcher & Fulcher, 2010).

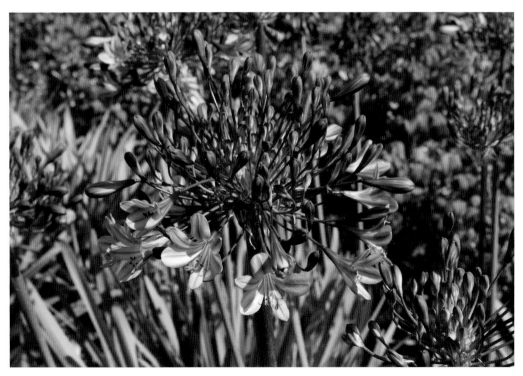

Figure 20. *Agapanthus* 'Brody', Pine Cottage Plants, Devon. Image: Graham Duncan.

Agapanthus 'Camilla' (Figure 21)

Cultivar name: in tribute to HRH the Duchess of Cornwall.

Height: medium (90 cm).

Description: elegant heads of nodding, violet-blue, widely funnel-shaped flowers with deep violet buds, carried on purplish stalks and slender, deep green scapes; leaves medium-width, arching, bright green.

Flowering: mid-season.

Hardiness: H4/USDA 8b/9a.

Uses: centre of mixed borders; patio pots.

Origin: Dick Fulcher, Pine Cottage Plants, Devon, UK; introduced 2007 (Dick Fulcher, pers. comm.).

Agapanthus campanulatus 'Oxford Blue'

Cultivar name: after the city of Oxford in southern England, UK.

Height: medium (65–75 cm).

Description: small heads of spreading or slightly nodding, violet-blue, widely funnel-shaped blooms, carried on purplish pedicels and erect or slanting, dark green or purplish-green scapes; leaves narrow, upright, glaucous-green, very free-flowering.

Flowering: mid- to late season.

Hardiness: H4/USDA 9b/10a.

Uses: front borders; patio pots; good cut flower.

Origin: Gary Dunlop, Ballyrogan Nurseries, Northern Ireland, UK; introduced 1995 (Snoeijer, 2004).

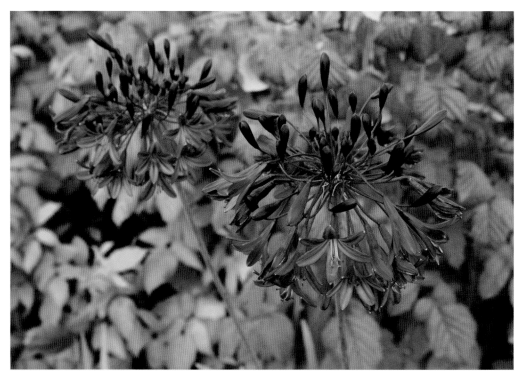

Figure 21. *Agapanthus* 'Camilla', Pine Cottage Plants, Devon. Image: Graham Duncan.

Agapanthus campanulatus **'Wendy'**
Synonyms: *Agapanthus campanulatus* subsp. *campanulatus* 'Wendy'; *Agapanthus* 'Wendy'.
Height: short (40–45 cm).
Description: a dwarf cultivar with striking dense, rounded heads of nodding white, widely funnel-shaped blooms, carried on purplish pedicels and slanting, green scapes; leaves narrow, light green, suberect, pseudostem purple-flushed.
Flowering: mid- to late season.
Hardiness: H4/USDA 8b/9a.
Uses: front borders; patio pots.
Origin: Gary Dunlop, Ballyrogan Nurseries, County Down, Northern Ireland; introduced 1995 (Snoeijer, 2004*)*.

Agapanthus campanulatus **'Wolkberg'** (see Plate 10 on page 205)
Synonym: *Agapanthus inapertus* subsp. *intermedius* 'Wolkberg'.
Cultivar name: after the Wolkberg Mountains, Limpopo, South Africa.
Height: tall (130–150 cm).
Description: small, dense, rounded heads of small, slightly nodding, bright blue, narrowly funnel-shaped blooms, carried on bright green pedicels and tall, sturdy, upright scapes; leaves narrow, suberect or arching, mid-green. Very free-flowering, fast-multiplying.
Flowering: mid- to late season.
Hardiness: H4/USDA 8b/9a.
Uses: wall-side borders; centre of mixed borders.
Origin: wild provenance unknown, plants ex hort Kirstenbosch (Kirstenbosch accession number: 677/54).
Note: Previously misidentified as *Agapanthus inapertus* subsp. *intermedius* from the Wolkberg in east-central Limpopo, and published as the cultivar *A. inapertus* subsp. *intermedius* 'Wolkberg' (Duncan, 1985; 1998); renamed *A. campanulatus* 'Wolkberg' (Fulcher & Fulcher, 2010). Although *A. campanulatus* is not known to occur as far north as the Wolkberg, in the interests of averting further confusion, it is considered expedient to maintain 'Wolkberg' as the cultivar name.

Agapanthus **'Castle of Mey'** (Figure 22)
Cultivar name: after the Castle of Mey on the north coast of Scotland, UK.
Height: short to medium (65–75 cm).
Description: dense, rounded heads of slightly nodding, violet blue, widely funnel-shaped flowers on slender, strong scapes, very free-flowering; leaves narrow, mid-green, upright.
Flowering: mid- to late season.
Hardiness: H4/USDA 8b/9a.
Uses: front borders; patio pots.
Origin: Crown Estate, Windsor, UK; introduced 1975 (Snoeijer, 2004).

Agapanthus **'Catharina'**
Cultivar name: in tribute to the wife and daughter of Kees Duivenvoorde.
Height: medium (80–100 cm).
Description: deep blue, spreading, narrowly funnel-shaped flowers in a rounded head, carried on erect or slanting, green, purple-speckled scapes; leaves medium width, erect with curved tips, grey-green, pseudostem purple-flushed.

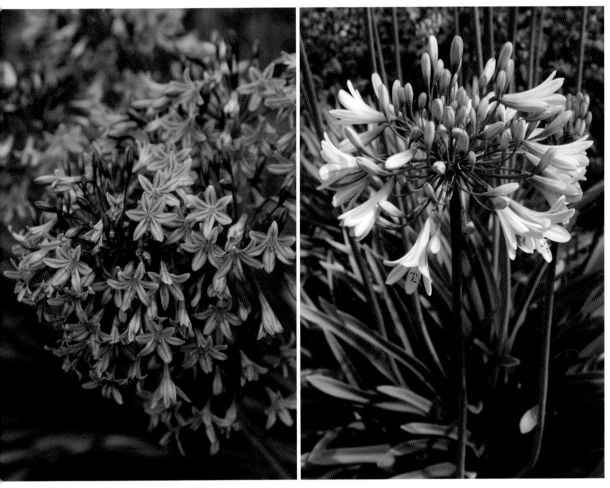

Figure 22 (left). *Agapanthus* 'Castle of Mey', Fairweather's Nursery, Hampshire. Image: FhF GreenMedia.
Figure 23 (right). *Agapanthus* 'Dartmoor', Pine Cottage Plants, Devon. Image: Graham Duncan.

Flowering: very early season.
Hardiness: H4/USDA 8b/9a.
Uses: front or centre of mixed borders; good cut flower.
Origin: Kees Duivenvoorde, Beverwijk, The Netherlands; introduced 1995 (Snoeijer, 2004).

Agapanthus caulescens **'Politique'** (see plate 7 on page 184)

Synonyms: *Agapanthus caulescens* subsp. *angustifolius* 'Politique'; *Agapanthus* 'Politique'.
Cultivar name: after the farm 'Politique' near Pietermaritzburg, KwaZulu-Natal, where it was originally collected.
Height: medium (90–110 cm).
Description: outstanding deep violet-blue, widely funnel-shaped flowers with deeper violet-blue perianth tubes, carried in dense, hemispherical heads on long, erect or slanting, glaucous scapes; leaves medium width, erect or arching above, intensely glaucous, very striking.

Flowering: late season.
Hardiness: H3/USDA 9b/10a.
Uses: centre of mixed borders; patio pots.
Origin: wild-collected by J. T. Beard at farm 'Politique' near Pietermaritzburg, KwaZulu-Natal, South Africa; cultivar selected and named by Duncan (1985) (Kirstenbosch accession number: 123/60).

Agapanthus **'Celebration'** AGM 2018 (subject to availability)

Height: medium (90 cm).
Description: striking dense heads of pendent or nodding, tubular, light blue blooms with grey-blue perianth tubes, contrasting dark anthers and vertical buds, carried on erect, robust green or purple-flushed scapes; leaves narrow, suberect, mid-green.
Flowering: mid-season.
Hardiness: H4/USDA 8b/9a.
Uses: centre of mixed borders; patio pots.
Origin: Dick Fulcher, Pine Cottage Plants, Devon, UK; introduced 2005 (Dick Fulcher, pers. comm.).

Agapanthus **'Dartmoor'** (Figure 23)

Cultivar name: after Dartmoor in South Devon, UK.
Height: medium (100–120 cm).
Description: Rounded heads of light lilac/mauve, widely funnel-shaped flowers on strong, upright, bright green scapes; leaves medium-width, suberect, yellowish-green, deeply channelled, plants vigorous.
Flowering: mid- to late season.
Hardiness: H4/USDA 8b/9a.
Uses: centre of mixed borders.
Origin: Dick Fulcher, Pine Cottage Plants, Devon, UK; selected and named 2000 (Fulcher & Fulcher, 2010).

Agapanthus **'Dokter Brouwer'**

Synonym: *Agapanthus* 'Dr Brouwer'.
Cultivar name: in tribute to Dr T. Brouwer, medical specialist in Heemskerk Hospital, North Holland.
Height: medium (80–100 cm).
Description: striking rounded heads of widely funnel-shaped flowers, dark blue in bud, opening to mid-blue, carried on dark green or purplish scapes; leaves narrow, suberect, relatively short, grey-green.
Flowering: mid- to late season.
Hardiness: H4/USDA 8b/9a.
Uses: front or centre of mixed borders; patio pots; good cut flower.
Origin: Kees Duivenvoorde, Beverwijk, The Netherlands; introduced and registered 1987 (Snoeijer, 2004).

Agapanthus **'Duivenbrugge Blue'**

Cultivar name: surname combination from Kees Duivenvoorde and his wife Catharina Verbrugge.
Height: medium (90–100 cm).
Description: hemispherical heads of violet-blue, widely funnel-shaped, spreading or slightly nodding blooms on slanting green scapes; leaves narrow to medium-width, light glaucous-green, arching.
Flowering: mid- to late season.
Hardiness: H4/USDA 8b/9a.

Uses: centre of mixed borders; good cut flower.

Origin: Kees Duivenvoorde, Beverwijk, The Netherlands; introduced 1998 (Snoeijer, 2004).

Agapanthus 'Eggesford Sky' AGM 2018 (Figure 24)

Cultivar name: after the Eggesford parish in Devon, UK.

Height: medium (110–120 cm).

Description: superb, light blue, full rounded heads of narrowly funnel-shaped flowers with prominent yellow anthers on bright green, slightly slanting scapes; leaves medium-width, suberect, mid-green.

Flowering time: mid-season.

Hardiness: H4/USDA 8b/9a.

Uses: centre of mixed borders; patio pots.

Origin: Dick Fulcher, Pine Cottage Plants, Devon, UK; selected and named 2000 (Fulcher & Fulcher, 2010).

Agapanthus 'Exmoor' AGM 2018

Cultivar name: after Exmoor in North Devon, England.

Height: medium (90–100 cm).

Description: striking hemispherical heads of dark blue, nodding, narrowly funnel-shaped flowers, carried on dark bluish-green pedicels and scapes; leaves medium width, suberect, bright green.

Flowering: mid-season.

Hardiness: H4/USDA 8b/9a.

Uses: centre of mixed borders.

Origin: Dick Fulcher, Pine Cottage Plants, Devon, UK; selected and named 2000 (Fulcher & Fulcher, 2010).

Agapanthus 'Flower of Love' AGM 2018 (Figure 25)

Height: short (40–60 cm).

Description: a dainty, dwarf plant with widely funnel-shaped, deep violet-blue, nodding flowers in dense, rounded heads, on erect green scapes, compact growth habit, very free-flowering; leaves narrow, suberect, grey-green.

Flowering: early season.

Hardiness: H4/USDA 8b/9a.

Uses: front borders; patio pots.

Origin: Dick Fulcher, Pine Cottage Plants, Devon, UK; selected and named 2011 (Dick Fulcher, pers. comm.).

Agapanthus 'Gem'

Height: medium (90–100 cm).

Description: rounded heads of mid-blue, widely funnel-shaped flowers, carried on purple-tinged, erect scapes; leaves narrow, sometimes semi-deciduous depending on local conditions.

Flowering: mid-season.

Hardiness: H4/USDA 8b/9a.

Uses: centre of mixed borders; patio pots.

Origin: Dick Fulcher, Bicton College, Devon, UK; selected and named 1993 (Fulcher & Fulcher, 2010).

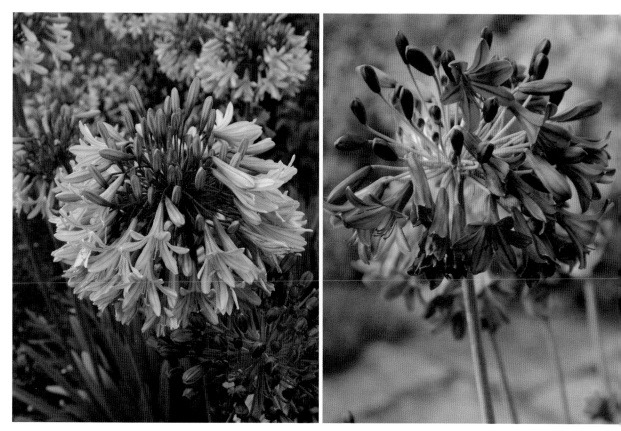

Figure 24 (left). *Agapanthus* 'Eggesford Sky', Pine Cottage Plants, Devon. Image: Graham Duncan.
Figure 25 (right). *Agapanthus* 'Flower of Love', Fairweather's Nursery, Hampshire. Image: FhF GreenMedia.

Agapanthus 'Golden Rule'

Height: short to medium (45–70 cm).
Description: variegated, light green, narrow leaves with narrow, yellowish-white margins; flowers light violet-blue, widely funnel-shaped; slow-growing.
Flowering: mid-season.
Hardiness: H3/USDA 9b/10a.
Uses: front borders; patio pots.
Origin: J.C. Archibald, Buckshaw Gardens, Dorset, UK; 1988 (Snoeijer, 2004).

Agapanthus 'Happy Blue' AGM 2018

Height: short to medium (60–70 cm).
Description: light violet-blue, widely funnel-shaped flowers in dense, hemispherical heads, carried on slender, slanting scapes; leaves narrow, mid-green, arching. Very free-flowering.
Flowering: mid-season.
Hardiness: H4/USDA 8b/9a.
Uses: front borders; patio pots.
Origin: J. van Vliet, Zwetsloot Ltd, Perthshire, UK.

Agapanthus 'Holbeach'

Cultivar name: after the town of Holbeach in Lincolnshire, eastern England.

Height: short (40–60 cm).

Description: small, dense, hemispherical heads of spreading, violet-blue, widely funnel-shaped flowers, sometimes with eight tepals per flower, produced on strong but narrow, suberect scapes; leaves narrow, suberect, mid-green.

Flowering: mid-season.

Hardiness: H4/USDA 8b/9a.

Uses: front borders; patio pots.

Origin: Kees Duivenvoorde, Beverwijk, The Netherlands; introduced 1997 (Snoeijer, 2004).

Agapanthus 'Ice Blue Star' AGM 2018

Height: medium (80–100 cm).

Description: full, rounded heads of large, light greyish-blue, widely funnel-shaped flowers, produced on strong, suberect, grey-green scapes; leaves narrow to medium-width, upright, mid-green.

Flowering: early to mid-season.

Hardiness: H5/USDA 7b/8a.

Uses: centre of mixed borders; patio pots.

Origin: Lady Bacon, Raveningham Hall, Norfolk, UK; introduced *circa* 1970s–1980s (Dick Fulcher, pers. comm.).

Agapanthus inapertus 'Avalanche' AGM 2018

Height: medium (80–120 cm).

Description: outstanding heads of white, tubular, pendent blooms on light green, curved pedicels, carried on greenish-grey, erect scapes; leaves medium-width, suberect, greenish-grey.

Flowering: mid- to late season.

Hardiness: H4/USDA 8b/9a.

Uses: wall-side borders; centre or rear of mixed borders.

Origin: Ken Rigney, Southampton, UK.

Agapanthus inapertus subsp. *inapertus* 'Sky' AGM 2018 (Figure 26)

Synonyms: *Agapanthus inapertus* subsp. *hollandii* 'Sky'; *Agapanthus inapertus* subsp. *hollandii* 'Sky Blue'; *Agapanthus* 'Sky'.

Height: tall (130–150 cm).

Description: striking heads of tubular, light blue, pendent blooms carried on yellowish-green pedicels and tall, yellowish-green, erect or slightly curved, slender scapes; leaves medium-width, grey-green, erect, curved in upper part.

Flowering: mid- to late season.

Hardiness: H4/USDA 8b/9a.

Uses: wall-side borders; centre or rear of mixed borders.

Origin: wild-collected at Lydenburg, Mpumalanga, South Africa, collector unknown; cultivar selected and named by Duncan (1985) (Kirstenbosch accession number: 958/84).

Agapanthus inapertus subsp. *inapertus* 'White' (Figure 27)

Synonyms: *Agapanthus inapertus* 'White'; *Agapanthus* 'White'.

Height: tall (130–150 cm).

Description: eye-catching heads of bright white, tubular pendent blooms, carried on erect, slender glaucous scapes; leaves medium-width, erect with rounded tips, intensely glaucous.

Flowering: late season.

Hardiness: H3/USDA 9b/10a.

Uses: wall-side borders; centre or rear of mixed borders; good cut flower.

Origin: ex hort, Kirstenbosch, cultivar selected and named by Duncan (1985) (Kirstenbosch accession number: 690/83).

Agapanthus inapertus subsp. *intermedius* '**August Bells**' AGM 2018 (subject to availability)

Height: medium (90–120 cm).

Description: striking heads of deep blue, nodding, tubular flowers, produced on strongly erect, light grey scapes; leaves medium-width, suberect, greyish-green, bases purple-flushed; very free-flowering.

Flowering: mid- to late season.

Hardiness: H5/USDA 7b/8a.

Uses: wall-side borders; centre or rear of mixed borders.

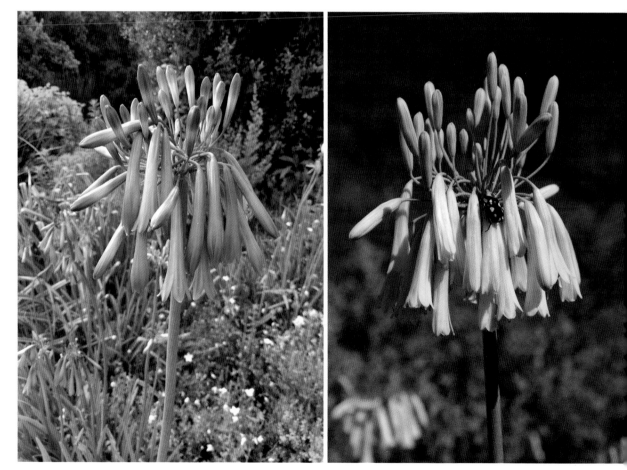

Figure 26 (left). *Agapanthus inapertus* subsp. *inapertus* 'Sky', Kirstenbosch. Image: Graham Duncan.
Figure 27 (right). *Agapanthus inapertus* subsp. *inapertus* 'White', Kirstenbosch. Image: Graham Duncan.

Origin: Grown at Broadleigh Gardens Taunton, Somerset, UK since ± 1988; cultivar named 2018 (Christine Skelmersdale, pers.comm.).

Agapanthus inapertus subsp. *pendulus* 'All Gold' (Figure 28)

Height: medium (80 cm).

Description: dense heads of deep indigo, tubular, pendent flowers; striking, suberect or spreading, greenish-golden, medium-width leaves and scapes, which hold their colour throughout the season; a selection from *A. inapertus* subsp. *pendulus* 'Graskop'.

Flowering: late season.

Hardiness: H3/USDA 9b/10a.

Uses: front borders; patio pots.

Origin: Dick Fulcher, Pine Cottage Plants, Devon, UK; selected and named 2009 (Fulcher & Fulcher, 2010).

Agapanthus inapertus subsp. *pendulus* 'Black Magic' (Figure 29)

Synonym: *Agapanthus* 'Black Magic'.

Height: medium (80 cm).

Description: striking clusters of tubular, curved, deepest indigo-black flowers, carried on erect, strong, green or purple-flushed scapes; leaves medium-width, yellowish-green, arching. A wild-collected plant from north-east of Graskop, northern Mpumalanga.

Flowering: late season.

Hardiness: H3/USDA 9b/10a.

Uses: front or centre of mixed borders; patio pots; good cut flower.

Origin: Richard Jamieson, Black Dog Plants, South Africa; selected and named ± 1994 (Richard Jamieson, pers. comm.).

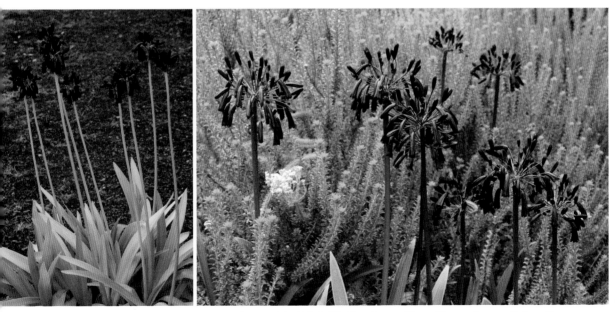

Figure 28 (left). *Agapanthus inapertus* subsp. *pendulus* 'All Gold', Pine Cottage Plants, Devon. Image: Graham Duncan.
Figure 29 (right). *Agapanthus inapertus* subsp. *pendulus* 'Black Magic', Kirstenbosch. Image: Graham Duncan.

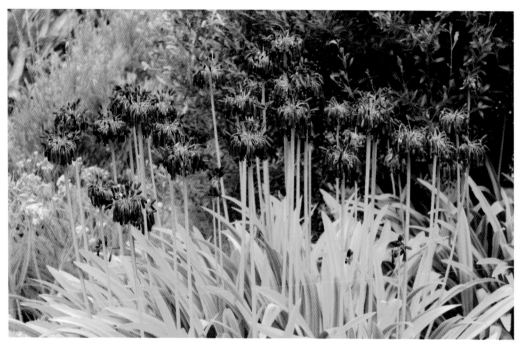

Figure 30. *Agapanthus inapertus* subsp. *pendulus* 'Graskop', Kirstenbosch. Image: Graham Duncan.

Agapanthus inapertus subsp. *pendulus* 'Graskop' (Figure 30)

Synonyms: *Agapanthus* 'Graskop'; *Agapanthus inapertus* 'Graskop'; *Agapanthus* 'Velvet Night'.
Cultivar name: after the town of Graskop in northern Mpumalanga, South Africa.
Height: short to medium (60–80 cm).
Description: small, dense heads of pendent, tubular, deepest violet blooms with shortly exserted stamens with violet immature anthers, carried on curved, green pedicels and erect, green scapes; leaves medium-width to broad, arching, yellowish-green; the shortest form of subsp. *pendulus*.
Flowering: late season.
Hardiness: H3/USDA 9b/10a.
Uses: front borders; patio pots.
Origin: wild-collected by E.E. Galpin at Graskop in 1937; cultivar selected and named by Duncan (1985) (Kirstenbosch accession number: 2221/37).

Agapanthus 'Indigo Dreams' (Figure 31)

Height: medium (70 cm).
Description: small, open heads of deep indigo, nodding or pendent, widely funnel-shaped blooms, with deepest indigo buds, carried on erect, slender, bright green scapes; leaves medium-width, green, arching; very free-flowering.
Flowering: mid- to late season.
Hardiness: H4/USDA 8b/9a.
Uses: front borders; patio pots.
Origin: Dick Fulcher, Pine Cottage Plants, Devon, UK; selected and named 2008 (Fulcher & Fulcher, 2010).

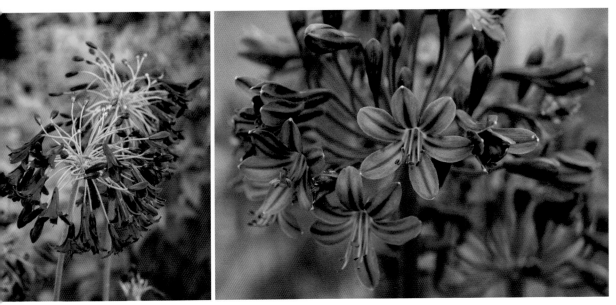

Figure 31 (left). *Agapanthus* 'Indigo Dreams', Fairweather's Nursery, Hampshire. Image: FhF GreenMedia.
Figure 32 (right). *Agapanthus* 'Inkspots', Fairweather's Nursery, Hampshire. Image: FhF GreenMedia.

Agapanthus **'Inkspots'** (Figure 32)
Synonym: *Agapanthus* 'Ink Spot'.
Height: tall (130–150 cm).
Description: striking, globular heads of widely funnel-shaped, spreading or nodding, deep blue flowers on very long, upright or slanting, shiny deep green scapes, very free-flowering; leaves narrow, deep green, suberect.
Flowering: mid- to late season.
Hardiness: H4/USDA 8b/9a.
Uses: wall-side borders; rear of mixed borders.
Origin: Ken Rigney, Southampton, UK.

Agapanthus **'Jessica'** AGM 2018 (subject to availability) (Figure 33)
Cultivar name: in tribute to a family member of Peter Seager.
Height: short (60 cm).
Description: small, compact heads of spreading, deep blue, widely funnel-shaped flowers, produced on thin scapes, very free-flowering; leaves narrow, bright green, suberect.
Flowering: mid-season.
Hardiness: H4/USDA 8b/9a.
Uses: front borders; patio pots.
Origin: Dick Fulcher, Pine Cottage Plants, Devon, UK, ex Peter Seager, Surrey, UK; introduced 2012 (Dick Fulcher, pers. comm.).

Agapanthus **'Jonny's White'** AGM 2018
Cultivar name: in tribute to John (Jonny) Clothier, friend of Christine Skelmersdale.
Height: short (45–60 cm).

Description: a dwarf plant with striking small, fairly dense heads of waxy bright white, nodding, widely funnel-shaped blooms, carried on strong, green scapes, free-flowering; leaves medium-width, mid-green, channelled, suberect.

Flowering: early to mid-season.

Hardiness: H4/USDA 8b/9a.

Uses: front borders; patio pots.

Origin: Broadleigh Gardens, Taunton, Somerset, UK; introduced 2014 (Christine Skelmersdale, pers. comm.).

Agapanthus **'Lady Grey'** AM (1951)

Synonym: *Agapanthus* 'Mabel Grey'

Cultivar name: in tribute to the sister of the Hon. Lewis Palmer.

Height: medium (65–85 cm).

Description: dense heads of deep blue, spreading, widely funnel-shaped blooms, carried on dull purple, upwardly curved pedicels and erect, green scapes; leaves narrow, erect with slightly curved tips, mid-green.

Flowering: mid-season.

Hardiness: H4/USDA 8b/9a.

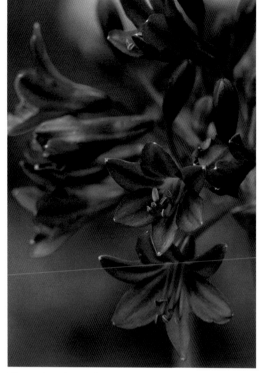

Figure 33. *Agapanthus* 'Jessica', Fairweather's Nursery, Hampshire. Image: FhF GreenMedia.

Uses: front or centre of mixed borders; patio pots.

Origin: The Hon. Lewis Palmer, Headbourne Worthy, Hampshire, UK; known since 1951 (Snoeijer, 2004).

Agapanthus **'Leicester'** AGM 2018

Cultivar name: after the city of Leicester in the East Midlands of England.

Height: medium (70–85 cm).

Description: hemispherical heads of white, widely funnel-shaped blooms with prominent purple anthers, carried on strong, erect or slanting, green, purple-flushed scapes; leaves narrow, suberect, strongly channelled, greyish-green.

Flowering: late season.

Hardiness: H4/USDA 8b/9a.

Uses: front or centre of mixed borders; patio pots.

Origin: Kees Duivenvoorde, Beverwijk, The Netherlands; introduced 1999 (Snoeijer, 2004).

Agapanthus **'Liam's Lilac'** (Figure 34)

Cultivar name: in tribute to the eldest grandson of Dick and Lorna Fulcher.

Height: medium (100–110 cm).

Description: striking, few-flowered umbels of narrowly funnel-shaped, nodding, lilac blooms, with deeper lilac perianth tubes, carried on erect or slanting, light green scapes and purplish pedicels, anthers deep lilac; leaves medium-width, arching, bright green.

Flowering: late season.

Hardiness: H4/USDA 8b/9a.

Uses: wall-side borders; centre of mixed borders.

Origin: Dick Fulcher, Pine Cottage Plants, Devon, UK; selected and named 1997 (Fulcher & Fulcher, 2010).

Agapanthus 'Lilac Time'

Height: medium (95–100 cm).

Description: large, dense heads of lilac, nodding, widely funnel-shaped blooms with rounded tepal tips and deep lilac anthers, carried on erect or slanting, light green scapes; leaves medium-width, suberect, mid-green.

Flowering: late season.

Hardiness: H4/USDA 8b/9a.

Uses: centre of mixed borders; patio pots.

Origin: Dick Fulcher, Pine Cottage Plants, Devon, UK; selected and named 1993 (Snoeijer, 2004).

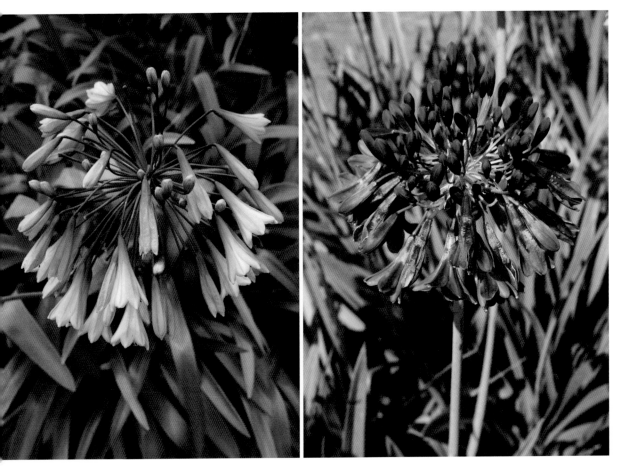

Figure 34 (left). *Agapanthus* 'Liam's Lilac', Pine Cottage Plants, Devon. Image: Graham Duncan.
Figure 35 (right). *Agapanthus* 'Lorna', Pine Cottage Plants, Devon. Image: Graham Duncan.

Agapanthus **'Lilliput'** AM 1977

Height: short (20–60 cm).

Description: small, dense, hemispherical heads of deep violet-blue, widely funnel-shaped flowers carried on erect or slanting green scapes; leaves narrow, upright or arching, deep green, pseudostem purple-flushed.

Flowering: late season.

Hardiness: H4/USDA 8b/9a.

Uses: front borders; patio pots.

Origin: Roland Jackman, Surrey, UK; selected *circa* early 1950s (Snoeijer, 2004).

Agapanthus **'Loch Hope'** AM 1977; AGM 1993; AGM 2018 (reconfirmed)

Cultivar name: after Loch Hope in Sutherland, northern Scotland, UK.

Height: tall (130–150 cm).

Description: dense rounded heads of large, nodding, violet-blue, narrowly funnel-shaped flowers, carried on tall green, somewhat flimsy scapes of irregular height; leaves medium-width, dark green, suberect.

Flowering: mid- to late season.

Hardiness: H5/USDA 7b/8a.

Uses: centre or rear of mixed borders.

Origin: The Savill Garden, Windsor, Surrey, UK; introduced 1974 (Snoeijer, 2004).

Agapanthus **'Lorna'** AGM 2018 (subject to availability) (Figure 35)

Cultivar name: in tribute to Lorna Fulcher, wife of Dick Fulcher.

Height: medium (90–100 cm).

Description: striking heads of deep indigo, pendent, large, widely funnel-shaped flowers carried on erect, glaucous scapes, free-flowering; leaves medium-width, suberect, yellowish-green.

Flowering time: mid-season.

Hardiness: H4/USDA 8b/9a.

Uses: centre of mixed borders; patio pots.

Origin: Dick Fulcher, Pine Cottage Plants, Devon, UK; raised 2010 (Dick Fulcher, pers. comm.).

Agapanthus **'Luly'** FCC 1977; AGM 2018

Cultivar name: the nickname of the Hon. Lewis Palmer.

Height: medium (70–90 cm).

Description: dense, large rounded heads of light violet-blue, nodding, widely funnel-shaped blooms, carried on erect or slanting, deep green scapes; leaves medium-width, suberect or arching, deep glaucous-green. Plants are semi-deciduous in mild climates, usually deciduous in cold parts.

Flowering: mid-season.

Hardiness: H4/USDA 8b/9a.

Uses: front or centre of mixed borders; patio pots.

Origin: Hon. Lewis Palmer, Headbourne Worthy, Hampshire, UK; known since 1972 (Snoeijer, 2004).

Agapanthus **'Lydenburg'** (Figure 36; see also Plate 2 on page 18)

Synonym: *Agapanthus inapertus* subsp. *hollandii* 'Lydenburg'.

Cultivar name: after the town of Lydenburg in northern Mpumalanga, South Africa.

Height: medium to tall (110–130 cm).

Description: very striking heads of pendent, deep blue, tubular blooms with deepest blue buds, carried on strong, erect green scapes; leaves medium-width, spreading, yellowish-green; a probable hybrid between *A. inapertus* and *A. praecox*. Plants are semi-evergreen in mild climates, usually deciduous in cold parts.
Flowering: late season.
Hardiness: H3/USDA 9b/10a.
Uses: wall-side borders; centre of mixed borders; good cut flower.
Origin: wild-collected by Beetge at Alkmaar, northern Mpumalanga; cultivar selected and named by Duncan (1985) (Kirstenbosch accession number: 461/44).

Agapanthus 'Lyn Valley'

Cultivar name: after Lyn Valley in northern Devon, UK.
Height: medium (110–120 cm).
Description: hemispherical heads of bright blue, widely funnel-shaped, spreading or slightly nodding blooms, carried on erect, strong green scapes; leaves medium-width, green, suberect. An *A. praecox* hybrid, but deciduous.
Flowering: mid-season.
Hardiness: H3/USDA 9b/10a.
Uses: centre of mixed borders; patio pots.
Origin: Dick Fulcher, Pine Cottage Plants, Devon, UK; selected and named 2002 (Fulcher, 2004).

Agapanthus 'Maria'

Cultivar name: in tribute to the youngest granddaughter of Dick and Lorna Fulcher.
Height: medium (90–100 cm).
Description: hemispherical heads of rich, dark blue, nodding, widely funnel-shaped flowers, carried on strong, slightly slanting green scapes; leaves narrow, suberect, mid-green; a cross between 'Nikki' and 'Northern Star'.
Flowering: mid- to late season.
Hardiness: H4/USDA 8b/9a.
Uses: centre of mixed borders; patio pots; good cut flower.
Origin: Dick Fulcher, Pine Cottage Plants, Devon, UK; selected and named 2007 (Fulcher & Fulcher, 2010).

Agapanthus 'Marianne'

Cultivar name: in tribute to Marianne Hendriks, a friend of Kees Duivenvoorde.
Height: short to medium (50–70 cm).
Description: hemispherical heads of bright blue, widely funnel-shaped flowers with deep blue buds, carried on slanting, light green scapes; leaves narrow, suberect, light green.
Flowering: mid-season.
Hardiness: H4/USDA 8b/9a.
Uses: front borders; patio pots; good cut flower.
Origin: Kees Duivenvoorde, Beverwijk, The Netherlands; introduced 1987 (Snoeijer, 2004).

Agapanthus 'Marjorie' AGM 2018

Cultivar name: in tribute to the wife of Bert Hopwood.
Height: medium (100–120 cm).

Description: nicely rounded, dense heads of light violet-blue, widely funnel-shaped blooms, carried on upright, yellowish-green scapes, free-flowering; leaves narrow, dense, erect or spreading, greyish-olive-green.
Flowering: mid-season.
Hardiness: H5/USDA 7b/8a.
Uses: centre of mixed borders.
Origin: Buckshaw Gardens, Lancashire, UK; known since 1989 (Snoeijer, 2004).

Agapanthus **'Marnie'** AGM 2018 (subject to availability)
Cultivar name: in tribute to a grand-daughter of the sister of Dick Fulcher.
Height: medium (80–90 cm).
Description: dense heads of nodding, widely funnel-shaped, violet-blue flowers, carried on upright or slanting, glaucous-green scapes, very free-flowering; leaves narrow, suberect, light glaucous-green.
Flowering: mid-season
Hardiness: H4/USDA 8b/9a.
Uses: centre of mixed borders; patio pots.
Origin: Dick Fulcher, Pine Cottage Plants, Devon, UK; selected and named 2001 (Dick Fulcher, pers. comm.).

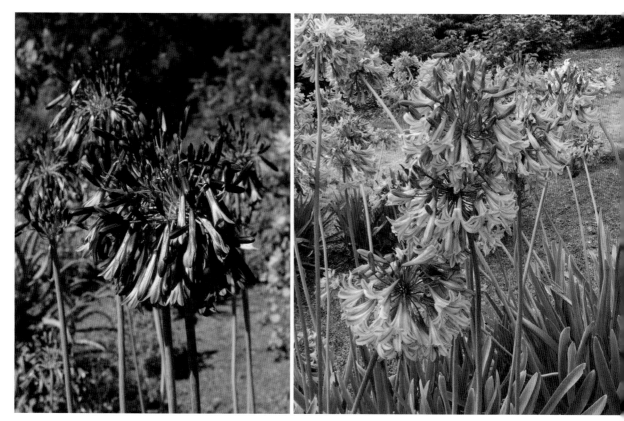

Figure 36 (left). *Agapanthus* 'Lydenburg', Kirstenbosch. Image: Graham Duncan.
Figure 37 (right). *Agapanthus* 'Maureen', Pine Cottage Plants, Devon. Image: Dick Fulcher.

Agapanthus **'Maureen'** AGM 2018 (Figure 37)

Cultivar name: in tribute to Maureen Bayly, who worked at Pine Cottage Plants.

Height: tall (130 cm).

Description: very striking rounded heads bearing large, nodding, light lavender, widely funnel-shaped blooms with recurved tepals, on tall, strong scapes, buds erect, deep lilac; leaves medium-width, olive-green, spreading.

Flowering: late season.

Hardiness: H4/USDA 8b/9a.

Uses: centre or rear of mixed borders.

Origin: Dick Fulcher, Pine Cottage Plants, Devon, UK; selected and named 2001 (Fulcher & Fulcher, 2010).

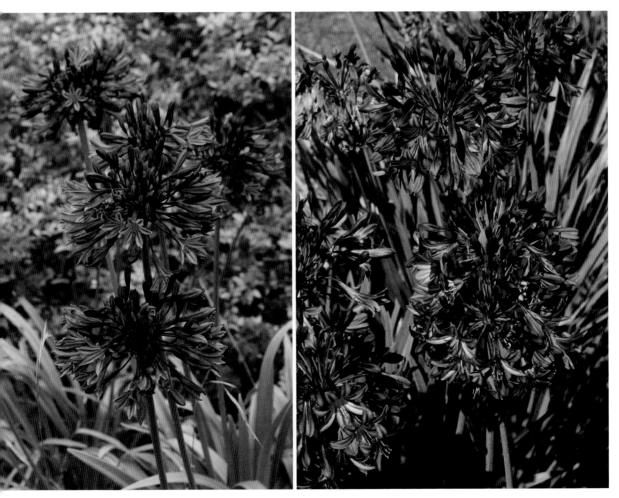

Figure 38 (left). *Agapanthus* 'Midnight Star', Marwood Hill Gardens, Devon. Image: Graham Duncan.
Figure 39 (right). *Agapanthus* 'Northern Star', Pine Cottage Plants, Devon. Image: Graham Duncan.

Agapanthus **'Midnight Star'** AGM 2018 (Figure 38)
Synonyms: *Agapanthus campanulatus* 'Navy Blue'; *Agapanthus* 'Navy Blue'.
Height: medium (80–90 cm).
Description: outstanding hemispherical heads of deep violet-blue, narrowly funnel-shaped flowers produced on sturdy, upright green scapes, pseudostem purple-flushed; leaves narrow, arching, mid-green.
Flowering: mid-season.
Hardiness: H5/USDA 7b/8a.
Uses: centre of mixed borders; patio pots.
Origin: Lady Priscilla Bacon, Raveningham Hall, Norfolk, UK; introduced 1989 (Snoeijer, 2004).

Agapanthus **'Monique'** AGM 2018
Height: medium (70–90 cm).
Description: open, rounded heads of spreading, deep blue, narrowly funnel-shaped blooms, carried on suberect, slender but sturdy green scapes, free-flowering; leaves medium-width, glaucous-green.
Flowering: mid- to late season.
Hardiness: H4: USDA 8b/9a.
Uses: front or centre of mixed borders; patio pots.
Origin: submitted to the 2014–2018 RHS Agapanthus Trial by Walter Blom Plants BV, Hillegom, The Netherlands.

Agapanthus **'Nikki'** FCC 2003
Synonym: *Agapanthus* 'Nicky'.
Cultivar name: in tribute to the second daughter of Dick and Lorna Fulcher.
Height: medium (70–90 cm).
Description: nodding, deep blue, widely funnel-shaped blooms with inky blue buds, carried in rounded heads on purple-flushed pedicels and slender, slanting or erect green scapes; leaves narrow, arching, deep-green; pseudostem purple-flushed.
Flowering: mid-season.
Hardiness: H4: USDA 8b/9a.
Uses: front or centre of mixed borders; patio pots.
Origin: Dick Fulcher, Pine Cottage Plants, Devon, UK; introduced 1998 (Fulcher & Fulcher, 2010).

Agapanthus **'Northern Star'** AGM 2018 (Figure 39)
Height: medium (100–110 cm).
Description: superb globular umbels of deep blue, widely funnel-shaped blooms with recurved tepals, carried on erect green scapes; leaves narrow, yellowish-green, suberect, pseudostem purple-flashed; very free-flowering.
Flowering: mid-season.
Hardiness: H4/USDA 8b/9a.
Uses: centre of mixed borders; patio pots.
Origin: Dick Fulcher, Pine Cottage Plants, Devon, UK; selected and named 2000 (Fulcher & Fulcher, 2010).

Agapanthus **'Notfred'** AGM 2018 (Figure 40)
Trade name: *Agapanthus* 'Silver Moon'.
Cultivar name: name combination from Notcutts Nurseries and Fred Nichols.
Height: short to medium (60–80 cm).
Description: elegant narrow, arching, grey-green, variegated leaves with broad, creamy-yellow or silvery stripes along margins and narrow central stripes; small, hemispherical heads of light violet-blue, narrowly funnel-shaped, nodding flowers on narrow, slanting scapes, fairly free-flowering, compact habit.
Flowering: mid- to late season.
Hardiness: H5/USDA 7b/8a.
Uses: front borders; patio pots.
Origin: Fred Nichols, Notcutts Nurseries, UK; introduced 2001 (Snoeijer, 2004).

Agapanthus **'Petite White'**
Height: short (60 cm).
Description: a dainty dwarf cultivar with small, hemispherical heads of white, widely funnel-shaped blooms, carried on contrasting brownish pedicels and slender green scapes, very free-flowering; leaves narrow, suberect, mid-green.
Flowering: mid-season.
Hardiness: H4/USDA 8b/9a.
Uses: front borders; patio pots.
Origin: Dick Fulcher, Pine Cottage Plants, Devon, UK.

Figure 40. *Agapanthus* 'Notfred', Pine Cottage Plants, Devon. Image: Graham Duncan.

Agapanthus 'Pinchbeck'

Cultivar name: after the village in Lincolnshire, eastern England.
Height: short to medium (50–80 cm).
Description: strong blue, slightly nodding, widely funnel-shaped blooms in open heads, borne on dark pedicels and erect, strong green scapes; leaves narrow, suberect, mid-green.
Flowering: early to late season.
Hardiness: H4/USDA 8b/9a.
Uses: front borders; patio pots.
Origin: Kees Duivenvoorde, Beverwijk, The Netherlands; introduced 1999 (Snoeijer, 2004).

Agapanthus 'Pinocchio'

Synonym: *Agapanthus campanulatus* 'Pinocchio'.
Height: short (50–60 cm).
Description: a dwarf cultivar with fairly dense, rounded heads of slightly nodding, light blue, widely funnel-shaped flowers carried on greenish-brown pedicels and upright, light green scapes; leaves arching, bright green, narrow; plants compact, strongly clump-forming.
Flowering: mid- to late season.
Hardiness: H3/USDA 9b/10a.
Uses: front borders; patio pots.
Origin: Maas & van Stein, Hillegom, The Netherlands; introduced 1996 (Snoeijer, 2004).

Agapanthus 'Polar Ice'

Height: medium (100 cm).
Description: hemispherical heads of bright white, slightly nodding, widely funnel-shaped flowers with light yellow tips and bright yellow anthers, carried on strong, slanting green scapes; leaves narrow, erect to suberect, light green.
Flowering: mid- to late season.
Hardiness: H4: USDA 8b/9a.
Uses: centre of mixed borders.
Origin: Maas & van Stein, Hillegom, The Netherlands; introduced 1981 (Snoeijer, 2004).

Agapanthus 'Prinses Marilène'

Cultivar name: in tribute to Princess Marilène of The Netherlands.
Height: medium (70–100 cm).
Description: hemispherical, open heads of bright white, slightly nodding, widely funnel-shaped blooms, carried on light green, radiating pedicels and upright or slanting, strong green scapes; leaves arching, narrow, light green.
Flowering: mid-season.
Hardiness: H4/USDA 8b/9a.
Uses: centre of mixed borders; patio pots; good cut flower.
Origin: Kees Duivenvoorde, Beverwijk, The Netherlands; registered and introduced 1998 (Snoeijer, 2004).

Agapanthus 'Purple Emperor'

Height: medium (80–100 cm).
Description: outstanding, dense, rounded heads of deepest indigo, with pendent or strongly nodding,

trumpet-shaped blooms carried on erect or slanting, green scapes; leaves narrow to medium width, suberect, light green.

Flowering: mid- to late season.

Hardiness: H4/USDA 8b/9a.

Uses: wall-side borders; centre of mixed borders.

Origin: Dick Fulcher, Pine Cottage Plants, Devon, UK, 2006; ex John Newbold, Dorset, UK, introduced 2006 (Fulcher & Fulcher, 2010).

Agapanthus 'Quink Drops' (Figure 41)

Height: medium (80–90 cm).

Description: magnificent dense heads of deep blue, pendent, trumpet-shaped blooms, with deepest blue buds, carried on curved, green pedicels and erect, grey-green scapes; leaves medium-width, erect, mid-green.

Flowering: mid-season.

Hardiness: H4/USDA 8b/9a.

Uses: wall-side borders; centre of mixed borders; patio pots.

Origin: raised by Graham Gough, Marchants Nursery, East Sussex, UK.

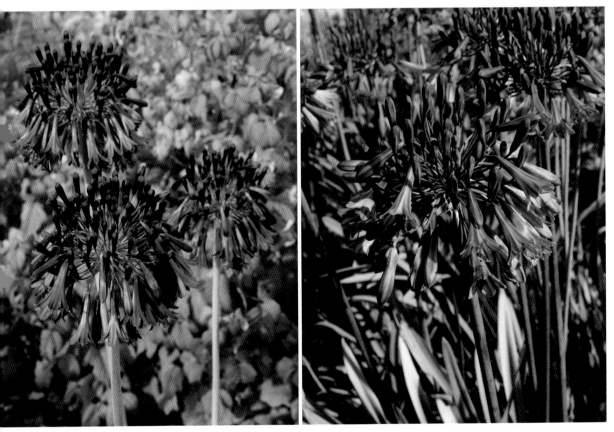

Figure 41 (left). *Agapanthus* 'Quink Drops', Pine Cottage Plants, Devon. Image: Graham Duncan.
Figure 42 (right). *Agapanthus* 'Rhapsody in Blue', Pine Cottage Plants, Devon. Image: Graham Duncan.

Agapanthus **'Rhapsody in Blue'** AGM 2018 (subject to availability) (Figure 42)

Height: medium (90–120 cm).

Description: strong blue, pendent, narrowly funnel-shaped flowers with deep blue anthers, carried on strong, upright, green scapes; leaves medium-width, suberect, slightly channelled, mid-green.

Flowering: mid-season.

Hardiness: H3/USDA 9b/10a.

Uses: wall-side borders; centre of mixed borders.

Origin: Dick Fulcher, Pine Cottage Plants, Devon, UK; selected and named 2009 (Fulcher & Fulcher, 2010).

Agapanthus **'Rotterdam'**

Cultivar name: after the port city of Rotterdam, The Netherlands.

Height: medium (70–80 cm).

Description: rounded, dense heads of light blue, widely funnel-shaped, spreading blooms with nicely contrasting blackish anthers, carried on tall, upright or slanting green scapes; leaves narrow, suberect, deep green.

Flowering: mid- to late season.

Hardiness: H4/USDA 8b/9a.

Uses: front borders; patio pots; good cut flower.

Origin: Kees Duivenvoorde, Beverwijk, The Netherlands; introduced 1999 (Snoeijer, 2004).

Agapanthus **'Royal Blue'** AGM 2018

Height: medium (75 cm).

Description: rounded heads of bright blue, widely funnel-shaped, slightly nodding blooms, carried on erect, green scapes, very free-flowering; leaves narrow, yellowish-green, arching.

Flowering: mid-season.

Hardiness: H5/USDA 7b/8a.

Uses: front borders; patio pots.

Origin: John Bond, The Savill Garden, Surrey, UK; introduced 1974 (Snoeijer, 2004).

Agapanthus **'Royal Velvet'** AGM 2018 (Figure 43)

Height: medium (90–100 cm).

Description: rounded, open heads of extraordinary deep mauve, slightly nodding, narrowly funnel-shaped blooms with deepest violet buds, carried on erect, green scapes; leaves medium-width, suberect or arching, mid-green; plants are sometimes semi-deciduous in mild climates.

Flowering: mid-season.

Figure 43. *Agapanthus* 'Royal Velvet' (centre), Pine Cottage Plants, Devon. Image: Graham Duncan.

Hardiness: H4/USDA 8b/9a.

Uses: centre of mixed borders; patio pots.

Origin: Dick Fulcher, Pine Cottage Plants, Devon, UK; selected and named 2011 (Dick Fulcher, pers. comm.).

Agapanthus 'Sandringham' AGM 2018

Cultivar name: after the Royal country house in Norfolk, England.

Height: short to medium (50–80 cm).

Description: hemispherical heads of widely funnel-shaped, violet-blue, nodding flowers, carried on tall, slanting, light green scapes; leaves narrow, suberect, mid-green, pseudostem purple-flushed. Very free-flowering.

Flowering: late season.

Hardiness: H5/USDA 7b/8a.

Uses: front borders; good cut flower.

Origin: Crown Estate, Windsor, UK; introduced 1995 (Snoeijer, 2004).

Agapanthus 'Sandy' AGM 2018

Synonym: *Agapanthus* 'Pretty Sandy'.

Height: short to medium (50–70 cm).

Description: small, rounded heads of widely funnel-shaped, light blue, spreading or slightly nodding blooms, carried on purplish-green pedicels and slender but firm, slanting, glaucous-green scapes, very free-flowering; leaves narrow, suberect, glaucous-green.

Flowering: mid-season.

Hardiness: H4/USDA 8b/9a.

Uses: front borders; patio pots.

Origin: J. van Vliet, Zwetsloot Ltd, Perthshire, UK.

Agapanthus 'Septemberhemel'

Height: medium (70 cm).

Description: nicely rounded, dense heads of deep violet-blue, widely funnel-shaped, nodding flowers, carried on strong, slanting, grey-green scapes; leaves narrow, mid-green, arching, pseudostem purple-flushed

Flowering: late season.

Hardiness: H4/USDA 8b/9a.

Uses: front borders; good cut flower.

Origin: Hans Kramer, De Hessenhof Nursery, The Netherlands; selected and introduced 2000 (Snoeijer, 2004).

Agapanthus 'Stars and Stripes' (Figure 44)

Height: medium (90 cm).

Description: hemispherical heads of large, widely funnel-shaped, light blue, slightly nodding flowers carried on stout, slanting scapes, with a broad, deep blue median stripe to each tepal; leaves medium-width, arching to suberect, light green.

Flowering: mid-season.

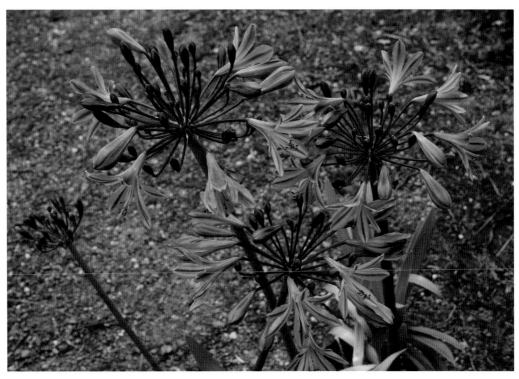

Figure 44. *Agapanthus* 'Stars and Stripes', Pine Cottage Plants, Devon. Image: Graham Duncan.

Hardiness: H4/USDA 8b/9a.
Uses: centre of mixed borders; patio pots.
Origin: unknown.

Agapanthus 'Stéphanie Charm'
Cultivar name: in tribute to a student who worked in Ignace van Doorslaer's nursery in 1999.
Height: short to medium (50–80 cm).
Description: white, widely funnel-shaped flowers borne in dense, rounded heads on strong, upright dark green scapes; leaves narrow, suberect to arching, mid-green.
Flowering: mid-season.
Hardiness: H4/USDA 8b/9a.
Uses: front borders; patio pots.
Origin: Ignace van Doorslaer, Belgium; named 1999 (Snoeijer, 2004).

Agapanthus 'Summer Days' AGM 2018
Height: medium (100–120 cm).
Description: large, rounded heads of very light blue, spreading, widely funnel-shaped blooms with striking exserted stamens, carried on tall, robust, upright scapes; leaves medium-width, glaucous, spreading.
Flowering: mid-season.

Hardiness: H4/USDA 8b/9a.

Uses: centre of mixed borders.

Origin: Dick Fulcher, Pine Cottage Plants, Devon, UK; selected and named 2004 (Fulcher & Fulcher, 2010).

Agapanthus **'Summer Delight'** AGM 2018

Height: medium (80 cm).

Description: dense, hemispherical heads of light purple, nodding, narrowly funnel-shaped blooms with deep purple buds, carried on long, arching, purplish pedicels and strong, erect scapes, old flowers ageing to pinkish-mauve.

Flowering: mid-season.

Hardiness: H4/USDA 8b/9a.

Uses: front or centre of mixed borders; patio pots.

Origin: Dick Fulcher, Pine Cottage Plants, Devon, UK; selected and named 2007 (Fulcher & Fulcher, 2010).

Agapanthus **'Sunset Skies'** (Figure 45)

Height: medium (100–110 cm).

Description: dense, rounded heads of striking mauve, slightly nodding, widely funnel-shaped flowers, produced on tall, strong green scapes; leaves medium-width, suberect, mid-green.

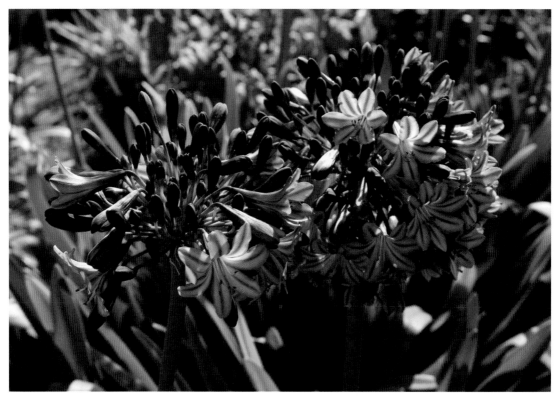

Figure 45. *Agapanthus* 'Sunset Skies', Pine Cottage Plants, Devon. Image: Graham Duncan.

Flowering: mid-season.
Hardiness: H4/USDA 8b/9a.
Uses: centre of mixed borders.
Origin: Dick Fulcher, Pine Cottage Plants, Devon, UK; selected and named 2007 (Fulcher & Fulcher, 2010).

Agapanthus 'Taw Valley'
Cultivar name: after a valley in North Devon, England.
Height: medium (80 cm).
Description: elegant hemispherical heads of deep blue, spreading or slightly nodding, widely funnel-shaped blooms, carried on slightly arching pedicels and slanting green stems, very free-flowering; leaves narrow, suberect, yellowish-green.
Flowering: mid- to late season.
Hardiness: H4/USDA 8b/9a.
Uses: front of mixed borders; patio pots.
Origin: Dick Fulcher, Pine Cottage Plants, Devon, UK; selected and named 2000 (Fulcher & Fulcher, 2010).

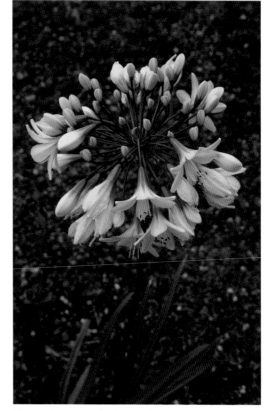

Figure 46. *Agapanthus* 'Twister', Pine Cottage Plants, Devon. Image: Graham Duncan.

Agapanthus 'Twister' AGM 2018 (Figure 46)
Height: short to medium (50–80 cm).
Description: very striking, dense, rounded heads of bicoloured, spreading or slightly nodding, widely funnel-shaped blooms with white tepals and bright blue perianth tubes, produced on erect, green scapes; leaves medium-width, suberect, light green, sometimes semi-deciduous in mild climates, vigorous and multiplies fast.
Flowering: early to mid-season.
Hardiness: H4/ USDA 8b/9a.
Uses: front borders; patio pots.
Origin: De Wet Plant Breeders, Johannesburg, South Africa; introduced 2008.

Agapanthus 'Wembworthy' (Figure 47)
Cultivar name: after the village in mid-Devon, England.
Height: tall (130–150 cm).
Description: large, lilac, widely funnel-shaped, nodding flowers in rounded heads, carried on erect, strong green scapes; leaves medium-width, suberect, light green.
Flowering: mid-season.
Hardiness: H4/USDA 8b/9a.
Uses: centre or rear of mixed borders.
Origin: Dick Fulcher, Pine Cottage Plants, Devon, UK; selected and named 2000 (Fulcher & Fulcher, 2010).

Agapanthus 'White Century'

Height: medium (80 cm).

Description: striking white, widely funnel-shaped, nodding flowers, carried on long, curved green pedicels and erect or slanting green scapes; leaves medium width, mid-green, arching.

Flowering: mid-season.

Hardiness: H4/USDA 8b/9a.

Uses: front or centre of mixed borders; patio pots.

Origin: Dick Fulcher, Pine Cottage Plants, Devon, UK; introduced 2010 (Fulcher & Fulcher, 2010).

Agapanthus 'Windsor Grey' (Figure 48)

Cultivar name: after the Crown Estate of Windsor in Berkshire, England.

Height: medium to tall (90–130 cm).

Description: unique dove-grey, narrowly funnel-shaped, nodding flowers in fairly dense heads, on long, green, slightly slanting scapes, very free-flowering; leaves medium-width, erect with curved tips, mid-green.

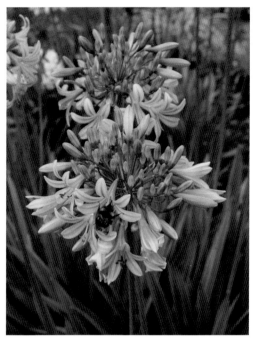

Figure 47. *Agapanthus* 'Wembworthy', Pine Cottage Plants, Devon. Image: Graham Duncan.

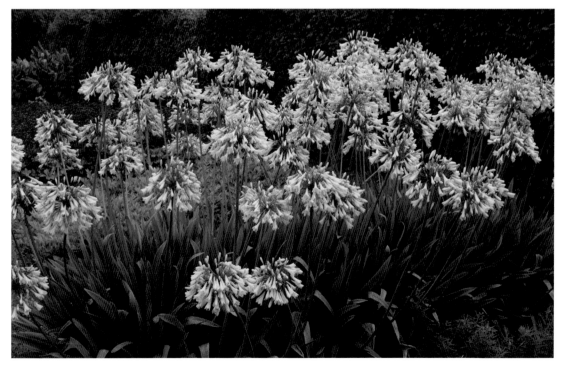

Figure 48. *Agapanthus* 'Windsor Grey', Avon Bulbs, Somerset. Image: Graham Duncan.

Flowering: mid- to late season.
Hardiness: H4/USDA 8b/9a.
Uses: wall-side borders; centre of mixed borders.
Origin: Crown Estate, Windsor, Berkshire, UK; introduced 1995 (Snoeijer, 2004).

EVERGREEN CULTIVARS

Agapanthus **'African Skies'** AGM 2018 (Figure 49)

Height: medium (100–120 cm).
Description: outstanding rounded heads of violet blue, widely funnel-shaped flowers with darker midveins and margins, produced on long, suberect pedicels and strong, upright green scapes; leaves medium-width, bright green, suberect.
Flowering: mid-season.
Hardiness: H3/USDA 9b/10a.
Uses: centre of mixed borders.
Origin: Dick Fulcher, Pine Cottage Plants, Devon, UK (Fulcher & Fulcher, 2010).

Agapanthus **'Ballerina'** AGM 2018 (Figure 50)

Height: medium (100–120 cm).
Description: striking, dense clusters of light blue, narrowly funnel-shaped, nodding blooms, borne on strong, upright scapes, very free-flowering; leaves medium-width, olive-green, arching; plants fast-multiplying.

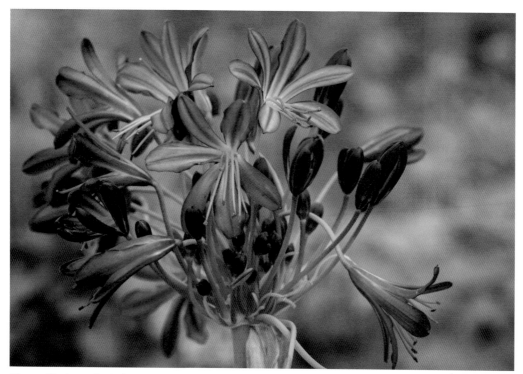

Figure 49. *Agapanthus* 'African Skies', Fairweather's Nursery, Hampshire. Image: FhF GreenMedia.

Flowering: mid- to late season.

Hardiness: H3/USDA 9b/10a.

Uses: centre of mixed borders; patio pots.

Origin: Richard Jamieson, Black Dog Plants, Cape Town, South Africa; introduced 2008.

Agapanthus **'Barnfield Blue'**

Cultivar name: after Barnfield in Gweek, Cornwall, UK (Sarah Wilks, pers. comm.).

Height: medium (100 cm).

Description: dense, rounded heads of large, bright blue, slightly nodding, narrowly funnel-shaped flowers; anthers brown; leaves broad, spreading, deep green; plants robust.

Flowering: mid-season.

Hardiness: H3/USDA 9b/10a.

Uses: centre of mixed borders, patio pots.

Origin: John Froggat of Gweek, Cornwall, UK, who named and exhibited a plant for the Royal Cornwall Show ± 2004, from seed collected from Barnfield in Gweek, Cornwall; introduced by Dick Fulcher, Pine Cottage Plants, 2006 (Fulcher & Fulcher, 2010).

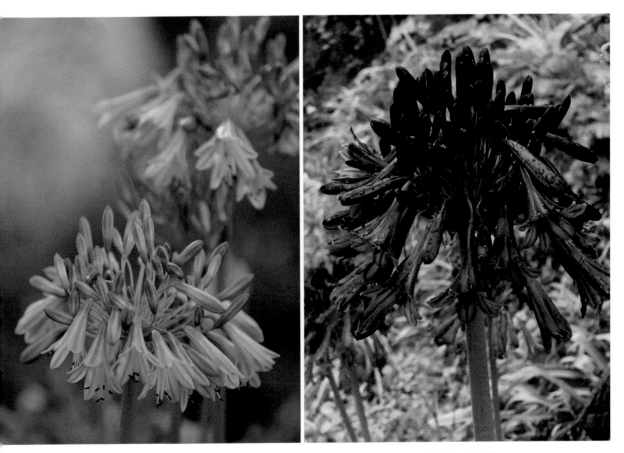

Figure 50 (left). *Agapanthus* 'Ballerina', Fairweather's Nursery, Hampshire. Image: FhF GreenMedia.
Figure 51 (right). *Agapanthus* 'Black Pantha', private garden, Johannesburg. Image: Keith Kirsten.

Agapanthus **'Black Pantha'** (Figure 51)
Synonym: *Agapanthus* 'Black Panther'
Height: medium (100–120 cm).
Description: outstanding dense heads of deep violet-blue, nodding, trumpet-shaped flowers carried on arching, purple-flushed green pedicels and tall, straight or slightly slanting, robust green scapes; buds almost black; leaves medium-width, grey-green, strap-shaped, arching.
Flowering: mid- to late season.
Hardiness: H3/USDA 9b/10a.
Uses: wall-side borders; centre of mixed borders; patio pots; good cut flower.
Origin: G. Morrison, Doncaster, Victoria, Australia; known since 1999 (Snoeijer, 2004).

Agapanthus **'Blue Boy'**
Height: medium (80–100 cm).
Description: large, dense heads of bright blue, suberect, narrowly funnel-shaped blooms, carried on upwardly arching green pedicels and sturdy, erect green stems; leaves broad, compact, arching, greyish-green.
Flowering: mid-season.
Hardiness: H3/USDA 9b/10a.
Uses: front or centre of mixed borders; patio pots.
Origin: Diack's Nurseries Ltd., Makarewa, New Zealand; known since 1998 (Snoeijer, 2004).

Agapanthus **'Blue Flare'**
Height: short (30–50 cm).
Description: rounded heads of light blue, upright, narrowly funnel-shaped flowers, borne on erect scapes, very free-flowering, multiple scapes per plant; pedicels green or brownish; leaves narrow, glaucous-green, slightly arching.
Flowering: mid-season.
Hardiness: H3/USDA 9b/10a.
Uses: front borders; patio pots.
Origin: Black Dog Plants, Cape Town, South Africa; registered 2012 (Richard Jamieson, pers. comm.).

Agapanthus **'Blue Globe'**
Height: medium (80–120 cm).
Description: globose, dense flowerheads of widely funnel-shaped, violet-blue flowers with rounded tepal tips, stamens included, anthers yellowish-brown; leaves narrow, dark green, suberect to erect.
Flowering: early season.
Hardiness: H3/USDA 9b/10a.
Uses: centre of mixed borders; patio pots.
Origin: Hoogervorst, Oegstgeest, The Netherlands; known since *circa* 1964 (Snoeijer, 2004).

Agapanthus **'Blue Ice'** AGM 2018 (Figure 52)
Height: medium (80–100 cm).
Description: dense heads of large, light violet-blue, narrowly funnel-shaped flowers with deep blue bases, borne on robust, upright green stems; leaves broad, suberect, mid-green with purple-flushed pseudostem; vigorous and fast-multiplying.
Flowering: mid-season.

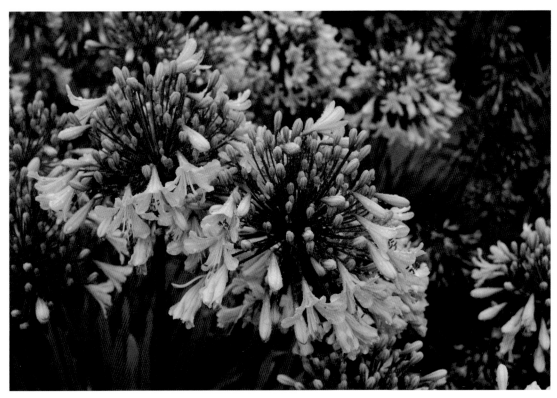

Figure 52. *Agapanthus* 'Blue Ice', Pine Cottage Plants, Devon. Image: Dick Fulcher.

Hardiness: H3/USDA 9b/10a.
Uses: centre of mixed borders; patio pots.
Origin: Dick Fulcher, Pine Cottage Plants, Devon, UK; raised 2001 (Dick Fulcher, pers. comm.).

Agapanthus **'Blue Jay'** (Figure 53)
Height: medium (80–100 cm).
Description: small, rounded heads of strong blue, widely funnel-shaped flowers on slender, brownish, upright stems; leaves narrow, mid-green, suberect; plants multiply rapidly.
Flowering: late season.
Hardiness: H3/USDA 9b/10a.
Uses: front or centre of mixed borders; patio pots.
Origin: Richard Jamieson, Black Dog Plants, Cape Town, South Africa; introduced 2009 (Richard Jamieson, pers. comm.).

Agapanthus **'Blue Nile'**
Synonyms: *Agapanthus praecox* 'Blue Nile'; *Agapanthus praecox* subsp. *orientalis* 'Blue Nile'.
Cultivar name: after the Blue Nile River in Sudan.
Height: tall (150–180 cm).
Description: light blue, widely funnel-shaped, nodding flowers in large, imposing heads, multiple upright, rigid stems per plant; leaves broad, dark green, arching, plants strongly clump-forming.

Flowering: mid- late season.
Hardiness: H3/USDA 9b/10a.
Uses: centre or rear of mixed borders.
Origin: Steven Benham, New Zealand; known since 1991 (Snoeijer, 2004).

Agapanthus 'Blue Pixie' (Figure 54)

Height: medium (70–80 cm).
Description: dense heads of light blue, suberect, narrowly funnel-shaped blooms on greenish-brown pedicels and strong, slanting green stems, multiple heads produced per plant; leaves narrow, suberect, green; fast multiplying.
Flowering: mid- to late season.
Hardiness: H3/USDA 9b/10a.
Uses: front borders; patio pots; mass planting.

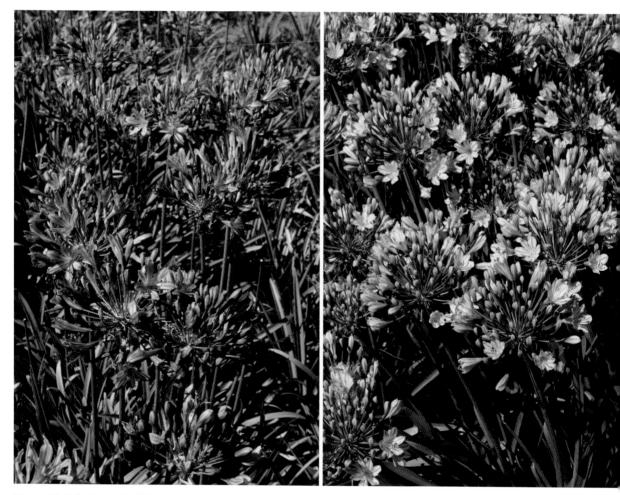

Figure 53 (left). *Agapanthus* 'Blue Jay', Black Dog Plants, Cape Town. Image: Graham Duncan.
Figure 54 (right). *Agapanthus* 'Blue Pixie', Black Dog Plants, Cape Town. Image: Graham Duncan.

Origin: Richard Jamieson, Black Dog Plants, Cape Town, South Africa; introduced 2006 (Richard Jamieson, pers. comm.).

Agapanthus **'Charlotte'** (Figure 55)

Cultivar name: in tribute to Charlotte, sister of Ignace van Doorslaer (Steven Hickman, pers. comm.)

Height: short (45–60 cm).

Description: a dwarf cultivar with striking bright blue, spreading or slightly suberect, widely funnel-shaped flowers, carried on sturdy, short green stems; leaves narrow, spreading or arching, deep green. Strongly clump-forming, very free-flowering, producing up to three flushes per season.

Flowering: early to late season.

Hardiness: H3/USDA 9b/10a.

Uses: front borders; patio pots.

Origin: Ignace van Doorslaer, Belgium; named 2001 (Snoeijer, 2004).

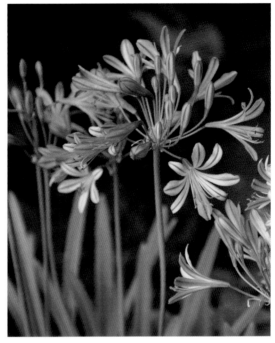

Figure 55. *Agapanthus* 'Charlotte', private garden, Cape Town. Image: Graham Duncan.

Agapanthus **'Cloudy Days'**

Height: medium (80–100 cm).

Description: large, hemispherical heads of bicoloured, widely funnel-shaped, nodding flowers with bright white tepals and prominent blue perianth tubes, carried on strong, erect or slanting green stems; leaves medium-width, suberect or arching, glossy, mid-green.

Flowering: early to mid-season

Hardiness: H3/USDA 9b/10a.

Uses: front or centre of mixed borders.

Origin: John Craigie, Queensland, Australia; selected and named early 2000s (Dick Fulcher, pers. comm.).

Agapanthus **'Cornish Sky'**

Synonym: *Agapanthus* 'Hole Park Blue'.

Height: tall (130 cm).

Description: robust, tall-growing plant with very large, dense heads of bright blue, slightly nodding, narrowly funnel-shaped flowers, produced on long, radiating green pedicels and sturdy, erect or slanting green stems; leaves broad, arching, mid-green, strongly clump-forming.

Flowering: late season.

Hardiness: H3/USDA 9b/10a.

Uses: centre or rear of mixed borders.

Origin: Dick Fulcher, Pine Cottage Plants, Devon, UK; introduced 2006, ex Robert Smith 2001, Trevean Nursery, Cornwall, UK. Prior to its naming and introduction as 'Cornish Sky', grown for many decades as an unnamed cultivar at Hole Park House, Kent, and named 'Hole Park Blue' after it had been named 'Cornish Sky' (Fulcher, 2004; Allison, 2019; Dick Fulcher, pers. comm.).

Agapanthus 'Croft's Pearl'

Height: medium (80 cm).

Description: long-lasting metallic blue, sterile flowers which do not open but remain permanently in bud stage, carried on radiating, yellowish-green pedicels and erect, yellowish-green scapes; leaves medium-width, yellowish-green, slightly glossy, arching.

Flowering: mid-season.

Hardiness: H3/USDA 9b/10a.

Uses: front borders; patio pots; good cut flower.

Origin: Richard Jamieson, Black Dog Plants, Cape Town, South Africa; registered 2012 (Richard Jamieson, pers. comm.).

Agapanthus 'Devon Dawn'

Height: medium (80–90 cm).

Description: large, rounded heads of deep blue, slightly nodding, widely funnel-shaped blooms, the tepals with prominent deeper blue median keels, carried on strong, upright green scapes; leaves medium-width, arching, mid-green.

Flowering: mid-season.

Hardiness: H3/USDA 9b/10a.

Uses: front borders; patio pots.

Origin: Dick Fulcher, Pine Cottage Plants, Devon, UK; selected and named 1997 (Fulcher & Fulcher, 2010).

Agapanthus 'Double Diamond' AGM 2018 (Figure 56)

Height: short (25–45 cm).

Description: a true dwarf cultivar with dense, small heads of bright white, spreading, narrowly or widely funnel-shaped flowers with double or triple the usual number of tepals and prominent yellow anthers, carried on short, suberect, slender, bright green scapes; leaves narrow, arching, mid-green; fast-multiplying.

Flowering: early to mid-season.

Hardiness: H3/USDA 9b/10a.

Uses: front borders; patio pots.

Origin: Jim Holmes, Cape Seed & Bulb, Stellenbosch, South Africa; known since 2000, introduced 2003 (Snoeijer, 2004).

Agapanthus 'Enigma'

Height: short to medium (50–75 cm).

Description: striking bicoloured cultivar with large, dense, hemispherical heads of spreading or slightly nodding, white, narrowly funnel-shaped blooms with blue perianth tubes and tepal outer surface median keels, and shortly exserted stamens with yellowish-brown pollen, carried on brownish pedicels and slanting green scapes; leaves medium-width, spreading, mid-green.

Flowering: mid-season.

Hardiness: H3/USDA 9b/10a.

Uses: front borders; patio pots.

Origin: Ken Rigney, Southampton, UK.

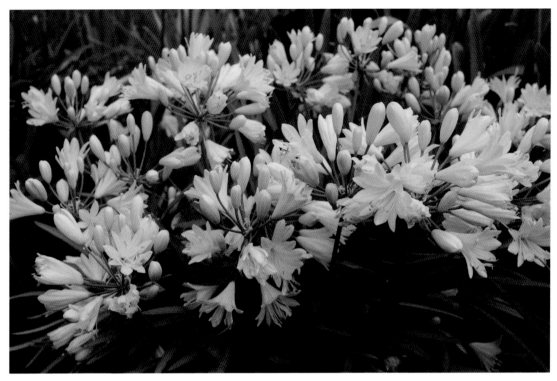

Figure 56. *Agapanthus* 'Double Diamond', Pine Cottage Plants, Devon. Image: Dick Fulcher.

Agapanthus **'Ever White'** AGM 2018

Height: short to medium (60–70 cm).

Description: semi-dwarf cultivar with dense, rounded heads of bright white, slightly nodding, narrowly funnel-shaped flowers with bright yellow anthers, carried on bright green, spreading pedicels and strong, slanting green scapes; leaves narrow, suberect, bright green; repeat-flowering, neat appearance.

Flowering: early to mid-season.

Hardiness: H3/USDA 9b/10a.

Uses: front borders; patio pots.

Origin: De Wet Plant Breeders, Johannesburg, South Africa.

Agapanthus **'Fireworks'** AGM 2018 (Figure 57)

Height: short (50–60 cm).

Description: excellent repeat-flowering cultivar with rounded heads of large, nodding, narrowly funnel-shaped, bicoloured blooms with white tepals and deep blue perianth tubes, carried on long, radiating, somewhat lax, purple-flushed pedicels and slanting green scapes; leaves medium-width, spreading to arching, mid-green. Similar to *A.* 'Twister', but the latter is deciduous with shorter pedicels and more widely flared tepals.

Flowering: mid- to late season.

Hardiness: H3/USDA 9b/10a.

Uses: front borders; patio pots.

Origin: De Wet Plant Breeders, Johannesburg, South Africa.

Agapanthus 'Full Moon' AGM 2018 (Figure 58)

Synonyms: *Agapanthus praecox* 'Full Moon'; *Agapanthus praecox* subsp. *orientalis* 'Full Moon'.

Height: medium (80–90 cm).

Description: magnificent dense, rounded heads of large, light blue widely funnel-shaped blooms with rounded inner tepal tips and prominent deep blue tepal median stripe, carried on robust, slanting green scapes, with numerous flowers open simultaneously; leaves medium-width to broad, suberect with curved tips, mid-green.

Flowering: mid-season.

Hardiness: H3/USDA 9b/10a.

Uses: front or centre of mixed borders; patio pots; good cut flower.

Origin: Richard Jamieson, Black Dog Plants, Cape Town, South Africa; registered 2012 (Richard Jamieson, pers. comm.).

Agapanthus 'Glen Avon'

Trade name: *Agapanthus* 'Fragrant Glen'.

Cultivar name: after a suburb of New Plymouth, New Zealand.

Height: medium (100 cm).

Description: striking, large, dense heads of up to 300 or more lilac-blue, narrowly funnel-shaped blooms on rigid, upright scapes, slightly fragrant, very free-flowering; broad, grey-green, arching leaves.

Flowering: late season.

Hardiness: H3/USDA 9b/10a.

Uses: centre of mixed borders; patio pots.

Origin: A.D. Gray, Glen Avon, New Plymouth, New Zealand; known since 1997 (Dawson & Ford, 2012).

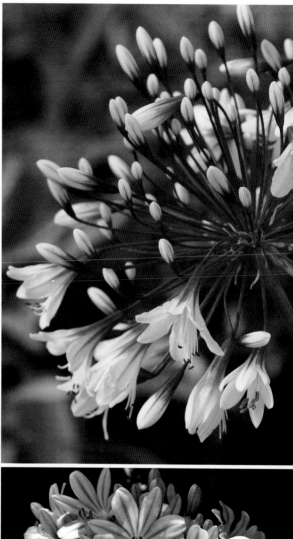

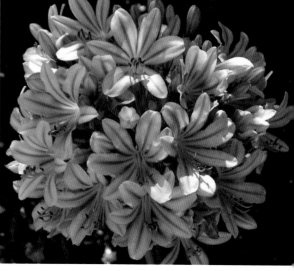

Figure 57 (top right). *Agapanthus* 'Fireworks', Fairweather's Nursery, Hampshire. Image: FhF GreenMedia.

Figure 58 (right). *Agapanthus* 'Full Moon', Black Dog Plants, Cape Town. Image: Richard Jamieson.

***Agapanthus* 'Gold Strike'** (Figure 59)

Synonyms: *Agapanthus* 'Geagold'; *Agapanthus* 'Goldstrike'.

Height: short (40–50 cm).

Description: narrow, variegated, light green, arching leaves with striking golden-yellow margins; flowers narrowly funnel-shaped, deep blue, carried in dense, hemispherical heads; free-flowering, compact growth habit, multiplies rapidly.

Flowering: mid- to late season.

Hardiness: H3/USDA 9b/10a.

Uses: front borders; patio pots.

Origin: Ian Gear, Heritage Horticulture Nursery, New Zealand; raised in 1990 (Dawson & Ford, 2012).

***Agapanthus* 'Hanneke'** AGM 2018 (subject to name clarification and availability) (Figure 60)

Cultivar name: in tribute to Hanneke Jamieson, wife of Richard Jamieson.

Height: tall (140 cm).

Description: dense heads of deep violet-blue, narrowly funnel-shaped, nodding flowers, produced on upright, straight scapes; leaves wide, spreading to suberect, olive green.

Flowering: mid- to late season.

Hardiness: H3/USDA 9b/10a.

Uses: centre or rear of mixed borders; good cut flower.

Origin: Richard Jamieson, Black Dog Plants, Cape Town, South Africa; registered 2012 (Richard Jamieson, pers. comm.).

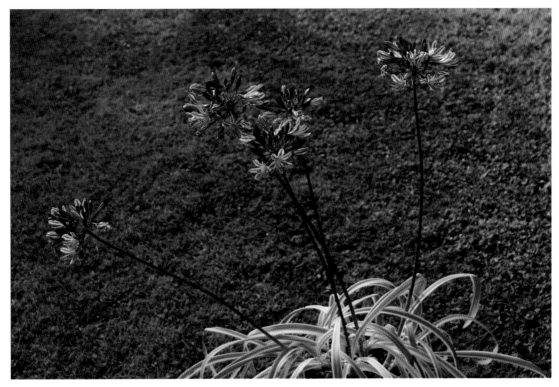

Figure 59. *Agapanthus* 'Gold Strike', Pine Cottage Plants, Devon. Image: Graham Duncan.

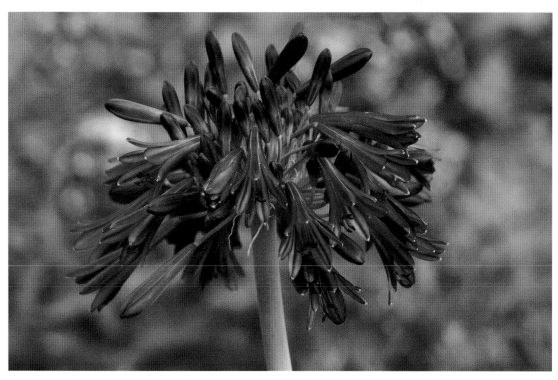

Figure 60. *Agapanthus* 'Hanneke', Fairweather's Nursery, Hampshire. Image: FhF GreenMedia.

Agapanthus **'Hoyland Blue'** AGM 2018

Cultivar name: after the town of Hoyland in Yorkshire, UK.

Height: medium (70 cm).

Description: dense, hemispherical heads of light blue, spreading or slightly nodding, narrowly funnel-shaped blooms with strongly rounded inner tepal tips, ageing to pink, carried on bright green pedicels and erect or slanting, robust scapes; leaves medium-width, suberect with recurved tips, mid-green. Plants are very free-flowering.

Flowering: late season.

Hardiness: H4/USDA 8b/9a.

Uses: front borders; patio pots.

Origin: Steven Hickman, Hoyland Plant Centre, South Yorkshire, UK; introduced 2012 (Steven Hickman, pers. comm.).

Agapanthus **'Hoyland Chelsea Blue'** AGM 2018 (subject to availability)

Cultivar name: after the town of Hoyland in Yorkshire and in commemoration of its introduction at the Chelsea Flower Show.

Height: medium (80–100 cm).

Description: striking dense, large rounded heads of dark blue, widely funnel-shaped flowers with slightly recurved tepals with deepest blue buds, carried on radiating, bright green pedicels and tall, strong green scapes; leaves broad, arching and strongly distichous, surfaces ridged.

Flowering: mid- to late season.

Hardiness: H3/USDA 9b/10a.
Uses: centre of mixed borders; patio pots.
Origin: Steven Hickman, Hoyland Plant Centre, South Yorkshire, UK; introduced 2013 (Steven Hickman, pers. comm.).

Agapanthus 'Jacaranda' AGM 2018

Height: medium (100 cm).
Description: hemispherical, open heads of bright violet-blue, slightly nodding, widely funnel-shaped blooms, carried on long, purplish-grey pedicels and upright, erect or slightly slanting, green scapes; leaves medium-width, suberect or slightly arching, yellowish-green.
Flowering: early season.
Hardiness: H3/USDA 9b/10a.
Uses: centre of mixed borders.
Origin: Ken Rigney, Southampton, UK.

Agapanthus 'James'

Cultivar name: in tribute to the youngest grandchild of Dick Fulcher and Lorna Fulcher.
Height: medium (70–80 cm).
Description: hemispherical heads of large, light to mid-blue, nodding, narrowly funnel-shaped blooms, carried on suberect, green scapes; leaves narrow, bright green, arching.
Flowering time: mid-season
Hardiness: H3/USDA 9b/10a.
Uses: front borders; patio pots.
Origin: Dick Fulcher, Pine Cottage Plants, Devon, UK; introduced 2010 (Fulcher & Fulcher, 2010).

Agapanthus 'Jodie'

Cultivar name: in tribute to a granddaughter of Dick and Lorna Fulcher.
Height: tall (140–150 cm).
Description: sparse, but striking hemispherical heads of light blue, widely funnel-shaped, spreading blooms on very long, erect or slanting scapes; leaves broad, light green, suberect, forms large clumps.
Flowering: very late season.
Hardiness: H4/USDA 8b/9a.
Uses: centre or rear of mixed borders.
Origin: Dick Fulcher, Pine Cottage Plants, Devon, UK; selected 1999 (Dick Fulcher, 2004; pers. comm.).

Agapanthus 'Joni' AGM 2018 (subject to availability) (Figure 61)

Synonym: *Agapanthus* 'Jonie'.
Cultivar name: in tribute to Canadian singer-songwriter, Joni Mitchell.
Height: short (35–50 cm).
Description: striking dwarf cultivar with compact heads of nodding, bright blue, long-lasting tubular flowers, carried on short, upright, green scapes; leaves narrow, arching, mid-green; a cross with *A. praecox* and *A. inapertus* in its background, often producing second flush of blooms.
Flowering: mid-season.
Hardiness: H3/USDA 9b/10a.
Uses: front borders; patio pots.
Origin: Richard Jamieson, Black Dog Plants, Cape Town, South Africa; registered 2012 (Richard Jamieson, pers. comm.).

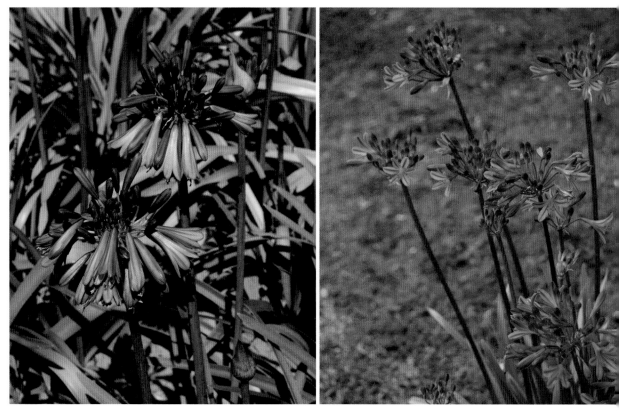

Figure 61 (left). *Agapanthus* 'Joni', Black Dog Plants, Cape Town. Image: Graham Duncan.
Figure 62 (right). *Agapanthus* 'Lapis Lazuli', private garden, Cape Town. Image: Graham Duncan.

Agapanthus **'Lapis Lazuli'** (Figure 62)

Height: short (50–60 cm).
Description: very free-flowering dwarf cultivar producing numerous compact, hemispherical heads of bright blue, widely funnel-shaped flowers on slender but sturdy scapes; repeat-flowering; leaves narrow, suberect, mid-green.
Flowering: early to mid-season.
Hardiness: H3/USDA 9b/10a.
Uses: front borders; patio pots.
Origin: V.J. Hooper, Waitara, Taranaki, New Zealand (Dawson & Ford, 2012).

Agapanthus **'Lavender Haze'** (Figure 63)

Height: short to medium (60–80 cm).
Description: lavender-blue, widely funnel-shaped flowers in large, hemispherical heads, carried on strong, upright scapes; leaves narrow, arching, mid-green.
Flowering: mid-season.
Hardiness: H3/USDA 9b/10a.
Uses: front borders; patio pots.
Origin: R.J. & D.M.L. Wood, New Plymouth, New Zealand; known since 2001 (Snoeijer, 2004).

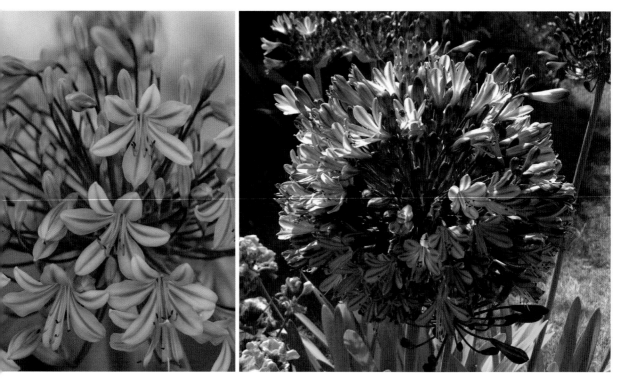

Figure 63 (left). *Agapanthus* 'Lavender Haze', Fairweather's Nursery, Hampshire. Image: FhF GreenMedia.
Figure 64 (right). *Agapanthus* 'Megan's Mauve', Pine Cottage Plants, Devon. Image: Dick Fulcher.

Agapanthus **'Megan's Mauve'** AGM 2018 (Figure 64)

Cultivar name: in tribute to the daughter of a friend of Dick and Lorna Fulcher.
Height: medium (100–120 cm).
Description: outstanding full, rounded heads of large, unusual mauve, narrowly funnel-shaped, suberect flowers with purple buds, the tepals all with a prominent deep mauve median stripe, carried on strong, green scapes; leaves broad, arching.
Flowering: mid-season.
Hardiness: H3/USDA 9b/10a.
Uses: centre or rear of mixed borders; patio pots.
Origin: Dick Fulcher, Pine Cottage Plants, Devon, UK; raised 2000 (Fulcher & Fulcher, 2010).

Agapanthus **'Monica'** (Figure 65)

Cultivar name: in tribute to a customer of Pine Cottage Plants.
Height: medium (90–100 cm).
Description: dense, rounded heads of light blue, nodding or pendent, widely funnel-shaped blooms, carried on strong, erect or slanting green scapes; leaves fairly broad, arching, mid-green.
Flowering: mid-season.
Hardiness: H3/USDA 9b/10a.
Uses: centre of mixed borders; patio pots.
Origin: Dick Fulcher, Pine Cottage Plants, Devon, UK.

Agapanthus 'Pavlova'

Height: short (45 cm).

Description: a compact, dwarf plant with small, dense heads of creamy-white, narrowly funnel-shaped, slightly nodding, sterile blooms, carried on strong, erect or slanting green scapes; leaves suberect or slightly arching, grey-green, narrow.

Flowering: mid-season.

Hardiness: H3/USDA 9b/10a.

Uses: front borders; patio pots.

Origin: Terry Hatch, Joy Plants, Auckland, New Zealand; known since 2011 (Dawson & Ford, 2012).

Agapanthus 'Peter Franklin' AGM 2018 (subject to availability) (Figure 66)

Cultivar name: in tribute to London grower of agapanthus, Peter Franklin.

Height: tall (120–160 cm).

Description: very striking tall-growing plants with large, rounded heads of pure white, widely funnel-shaped, nodding blooms with bright yellow anthers, produced on strong green scapes; leaves broad, arching, deep green.

Flowering: mid-season.

Hardiness: H3/USDA 9b/10a.

Uses: centre or rear of mixed borders.

Origin: Dick Fulcher, Pine Cottage Plants, Devon, UK; ex Peter Franklin, London, UK; named 2010 (Dick Fulcher, pers. comm.).

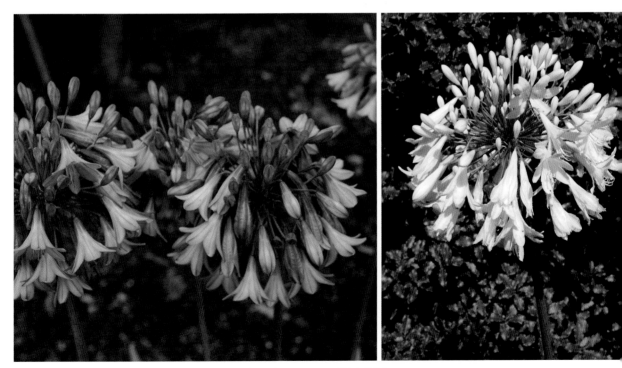

Figure 65 (left). *Agapanthus* 'Monica', Pine Cottage Plants, Devon. Image: Dick Fulcher.
Figure 66 (right). *Agapanthus* 'Peter Franklin', Pine Cottage Plants, Devon. Image: Graham Duncan.

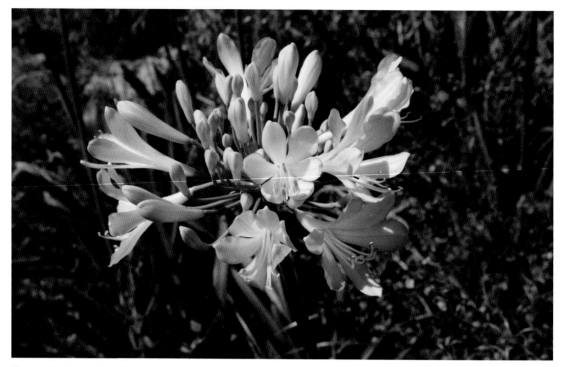

Figure 67. *Agapanthus* 'Phantom', Black Dog Plants, Cape Town. Image: Graham Duncan.

Agapanthus **'Peter Pan'**

Synonyms: *Agapanthus africanus* 'Peter Pan'; *Agapanthus praecox* subsp. *minimus* 'Peter Pan'.

Cultivar name: after the mythical character Peter Pan in the play by Scottish novelist and playwright J.M. Barrie.

Height: short (40–50 cm).

Description: rounded heads of dense, light blue, widely funnel-shaped, spreading or suberect blooms, carried on radiating bright green pedicels and erect, light green, rigid scapes; leaves arching, narrow, light green; strongly clump-forming, very free-flowering.

Flowering: mid- to late season.

Uses: front borders; patio pots.

Origin: J.N. Giridlian, Oakhurst Gardens, California, USA; raised 1949. Original clone rare in cultivation, now mainly seed-propagated (Snoeijer, 2004).

Agapanthus **'Phantom'** (Figure 67)

Height: medium (90–110 cm).

Description: striking bicoloured, rounded heads of large white, narrowly funnel-shaped blooms, flushed with light blue along the tepal margins, with prominent stamens and yellow anthers; leaves broad, suberect, light green.

Flowering: mid-season.

Hardiness: H3/USDA 9b/10a.

Uses: centre of mixed borders; patio pots.

Origin: Coleton Fishacre Gardens, Devon, UK; known since ± 1990 (Snoeijer, 2004).

Agapanthus 'Poppin Purple'

Height: short (60 cm).

Description: rounded heads of purple, slightly nodding, narrowly funnel-shaped blooms with deep purple buds, carried on green pedicels and erect or suberect, strong green scapes; leaves medium width, arching, yellowish-green.

Flowering: mid-season.

Hardiness: H4/USDA 8b/9a.

Uses: front borders; patio pots.

Origin: De Wet Plant Breeders, Johannesburg, South Africa; introduced 2019.

Agapanthus praecox 'Adelaide' (Figure 68)

Synonyms: *Agapanthus* 'Adelaide'; *Agapanthus praecox* subsp. *minimus* 'Adelaide'

Cultivar name: after the town of Adelaide in south-central Eastern Cape, South Africa.

Height: medium (80 cm).

Description: small, rounded heads of large, bright blue, widely funnel-shaped, spreading or slightly nodding blooms, carried on greenish-brown pedicels and slender, greenish-brown, slanting scapes; leaves arching, grey-green, channelled, narrow.

Flowering: early to late season.

Hardiness: H3/USDA 9b/10a.

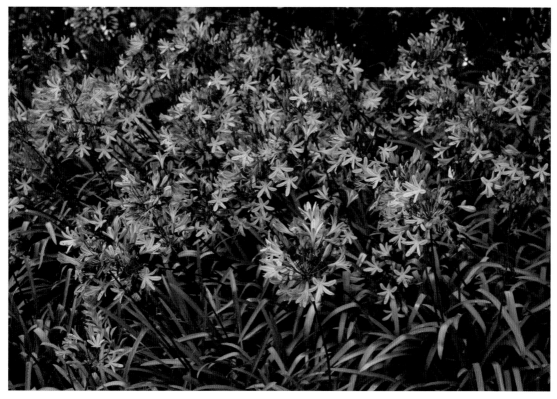

Figure 68. *Agapanthus praecox* 'Adelaide', Kirstenbosch. Image: Graham Duncan.

Uses: front borders; patio pots.

Origin: wild-collected at Adelaide, Eastern Cape, South Africa, April 1928, by N.E. Meyer; cultivar selected and named by Duncan (1985) (Kirstenbosch accession number: 676/28).

Agapanthus praecox **'Albiflorus'** (Figure 69)

Synonyms: *Agapanthus orientalis* 'Albus'; *Agapanthus praecox* 'Albus'; *Agapanthus praecox* subsp. *orientalis* 'Albus'; *Agapanthus praecox* subsp. *orientalis* 'var. *albiflorus*'; *Agapanthus umbellatus* var. *albiflorus*.

Height: medium to tall (100–130 cm).

Description: large, dense, rounded heads of white, narrowly funnel-shaped blooms with bright yellow pollen, carried on strong, erect or slanting, green scapes; leaves suberect, broad, deep green. Flowering: mid- to late season.

Hardiness: H3/USDA 9b/10a.

Uses: centre of mixed borders; mass planting; good cut flower.

Origin: United Kingdom, known since 1864 (Snoeijer, 2004). A white form which compares well with this cultivar was recorded at the mouth of the Umzimvubu River near Port St Johns, Eastern Cape by Frances Leighton in the early 1930s (*Leighton s.n.*, in PRE), growing among blue-flowered plants.

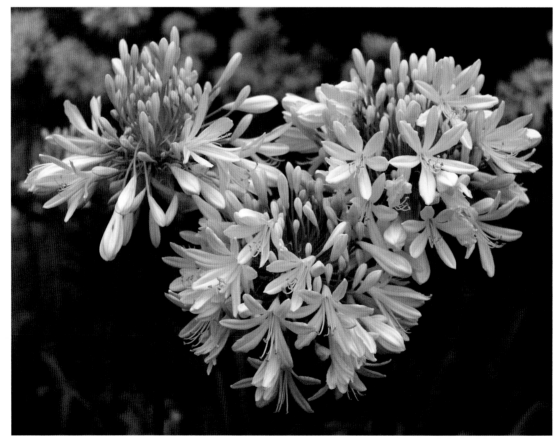

Figure 69. *Agapanthus praecox* 'Albiflorus', Kirstenbosch. Image: Graham Duncan.

Agapanthus praecox **'Argenteus Vittatus'** AGM 1993 (see Figure 9 on page 15)

Agapanthus 'Argenteus Vittatus'.

Height: short (45–60 cm).

Description: Narrow, glaucous-green, arching leaves with fairly broad, white margins; small, rounded heads of bright blue, spreading or suberect, bright blue, narrowly funnel-shaped blooms, carried on slanting glaucous scapes; must have full sun to flower.

Flowering: early season.

Hardiness: H3/USDA 9b/10a.

Uses: front borders; patio pots.

Origin: Known in the UK since 1865, still commonly grown in Madeira (Snoeijer, 2004) and the Canary Islands.

Agapanthus praecox **'Flore Pleno'** (see Figure 199 on page 177).

Synonyms: *Agapanthus* 'Flore Pleno'; *Agapanthus umbellatus* var. *flore-pleno*.

Height: short to medium (60–80 cm).

Description: open heads of light violet-blue, narrowly funnel-shaped, spreading or slightly nodding flowers with more than 6 tepals per bloom, carried on suberect green pedicels; erect green scapes; flowers sometimes remain closed or only open partially; leaves medium-width, mid-green, suberect.

Flowering: early to mid-season.

Hardiness: H4/USDA 8b/9a.

Uses: front borders; patio pots.

Origin: Élie-Abel Carrière, France; known since 1878 in France, published and illustrated by Carrière (1882). A plant collected at Alice in the Eastern Cape (Kirstenbosch Garden accession number 447/53) strongly resembles this cultivar.

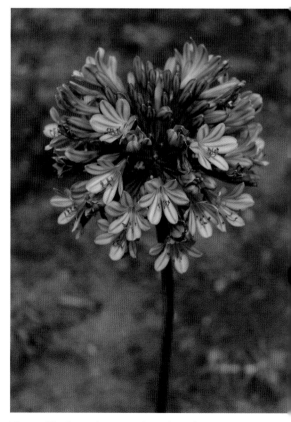

Agapanthus praecox **'Mt. Thomas'** (Figure 70)

Synonyms: *Agapanthus* 'Mount Thomas'; *Agapanthus* 'Mt Thomas'; *Agapanthus praecox* subsp. *orientalis* 'Mt. Thomas'

Cultivar name: after Mt. Thomas in the Amathole District of east-central Eastern Cape, South Africa.

Height: medium (85–100 cm).

Description: bold, strongly rounded, dense heads of mid-blue, narrowly funnel-shaped blooms, carried on upright, deep green scapes; leaves broad, spreading to suberect, intensely glaucous.

Flowering: mid-season.

Hardiness: H3/USDA 9b/10a.

Uses: centre of mixed borders; patio pots.

Origin: Wild-collected on Mt. Thomas, Eastern Cape, South Africa, January 1955 by M. Wilson; cultivar selected and named by Duncan (1985) (Kirstenbosch accession number: 82/55).

Figure 70. *Agapanthus praecox* 'Mt. Thomas', Kirstenbosch. Image: Graham Duncan.

Agapanthus praecox **'Storms River'** (Figure 71)

Synonyms: *Agapanthus praecox* subsp. *minimus* 'Storms River'; *Agapanthus* 'Storms River'
Cultivar name: after Storms River Mouth in the extreme south-western Eastern Cape, South Africa.
Height: medium (75–90 cm).
Description: striking rounded heads of white, widely funnel-shaped, slightly nodding blooms with a light blue tinge, carried on light green pedicels and slanting, deep green scapes; leaves broad, arching, yellowish-green.
Flowering: mid-season.
Hardiness: H3/USDA 9b/10a.
Uses: centre of mixed borders; patio pots.
Origin: wild-collected at Storms River Mouth by F.M. Leighton 1954; cultivar selected and named by Duncan (1985) (Kirstenbosch accession number: 36/54).

Agapanthus **'Purple Cloud'** (Figure 72)

Synonyms: *Agapanthus inapertus* 'Purple Cloud'; *Agapanthus* 'Storm Cloud'.
Height: tall (150–200 cm).
Description: outstanding, deep violet-blue, trumpet-shaped, nodding blooms on erect, very tall green scapes; leaves broad (4 cm), upright, grey-green, curved at tips, pseudostem purple-flushed.
Flowering: mid-season.
Hardiness: H3/USDA 9b/10a.
Uses: centre or rear of mixed borders.
Origin: Hugh Redgrove, Topline Nurseries, Oratia, New Zealand; known since 1991 (Dawson & Ford, 2012).

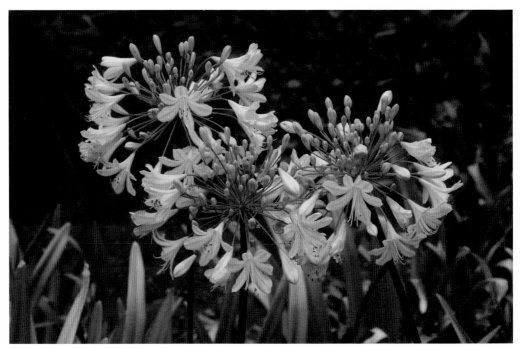

Figure 71. *Agapanthus praecox* 'Storms River', Kirstenbosch. Image: Graham Duncan.

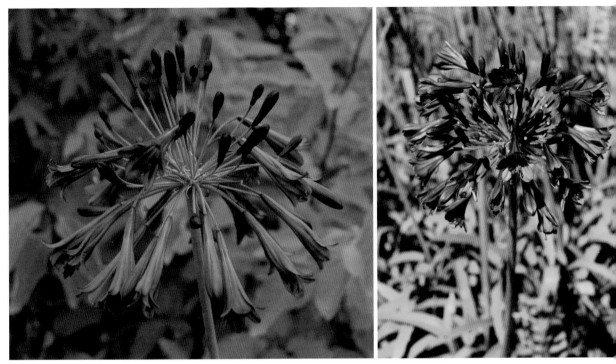

Figure 72 (left). *Agapanthus* 'Purple Cloud', Fairweather's Nursery, Hampshire. Image: FhF GreenMedia.
Figure 73 (right). *Agapanthus* 'Purple Delight', Kirstenbosch. Image: Graham Duncan.

Agapanthus **'Purple Delight'** AGM 2018 (Figure 73)

Height: medium (90 cm).
Description: striking hemispherical umbels of violet-blue, narrowly funnel-shaped, slightly nodding blooms, with violet anthers, produced on radiating green pedicels and erect, green scapes; leaves narrow, suberect, shiny green; very free-flowering.
Flowering: late season.
Hardiness: H3/USDA 9b/10a.
Uses: centre of mixed borders; patio pots.
Origin: Richard Jamieson, Black Dog Plants, Cape Town, South Africa; selected ± 1994 (Richard Jamieson, pers. comm.).

Agapanthus **'Queen Mum'** (Figure 74)

Cultivar name: in tribute to HM Queen Elizabeth the Queen Mother.
Height: medium (100–120 cm).
Description: striking large, very dense, rounded heads of widely funnel-shaped, nodding blooms with white tepals and bright blue perianth tubes, carried on robust, slightly slanting green scapes; leaves broad, suberect with rounded tips, olive green.
Flowering: early to mid-season.
Hardiness: H3/USDA 9b/10a.
Uses: centre of mixed borders; patio pots.
Origin: John Craigie, Pine Mountain Nursery, Queensland, Australia; registered 2005.

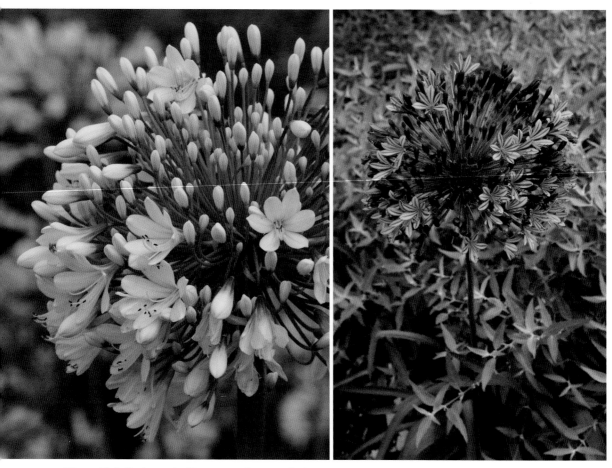

Figure 74 (left). *Agapanthus* 'Queen Mum', Fairweather's Nursery, Hampshire. Image: FhF GreenMedia.
Figure 75 (right). *Agapanthus* 'Regal Beauty', Kew. Image: Graham Duncan.

Agapanthus **'Regal Beauty'** (Figure 75)
Height: medium (80–100 cm).
Description: large, dense, rounded heads of violet-blue, narrowly funnel-shaped flowers with deep violet buds, carried on sturdy, radiating green pedicels and slanting green stems; leaves broad, long, bright green, spreading.
Flowering: mid- to late season.
Hardiness: H3/USDA 9b/10a.
Uses: front or centre of mixed borders; patio pots.
Origin: R.J. and D.M.L. Wood, New Plymouth, New Zealand (Snoeijer, 2004).

Agapanthus **'San Gabriel'** (Figure 76)
Synonym: *Agapanthus praecox* 'San Gabriel'.
Cultivar name: after the San Gabriel hills above San Gabriel Nursery, California, USA.
Height: short to medium (50–75 cm).

Description: variegated, fairly broad, arching leaves with wide, golden-yellow margins on one side; scapes mid-green with cream stripes, flowers funnel-shaped, light violet-blue, carried on mid-green, spreading pedicels; shy to bloom.
Flowering: mid- to late season.
Hardiness: H3/USDA 9b/10a.
Uses: front borders; patio pots.
Origin: Monrovia Nursery, Azusa, California, USA; selected 1986, named by Joe Sharman, Monksilver Nursery, UK (Snoeijer, 2004).

Agapanthus **'Selma Bock'** (Figure 77)

Synonym: *Agapanthus praecox* 'Selma Bock'.
Cultivar name: in tribute to Miss Selma Bock of Constantia, Cape Town, from who's garden the plants were obtained.
Height: medium to tall (100–130 cm).
Description: dense, rounded heads of widely funnel-shaped, bicoloured blooms with white tepals and blue perianth tubes, carried on erect or slanting, strong green scapes of varying length; leaves broad, suberect, bright green; vigorous and free-flowering.
Flowering: late season.
Hardiness: H3/USDA 9b/10a.
Uses: centre or rear of mixed borders.
Origin: Selma Bock, Constantia, Cape Town; an *A. praecox* hybrid, selected and named by J.P. Rourke and G.D. Duncan in 1990 (Kirstenbosch accession number: 188/90).

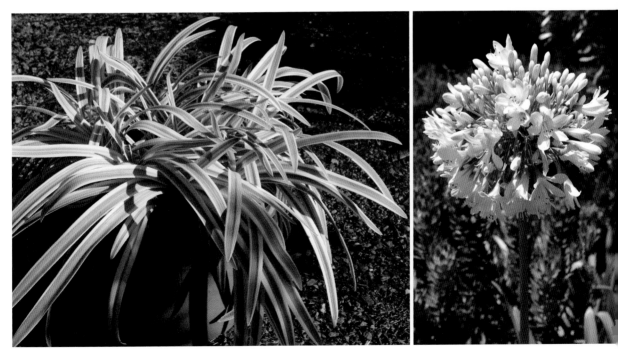

Figure 76 (left). *Agapanthus* 'San Gabriel', Pine Cottage Plants, Devon. Image: Graham Duncan.
Figure 77 (right). *Agapanthus* 'Selma Bock', Kirstenbosch. Image: Graham Duncan.

Agapanthus 'Silver Baby' AGM 2018

Synonym: *Agapanthus* 'Silverbaby'.

Height: short (40–50 cm).

Description: a dwarf cultivar with small, hemispherical heads of silvery white, narrowly funnel-shaped blooms with ice blue tepal edging and bright yellow anthers, carried on bright green scapes; leaves fairly broad, light green, arching.

Flowering: early to mid-season.

Hardiness: H3/USDA 9b/10a.

Uses: front borders; rockeries; patio pots.

Origin: Duncan & Davies Nurseries Ltd., Waitara, New Zealand; known since 2001 (Snoeijer, 2004).

Agapanthus 'Silver Lining' (Figure 78)

Height: short to medium (60–100 cm).

Description: elegant, dense heads of nodding, white, narrowly funnel-shaped blooms, flushed with silvery blue on tepal inner surfaces, with contrasting bright yellow anthers, carried on strong, erect green stems; leaves suberect, bright green, slightly channelled.

Flowering: late season.

Hardiness: H4: USDA 8b/9a.

Uses: front or centre of mixed borders; patio pots.

Origin: Dick Fulcher, Pine Cottage Plants, Devon, UK (Dick Fulcher, pers. comm.).

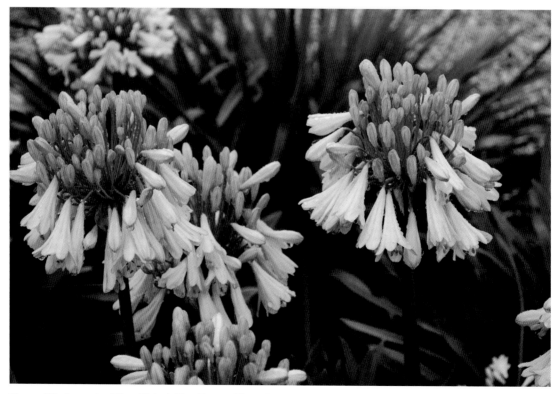

Figure 78. *Agapanthus* 'Silver Lining', Pine Cottage Plants, Devon. Image: Dick Fulcher.

Agapanthus **'Silver Mist'**

Height: short to medium (45–80 cm).

Description: rounded heads of white, spreading, widely funnel-shaped blooms with a light silvery blue tinge, carried on erect or slanting, strong green scapes of variable length; leaves broad, suberect, mid-green.

Flowering: late season.

Hardiness: H3/USDA 9b/10a.

Uses: front borders; patio pots.

Origin: Dick Fulcher, Bicton College, Devon, UK; selected and named 1993 (Dick Fulcher, pers. comm.).

Agapanthus **'Snow Cloud'** AGM 2018

Synonyms: *Agapanthus* 'Fragrant Snow'; *Agapanthus* 'Snowcloud'.

Height: medium (80–120 cm).

Description: extremely dense, large rounded heads of white, narrowly funnel-shaped blooms with bright yellow anthers, carried on radiating green pedicels and tall, strong green scapes; leaves dark green, suberect or spreading.

Flowering: early to mid-season.

Hardiness: H4/USDA 8b/9a.

Uses: centre of mixed borders.

Origin: V.J. Hooper, Waitara, Taranaki, New Zealand; known since 1997 (Snoeijer, 2004).

Agapanthus **'Snow Crystal'** AGM 2018 (Figure 79)

Height: medium (80 cm).

Description: dense, rounded heads of widely funnel-shaped, white flowers with rounded tepal tips, and prominent anthers with deep brown pollen, carried on radiating green pedicels and strong, erect green scapes; leaves medium width, suberect, mid-green.

Flowering: mid- to late season.

Hardiness: H3/USDA 9b/10a.

Uses: front borders; patio pots.

Origin: Dick Fulcher, Pine Cottage Plants, Devon, UK; raised 2006 (Dick Fulcher, pers. comm.)

Agapanthus **'Snowstorm'**

Synonym: *Agapanthus* 'Snow Storm'.

Height: medium (80–100 cm).

Description: small heads of white, upward-facing, narrowly funnel-shaped flowers with bright yellow anthers, very floriferous, fast-growing, producing multiple narrow, green stems per plant; leaves narrow, mid-green, spreading.

Flowering: mid-season.

Hardiness: H3/USDA 9b/10a.

Uses: front borders; patio pots.

Origin: R.W. Rother, Emerald, Victoria, Australia; known since 1995 (Snoeijer, 2004).

Agapanthus **'Strawberry Ice'** (Figure 80)

Height: short to medium (50–70 cm).

Description: dense, medium-sized heads of white, spreading or suberect, narrowly funnel-shaped

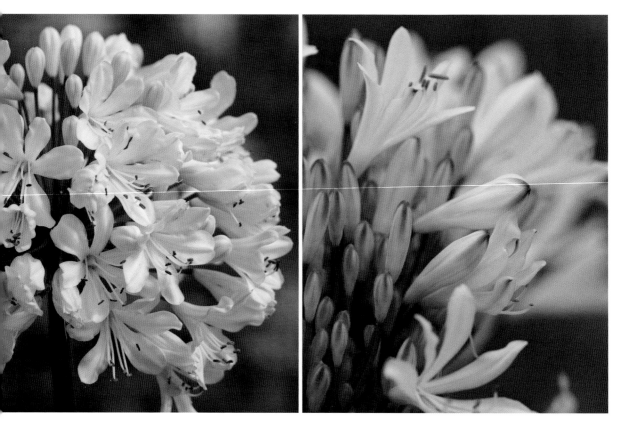

Figure 79 (left). *Agapanthus* 'Snow Crystal', Fairweather's Nursery, Hampshire. Image: FhF GreenMedia.
Figure 80 (right). *Agapanthus* 'Strawberry Ice', Fairweather's Nursery, Hampshire. Image: FhF GreenMedia.

blooms, flushed with light pink on tepal outer surfaces, becoming deeper pink as flowers age, produced on upturned green pedicels and erect green scapes; leaves narrow, light green, arching.
Flowering: mid- to late season.
Hardiness: H3/USDA 9b/10a.
Uses: front borders; patio pots.
Origin: New Zealand (breeder unknown), where it is apparently unavailable in the trade (Murray Dawson, pers. comm.).

Agapanthus 'Sweet Surprise'

Height: short (50–60 cm).
Description: rounded heads of light blue, spreading, narrowly funnel-shaped flowers with strongly rounded inner tepal tips, a prominent deep blue median keel to each tepal, and deep blue perianth tubes, carried on upturned, deep green pedicels and suberect, slender green scapes; leaves arching, narrow, green.
Flowering: early to mid-season.
Hardiness: H3/USDA 9b/10a.
Uses: front borders; patio pots; good cut flower.
Origin: Ken Rigney, Southampton, UK.

Agapanthus 'Tigerleaf'

Synonym: *Agapanthus praecox* subsp. *orientalis* 'Tigerleaf'.
Height: short to medium (60–80 cm).
Description: arching, narrow green leaves with striking, broad yellow margins; flowers narrowly funnel-shaped, violet-blue.
Flowering: mid-season.
Hardiness: H3/USDA 9b/10a.
Uses: front borders; patio pots.
Origin: Hugh Redgrove, New Zealand; introduced 1991 (Snoeijer, 2004).

Agapanthus 'Tinkerbell'

Synonyms: *Agapanthus praecox* subsp. *minimus* 'Tinkerbell'; *Agapanthus praecox* 'Tinkerbell'.
Height: short (40–50 cm).
Description: narrow, light green, spreading or prostrate leaves with narrow yellow stripes and creamy-white broad margins; flowers narrowly funnel-shaped, bright violet-blue, produced on radiating grey-green pedicels and slanting, grey-green scapes; flowers infrequently, but multiplies rapidly.
Flowering: mid- to late season.
Hardiness: H4/USDA 8b/9a.
Uses: front borders; patio pots.
Origin: Barrie McKenzie, Topline Nurseries, Oratia, New Zealand; raised 1991 (Dawson & Ford, 2012).

Agapanthus 'White Heaven' (Figure 81)

Height: medium (80–120 cm).
Description: large, dense, rounded heads of white, widely funnel-shaped, upturned flowers with up to nine tepals per flower, borne on bright green pedicels and sturdy, upright green scapes; leaves broad, shiny, deep green, arching.
Flowering: mid- to late season.
Hardiness: H3/USDA 9b/10a.
Uses: front or centre of mixed borders; patio pots.
Origin: C.J. de Jong and A. Ph. M. Rijnbeek, Boskoop, The Netherlands; introduced 1999 (Snoeijer, 2004).

Figure 81. *Agapanthus* 'White Heaven', Kew.
Image: Graham Duncan.

Agapanthus **'White Flash'** (Figure 82)

Height: short (40–60 cm).

Description: small, hemispherical heads of white, narrowly funnel-shaped flowers with bright yellow anthers, carried on spreading or upturned, bright green pedicels and narrow, slanting green stems; multiple heads produced per plant; leaves narrow, mid-green, arching.

Flowering: early season.

Hardiness: H3/USDA 9b/10a.

Uses: front borders; patio pots.

Origin: ex horticulture, Mrs Stewart, Newlands Cape Town, 1984; named by Richard Jamieson (Kirstenbosch accession number: 819/84).

Figure 82 (left). *Agapanthus* 'White Flash', Kirstenbosch. Image: Graham Duncan.
Figure 83 (right). *Agapanthus* 'Zambezi', Ferndale Nurseries, Cape Town. Image: Graham Duncan.

Agapanthus **'Zambezi'** (Figure 83)

Cultivar name: after the Zambezi River which flows from its source in Zambia through Angola, Namibia, Botswana and Zimbabwe to Mozambique and the Indian Ocean.

Height: short (50–60 cm).

Description: broad, deep green, spreading leaves streaked with creamy-yellow, with golden-yellow margins; flowers light blue, widely funnel-shaped, carried on radiating, yellowish-green pedicels and slightly slanting, grey-green scapes. Unusually for a variegated agapanthus, it is a prolific, reliable flowerer, often producing a second flush.

Flowering: early to mid-season, sometimes late season.

Hardiness: H3/USDA 9b/10a.

Uses: front borders; patio pots.

Origin: Keith Kirsten Horticulture International, Johannesburg, South Africa; introduced 2015.

Agapanthus **'Zigzag White'** AGM 2018 (subject to availability)

Height: medium (100–120 cm).

Description: hemispherical heads of large, nodding, white, widely funnel-shaped blooms with exserted, bright yellow anthers, carried on upward-facing pedicels and slightly bent (zig zag), strong dark green scapes; leaves broad, bright green, suberect.

Flowering: mid- to late season.

Hardiness: H3/USDA 9b/10a.

Uses: centre of mixed borders.

Origin: supplied to the RHS 2014–2018 Agapanthus trial by Cotswold Garden Flowers, Worcestershire, UK; raiser unknown (Dick Fulcher, pers. comm.).

3. CULTIVATION AND PROPAGATION

CULTIVATION

Agapanthus ranks among the most easily cultivated rhizomatous plants, and with attention to six key requirements (aspect, growing medium, watering, feeding, hardiness (over-wintering) and pest and disease control), can be grown successfully in almost any garden, except for those in the hottest and coldest parts. Dependent upon local conditions, one's choice is between deciduous and evergreen types. In addition to the elegance of wild species, with modern breeding and selection, a wide range of flower colours has been produced, from blackish purple to bicoloured and every shade of blue, white, cream, and even light pink. Striking when in flower en masse in garden beds, rockeries or borders, they are also eminently suited to container cultivation. Flowering takes place over a long period from early summer to early autumn, and a varied collection of cultivars and species (especially among the evergreens) can provide colour for up to five months of the year. Even when not in flower, the lush foliage of the evergreens remains attractive.

Figure 84. *Agapanthus praecox* flowering in light shade, Constantia, Cape Town. Image: Graham Duncan.

A word of caution is necessary regarding robust forms of the evergreen *A. praecox* and its intraspecific hybrids. Vigorous and tough, they grow easily in poor soils, establishing and spreading rapidly by wind- and water-dispersed seeds in temperate climates. They form dense colonies and invade forest margins, open forest, woodland, clifftops and drainage channels, sometimes supplanting natural groundcover vegetation with their thick rhizomes and fleshy root mats that are difficult to dig out. Due to the invasive nature of *A. praecox* (in particular the previously recognised subsp. *orientalis*), nursery industries in New Zealand and Australia, where *A. praecox* is a declared invasive weed, currently market various categories of agapanthus cultivars including 'eco-friendly', 'environment safe', 'low fertility', 'non-invasive', 'self-sterile' and 'sterile' (Dawson *et al.*, 2018).

ASPECT

Agapanthus are sun-loving plants, and the more sun they receive the more successfully they will flower. Yet, numerous wild forms of *A. praecox* including the cultivars 'Adelaide' and 'Storms River' occur naturally in dappled shade, and will also flower well in these conditions (Figure 84). When grown in dappled shade, the scapes of *A. inapertus* more or less maintain their upright posture, whereas those of the evergreens tend to bend strongly towards the light. In general, agapanthus requires at least full morning sun or very good light throughout the day in summer, and should not be planted too close to robust perennials which may shade out their leaves and inhibit flowering. In cold climates, the mostly tender, evergreen agapanthus and some of the tender deciduous ones can be successfully grown under the eaves against warm, south- or west-facing walls, provided they are well mulched and kept on the dry side in winter. Alternatively, they can be very successfully grown in pots or tubs placed on a sunny patio, which can be moved indoors for the winter. In warm climates, containers are best placed where they will receive morning sun and afternoon shade, and not where they will overheat on very hot days.

The evergreens require at least moderately good light in winter, and naturally the deciduous ones require no sun when dormant. When grown in excessively shaded conditions, the evergreens produce lush foliage and seldom flower, or if they do, their scapes are grossly slanted towards the sun, whereas the deciduous species and cultivars perform very poorly in excessive shade, and eventually succumb. The scapes of some of the species and many of the cultivars are naturally at least slightly slanting, but in general, the more sun the plants receive, the less slanting and stronger the scapes will be.

GROWING MEDIUM AND PLANTING

Evergreen agapanthus are generally undemanding and able to survive and flower reasonably well in almost any alkaline, neutral or acid soil (loam, sand, chalk or clay) containing some organic matter, whereas deciduous agapanthus have much higher soil fertility requirements to produce flowers, and perform better in heavier, richer, acidic soils. Best results for both evergreen and deciduous types are obtained from well-aerated, loamy, well-drained yet water-retentive soils, containing plenty of good compost. Poorly drained or waterlogged soils result in failure to flower and rotting of the rhizome. Manure can be added to the soil surface around the plants at planting time, and allowed to decompose slowly, but must not touch the plants or be dug into the soil, as it may be too strong and cause burning and subsequent rotting. *A. africanus* and *A. walshii* are exceptional among the evergreens in having particular requirements for successful cultivation over the long term. *A. walshii* is undoubtedly the more difficult of the two, and in cold climates, both are best suited to cultivation in containers in extremely well-drained, acid sandy soil, such as equal parts of coarse river sand and bonfire soil or

perlite, with a thick layer of acid compost placed at the base of the container, and a mulch of acid compost, gravel or stone chips placed over the surface (Duncan, 1998; 2004) (Figure 85). In temperate climates, these two species can be grown outdoors in rock gardens, wedged between rocks.

Agapanthus are best planted out from nursery containers in spring and early summer, especially in cold climates, once active growth has started and the likelihood of frost has passed. In temperate climates, planting can be done successfully at any time of year except for the very hottest months. Newly lifted or divided agapanthus should ideally be replanted as soon as possible, except where the rhizome has been cut or damaged, in which case allow the cut surface to form a callus in a cool, dry place for one to two days before replanting. Be sure to replant agapanthus at more or less the same level as they were growing previously, and the evergreens in particular should be planted with their relatively shorter pseudostems above ground level. Improve drainage by incorporating gravel, crushed stone chips, milled bark or well-rotted compost.

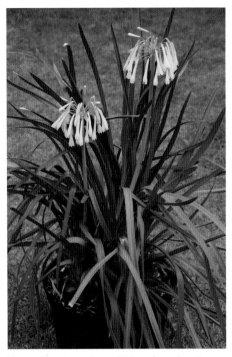

Figure 85. *Agapanthus walshii* performs best in containers. Image: Graham Duncan.

IN POTS

With smaller outdoor living spaces, the current trend is towards short, free-flowering agapanthus cultivars, and these are ideal for patio pots and tubs which can conveniently be moved indoors for the winter months in cold climates (Figures 86, 87).

For container-grown agapanthus, any good potting compost containing loam will do (with the exception of *A. africanus* and *A. walshii* which need much less fertile media), with the addition of horticultural grit, gravel or gritty sand, mixed in a ratio of 2:1 to improve drainage, and for this purpose John Innes potting composts no. 2 or no. 3 are recommended (Fulcher & Fulcher, 2010; Hickman & Hickman, 2018). Grown in containers, agapanthus flower more prolifically with their roots somewhat restricted (but not heavily pot-bound), with regular watering and feeding in summer. Terracotta pots or wooden tubs are best in cold climates, but these dry out too rapidly in warmer parts, where less porous materials are required. Pots of 15-20 litres (approx.

Figure 86. The dwarf evergreen *Agapanthus* 'Joni', an outstanding container subject.
Image: Graham Duncan.

33-35 cm diam.) are ideal for dwarf cultivars, and 25-30 litre pots (approx. 38-41 cm diam.) easily accommodate medium-sized and larger types. The extensive fleshy roots of agapanthus rapidly result in pot-binding and failure to flower, and in particular, the evergreens need repotting every four years, but less frequently for deciduous types, about once every six years (Duncan, 1985). Alternatively, if frequent repotting is not possible, provision of an annual top-dressing of well-rotted compost is recommended in spring. Repotting is ideally carried out directly after flowering so that newly divided plants will form new roots before the onset of cold winter weather. Pot rims should ideally be wider than their bases, to allow for easy removal of the root cluster when repotting, and sufficient space between the rim of the pot and the soil surface, to allow for accumulation of sufficient water during irrigation.

Figure 87. The dwarf evergreen *Agapanthus* 'Charlotte', ideal for small containers. Image: Graham Duncan.

WATERING

Agapanthus, especially the deciduous types, need plenty of water during their active growing season (Figure 88). When grown in general garden beds, the deciduous species and *A. praecox*, and their hybrids and cultivars, ideally require weekly deep watering from spring until late summer, increased to twice weekly in very hot and dry weather. For agapanthus grown in containers, watering has to be more closely monitored, and increased to twice or even three times per week, depending on local conditions. Insufficient watering often results in leaf collapse and failure to flower. In warm climates where soil desiccation is rapid, containers can be placed in deep saucers kept filled in overly hot weather. In autumn, watering can be reduced, and throughout winter, deciduous agapanthus easily survive without any water, as long as their roots remain covered with soil. Yet, in winter rainfall areas, they easily survive winter moisture, as long as the soil is well drained (Duncan, 2010). Once fully established, robust forms of the evergreen *A. praecox* and its hybrids are remarkably waterwise. Ideally though, evergreen agapanthus should receive at least one monthly deep watering in summer (Figure 89).

In their natural habitats, the evergreen *A. africanus* and *A. walshii* from the winter rainfall area of the Western Cape experience moist winters and survive hot and dry summers by means of fleshy roots which extend beneath the cooler environment of surrounding rock slabs. When grown in containers, these two species are exceptional in requiring far less moisture compared with all other agapanthus, both in winter and summer. Grown under cover, a heavy watering about once per week in summer, and about once every 10 days in winter, is all that is required, allowing the growing medium to dry out substantially between applications of water. A major problem experienced with

Figure 88 (left). Deciduous agapanthus, such as *A. caulescens* 'Politique' require regular, heavy watering in summer. Image: Graham Duncan.

Figure 89 (right). Evergreen agapanthus such as *A.* 'Black Pantha' should ideally receive at least one heavy watering per month in summer. Image: Graham Duncan.

the cultivation of *A. africanus* and *A. walshii* is that mature plants tend to rot directly after they have flowered. The precise reasons for this are unclear, but they should certainly never be kept overly wet, especially directly after flowering (Duncan, 2004).

HARDINESS AND WINTER PROTECTION

Success with the cultivation of agapanthus in cold climates depends largely upon protecting the rhizomes and roots from freezing as a result of harsh winter frosts. Dependent upon local conditions, plants of a particular species or cultivar may be semi-evergreen in mild parts, but deciduous elsewhere, such as the hybrid *A.* 'Lydenburg' (Figure 90). In areas with mild winters such as in Cornwall and the Isles of Scilly in the south-west of England, evergreen agapanthus require no winter protection. In colder parts, most evergreens can be regarded as half-hardy and able to withstand temperatures down to -5 °C, especially with some artificial protection in winter. Left unprotected in very cold winter climates such as the interior of northern England, deep, heavy frosts will kill most agapanthus rhizomes and roots in garden beds, except for certain cultivars and hybrids of *A. campanulatus*, and wild forms of this species from high mountain slopes of Lesotho and South Africa (Figure 91). For less hardy plants, damage can be substantially reduced by provision of a 10–15 cm mulch-layer of milled

bark, straw, bracken litter, twigs, peat or leaf mould in late autumn, placed over the desiccated remains of the deciduous types. Large, established clumps of the evergreen *A. praecox*, grown in a protected place such as against a south-facing wall, will usually survive with heavy mulching placed close-up against the pseudostem and between the leaves. In very cold parts, cover the mulch with fleece or a horticultural frost blanket, remove these and the mulch layer only once all risk of frost is over from mid- to late spring, and replace with a layer of compost or cow manure (the latter not touching the plants) for the summer to retain moisture and suppress weed growth.

With changing climates and rising temperatures, especially in cities, an increasing number of agapanthus cultivars can be grown outdoors year-round. For agapanthus grown in tubs or pots, the difficulty of over-wintering is solved by moving deciduous cultivars under cover such as into a garage or dark shed (since no light is required), and the evergreens (with the exception of *A. africanus* and *A. walshii* which need good light or as much sun as possible throughout the year) can be moved into an unheated conservatory, or placed beneath benches of a cool greenhouse or into unheated polytunnels for the winter. Since flower initiation and differentiation take place as a result of cold temperature in late autumn and early winter, storage temperature should not be too high in winter, and Van Dijk (2004) recommends a winter storage temperature of no more than 8°C, failing which the plants don't flower well, or come into bloom too early (especially the deciduous ones), and scapes tend to be not as sturdy. While in storage, provide evergreens with a monthly deep watering, but deciduous

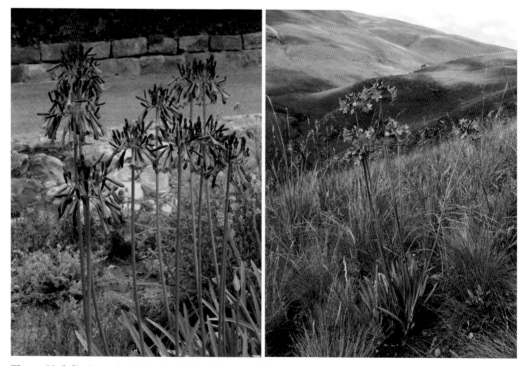

Figure 90 (left). *Agapanthus* 'Lydenburg' is deciduous in cold climates but often semi-evergreen in temperate parts. Image: Graham Duncan.

Figure 91 (right). *Agapanthus campanulatus* flowering at over 1980 m, Highmoor, Maloti-Drakensberg Park, western KwaZulu-Natal, able to withstand heavy winter frosts. Image: Neil Crouch.

agapanthus can be kept dry or just slightly moist, provided they are stored in soil and not bare-rooted. Stored containers can be placed out again from mid- to late spring.

Whereas wild forms of *A. praecox* from coastal habitats are tender, those from inland, high altitude parts such as the eastern Karoo are frost-hardy and able to survive heavy snowfalls in winter (Figure 92). Although both *A. africanus* and *A. walshii* are occasionally subject to light frosts in the wild, they are highly susceptible to frost in cold climates, as observed for *A. africanus* (Palmer, 1967), and for *A. walshii* (Martyn Rix, pers. comm.). One reason for seemingly healthy agapanthus sometimes not flowering in cold climates is due to the developing flower buds having been frosted over the winter, in the absence of adequate protection. It is interesting to note that agapanthus developed for cold resistance in the UK, such as cultivars and hybrids of *A. campanulatus*, often do not perform well when grown in temperate climates in South Africa (Richard Jamieson, per. comm.).

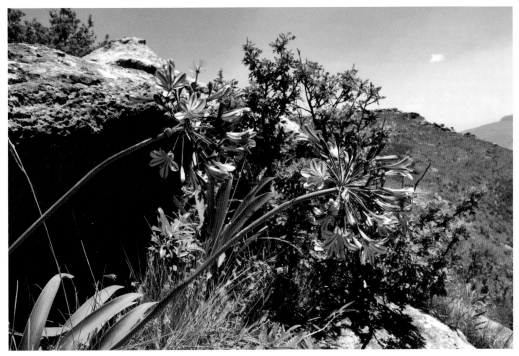

Figure 92. *Agapanthus praecox*, Barkly Pass, Eastern Cape, is subject to snowfalls in winter. Image: Graham Duncan.

IN THE GARDEN

Agapanthus has multiple uses in both temperate and cold climate gardens. Where winter temperatures do not fall below -5°C for long periods, most evergreen and deciduous plants can be grown outdoors with ease, but where severe winters are experienced, most deciduous agapanthus require heavy mulching, as do all evergreens, and in the case of the latter, added protection in the form of a frost blanket may be required. Of major importance is the fact that the roots and rhizomes are unable to tolerate waterlogged conditions in winter, which result in rotting, thus good drainage is of primary concern. In susceptible areas, agapanthus are best planted where they remain reasonably dry over

winter, yet in temperate climates the deciduous ones easily tolerate heavy rainfall when dormant in winter, provided the soil is well drained.

Compost, crushed stone chips and coarse grit can be mixed into clay soils to improve drainage. Tall-growing evergreens like *A.* 'Cornish Sky' and *A.* 'Peter Franklin' as well as deciduous plants like *A. inapertus* subsp. *inapertus* 'Sky' and *A.* 'Inkspots' can be planted en masse towards the rear of borders and garden beds; medium-sized evergreens like *A.* 'Blue Pixie' (Figure 93) and *A. praecox* 'Storms River' are suited to mass planting, and the deciduous *A.* 'Bressingham Blue' and *A.* 'Midnight Star' are seen to best advantage in borders, placed towards the centre. Dwarf evergreens like *A.* 'Charlotte' and *A.* 'Double Diamond', and the deciduous *A.* 'Lilliput' and *A.* 'Petite White' are ideal as edging material for front borders and rock garden pockets. Grown towards the centre and rear of mixed borders, deciduous agapanthus like *A. caulescens* require careful placing, spaced sufficiently away from surrounding perennials such that their leaves are not overshadowed when in leaf in summer, which

Figure 93. *Agapanthus* 'Blue Pixie' planted en masse, Black Dog Plants, Cape Town. Image: Graham Duncan.

Figure 94. *Agapanthus caulescens* in a mixed border, Exbury, Hampshire. Image: Graham Duncan.

Figure 95. *Agapanthus* 'White Flash' beside a stone pathway, Kirstenbosch. Image: Graham Duncan.

Figure 96. *Agapanthus* 'Snowstorm' planted along a paved walkway, private garden, Johannesburg. Image: Anthony Tesselaar.

discourages flowering, and such that their exact position is known when they are dormant in winter (Figure 94). Large and medium-sized evergreens are suited to windy, coastal gardens, and to mass planting along roadsides, embankments, pavement beds and within traffic islands, and the smaller evergreens are eminently suited to rock gardens, atop dry stone walls, alongside stone pathways (Figure 95), and flanking paved walkways (Figure 96), and their mats of fleshy roots are useful in preventing soil erosion.

With their erect or slanting scapes, arching leaves and wide range of striking blue or white flower heads, agapanthus provide excellent contrast when used in mixed plantings with a range of summer-growing herbaceous plants which flower simultaneously. Yellow- and orange-flowered cultivars of *Crocosmia* such as *C.* 'Lucifer' and *C.* 'Zeal Tan', *Hemerocallis* (e.g. *H.* 'Bonanza') and orange – or yellow-flowered *Kniphofia* (e.g. *K.* 'Alkazar' (orange); *K.* 'Sunningdale Yellow') are especially well suited, as are achilleas (e.g. *A.* 'Walther Funcke', *A.* 'Terracotta'), alliums (e.g. *Allium* 'Mt Everest'

and *A*. 'Gladiator'), coreopsis, dahlias, globe thistle *Echinops bannaticus* 'Blue Glow', *Eucomis autumnalis, E. pallidiflora* subsp. *pole-evansii, Galtonia candicans*, heleniums, hydrangeas (e.g. *H. paniculata* 'Praecox') and penstemons (Figure 97). Agapanthus also provide excellent contrast when planted in drifts between ornamental grasses such as the hairy sedge (*Carex testacea*) whose cascading mound turns coppery brown in summer.

In temperate climates, deciduous, autumn-flowering corms like the low-growing orange *Chasmanthe aethiopica* can be used to extend the flowering season when interplanted with deciduous, summer-growing *A. inapertus* subsp. *pendulus* 'Graskop', and winter- and spring-flowering corms like *Chasmanthe bicolor* and *C. floribunda*, and the winter-growing bulb *Veltheimia bracteata* can be used in mixed plantings with evergreens like *A. praecox* 'Storms River'. For a striking colour combination, the evergreen orange *Watsonia pillansii*, planted as a backdrop to borders of *A. praecox* 'Adelaide' makes an eye-catching display (Figure 98).

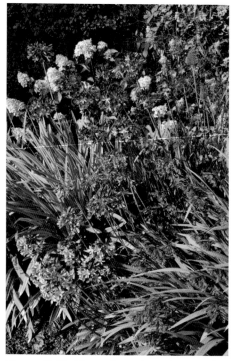

Figure 97. Deciduous *Agapanthus* cultivars used in combination with *Hydrangea, Crocosmia* and *Kniphofia*, Pine Cottage Plants, Devon. Image: Graham Duncan.

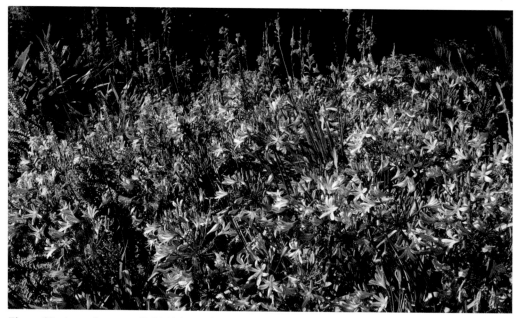

Figure 98. *Agapanthus praecox* 'Adelaide' interplanted with *Watsonia pillansii*, Kirstenbosch. Image: Graham Duncan.

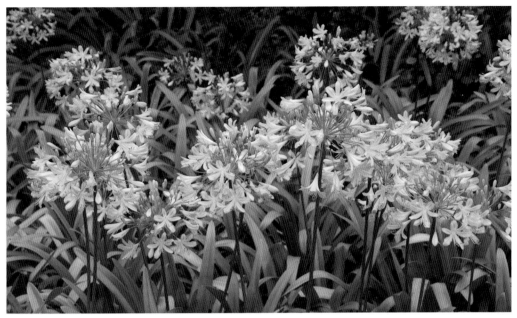

Figure 99. *Agapanthu praecox* 'Storms River' is an excellent groundcover for binding the soil and suppressing weed growth. Image: Graham Duncan.

Although agapanthus infructescences have decorative appeal during the maturation period and when dispersing its seed, in temperate climates it is wise to remove faded flower heads of the evergreens as soon as possible to prevent self-seeding and monopolisation of the garden. However, in some cultivars, this practice encourages production of additional flower stems. The thick fleshy roots of the evergreen agapanthus are useful in preventing erosion by stabilising steep banks, and those with dense clusters of spreading leaves such as *A. praecox* 'Storms River' make excellent groundcovers, effectively suppressing weed growth (Figure 99).

CUT FLOWERS

Agapanthus is increasing in importance as an export crop in the cut flower trade. It is popular for spring and summer arrangements and grown for this purpose in a number of countries including The Netherlands, New Zealand, United Kingdom, South Africa and Mexico. Picked shortly after the spathe bracts have dropped off and the first few buds have opened, the flowers can remain fresh in the vase for up to 10 days. The British botanist John Lindley noted in his article on *Agapanthus umbellatus* var. *maximus* (= *A. praecox*) that agapanthus with deep blue or purple flowers lose much of their colour when kept inside the greenhouse during the flowering season, as opposed to being placed outdoors (Lindley, 1843), and this colour dissipation is especially marked in cut flowers of the pendent, deep violet-blue flowers of *A. inapertus* subsp. *pendulus*. Blue- or purple-flowered agapanthus thus require placement in bright light in the home to retain as much colour as possible, and breeding and selection for colour retention requires development. A further challenge in the agapanthus cut flower industry is the tendency of buds and open flowers to detach from the pedicel after harvesting, rendering the cut stem useless. Recent research into this occurrence in export *A. praecox* cultivars grown in New Zealand, identified carbohydrate supply as an important factor influencing bud and

flower detachment. Longer stems (50 cm) as opposed to shorter ones (25 cm), placed in solutions containing 2.5% or 5% sucrose, markedly reduced the rate of detachment, resulting in a higher number of open flowers held on the stem. A conclusion reached was that the long-term solution would be to develop cultivars that are not prone to this disorder by breeding for cultivars with fewer flowers per head, on longer stems (Burge *et al.*, 2010).

Agapanthus cut flowers in commercial trade are typically cultivars or hybrids of *A. praecox* with small to medium-sized flower heads, sold in bunches of 5 or 10 stems. The ever-increasing range of available cultivars allows for harvesting over a longer period from early to late summer. Some of the more popular cultivars sold in UK and European markets include the blue-flowered *A.* 'Atlantic', *A.* 'Catharina', *A.* 'Columba', *A.* 'Donau', *A.* 'Dokter Brouwer' and *A.* 'Queen of the Ocean', and in the white-flowered range, *A.* 'Casablanca', *A.* 'Glacier Stream', *A.* 'Gletsjer', *A.* 'Prinses Marilène' and *A.* 'Volendam'. Among the tubular-flowered cultivars, *A. inapertus* subsp. *inapertus* 'White' (Figure 100) and *A. inapertus* subsp. *pendulus* 'Black Magic' also have potential.

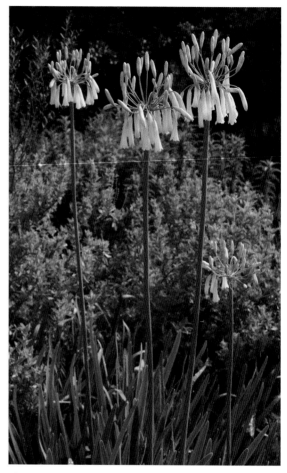

Figure 100. *Agapanthus inapertus* subsp. *inapertus* 'White' has potential as a cut flower. Image: Graham Duncan.

FEEDING

Agapanthus are heavy feeders, and their flowering performance and general health are greatly advanced by the application of pellet, granular and liquid fertilizers. For seedlings and young plants, application of high nitrogen, non-toxic, non-burning, organic fertilisers such as those derived from chicken litter give excellent results in providing water-insoluble nitrogen that is released slowly over a long period, supplying a full balance of nutrients that do not leach rapidly. These fertilizers, applied in pellet form to the soil surface, speed up vegetative development, as do liquid feeds of seaweed extract. Once the plants approach flowering size, discontinue high nitrogen feeding and apply a slow-release, high potash (potassium) granular fertilizer like 3:1:5 to plants in the garden three times during the growing period in early spring, early summer and late summer. Containerised plants need more frequent fertilization with a high potash liquid feed, applied every three to four weeks from early spring to mid-autumn. It is most important to continue feeding after flowering until late autumn, as this is when flower initiation takes place for the following flowering season.

PROPAGATION

SEED

As a result of its extraordinary propensity to hybridisation, it is essential to note that agapanthus seed harvested from different species and cultivars grown in close proximity strongly diminishes their homogeneity, resulting in seedlings with widely differing growth forms, and variation in flower colour and shape. Thus, propagation from seed is only recommended where it has been harvested from wild populations, or where species and cultivar homogeneity is not required, for instance where selection is to take place from open-pollinated plants for the purpose of cultivar development.

The flat, papery black seeds of all agapanthus have limited viability of up to one year when stored at room temperature, and the sooner they are sown, the better germination will be. In warm regions, they are best sown immediately upon ripening from late summer to early winter. Alternatively, seeds can be sown in spring, and viability can be preserved over winter in cold storage by placing seeds into paper packets within sealed containers in the vegetable compartment of a fridge. In cold parts, sowing in spring is preferable, once temperatures are on the rise. For small quantities, sow the seeds in deep seed trays in a well-drained, well-aerated mixture such as a good commercial seedling mix, or a home-made mix such as equal parts of river sand and finely sifted compost, but for *A. africanus* and *A. walshii*, provide a mixture that is on the acid side. Prior to sowing, flatten the surface of the mixture and water well with a watering can fitted with a fine rose cap, to allow seeds to 'stick' to the moist medium and reduce incidence of 'floating' to the surface during subsequent watering. Sow the seeds thinly and cover to a depth of up to 5 mm. Water well and place the trays in a lightly shaded position under cover, such as in a cool greenhouse or cold frame, keeping the sowing medium moist, but not constantly wet. Fulcher & Fulcher (2010) recommend a minimum temperature of 15°C for seed germination, and fresh seed normally germinates readily within three to eight weeks (Duncan, 1998; 2004). Once seedlings are several weeks old, move the trays into bright light under cover, and feed with a high nitrogen liquid fertilizer, or apply slow-release granules high in nitrogen. Allow seedlings to remain in the trays for their first year, thereafter pot them up individually into

Figure 101. Two-year-old seedlings of a dwarf form of *Agapanthus praecox*, ready for potting-up individually into small pots or seedling starter trays. Image: Graham Duncan.

small pots or seedling starter trays in the spring of the second year, and allow them to harden-off in full sun or bright light for a further year (Figure 101). Young plants can be planted out into the garden during late spring in their third year, or alternatively into permanent containers. In ideal conditions, flowering from seed can generally be expected from the third year onwards, but dwarf hybrids can sometimes flower in an even shorter period, and at Kirstenbosch *A. africanus* has flowered within two and a half years (30 months) (Figure 102).

DIVISION

For the home gardener wishing to increase stock while simultaneously preserving the precise genetic characteristics of a species or cultivar, division is the most feasible means. In temperate climates, thick clumps of evergreen and deciduous agapanthus in the garden can be divided immediately after the flowering period in autumn, or alternatively this can be done in early spring, just before new leaves and growth shoots appear (Duncan, 1985). The many forms of *A. praecox* are so tough that division in summer, except during the very hottest months, rarely sets them back much,

Figure 102. *Agapanthus africanus* seedlings flowering within 30 months, Kirstenbosch. Image: Graham Duncan.

provided they are replanted immediately and kept moist until established. In cold climates, division and replanting are most successfully done in spring or early summer, once temperatures are on the rise, and the likelihood of frost has passed. It can also be carried out in late summer and early autumn, ensuring that divisions are replanted immediately and heavily mulched for the winter.

Overcrowded clumps often fail to flower. The evergreens can be lifted and divided every four years, and often flower best in the summer season immediately after replanting. Conversely, deciduous species and cultivars are best divided in spring, just before active growth begins; they strongly resent disturbance to the roots (Palmer, 1956) and like to remain in the same position for up to six years, and will often flower poorly or sometimes not at all in the season immediately after replanting (Duncan, 1998). Clumps of the more delicate cultivars can be slowly teased apart, or if heavily pot-bound, soaked in water to remove soil, before careful separation by cutting the rhizomes apart with a sharp knife or hand saw. In extremely pot-bound agapanthus, the pot may have to be cut along the sides, or broken, in order to prevent excessive damage to the roots during removal. In the garden, large clumps of both evergreen and deciduous types can be lifted and divided by initially digging a deep circle around the clump and lifting it as far as possible, then placing two forks back to back in the centre and slowly levering the rootstocks apart. Alternatively, they may simply be chopped into individual portions with a sharp spade, ensuring that each portion has sufficient root material and at least one healthy shoot. The inevitable injury which occurs to rootstocks during division results in a stream of sticky sap, in which case allow the sap to cease and form a callus over a period of one to two days, before replanting, failing which the rootstock may rot in moist conditions. To compensate for the loss of root material and resultant loss of moisture uptake during division, trim the leaves of evergreen agapanthus back to about half their original length, before the portions are replanted.

MICROPROPAGATION

Clonal propagation of agapanthus by means of tissue culture preserves uniformity and vigour, allowing for a speedier production period from young plant to flowering-size individual. It is the most effective way of simultaneously producing large numbers of plants which are exactly true to type, and in ideal conditions, flowering plants can be produced from tissue culture within 3 years. Several techniques are used, which involve *in vitro* culture of shoot-tip and rhizome explants of seedlings, or of young flower buds, placed on a semi-solidified growing medium such as agar, to which growth hormones are applied to increase shoot multiplication. The *in vitro*-raised plants are then established under greenhouse conditions and allowed to harden off before being potted-up and grown on. Baskaran & van Staden (2013) reported the successful multiplication of *A. praecox* using shoot-tip explants of seedlings for the potential purpose of conservation to relieve pressure on wild populations, for commercial production, and to produce phytomedicines. Yaacob *et al.* (2014) induced direct regeneration of *A. praecox* from rhizome explants of seedlings, and Fogaça *et al.* (2016) successfully used two systems for multiplication of *A. praecox* using floral buds in a semi-solidified medium, and in a less costly, liquid medium.

At Frontier Laboratory in Cape Town, Andy Hackland has successfully used the completely closed flower buds/primordial region, and the shoot apical/leaf primordial region, to initiate multiplication of agapanthus cultivars for commercial production, and the process involves four stages. In stage 1, the explants are placed onto a high cytokinin agar gel medium to stimulate adventitious shoot formation. Once shoots have developed, stage 2 multiplication is stimulated by cytokinin levels of 0.5–2.0 mg/L, depending on the cultivar. During stage 3, root formation is stimulated by placing excised shoots onto 0.1–1.0 mg Indole-3-butyric acid (IBA) (auxin), however explants placed on a zero concentration auxin medium at this stage will also form roots. Stage 4 is the hardening-off stage, in which the material is placed in the greenhouse, planted into a growing medium with an air-fill porosity (AFP) of 15–20%. A 100% humid environment is provided, with 80%+ shade used for the first 10–14 days, following which humidity is lowered over the next 2 weeks. After 4 weeks, plantlets are moved to higher light levels, under 45–60% shade during the summer months (Andy Hackland, pers. comm.).

In some instances, variation as a result of tissue culture can occur within agapanthus cultivars (Snoeijer, 2004), resulting in propagules that are not as strong as the mother plant, or are deformed. Micropropagation is thus sometimes unsuccessful, especially with variegated cultivars, as reported for *A.* 'Gold Strike' raised in New Zealand (Dawson & Ford, 2012).

PESTS AND DISEASES

PESTS

African boll worm

The ubiquitous African boll worm moth *Helicoverpa armigera* (Family Noctuidae) is widespread throughout South Africa, and its larvae are a serious pest on many agricultural and ornamental crops. In the Western Cape, the larvae attack flower buds of *A. africanus*, resulting in malformed flowers (Figure 103). In severe infestations, spraying with a biological insecticide containing the naturally occurring micro-organism *Bacillus thuringiensis* subsp. *kurstaki* is suggested.

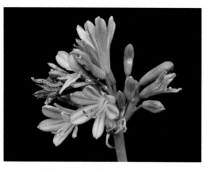

Figure 103. Larva of the African boll worm (*Helicoverpa armigera*) consuming tepals of *Agapanthus africanus*. Image: Graham Duncan.

Agapanthus borer

The moth species also known as agapanthus borer *Neuranethes spodopterodes* (Family Noctuidae), is endemic to South Africa, and historically occurred in the eastern and northern summer rainfall provinces of KwaZulu-Natal, Mpumalanga and Limpopo. During the summer of 2010–2011, larvae of this moth were seen to attack cultivated plants of *A. praecox* in the northern provinces of Gauteng and North West, and rapidly spread, via the nursery trade, to the Western Cape in the south (Figure 104). A subsequent survey determined that it was also present in cultivated plants in Mpumalanga and

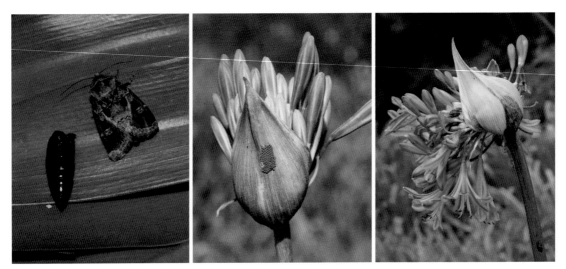

Figure 104 (left). Pupal case and newly emerged female moth of the agapanthus borer (*Neuranethes spodopterodes*). Image: Graham Duncan.

Figure 105 (middle). Newly laid egg cluster of the agapanthus borer (*Neuranethes spodopterodes*) on a spathe bract of *Agapanthus praecox*. Image: Graham Duncan.

Figure 106 (right). Spathe bract and scape of *Agapanthus praecox* damaged by agapanthus borer (*Neuranethes spodopterodes*). Image: Graham Duncan.

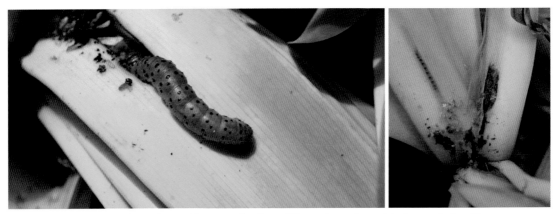

Figure 107 (left). Advanced stage larva of the agapanthus borer (*Neuranethes spodopterodes*). Image: Graham Duncan.

Figure 108 (right). *Agapanthus praecox* leaf bases, severely damaged by agapanthus borer (*Neuranethes spodopterodes*) with characteristic excrement. Image: Graham Duncan.

KwaZulu-Natal, where it was attacking *A. praecox*, *A. inapertus* and their hybrids (Picker & Kruger, 2013). It also attacks other species of *Agapanthus* including *A. campanulatus*, *A. caulescens* and *A. coddii* (Dabee, 2013) and poses a substantial threat to the commercial agapanthus industry in South Africa, as well as being a potential threat to wild populations of *A. africanus* and *A. walshii* in the south-western Cape (Picker & Kruger, 2013).

The eggs are laid in clusters on the outer surface of leaves, and on the spathe bracts enclosing the unopened flower buds, mainly at the beginning of summer (Figure 105). Upon hatching, the voracious larvae rapidly consume surrounding tissue, then bore downwards into the scape (Figure 106) and lower parts of the inner leaves (Figure 107), which collapse, leaving behind their characteristic excrement (Figure 108). Eventually they bore into the rhizome, which they proceed to hollow out, leading to the death of the plant. The larvae prefer the warmer parts of South Africa and are absent from the interior of the country where cold winters are experienced (Picker & Kruger, 2013).

For control of the agapanthus borer, preventative spraying every 2–3 weeks with a biological insecticide in the form of a water dispersible granule containing the naturally occurring micro-organism *Bacillus thuringiensis* subsp. *kurstaki* is suggested. It does not harm important beneficial insects such as honeybees, and is not harmful to humans and wildlife. It is ingested by the larvae, disrupting the gut functions by destroying the larvae's stomach, causing it to stop feeding within a few hours, and die within 2–5 days.

A parasitoid wasp belonging to the genus *Trichogramma* (family Hymenoptera) has been found to heavily infest eggs of the agapanthus borer in South Africa, and could potentially be used as a biological control agent to reduce its impact on cultivated plants (Dabee, 2013).

Cherry spot moth

Larvae of the cherry spot moth (*Diaphone eumela*: Family Noctuidae) are partial to the flower buds of agapanthus (Figure 109). They are found mainly in the northern and eastern summer rainfall parts of South Africa, but are also encountered in the south-western Cape, including at Kirstenbosch. In severe infestations, control by spraying with a biological insecticide containing the naturally occurring micro-organism *Bacillus thuringiensis* subsp. *kurstaki* is suggested.

Gall midge

For about 20 years, an unidentified gall midge was seen to affect young flower buds of *Agapanthus* species at Kirstenbosch, causing severe malformation (Duncan, 1998) (Figure 110). In 2014, an undescribed gall midge was noted attacking the flower buds of *Agapanthus* cultivars in England, causing buds to become deformed, change colour and fail to open, and severe infestations led to the collapse of the entire flower head. The midge may have originated in South Africa, where it had caused identical damage to flower heads of agapanthus, and was described as the new genus and new species *Enigmadiplosis agapanthi* (Harris *et al.*, 2016).

Figure 109. Larva of the cherry spot moth (*Diaphone eumela*) consuming flower buds of *Agapanthus praecox*. Image: Graham Duncan.

A research project initiated by the Royal Horticultural Society to study the biology of the midge, to determine whether it is identical to the midge in South Africa, and to develop possible methods of control, is under way (Hayley Jones, pers. comm.). The midge has a long active period from early to late summer, and undergoes a winter phase within the soil. The larvae develop inside the flower buds, emerge when mature, drop to the ground to pupate, and within two weeks, the adults emerge. As a fully effective control of this pest has not yet been developed, it is recommended that infected flower heads be removed and destroyed immediately, and if necessary, the entire plant should be destroyed in severe infestations. A soil drench using the contact insecticide Calypso 480 SC may provide some level of control of larvae once they have dropped to the ground (AHDB Horticulture, 2017).

Mealybug

These small white, waxy sucking insects attack the leaf bases of agapanthus, and their presence should be suspected when oily, white deposits are noted. They are especially prevalent in plants grown in containers in enclosed, warm and dry conditions, such as in greenhouses and conservatories. They are spread from one plant to another by ants that feed on their honeydew excretion, upon which a black mould may sometimes develop. Ants can be controlled by pouring neat Jeyes Fluid down ant holes, then washing it down with water. Mealy bugs can be controlled by spraying with a biological formulation containing the fungus *Metarhizium anisopliae*.

Red spider mite

The upper and lower surfaces of the leaves of both evergreen and deciduous species of agapanthus are susceptible to infestation by red spider mite from mid- to late summer, in garden beds, and especially in warm, enclosed conditions in greenhouses and conservatories. These minute, red, sap-sucking insects form a fine greyish web, causing the leaves to lose colour, and in severe infestations, turn

Figure 110. Severe malformation of *Agapanthus praecox* flower buds caused by gall midge larvae (probably *Enigmadiplosis agapanthi*). Image: Graham Duncan.

Figure 111. Infestation of *Agapanthus inapertus* subsp. *pendulus* 'Graskop' leaves by red spider mites. Image: Graham Duncan.

an unsightly white (Figure 111). Spraying with a biological formulation containing the fungus *Metarhizium anisopliae* is suggested, ensuring that both sides of the leaves are covered.

Snails

In warm, temperate and cold climates, the leaf undersides of forms of the broader-leafed evergreen *A. praecox* and its cultivars often harbour large numbers of common garden snails (*Cornu aspersum*). They seldom do any physical damage to the leaves, but feed on other garden plants, and are transmitters of viral disease.

Snout beetle

These highly destructive nocturnal, small grey or light brown beetles chew the leaf margins and upper surfaces of agapanthus, especially the evergreen species, leaving behind characteristic round bite marks (Figure 112). During the daytime they are concealed among dry leaves on the ground, or between the centre leaves, at the base. In severe infestations, spray with a biological formulation containing the fungus *Metarhizium anisopliae*, as a full cover spray.

Thrips

These minute, elongated, black or brown insects feed on the undersides of agapanthus leaves, leaving behind characteristic white streaks, and also attack developing flower buds, resulting in deformed flowers. They are prevalent during the hot summer months. In severe infestations, spray with a biological formulation containing the fungus *Metarhizium anisopliae*, ensuring that the leaf undersides are fully covered.

DISEASES

Agapanthus fungus

The agapanthus fungus *Phomopsis agapanthi* (previously *Sphaeropsis agapanthi*) attacks the leaves of both evergreen and deciduous types, causing them to turn brown, dry out and die back from the tips (Figure 113). The disease is especially prevalent during the hot summer

Figure 112. Damage to leaf margins and surfaces of *Agapanthus praecox* 'Storms River' by snout beetles. Image: Graham Duncan.

Figure 113. The agapanthus fungus *Phomopsis agapanthi* causes leaves to die back from the tips, and leaves of the evergreen species are sometimes subject to unsightly reddish blotches. Image: Graham Duncan.

months, and one of the causes may be the result of soil that has become excessively compacted as a result of decomposition, or has remained excessively wet for long periods, resulting in insufficient oxygen uptake by the roots. Remove all affected leaves, lift and replant the rhizomes into new, well-drained soil, and spray with a biological formulation containing the fungus *Trichoderma asperellum*.

Leaf spots

The leaves of evergreen agapanthus are sometimes subject to fungal diseases which result in the formation of unsightly reddish blotches (Figure 113). Unfortunately, little is known about them. The best course of action is to cut off and destroy affected portions of leaves as soon as the disease is noticed, improve ventilation, ensure good drainage of the growing medium, and spray with a biological formulation containing the fungus *Trichoderma asperellum*. Feeding will help make plants stronger and better able to withstand disease, but it won't cure them.

Virus

Agapanthus is susceptible to a number of viral infections, recognised as mosaics or streaking, which, apart from detracting from aesthetic appeal, have the effect of severely weakening the plant (Figure 114). Plants initially become infected when insect vectors such as mealy bugs and thrips transmit virus in sap from infected plants to healthy ones. Infected sap is also spread from infected to healthy plants vegetatively (cutting of flower stems, leaves, roots and rhizomes) by means of cutting implements such as secateurs. In a study undertaken of *A. praecox* grown for cut flowers and garden production on the French Riviera, six different virus infections were identified among various plantings, of which the major ones were tomato spotted wilt virus (TSWV), odontoglossum ringspot virus (ORSV), impatiens necrotic spot virus (INSV) and cacao yellow mosaic virus (CYMV), and there are no symptoms during the latent stage (Pionnat & Favre, 2000). Eggplant mottled dwarf virus (EMDV) has also been identified in agapanthus in the Latium region of west-central Italy, evident in the leaves as a bright mosaic of white and yellow patches and stripes on leaves, scapes and flower buds, and the symptoms include colour-breaking and flower distortion (Zhai *et al.*, 2014). Secondary fungal infection sometimes develops across the surfaces of infected leaves.

No cure exists for viral disease, and infected plants have to be removed and discarded, preferably by burning, to avoid its spread to healthy plants. Cutting implements must be cleaned by wiping away soil, sap and other debris with a damp cloth, then disinfecting by wiping with ethanol or isopropyl alcohol.

Figure 114. Severe viral streaking of *A. praecox* leaves. Image: Graham Duncan.

4. AGAPANTHUS AND THE ENVIRONMENT

CONSERVATION

Most species of the genus *Agapanthus* are not under threat in their native habitats, due mainly to their wide distribution and preference for inaccessible terrain. A notable exception, however, is *A. walshii*, an evergreen plant endemic to rocky sandstone mountain slopes and flats of the Elgin Valley in the south-western part of the Western Cape (Figure 115). Known from a restricted range of 35 square km, and recorded from fewer than 5 locations, the largest population occurs adjacent to an informal settlement, and is threatened by habitat loss due to ongoing unregulated expansion of the settlement, and is assessed as Endangered (Duncan, 2004; Duncan & Pillay, 2004). During a recent visit to this location by the author in November 2018, not a single plant could be found, due mainly to alien invasive acacias which had swamped part of the habitat, and possibly due also to fires which had taken place at abnormal times of the year (related to the settlement). A second population has lost some habitat to infrastructure development related to a hydro-electric power station, but this

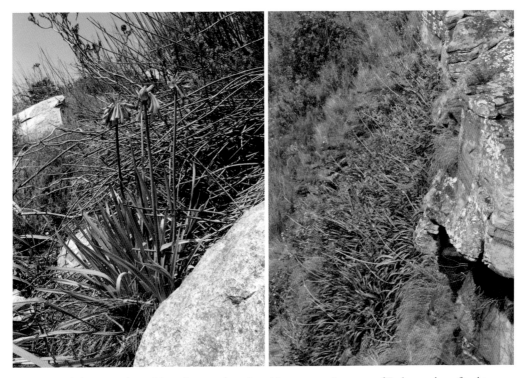

Figure 115 (left). *Agapanthus walshii*, a threatened species with a conservation status of Endangered, confined to rocky sandstone slopes of the Elgin Valley. Image: Graham Duncan.
Figure 116 (right). *Agapanthus coddii*, a range-restricted species from the Waterberg Mountains, Limpopo, has a conservation status of Rare. Image: Sylvie Kremer-Köhne.

threat is not ongoing. A proportion of this population is protected within the greater Kogelberg Biosphere Reserve which includes the Steenbras Nature Reserve, where it is not threatened. Other small populations exist on private farmland within the area occupied by the hydro-electric power station, and these, too, appear to be safe.

The deciduous, summer-growing *A. coddii* is a range-restricted species with an area of occurrence of 160 square km within the western end of the Waterberg Mountains in the Waterberg Biosphere Reserve north-east of Thabazimbi, in western Limpopo. Its habitat on precipitous rocky slopes is inaccessible and largely protected within private conservancies, and within the Marakele National Park (Figure 116). It is not considered threatened, but owing to its restricted range, its conservation status is categorised as Rare (von Staden, 2004).

The conservation status of *A. pondoensis* has not yet been assessed, however its rocky, often precipitous habitat is largely inaccessible, and the species is probably not threatened.

PHYTOGEOGRAPHY

The distribution data are based on preserved herbarium material in B, BOL, G, K, LINN, NBG, NH, NU, PRE, SAM, SBT and UPS, recorded in full degree and quarter degree grid square increments according to the reference system of Edwards & Leistner (1971).

Agapanthus is endemic to South Africa, Lesotho, Mozambique and Eswatini (Swaziland) (Duncan, 2003; 2004). It occurs from the southern and northern Cape Peninsula in the south-western part of the Western Cape, in an easterly direction along the south coast and inland within this province, to the southern, central, northern, eastern and north-eastern parts of the Eastern Cape. Further

Figure 117. *Agapanthus caulescens* on sandstone rock faces, Tugela Gorge, KwaZulu-Natal. Image: Neil Crouch.

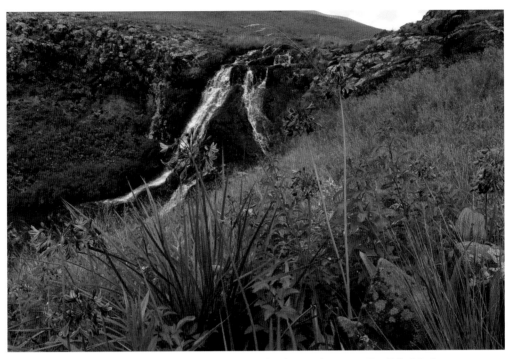

Figure 118. *Agapanthus campanulatus*, Highmoor, Maloti-Drakensberg Park, western KwaZulu-Natal. Image: Neil Crouch.

east it occurs throughout KwaZulu-Natal, in western, northern, central and eastern Lesotho, eastern and north-eastern Free State, southern Gauteng, southern, central, northern and eastern Mpumalanga, northern and western Eswatini, southern Mozambique, and in southern, western, central, northern and eastern Limpopo. It is absent from South Africa's Northern Cape and North West provinces. The most southerly populations are those of *A. africanus* in the vicinity of Gansbaai in the Caledon grid (3419 CB) in the southern Cape, and the most northerly record is *A. inapertus* subsp. *intermedius* in the Waterpoort grid (2229 DD) in the northern Soutpansberg, in northern Limpopo. The most easterly populations are *A. inapertus* subsp. *intermedius* in the Maputo grid (2532 CC) at M'Ponduine near Namaacha in southern Mozambique, *A. caulescens* in the Ubombo grid (2732 AA) in the Lebombo

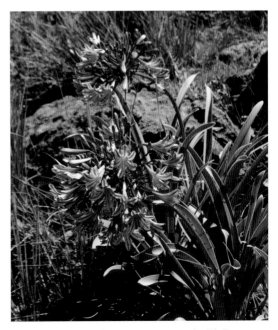

Figure 119. *Agapanthus praecox* among rocks, Khalinyanga, Eastern Cape. Image: Graham Duncan.

Mountains and in the Mtubatuba grid (2832 AC) in the Dukuduku State Forest east of Mtubatuba, as well as *A. campanulatus* north of Richards Bay in the Mtubatuba grid (2832 CA), in the far north-eastern parts of KwaZulu-Natal. The furthest inland records are *A. coddii* and *A. caulescens* in the Thabazimbi grid (2427 BC) in the Waterberg in western Limpopo, and *A. campanulatus* near Clocolan in the Senekal grid (2827 DC) in the eastern Free State and at Mamathes in the Maseru grid (2927 BA), in north-western Lesotho. The species of *Agapanthus* are concentrated in the eastern, north-eastern and northern summer rainfall parts of South Africa, and there are five centres of diversity, each supporting three species: the 3129 (Port St Johns) grid in the north-eastern Eastern Cape (*A. campanulatus*, *A. pondoensis* and *A. praecox*), the 3030 (Port Shepstone) grid in southern KwaZulu-Natal (*A. campanulatus*, *A. caulescens* and *A. praecox*), the 2930 (Pietermaritzburg) grid in south-central KwaZulu-Natal (*A. campanulatus*, *A. caulescens* and *A. praecox*), the 2730 (Vryheid) grid in northern KwaZulu-Natal and southern Mpumalanga (*A. campanulatus*, *A. caulescens* and *A. inapertus* (subsp. *inapertus*)), and the 2430 (Pilgrim's Rest) grid in northern Mpumalanga and east-central Limpopo (*A. campanulatus*, *A. caulescens* and *A. inapertus* subsp. *inapertus*, *A. inapertus* subsp. *intermedius* and *A. inapertus* subsp. *pendulus*) (Map 1). *A. caulescens* is the most widespread species, found at Bizana in the extreme north-eastern part of the Eastern Cape, and from isolated records north of Queenstown and north-west of Ngcobo in the central and east-central parts of this province, respectively, to the western

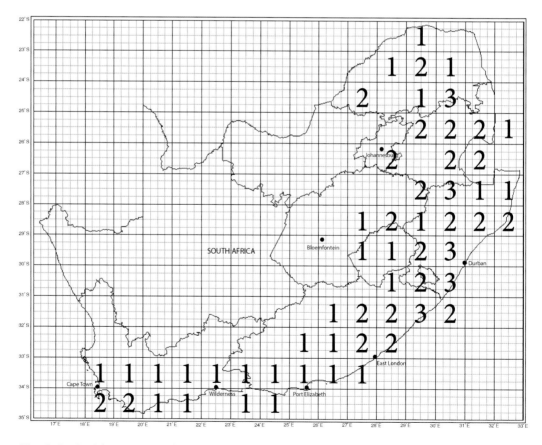

Map 1. Species richness in *Agapanthus* in geographical degree squares.

Soutpansberg in northern Limpopo (Figure 117). *A. campanulatus* is the second-most widespread species, occurring from Komga in the Eastern Cape to near Shiluvane in east-central Limpopo, and is concentrated in KwaZulu-Natal (Figure 118). The third-most widespread agapanthus is *A. praecox*, occurring from west of Wilderness in the southern Cape to Krantzkloof Nature Reserve in south-eastern KwaZulu-Natal, and inland to Mortimer and north of Pearston in the western Eastern Cape and Barkly Pass in the northern Eastern Cape (Figure 119).

ECOLOGY, HABITAT AND ADAPTIVE STRATEGIES

ECOLOGY AND HABITAT

Agapanthus occurs within six of the nine biomes recognised in South Africa, Lesotho and Eswatini (Mucina & Rutherford, 2006): Fynbos (3 species: *A. africanus*, *A. praecox*, *A. walshii*), Forests (1 species: *A. praecox*), Albany Thicket (1 species: *A. praecox*), Indian Ocean Coastal Belt (4 species: *A. campanulatus*, *A. caulescens*, *A. pondoensis*, *A. praecox*), Savanna (3 species: *A. campanulatus*, *A. caulescens*, *A. inapertus*) and Grassland (5 species: *A. campanulatus*, *A. caulescens*, *A. coddii*, *A. inapertus*, *A. praecox*). The species occur in at least 36 vegetation types recognised in South Africa, Lesotho and Eswatini (Mucina & Rutherford, 2006), in two of the three principal floristic regions (Cape Floristic and Maputaland-Pondoland) and in nine of the 19 centres of floristic endemism recognised in southern Africa (Albany, Barberton, Drakensberg Mountain, Maputaland, Pondoland, Sekhukhuneland, Sneeuberg, Soutpansberg and Wolkberg) (Van Wyk & Smith, 2001; Clark *et al.*, 2009; Carbutt, 2019).

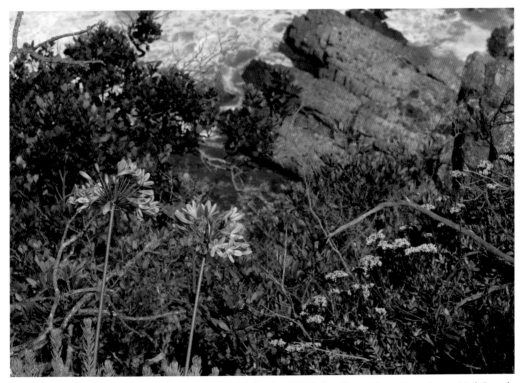

Figure 120. Dwarf form of *Agapanthus praecox* on coastal rocks near Harkerville, southern Cape. Image: Neil Crouch.

The altitudinal range for *Agapanthus* varies greatly from close to sea level (e.g. *A. africanus* on flats and low hill slopes in the southern Cape Peninsula and near Gansbaai on the Cape south coast; *A. praecox* on coastal embankments near Wilderness, Knysna and Harkerville (Figure 120), and river mouths at Storms River mouth in the southern Eastern Cape, and Port St Johns in the north-eastern Eastern Cape) to just over 3,000 m for *A. campanulatus* on summit slopes of Thaba Putsoa (Blue Mountain) in south-western Lesotho, and near The Sentinel in the northern Drakensberg, where north-eastern Lesotho meets South Africa's KwaZulu-Natal and Free State provinces (Figure 121).

The species occupy a wide range of habitats, including areas of high winter rainfall, with alternating hot and dry summers in the south-western parts (*A. africanus*, *A. walshii*), year-round rainfall in the southern parts (*A. praecox*), and high summer rainfall alternating with dry winters in the eastern, north-eastern, northern and north-western

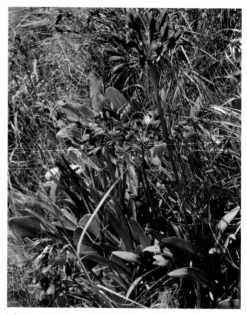

Figure 121. Broad-leafed form of *Agapanthus campanulatus* flowering at over 3000 m near The Sentinel, Royal Natal National Park, western KwaZulu-Natal. Image: Sona Harrap.

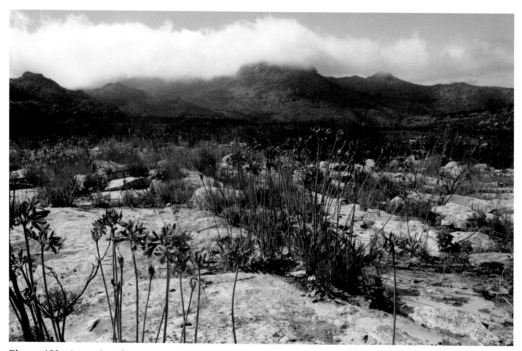

Figure 122. *Agapanthus africanus* on sandstone rock sheets, Silvermine Nature Reserve, southern Cape Peninsula, with *Watsonia tabularis*. Image: Graham Duncan.

Figure 123. *Agapanthus caulescens* on inaccessible sandstone rock faces, Royal Natal National Park, western KwaZulu-Natal. Image: Neil Crouch.

parts (*A. praecox*, *A. pondoensis*, *A. campanulatus*, *A. caulescens*, *A. inapertus* and *A. coddii*). *Agapanthus* is usually associated with stony or rocky terrain, the roots often wedged between rock crevices in minimal soil on flats, hill and mountain slopes and summits (e.g. *A. africanus* and *A. praecox*) (Figure 122), along riverbanks, beside waterfalls and in wooded ravines (e.g. *A. caulescens*), on boulder-strewn slopes (e.g. *A. inapertus* subsp. *parviflorus*), below cliffs (e.g. *A. coddii*) and on ledges of precipitous rock faces (e.g. *A. caulescens*, *A. pondoensis*) (Figure 123). *A. africanus* and *A. walshii* from the winter rainfall region, and *A. coddii* from the far north-western part, only occur on sandstone, the former two in nutrient-poor, acid sand, the latter in relatively fertile loam. The summer-growing *A. inapertus* subsp. *inapertus* is usually encountered in dolomitic media, and certain species occupy more than one soil type, such as *A. praecox* (e.g. sandstone and dolerite) and *A. campanulatus* (sandstone and dolomite). Some species occur in seasonally or permanently wet sites, such as certain forms of *A. campanulatus*, which favour seasonal swamps and seepage zones, often in acidic, black, turfy soil (Figure 124), and *A. coddii* which grows in acidic loam on permanently moist, rocky seepage slopes. The species occur in north-, south-, east and west-facing aspects, in full sun or light to moderate shade, or sometimes in deep shade (e.g. *A. praecox*). Most deciduous, summer-growing species and the evergreen *A. africanus* and *A. walshii* from the south-western Cape prefer full sun, whereas the evergreen *A. praecox* is usually found in lightly to moderately shaded environments, however exceptions are frequent, and *A. africanus* and *A. campanulatus* can sometimes be seen in dappled shade, and *A. praecox* in full sun, and *A. pondoensis* in full sun or deep shade.

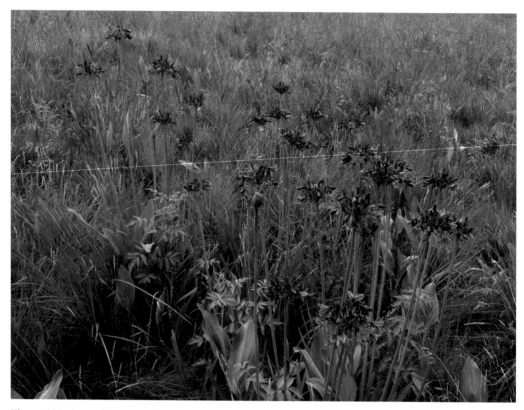

Figure 124. *Agapanthus campanulatus* on a grassland seepage slope, Highmoor Maloti-Drakensberg Park, western KwaZulu-Natal. Image: Neil Crouch.

Agapanthus is gregarious, occurring in small to large groups, or sometimes in vast colonies, rarely as solitary individuals, often in close association with low scrubby growth including shrubs, bracken and grasses. Populations can number hundreds or even thousands of individuals for plants of *A. campanulatus* on high altitude mountain slopes at Sani Pass in western KwaZulu-Natal (see Figure 233) and *A. inapertus* subsp. *inapertus* on grassy hills near Graskop in northern Mpumalanga (Figure 125). Different *Agapanthus* species sometimes occur within fairly close proximity, but as far as I'm aware, never in mixed populations. For example, *A. africanus* and *A. walshii* both occur as isolated populations within the Simonstown grid (3418 BB and 3418 BD), and *A. campanulatus* and *A. inapertus* subsp. *inapertus* are both found within the Pilgrim's Rest grid (2430 AA).

The lowest temperature experienced across the range of habitats in which agapanthus grow is -20°C during the winter months in the highlands of Lesotho (*A. campanulatus*), when the plants are dormant. Sub-zero winter temperatures accompanied by snowfalls also occur regularly where *A. campanulatus* grows in the interior of South Africa, including Mont-aux-Sources and The Sentinel in western KwaZulu-Natal, as well as on Barkly Pass in the Eastern Cape, where the evergreen *A. praecox* grows. Severe winter frosts are regularly experienced in the eastern and south-eastern Free State, where *A. campanulatus* occurs. Mid-summer temperatures often rise well above 30°C in eastern Limpopo, in the lowveld of Mpumalanga, and in northern KwaZulu-Natal, where several species are found (*A. campanulatus, A. caulescens* and *A. inapertus*) as well as in the south-western Cape (*A. africanus*,

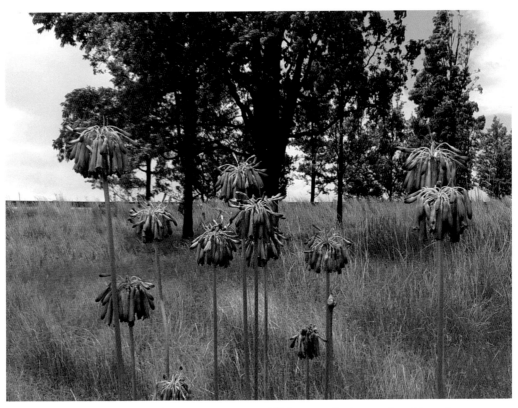

Figure 125. *Agapanthus inapertus* subsp. *inapertus* on a grassy hill slope near Graskop, northern Mpumalanga. Image: Wessel Stoltz.

A. walshii). Areas with the highest average annual rainfall where agapanthus occur are in the northern Drakensberg in the Amphitheatre World Heritage Site (*A. campanulatus*), with an annual average of 1354 mm, and at Kirstenbosch National Botanical Garden in the suburb of Newlands (*A. africanus*) which receives on average 1310 mm per annum. The area with the lowest average annual rainfall is probably in the Eastern Cape interior, in the vicinity of Somerset East, with an annual average of 348 mm (*A. praecox*); to the north and south of Queenstown, with 399 mm (*A. caulescens* and *A. praecox*), and to the north of Pearston and at Mortimer, with *c.* 400 mm (*A. praecox*).

ADAPTIVE STRATEGIES

Dealing with cold and drought

The leaves of most agapanthus in the eastern, north-eastern and northern parts of the distribution range are deciduous, desiccating and turning yellow as temperatures decrease markedly in late autumn and early winter. The plants remain dormant during the cold and dry winter months, surviving by means of fleshy rhizomes and perennial, fleshy roots. In general, species in areas occurring on exposed, high-lying ground in the summer rainfall areas have relatively narrow, deep-seated rhizomes, like those of *A. campanulatus* and *A. inapertus*. The rhizomes of most forms of the evergreen *A. praecox*, which occurs mainly in mild coastal climates and in protected gullies, have their rhizomes lying close

to the surface, however forms of this species from cold, inland parts such as on Barkly Pass in the Eastern Cape interior are adapted to cold and snow by having thick layers of old, dried leaf bases which surround the base of the pseudostem (Figure 126). The plants are securely wedged between sandstone rocks, and although the leaves may be scorched or cut back completely by severe cold, the rhizomes survive and sprout again in spring. In the south-western Cape, the evergreen *A. africanus* and *A. walshii* survive hot, dry summers by means of relatively narrow, leathery leaves which limit transpiration, and extensive mats of fleshy roots which lie within a relatively cooler environment between rock crevices and boulders, and beneath rock sheets (Figure 127).

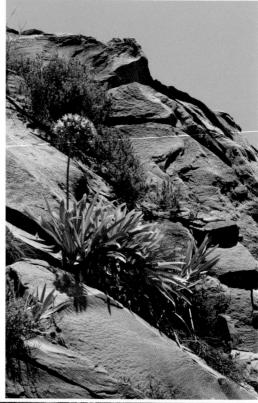

Figure 126 (right). *Agapanthus praecox* on rocky sandstone slopes, Barkly Pass, Eastern Cape, survives sub-zero winter temperatures by means of thick layers of old, dried leaf bases surrounding the base of the pseudostem. Image: Graham Duncan.

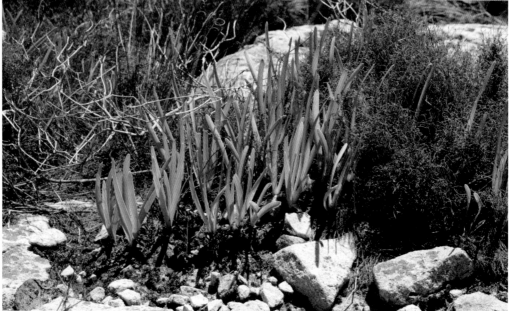

Figure 127. *Agapanthus africanus* survives hot, dry summers by means of leathery leaves and thick mats of fleshy roots beneath sandstone rock sheets, southern Cape Peninsula. Image: Graham Duncan.

Fire

Fire is an important natural phenomenon in some habitats where agapanthus occurs. Flowering is stimulated by the clearing of smothering overgrowth and subsequent release of extra nutrients back into the soil from ash. In particular, *A. africanus* and *A. walshii* from the fire-prone mountains of the south-western Cape are strongly stimulated to profuse flowering within approximately 12 months of late summer bush fires which periodically sweep through their fynbos habitats. Their evergreen leaves are burnt away, and the new leaf fans emerge within a few months, with the onset of autumn rains (Figure 128) and flowering takes place within 12 months (Figures 129, 130). However, these species are not true pyrophytes, since significantly reduced, sporadic flowering does take place in ensuing summers during inter-fire periods (Duncan, 2004) (Figure 131).

Fires generally occur in fynbos at intervals of 10–15 years across the Fynbos Biome, and are strongly seasonal and concentrated in summer in the west, but are markedly less seasonal in the east, where rainfall is evenly distributed across all seasons (van Wilgen *et al.*, 2010). Too-frequent fires, however, can have a detrimental effect on populations of agapanthus, and many other plants, in eliminating seedlings before their roots have become sufficiently well established to survive dry summers.

Fire is also an important natural phenomenon in grasslands of the summer rainfall parts of South Africa, usually occurring in late winter and early spring, just before the first summer rains, and active vegetative growth, begins. The winter-dormant rhizomes of especially *A. campanulatus*, *A. caulescens* and *A. inapertus* respond strongly to winter fires, and prolific flowering takes place within about seven months. Like those from the south-western Cape, none of the summer-growing, deciduous agapanthus are true pyrophytes, since flowering also takes place during inter-fire periods. In inland parts of the Eastern Cape and in southern KwaZulu-Natal, plants of the evergreen *A. praecox* are also subject to winter bush fires, but the rhizomes generally survive as they are often deeply wedged between boulders, resprouting within a few weeks.

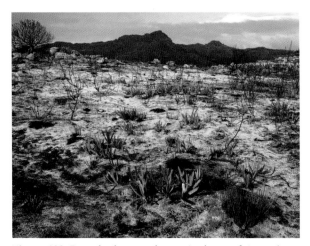

Figure 128. Burnt landscape and emerging leaves of *Agapanthus africanus* within three months of a fire, southern Cape Peninsula. Image: Graham Duncan.

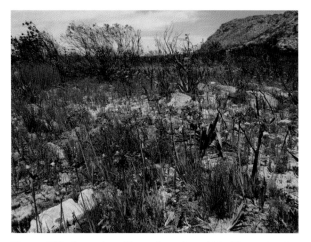

Figure 129. *Agapanthus africanus* flowering within 12 months of fire, southern Cape Peninsula. Image: Graham Duncan.

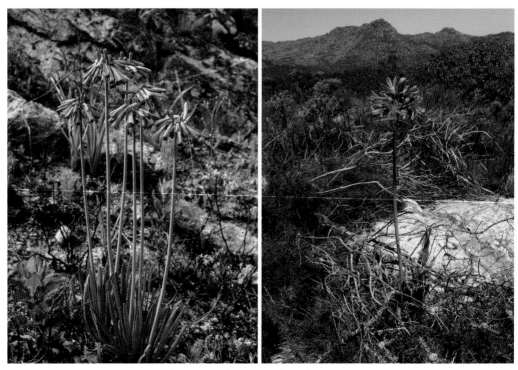

Figure 130 (left). *Agapanthus walshii* flowering within 12 months of fire, Elgin Valley. Image: Barbara Knox-Shaw.
Figure 131 (right). Sporadic flowering of *Agapanthus africanus* in unburnt fynbos, southern Cape Peninsula. Image: Graham Duncan.

Defence

Calcium oxalate crystals (raphides) are present in the mesophyll layer of agapanthus leaves (Agardh, 1992; Kubitzki, 1998) and may be a defence mechanism against predation by herbivores, as they can produce severe toxic reactions when ingested. However, their presence is ineffective in deterring locusts and grasshoppers (family Pyrgomorphidae), including an unidentified species of grasshopper (*Dictyphorus* sp.) which feeds on scapes and flower buds of *A. praecox* on Barkly Pass in the Eastern Cape (Figure 132), and nymphs of the green milkweed locust (*Phymateus viridipes*) which feed on flower buds of *A. pondoensis* near Fraser Falls in the Eastern Cape.

Figure 132 (right). An unidentified grasshopper of the genus *Dictyphorus* feeds on scapes and flower buds of *Agapanthus praecox*, Barkly Pass, Eastern Cape. Image: Graham Duncan.

PHENOLOGY

In the wild, the species of *Agapanthus* have a combined flowering period of about four months. Commencing in mid-December (early summer), *A. africanus* has been recorded in flower in the Steenbras Mountains east of Cape Town, as has *A. pondoensis* in the Eastern Cape, and the season ends with very late-flowering forms of *A. praecox* in the Suuranys Mountains in the southern Eastern Cape, in mid-April (mid-autumn). January is the month in which flowering reaches a climax, when all eight species can be found in bloom. *A. praecox* has the longest flowering period, the numerous different forms in bloom for about three and a half months, from late December to mid-April.

The growth, flowering and seed production cycles in both evergreen and deciduous agapanthus are characterised by active vegetative growth during winter or summer (depending on the species), flowering in summer, and seed production in autumn. The evergreen *A. africanus* and *A. walshii* from the winter rainfall area produce most of their new leaves during autumn and winter, as does *A. praecox* from all-year rainfall parts of the southern Cape, while simultaneously losing its oldest, outer ones. *A. praecox* from the eastern summer rainfall areas produces most of its new leaves in summer. The growing period of four of the deciduous, summer-growing species (*A. campanulatus*, *A. caulescens*, *A. coddii*, *A. inapertus*) extends for about eight months, from early October to late May, followed by a period of dormancy of about four or five months (Figure 133), however the deciduous *A. pondoensis* has a much shorter dormancy of only four to six weeks from late autumn to mid-winter.

Due to the short-lived nature of agapanthus seeds, germination ideally has to take place as quickly as possible after dispersal. Seeds of *A. africanus* and *A. walshii* lie dormant for about two months from

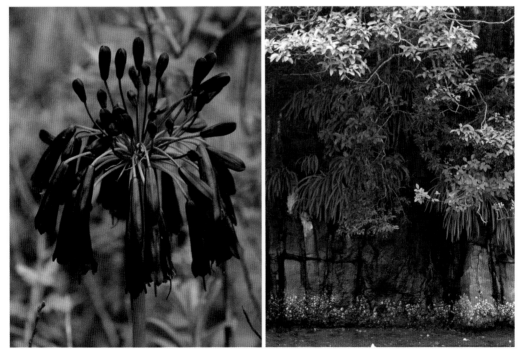

Figure 133 (left). *Agapanthus inapertus* subsp. *pendulus,* a deciduous, summer-growing plant which flowers in late summer and is dormant in winter. Image: Leigh Voigt.
Figure 134 (right). Non-flowering plants of *Agapanthus praecox*, Mtentu River, Eastern Cape. Image: Neil Crouch.

late summer to mid-autumn before germinating with the onset of autumn and winter rains, as do those of *A. praecox* from the southern Cape. Seeds of *A. praecox* in mainly summer rainfall areas, and those of all deciduous species, presumably lie dormant during the cold, dry winters, germinating in early summer with the onset of summer rains. It seems implausible that seedlings in the summer rainfall area would be able to establish themselves sufficiently quickly in late autumn, before cold winter conditions set in, especially those from high altitude.

A notable feature of flowering phenology within populations of the evergreen *A. praecox* is that a remarkably low percentage of mature plants flower in any given year; in populations numbering hundreds of individuals, it is not uncommon for fewer than 20% of mature plants to flower, or sometimes none at all (Figure 134). Although numerous mature individuals within populations of deciduous species fail to flower, the number of non-flowering plants is relatively low, as compared with *A. praecox*, and with *A. africanus* and *A. walshii* during interfire periods.

In cultivation, flowering in wild-collected, evergreen plants often commences much earlier than in the wild, for example *A. praecox* from Adelaide in the Eastern Cape flowers up to two months earlier in garden beds at Kirstenbosch, commencing in October.

5. AGAPANTHUS BIOLOGY

MORPHOLOGY

Few unique morphological characters are to be found in agapanthus, thus it is a particular combination of character states which have to be taken into account when identifying a plant. Certain species are especially variable depending on geographical location, in particular, *A. caulescens*, *A. inapertus* and *A. praecox*, and significant variation often occurs within the same population. Examples of the two morphological extremes are *A. praecox* with evergreen leaves and funnel-shaped perianths produced in more or less rounded flower heads, and *A. inapertus* subsp. *inapertus* with deciduous leaves and tubular perianths produced in more or less bell-shaped flower heads (Figures 135, 136).

Figure 135. General morphology of *Agapanthus*. Pseudo-umbel with funnel-shaped flowers (centre), ripe infructescence (left) and evergreen leaves (right) of *A. praecox*. Artist: Leigh Voigt.

Figure 136. General morphology of *Agapanthus*. Pseudo-umbel with tubular flowers (centre), ripe infructescence (right) and deciduous leaves (left) of *A. inapertus* subsp. *inapertus*. Artist: Leigh Voigt.

HABIT

Agapanthus is an evergreen or deciduous, rhizomatous perennial (Du Plessis & Duncan, 1989). Three species, *A. africanus* and *A. walshii* from the south-western and southern Western Cape, as well as the widespread *A. praecox* from the southern Western Cape, Eastern Cape and southern KwaZulu-Natal, are evergreen, whereas *A. campanulatus*, *A. caulescens*, *A. coddii*, *A. inapertus* and *A. pondoensis*, which collectively occur from the Eastern Cape to Limpopo, are deciduous and summer-growing. The flowering plant varies in height from 200 mm, as in small forms of *A. africanus*, to 2.1 m in tall-growing forms of *A. inapertus* subsp. *inapertus*. The rhizomes of the deciduous species are dormant during unfavourable cold and dry winter weather, whereas those of the evergreen *A. africanus* and *A. walshii*, are adapted to maintain leaf growth during hot, dry summers. Southern and eastern coastal forms of *A. praecox* are evergreen, whereas inland forms of this species may temporarily be partially or fully cut back by frost and snow during severe winters, but subsequently produce new leaves.

ROOTS AND RHIZOME

The roots in *Agapanthus* are adventitious, perennial and fleshy, and arise from nodes on the rhizome, forming extensive root systems. They are white or cream-coloured, and covered with a multiple velamen (Goebel, 1933), a spongy, multiple epidermis which assists the plant in absorbing water, and reduces moisture loss. The main roots which develop on the rhizome are initially unbranched for the first year, but during the second year produce much thinner, branched or unbranched rootlets at irregular intervals, and these vary from 1–3 mm in diameter. Considerable variation occurs in diameter of the main roots, from 4 mm in *A. africanus* and small forms of *A. praecox*, up to 10 mm in large forms of *A. caulescens* and in certain forms of *A. pondoensis*.

The storage and regenerative organ is a well-developed, narrowly to broadly cylindrical, persistent rhizome, without a tunic. It is usually subterranean or sometimes partially exposed, with erect, suberect or spreading orientation, and has light brown, white or cream-coloured tissue. In the evergreen species the upper part of the rhizome is covered with the fibrous remains of old leaf bases (Figure 137), whereas the deciduous species differ in having a slightly or strongly swollen, bulb-like apex (Figure 138), formed from thickened leaf bases, from which the new shoot emerges in early summer. After flowering, the rhizomes of the evergreen species multiply either by splitting into two at the apex, or by the development of new buds in the upper part of the rhizome, whereas in the deciduous species, new plants are formed from one or more buds which develop next to the swollen apex. Rhizome diameter and length are extremely variable, from the short, narrow rhizomes of small

Figure 137 (left). Rhizome of the evergreen *Agapanthus praecox*, showing desiccated outer leaves (above) and fibrous covering from old leaf bases (below). Image: Graham Duncan.

Figure 138 (right). Bulbous rhizome apex of the deciduous *Agapanthus pondoensis*. Image: Graham Duncan.

forms of *A. praecox* (50 × 15 mm) to the broad, long ones in large forms of this species (220 × 50 mm). Similarly, the diameter of the swollen apex in deciduous species varies from small (20 mm) in *A. campanulatus* to relatively large (60 mm) in robust forms of *A. caulescens*.

PSEUDOSTEM AND LEAVES

The leaf bases are membranous, tightly sheathing and overlapping, forming a short to long, narrow or broad, white, green or purple-flushed pseudostem. Pseudostem width varies significantly in some species, as in *A. caulescens* (15–40 mm) and *A. praecox* (12–50 mm). In the evergreen species, the remains of the old leaf bases form a thick, fibrous layer (burnt away during fires) around the base of the pseudostem, especially in *A. praecox*, whereas in deciduous species, the leaf bases more or less disintegrate with the onset of cold winter weather. The deciduous species have one or up to nine tubular, basal sheaths located in the lower part of the pseudostem, which terminate in relatively short, strap-shaped or linear leaves with obtuse or acute apices (Figure 139). These basal sheathing leaves emerge together with the new shoot in early summer, and die back in early autumn, before the shoot dies back in late autumn and early winter. By contrast, basal sheathing leaves are absent in the evergreen species.

The leaves in *Agapanthus* are simple, alternate and glabrous, with parallel venation, almost always distichous, rarely rosulate, forming prominent, narrow or wide fans. They contain a

Figure 139. Basal leaf sheaths of *Agapanthus inapertus* subsp. *inapertus*. Image: Graham Duncan.

sticky, acrid sap, and raphides (calcium oxalate crystals) occur in the mesophyll layer (Agardh, 1992). Leaf orientation varies from spreading to arching, suberect or erect. In the evergreen species, new leaves emerge sequentially from lateral meristems, with the old, outermost leaves gradually turning yellow and shedding to both sides. In deciduous species, a new leaf shoot comprising 6–12 leaves is produced each summer, dying back completely to a bud on the rhizome towards late autumn.

The main leaf shapes are strap-shaped, linear, lanceolate and oblanceolate, and within some species, leaf shape is variable (e.g. *A. inapertus* and *A. praecox*), in which they are strap-shaped or oblanceolate, depending on the subspecies or morphological form. Leaf width, length and colour vary significantly in both deciduous and evergreen species, especially in *A. caulescens*, *A. inapertus* and *A. praecox*. In *A. caulescens*, for example, leaf width varies from 20–60 mm wide, leaf length from 200–650 mm long, and leaf colour from light to bright green, dark green or intensely glaucous; in *A. inapertus* leaf width varies from 12–45 mm, leaf length from 25–70 mm long, and leaf colour from green to yellowish-green, glaucous green or intensely glaucous, and in *A. praecox*, leaf width varies from 7–50 mm wide, 150–600 mm long, and leaf colour from light to dark green or intensely glaucous (Figures 140, 141).

Figure 140. Light green, arching leaves of *Agapanthus praecox*, Umtamvuna Nature Reserve, KwaZulu-Natal. Image: Graham Grieve.

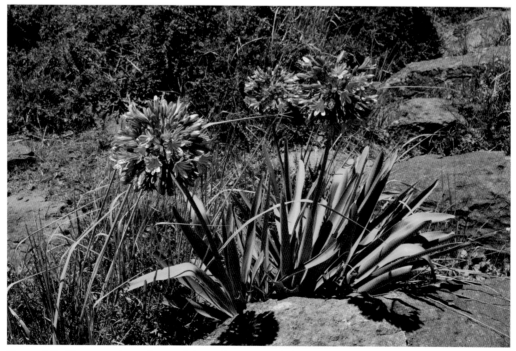

Figure 141. Glaucous, suberect leaves of *Agapanthus praecox*, Khalinyanga, Eastern Cape. Image: Graham Duncan.

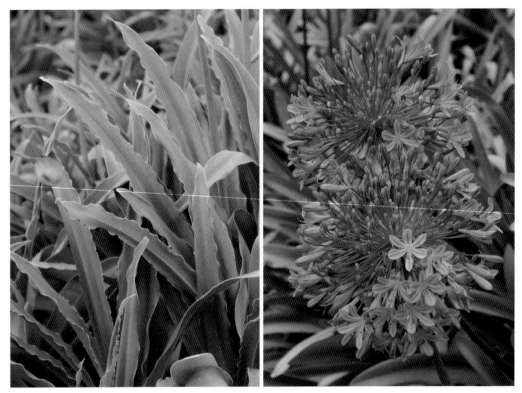

Figure 142 (left). Unusual form of *Agapanthus inapertus* subsp. *pendulus* from Graskop with undulate, ridged leaf margins. Image: Graham Duncan.
Figure 143 (right). Rounded pseudo-umbel and straight pedicels of fully open flowers of *Agapanthus praecox*. Image: Graham Duncan.

Significant variation occurs in leaf colour in certain populations of *A. praecox*, such as at Khalinyanga in the Eastern Cape, where both intensely glaucous and green-leafed individuals occur within the same population. Leaf surfaces are usually matte green or glaucous, but glossy surfaces also occur, as in forms of *A. praecox*, and in *A. inapertus* subsp. *intermedius* from M'Ponduine in southern Mozambique. Leaf margins are mostly flat, but sometimes wavy and cartilaginous, as in certain forms of *A. caulescens* and *A. inapertus* subsp. *pendulus* (Figure 142). Leaf apex morphology often varies within species, as in *A. caulescens* (acute, subacute or obtuse), *A. inapertus* and *A. praecox* (acute or subacute) and *A. coddii* (usually obtuse, sometimes subacute). The leaves have a prominent midrib along the lower surface, and, depending on the species or morphological form, leaf surfaces may be almost flat or shallowly to deeply channelled. In a vegetative state, the evergreen, leathery leaves of *A. africanus* and *A. walshii* are almost indistinguishable, however *A. africanus* often forms large mats of plants, whereas in *A. walshii* the clumps are usually significantly smaller.

INFLORESCENCE

The inflorescence in *Agapanthus* is a compound pseudo-umbel which emerges from the apical meristem in the centre of the growing shoot. The pseudo-umbel comprises several or numerous partial inflorescences or groups of pedicels, which are in effect, abbreviated bostryxes (Traub, 1943;

Müller-Doblies, 1980), and comprise two main types, those with more or less rounded heads and straight pedicels (e.g. *A. praecox*) (Figure 143) and those with more or less bell-shaped heads and curved pedicels (e.g. *A. inapertus* subsp. *inapertus*) (Figure 144). Mori & Sakanishi (1989) found that floral initiation in *A. praecox* (incorrectly identified by these authors as *A. africanus*) grown in Japan, began in November (late autumn) and that floral differentiation began in December (early winter). According to Reimherr (1983), a period of cold of 8–10°C for 60–90 days in late autumn and winter is favourable and even necessary for floral initiation to occur. Mutations sometimes occur within the inflorescence, usually in the development of a structure which resembles branched pedicels, but which is actually a 'mini' scape, usually with 3 or more pedicelled flowers, known as a pseudo-umbellula (Müller-Doblies, 1980) (Figure 145). The occurrence of pseudo-umbellulae is most often seen in cultivated, evergreen plants, especially in *A. praecox*, but is also recorded from at least one wild population of *A. africanus* from Betty's Bay (*Leighton* 2937 in BOL), and in cultivated specimens of *A. inapertus* subsp. *intermedius* from M'Ponduine in southern Mozambique, grown at Kirstenbosch. Less commonly, mutations resulting in the fusion of several pedicels into one occur, as well as the appearance of branched scapes, usually in *A. praecox*, in which the branching seems to appear from within the pseudostem, where two scapes appear next to each other from the same leaf axil (Hannibal, 1943). Mutations can occur randomly, or be the result of hormonal imbalance in meristematic cells.

The agapanthus flower head is carried on an erect, suberect or upwardly arching scape, which is solid and slightly or strongly compressed in cross section. The evergreen species have moderately to strongly compressed scapes whereas in the deciduous ones they are only slightly compressed. The scapes are covered with a powdery bloom, and in *A.*

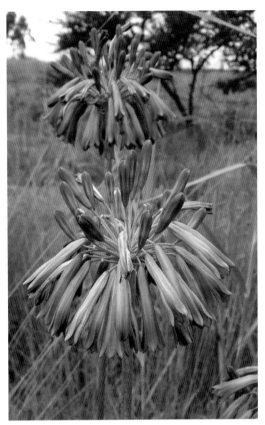

Figure 144. Bell-shaped pseudo-umbel and more or less curved pedicels of fully open flowers of *Agapanthus inapertus* subsp. *inapertus*. Image: Duncan McKenzie.

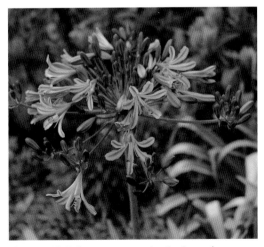

Figure 145. Inflorescence mutation in *Agapanthus praecox*, showing pseudo-umbellulae. Image: Graham Duncan.

africanus and *A. walshii* it is usually a prominent bluish-grey. During the bud stage, the developing flower head is enclosed by two large, deciduous, narrowly or broadly ovate, membranous, green or brown spathe bracts. The spathe bracts are joined along two opposite margins, and as the pedicels elongate and the flower buds enlarge, the bracts usually split longitudinally along one of the margins (or less frequently, along both) from the base upwards, exposing the flower buds, which begin opening a few days thereafter (Figure 146). After splitting, the spathe bracts desiccate rapidly and fall to the ground within one to several days.

Within the flower head, the orientation of the pedicels at anthesis varies from erect to suberect, spreading, or downwardly oriented, except within species with tubular flowers (*A. inapertus*, *A. walshii*), in which the pedicels are slightly to strongly arcuate at anthesis. Pedicels vary from rigid to flaccid, and are usually in shades of green, but sometimes flushed with purple or purplish brown. One to several white, filiform bracteoles up to 20 mm long occur at the base of some of the pedicels.

Figure 146. Spathe bract splitting along one margin in *Agapanthus praecox*. Image: Graham Duncan.

FLOWERS

Perianth

The perianth in *Agapanthus* is biseriate and slightly to strongly zygomorphic because of the declinate orientation of the stamens and/or styles, and in species with funnel-shaped flowers, the lower outer tepal is sometimes set apart from the lower two inner tepals, as in certain forms of *A. praecox*. The perianth has 6 tepals (3 outer and 3 inner), fused below to form a short to long, cylindrical tube. Rarely, 8, 10, 12 or 18 tepals can occur, in wild populations as well as in cultivation. Perianth shape in agapanthus does not form strongly discontinuous entities, but is more or less continuously varying, from those with very widely spreading or sometimes recurved tepals, here referred to as widely funnel-shaped (e.g. forms of *A. africanus*, *A. campanulatus*) and short perianth tubes, to those with minimally spreading tepals and usually relatively long tubes (e.g. forms of *A. inapertus*, *A. walshii*), and a wide range of intermediates occurs between the extremes. The shortest tubes are those of *A. campanulatus* (5 mm long), and the longest ones occur in *A. inapertus* subsp. *inapertus* (up to 32 mm long). In this work, four major perianth shapes are distinguished at anthesis, i.e. when the anthers are ripe and the flower is fully open, on warm, sunny days: widely funnel-shaped (previously described as salver-shaped, see page 20), narrowly funnel-shaped, tubular and trumpet-shaped. Perianth shape is variable within some taxa, i.e. *A. africanus*, *A. campanulatus* and *A. praecox* (widely or narrowly funnel-shaped), *A. inapertus* subsp. *intermedius* (widely or narrowly funnel-shaped or trumpet-shaped) and *A. walshii* (tubular or trumpet-shaped).

In taxa with widely funnel-shaped perianths (certain forms of *A. africanus* and *A. campanulatus*, *A. caulescens*, *A. coddii*, certain forms of *A. praecox* and certain forms of *A. inapertus* subsp. *intermedius*) the lower part of the tepals diverges widely, at an angle >30° from the longitudinal axis, and the tube varies from 5–25 mm long (Figure 147). In those with narrowly funnel-shaped perianths (certain forms of *A. africanus* and *A. campanulatus*, *A. pondoensis*, certain forms of *A. praecox* and certain forms of *A. inapertus* subsp. *intermedius*) the tepals diverge at an angle of >15° up to 30° from the longitudinal axis, and the tube varies from 5–25 mm long (Figure 148). In all forms of *A. inapertus* subsp. *inapertus*, *A. inapertus* subsp. *parviflorus* and *A. inapertus* subsp. *pendulus*, and in most forms of *A. walshii*, the perianth is tubular, in which the tepals diverge at an angle of up to 15° from the longitudinal axis, and the tube varies from 10–32 mm long (Figure 149). In certain forms of *A. inapertus* subsp. *intermedius* and *A. walshii*, the perianth is trumpet-shaped, in which the tepals are slightly recurved at the tips, and the tube varies from 10–18 mm long (*A. inapertus* subsp. *intermedius*) (Figure 150) and 18–31 mm long (*A. walshii*).

Agapanthus flowers open from the outer perimeter towards the centre of the pseudo-umbel, and the orientation of the perianth at anthesis varies from suberect to spreading or nodding in species with funnel-shaped flowers, and in those with tubular and trumpet-shaped flowers it is nodding or pendent. Outer tepal shape differs from inner tepal shape in all species, and the outer tepals are narrower than the inner ones. Outer tepals are usually oblanceolate or narrowly oblanceolate, and the inner tepals are usually spathulate. Tepal colour varies in shades of light to deep blue, violet or blackish violet, or rarely deep magenta, mauvish-blue, pure white, bluish white, cream-coloured or bicoloured (blue and white).

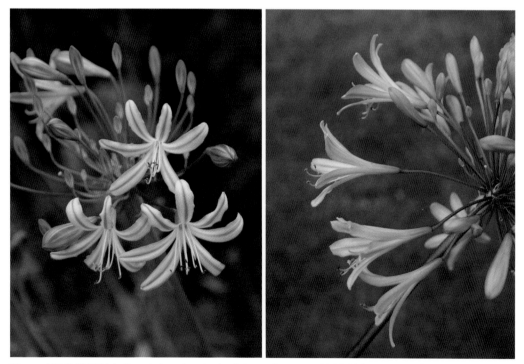

Figure 147 (left). Widely funnel-shaped perianth of *Agapanthus praecox* 'Adelaide'. Image: Graham Duncan.
Figure 148 (right). Narrowly funnel-shaped perianth of *Agapanthus pondoensis*. Image: Graham Duncan.

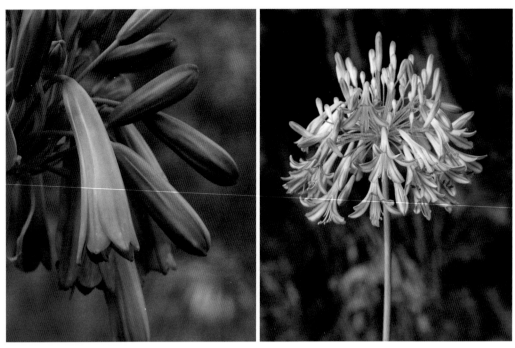

Figure 149 (left). Tubular perianth of *Agapanthus inapertus* subsp. *inapertus*. Image: Duncan McKenzie.
Figure 150 (right). Trumpet-shaped perianth of *Agapanthus inapertus* subsp. *intermedius*. Image: Graham Duncan.

Tepal outer surfaces have a prominent longitudinal median ridge, with the inner surfaces grooved along the same line, and in *A. africanus*, *A. walshii* and *A. inapertus* subsp. *pendulus* the tepals are distinctively thick-textured, in contrast to all other taxa in which they are relatively thin-textured. The outer tepal apices are usually acute or subacute, and the inner ones are usually obtuse, with the tepal margins usually flat, or sometimes slightly undulate. The number of flowers per head varies considerably, both within the same species and among different species, as in *A. africanus* (3–60 per head) and *A. praecox* (15–100 or more per head).

Stamens and pollen

The flowers of *Agapanthus* have 6 stamens. The filaments are inserted at the base of the tepals and are decurrent along the length of the perianth tube. The stamens are biseriate to a greater or lesser degree, and the filaments are of slightly or considerably differing length, with the filament located at the base of the 3 outer tepals slightly longer and inserted at a slightly higher level than the filament at the base of the inner tepals. In species with tubular flowers (*A. inapertus*, *A. walshii*) the filaments located at the base of the outer tepals are up to 4 mm longer than those at the base of the inner tepals, but in species with funnel-shaped flowers they are only 1 mm longer, or less. Stamen orientation at anthesis varies from slightly declinate in the tubular-flowered taxa to strongly declinate in all other taxa. The stamens are usually included within the perianth in most species, but in certain forms of *A. walshii* and *A. inapertus* subsp. *inapertus* they are slightly exserted, or rarely well-exserted in the latter taxon. Filament length varies from 9–38 mm: the shortest filaments are those in forms of *A. inapertus* subsp. *parviflorus* (9 mm) and *A. campanulatus* (10 mm), and the longest are those in forms of *A. praecox* (up to 35 mm) and *A. pondoensis* (up to 38 mm).

The anthers are longitudinal, 2-thecous and dorsifixed, versatile and introrse. The pollen is sulcate-reticulate, and in three species (*A. campanulatus, A. caulescens, A. coddii*), pollen colour is lilac. In the remaining five species (*A. africanus, A. inapertus, A. pondoensis, A. praecox, A. walshii*) pollen colour is light to dark brown or yellowish-brown, and where white forms of these species exist (*A. inapertus, A. praecox*) it is bright yellow, except in *A. walshii*, in which white forms have dark brown pollen (Figures 151–154). In all species, the anthers of stamens at the base of the inner tepals dehisce a few hours before those at the base of the outer tepals.

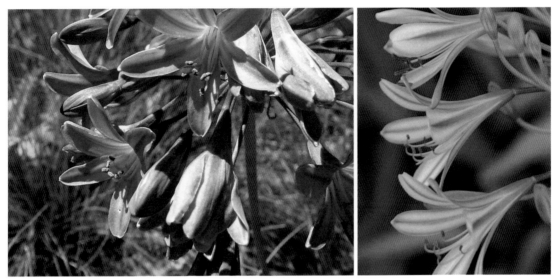

Figure 151 (left). Lilac pollen of *Agapanthus campanulatus*. Image: Cameron McMaster.
Figure 152 (right). Yellowish-brown pollen of *Agapanthus praecox*. Image: Graham Duncan.

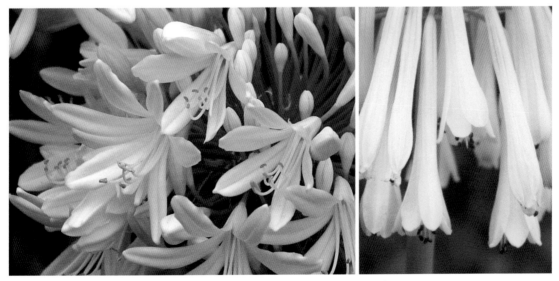

Figure 153 (left). Bright yellow pollen of *Agapanthus praecox* 'Albiflorus'. Image: Graham Duncan.
Figure 154 (right). Dark brown pollen of a white form of *Agapanthus walshii*. Image: Graham Duncan.

GYNOECIUM

Style and stigma

The gynoecium has a simple, slender, hollow style with a minutely capitate stigma, and a trilocular, hypogynous, light green or yellowish-green ovary. The styles in most species are moderately to strongly declinate, but in *A. inapertus*, *A. pondoensis* and *A. walshii* they are straight or slightly declinate. Styles are usually included, but sometimes slightly or strongly exserted, as in certain forms of *A. inapertus* subsp. *inapertus*. Styles are usually white in the lower half, shading to light blue above, or they may be uniformly white (e.g. *A. africanus*, *A. walshii*) or light to deep blue or lilac (e.g. forms of *A. caulescens*), or white with a light blue or light violet tip (*A. inapertus*). Style length varies from 7–39 mm: the shortest styles occur in forms of *A. campanulatus* (7 mm) and *A. inapertus* subsp. *parviflorus* (11 mm), and the longest styles are found in forms of *A. inapertus* subsp. *inapertus* (32 mm), *A. praecox* (34 mm) and *A. pondoensis* (39 mm).

Ovary

The trilocular ovary in agapanthus is superior and syncarpic, with axile placentation. Two ovary shapes occur, ellipsoid and oblong, with most species having ellipsoid ovaries. Inner septal nectaries are present within the ovary dome in all species, and nectar quantities vary: the long-tubed, putatively bird-pollinated taxa (*A. inapertus*, *A. walshii*) contain greater quantities of nectar than those with funnel-shaped flowers. Within each locule, ovules are arranged in two rows, and ovule production is minimally variable, ranging from three to six per row, as in *A. campanulatus* and *A. praecox*, respectively, although this varies each season, and rarely do all ovules develop into viable seeds.

Fruit

The ripe fruits of agapanthus are dry, papyraceous, loculicidal capsules that dehisce longitudinally. Capsule shape is ellipsoid in all species, varying from narrowly to widely ellipsoid (Figures 155, 156). During the ripening process, capsule lustre varies from matt green (*A. praecox*) or matt purplish green (forms of *A. caulescens*) to glossy green (*A. africanus*, *A. walshii*). Capsule length and width

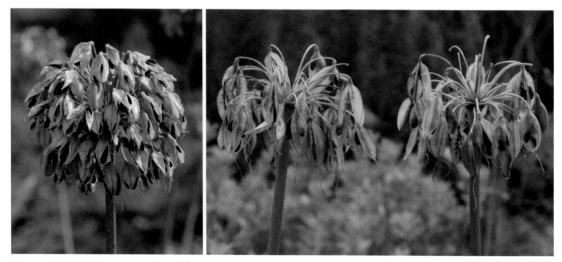

Figure 155 (left). Ripening capsules of *Agapanthus praecox* 'Mt. Thomas'. Image: Graham Duncan.
Figure 156 (right). Ripe capsules of *Agapanthus inapertus* subsp. *inapertus* 'White'. Image: Graham Duncan.

varies considerably within all species, especially in *A. caulescens* (18–35 mm long, 6–11 mm wide), *A. praecox* (27–40 mm long, 5–12 mm wide) and *A. inapertus* (20–40 mm long, 6–16 mm wide). Certain forms of *A. campanulatus* have the smallest capsules (15 mm long) and certain forms of *A. walshii* have the longest ones (up to 45 mm). Capsule apices are acute, subacute or obtuse, but within some species, capsules vary in their apex morphology, such as *A. inapertus*, which has obtuse apices in subsp. *pendulus*, but acute apices in subsp. *parviflorus*. Similarly, capsule apices in *A. praecox* can be acute, subacute or obtuse, depending on the particular form. During the maturation process, the capsules of flowers which had suberect, spreading or nodding orientation, become strongly pendent, whereas those with pendent flowers remain pendent in fruit. Mature capsules split from the apex towards the base, and the dried capsules are persistent, remaining attached to the pedicels for up to a year or more.

Seed

Agapanthus seeds are dry, more or less ovate or oblong, flat and black, with a light, papery, narrowly to broadly oblong, black wing situated opposite the micropyle, making them aerodynamic. The seed and wing is glossy or matt, and the characteristic black colour is due to the thin, phytomelan-encrusted seed coat. Seed length varies from 3–7 mm long and from 2–5 mm wide, with *A. inapertus* subsp. *parviflorus* having the smallest seeds (3 × 2 mm), and *A. coddii* the largest ones (7 × 5 mm). Wing shape varies from narrowly to broadly oblong; wing length varies considerably from 4–9 mm long and from 3–5 mm wide, with *A. africanus* having the smallest wings (4 × 3 mm) and the largest ones in certain forms of *A. inapertus* subsp. *inapertus* and *A. coddii* (9 × 5 mm) (Figure 157).

Figure 157. Variation in seed shape and size of *Agapanthus*. A: *A. africanus*; B: *A. praecox*; C: *A. coddii*; D: *A. inapertus* subsp. *inapertus*. Image: Graham Duncan.

POLLINATION BIOLOGY

In the wild, species of *Agapanthus* produce a heavy seed-set, and pollination systems appear to be of two main types, generalist and bird-pollinated (ornithophily). Species with funnel-shaped flowers (e.g. *A. praecox, A. campanulatus*) are generalists, and those with tubular and trumpet-shaped flowers (*A. inapertus, A. walshii*) are putatively bird-pollinated, however at least one taxon among the putatively bird-pollinated species (*A. inapertus* subsp. *parviflorus*) also has insects as pollinators. In pollination experiments carried out in cultivation at Kirstenbosch, *A. campanulatus* was found to be strongly self-compatible, confirming a previous study undertaken in the wild (Johnson *et al.*, 2009), *A. africanus, A. pondoensis* and *A. praecox* were found to be partially self-incompatible, and *A. inapertus* subsp. *pendulus* was found to be completely self-incompatible. Despite the high level of self compatibility within *A. campanulatus*, Johnson *et al.* (2009) found that reproductive output in bagged, unmanipulated flowers was significantly lower than in those that were hand-pollinated, indicating that this species nevertheless relies on pollinators for successful fertilisation. In a study of ultraviolet reflectance patterns in some members of the Amaryllidaceae, and its possible significance for pollination, flowers of *A. africanus*

and *A. praecox* were photographed in bright sunshine to produce Human visual spectrum (HVS) and Ultraviolet (UV) images, to produce comparisons of their reflectance patterns. Clear contrast was found on the tepals of both species, with both HVS and UV distinction of the median keel, indicating that ultraviolet reflectance may play an important role in the pollination of *Agapanthus* in attracting insects and birds (Conran, 2003–2004). All species contain nectar within the base of the perianth tube, and pollinators appear to be attracted mainly by colour and shape, receiving rewards of nectar and pollen. Scent plays a role in pollinator attraction in certain species, such as *A. campanulatus* (Jersáková *et al.*, 2012) and at least one form of *A. praecox* emits a faint, spicy-sweet scent to the human nose.

GENERALIST POLLINATION

According to Vogel (1998), *Agapanthus* flowers conform to bee, moth and bird pollination syndromes. During the course of fieldwork, and from observation in cultivation, I have found that at least two species with funnel-shaped flowers (*A. campanulatus*, *A. praecox*) are visited by multiple pollinators including long-tongued flies, butterflies, moths, solitary bees and honey bees, beetles and sunbirds. Other species with these flower shapes (*A. africanus*, *A. caulescens*, *A. coddii*, *A. pondoensis*) are also assumed to conform to generalist pollination, although definitive pollinator sightings for these species in the wild are unrecorded.

The lower tepals of species with funnel-shaped flowers provide an easy landing platform for insects. *A. africanus* and *A. praecox* have sometimes been speculated to be pollinated by carpenter bees in the wild, yet during the course of fieldwork, I have never encountered carpenter bees as pollinators of these or any other species of *Agapanthus*. Despite producing a heavy seed set, I have never seen any pollinators of *A. africanus* in the wild. In cultivation at Kirstenbosch, however, the carpenter bee *Xylocopa caffra* (family Apidae) regularly visits flowers of both blue- and white-flowered forms of *A. praecox* for nectar (Figure 158), and the giant carpenter bee *Xylocopa flavorufa* (family Apidae) does so

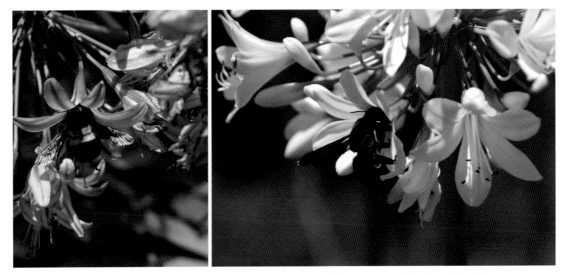

Figure 158. A carpenter bee (*Xylocopa caffra*) feeding on nectar of *Agapanthus praecox*, in cultivation, Kirstenbosch. Image: Graham Duncan.

Figure 159. A giant carpenter bee (*Xylocopa flavorufa*) feeding on nectar of *Agapanthus praecox* 'Selma Bock' in cultivation, Kirstenbosch. Image: Graham Duncan.

to a lesser extent (Figure 159). I have observed the solitary, tangle-veined, long-proboscid fly *Psilodera fasciata* (family Acroceridae) as a regular visitor to small-flowered forms of *A. praecox* at Knysna and Storms River Mouth in the southern and Eastern Cape, which it visits for nectar, and the same species is also often seen visiting *A. praecox* in cultivation at Kirstenbosch. I have also observed the nectar-feeding, long-proboscid, tabanid fly *Philoliche aethiopica* (family Tabanidae) (Figure 160) on Barkly Pass in the Eastern Cape, and two species of solitary, long-proboscid bee, *Amegilla capensis* (family Apidae) (Figure 161) as well as another, unidentified member of the genus *Amegilla*, (Figure 162) as pollinators of *A. praecox* with medium-sized flowers at Khalinyanga north of Ngcobo in the Eastern Cape.

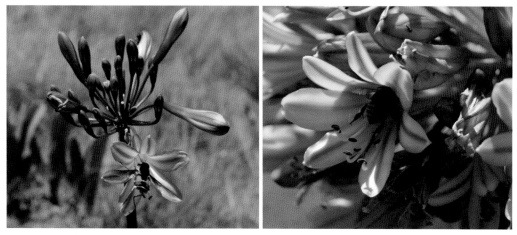

Figure 160 (left). A tabanid fly (*Philoliche aethiopica*) feeding on nectar of *Agapanthus praecox*, Barkly Pass, Eastern Cape. Image: Graham Duncan.
Figure 161 (right). A long-proboscid bee (*Amegilla capensis*) feeding on nectar of *Agapanthus praecox*, Khalinyanga, Eastern Cape. Image: Graham Duncan.

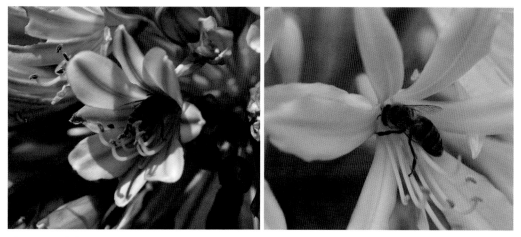

Figure 162 (left). An unidentified long-proboscid bee (*Amegilla* sp.) feeding on nectar of *Agapanthus praecox*, Khalinyanga, Eastern Cape. Image: Graham Duncan.
Figure 163 (right). A honey bee (*Apis mellifera* subsp. *capensis*) feeding on nectar of *Agapanthus praecox* in cultivation, Kirstenbosch. Image: Graham Duncan.

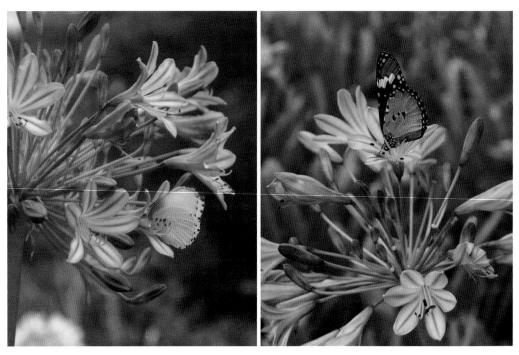

Figure 164 (left). Common dotted border butterfly (*Mylothris agathina*) feeding on nectar of *Agapanthus praecox* in cultivation, Kirstenbosch. Image: Graham Duncan.
Figure 165 (right). An African monarch butterfly (*Danaus chrysippus*) feeding on nectar of *Agapanthus praecox* in cultivation, Kirstenbosch. Image: Graham Duncan.

Throughout gardens in southern Africa, the widespread honey bee *Apis mellifera* (family Apidae) is the main pollinator of agapanthus with funnel-shaped flowers, especially *A. praecox* (Figure 163) and its hybrids, and it also visits less commonly grown species with funnel-shaped flowers, such as *A. campanulatus*, primarily for nectar. In foraging for nectar within funnel-shaped flowers, carpenter bees and honey bees acquire pollen loads upon exiting the flowers, and effect fertilisation when they brush over the stigmas of different clones.

In the wild, *A. praecox* is also visited by at least two species of butterfly in the family Papilionidae, the large, common citrus swallowtail (*Papilio demodocus*) which I have observed at Khalinyanga, and the large, green-banded swallowtail (*Papilio nireus*), observed by Colin Paterson-Jones on the Bosberg Mountains above Somerset East in the Eastern Cape. The small smoky orange tip *Colotis evippe* (family Peiridae) has been observed on small forms of *A. praecox* at Knysna by Fanie Avenant, and the Shaka's skipper butterfly *Kedestes chaka* (family Hesperiidae) has been observed on flowers of *A. campanulatus* at Underberg in the southern Drakensberg, KwaZulu-Natal (Neil Crouch, pers. obs.). In cultivation, several butterfly species have been observed visiting the flowers of *A. praecox* at Kirstenbosch, including the common dotted border (*Mylothris agathina*) (Figure 164) and the African monarch (*Danaus chrysippus*) in the family Danaidae (Figure 165), the citrus swallowtail, and the introduced cabbage white (*Pieris brassicae*) in the family Pieridae. I have also observed the day-flying African humming-bird moth *Macroglossum trochilus* (family Sphingidae) actively feeding on nectar of *A. campanulatus* in cultivation at Kirstenbosch (Figure 166).

In the Eastern Cape, the tangle-veined fly *Prosoeca ganglbaueri* (family Nemestrinidae), which has an exceptionally long proboscis 20–45 mm long, has been recorded feeding on nectar of *A. campanulatus* at Matatiele in the foothills of the western Drakensberg (Mike Whitehead, pers. obs.) (Figure 167). The nectar-feeding, long-proboscid tabanid fly *Philoliche aethiopica* (family Tabanidae) has also been recorded as a pollinator of *A. campanulatus* at Witsieshoek in the northern Drakensberg

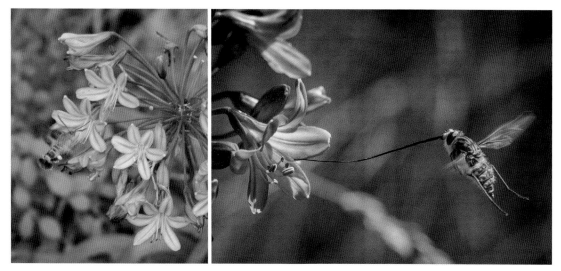

Figure 166 (left). An African humming-bird moth *Macroglossum trochilus* feeding on nectar of *Agapanthus campanulatus* in cultivation, Kirstenbosch. Image: Graham Duncan.

Figure 167 (right). A long-tongued tangle-veined fly (*Prosoeca ganglbaueri*) about to feed on nectar of *Agapanthus campanulatus* near Matatiele, Eastern Cape. Image: Michael Whitehead.

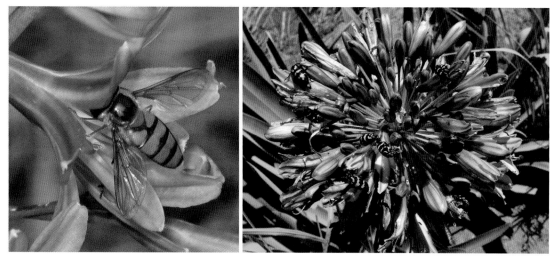

Figure 168 (left). The large red-eyed fly (*Asarkina africana*) is a pollinator of *Agapanthus campanulatus* in the southern Drakensberg. Image: Neil Crouch.

Figure 169 (right). The spotted blister beetle (*Ceroctis capensis*) consumes the tepals of *Agapanthus praecox* at Khalinyanga, Eastern Cape. Image: Graham Duncan.

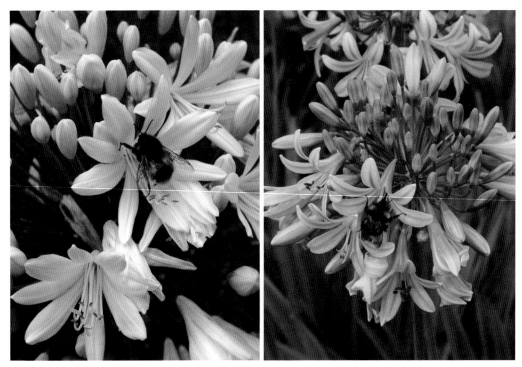

Figure 170 (left). A garden bumblebee (*Bombus hortorum*) feeding on nectar of *Agapanthus* 'White Heaven' in cultivation, Kew. Image: Graham Duncan.

Figure 171 (right). A large earth bumblebee (*Bombus terrestris*) feeding on nectar of *Agapanthus* 'Wembworthy' in cultivation, Pine Cottage Plants, Devon. Image: Graham Duncan.

in the eastern Free State by Jersáková *et al.* (2012). These authors found that differences in floral brightness in this species had minimal effect in attracting tabanid flies, and that its floral scent was of much greater importance, and dominated by four chemical compounds, of which the sweet-smelling ethyl acetate was the most abundant. The red-eyed fly *Asarkina africana* (family Syrphidae) has also been observed as a pollinator of *A. campanulatus* in the southern Drakensberg (Neil Crouch, pers. obs.) (Figure 168).

In cultivation at Kirstenbosch, several species of monkey beetle including *Pachycnema crassipes* (family Scarabaeoidae) visit the flowers of *A. coddii* and *A. inapertus* in search of pollen, and these may also effect pollination. A small, unidentified sweat bee or flower bee, possibly of the genus *Nomiodes* (family Halictidae) has also been seen to feed on nectar of *A. praecox* 'Adelaide' in cultivation at Kirstenbosch, and may also effect pollination. On Khalinyanga Mountain north of Ngcobo, the tepals of *A. praecox* were seen to be heavily predated by the spotted blister beetle *Ceroctis capensis* (family Anthicidae), and their clambering activity could also effect pollination (Figure 169).

In the United Kingdom, the widespread northern hemisphere garden bumblebee *Bombus hortorum* (family Apidae) feeds on nectar of various agapanthus cultivars (Figure 170). Another widespread species, the large earth bumblebee *Bombus terrestris* from Europe, North Africa and Western Asia, also visits agapanthus flowers in the U.K. (Figure 171), and a feral population of this invasive species is recorded as an effective pollinator of *A. praecox* in Tasmania, where it has assisted in the naturalisation of this species (Hingston, 2006).

ORNITHOPHILY

The two species with pendent or nodding, tubular and/or trumpet-shaped flowers (*A. walshii*, *A. inapertus*), most forms of which have long perianth tubes, sometimes up to 31 or 32 mm, respectively, are inferred as being bird-pollinated, in particular by sunbirds. *A. walshii* is putatively pollinated by the fynbos endemic orange-breasted sunbird *Anthobaphes violacea* (family Nectariniidae) (Duncan, 2004), and the widespread malachite sunbird *Nectarinia famosa* may also be a visitor. Although no actual sightings of bird pollination in *A. walshii* are recorded, near-confirmation of orange-breasted sunbird pollination was recently made in the wild in January 2019 at Elgin, when a male bird was seen within a few metres of flowering plants, but refrained from visiting the flowers, probably due to human presence (Barbara Knox-Shaw, pers. obs.).

Several sunbird species (family Nectariniidae) are potential pollinators of *A. inapertus,* such as the amethyst sunbird (*Chalcomitra amethystina*) and the white-bellied sunbird (*Cinnyris talatala*), yet no documented sightings of actual bird-pollination of this species in the wild appear to exist. However, in cultivation at Kirstenbosch, far from their natural habitat in the northern summer rainfall parts of South Africa, *A. inapertus* subsp. *inapertus* and *A. inapertus* subsp. *pendulus* are regularly visited by orange-breasted sunbirds (Figure 172) and, to a lesser extent, by the widespread southern double-collared sunbird (*Cinnyris chalybeus*) (Figure 173). Typically, the sunbird clings to the sturdy scape, inserts its beak deep into the perianth tube and forages for nectar within one to several flowers per flower head, for a period of 5–10 seconds per flower. Upon entering and exiting the flowers, pollen

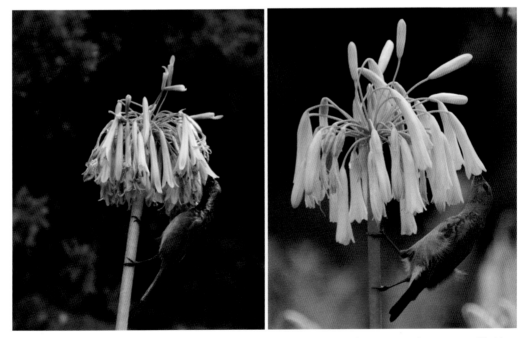

Figure 172 (left). A male orange-breasted sunbird feeding on nectar of *Agapanthus inapertus* subsp. *inapertus* 'Sky' in cultivation, Kirstenbosch. Image: Graham Duncan.

Figure 173 (right). A male southern double-collared sunbird feeding on nectar of *Agapanthus inapertus* subsp. *inapertus* 'White' in cultivation, Kirstenbosch. Note the pollen-covered base of the beak and chin. Image: Graham Duncan.

is deposited around the base of the beak and chin, and on the forehead, and fertilisation takes place when pollen comes into contact with the stigmas of different clones. Orange-breasted sunbirds and southern double-collared sunbirds have also been seen to 'rob' nectar from the funnel-shaped flowers of *A. caulescens* and *A. praecox* at Kirstenbosch, by piercing the base of the perianth tube. In addition to putative sunbird pollination, I have observed the tubular, relatively short flowers of *A. inapertus* subsp.

parviflorus being visited for pollen by the East African lowland honey bee *Apis mellifera* subsp. *scutellata* (family Apidae), the only instance I have had of a honey bee visiting an agapanthus in the wild, and by the spotted blister beetle *Ceroctis capensis* (family Anthicidae), both near Dullstroom in north-central Mpumalanga (Figure 174). In addition, an unidentified subspecies of *A. inapertus* is recorded as a host flower of the short-tongued, oil-collecting bee *Rediviva colorata* (family Melittidae) in northern and north-western Mpumalanga (Whitehead et al., 2008). *A. inapertus* subsp. *inapertus* and *A. inapertus* subsp. *pendulus* often receive opportunistic visits from the Cape honey bee (*Apis mellifera* subsp. *capensis*) in cultivation at Kirstenbosch. The bee enters the mouth of the flower, and forces its way upwards to reach nectar at the top of the perianth tube. This foraging activity could easily result in pollen being deposited onto the stigma when the bee enters and exits the flower.

Figure 174. A spotted blister beetle (*Ceroctis capensis*) feeding on pollen of *Agapanthus inapertus* subsp. *parviflorus*, Dullstroom, Mpumalanga. Image: Graham Duncan.

SEED DISPERSAL

ANEMOCHORY

Following fertilisation, maturation of the fleshy green seed pods into dry capsules takes place over a period of two to three months. The primary mode of seed dispersal in *Agapanthus* is by wind (anemochory). The capsules are loculicidally dehiscent, splitting along three longitudinal lines aligned with the locules, from the tip of the capsule to its base, revealing rows of papery black seeds, each attached to the locule walls by means of the funiculus, a very thin, white stalk ± 0.5 mm long. The ripe capsules in all species have pendent orientation, with the aerodynamic seeds attached to the locule wall in their uppermost part, with the thin, papery wing below. During wind gusts, the seeds detach from the funiculus and are blown short distances of up to several metres away from the mother plants. In very windy environments, such as in the mountains of the south-western Cape where *A. africanus* and *A. walshii* occur, wind often disperses the seeds further away from where they initially landed, until they come to rest within bushes or rock crevices. Seeds from an infructescence are not dispersed simultaneously, but do so over a period of weeks or months, dependent upon weather conditions (Figure 175). The ripe infructescences are held well above the leaves, allowing the seeds to easily be carried away by wind, and remain attached to the plant during dispersal, and the desiccated remains

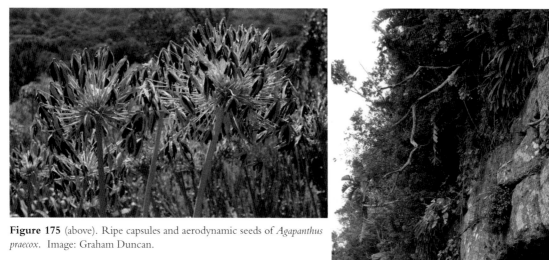

Figure 175 (above). Ripe capsules and aerodynamic seeds of *Agapanthus praecox*. Image: Graham Duncan.

Figure 176 (right). *Agapanthus praecox* overhanging the Mtentu River, Eastern Cape, adapted to secondary seed dispersal by water. Image: Neil Crouch.

of the scape and pedicels are often to be seen attached for up to a year or more thereafter. In the wild, *Agapanthus* seeds are dispersed from early autumn to early winter (March to June), with a peak dispersal period in mid-autumn (April). Seed viability is excellent when fresh, but decreases rapidly after six months. Seeds of the evergreen species from the Cape Floristic Region (*A. africanus*, *A. walshii* and southern forms of *A. praecox*) are dispersed just prior to the onset of autumn or winter rains, and thus, depending on when the rains fall, they undergo a short dormant period of up to two months before germinating, allowing the seedlings a period of about six months in which to become well established by the start of the hot, dry summer. By contrast, seeds of all the deciduous species and eastern forms of *A. praecox* are presumed to remain dormant for about six months during the dry winter months, and germinate in early summer after the first rains.

HYDROCHORY

In addition to being aerodynamic, *Agapanthus* seeds are buoyant, and secondary dispersal by water plays a role in the distribution of seeds of species inhabiting rocky embankments and cliff faces above rivers, such as *A. pondoensis* at Magwa Falls in the Eastern Cape, and terrain along riverbanks and at river mouths, such as *A. praecox* above the Mtentu River in the Eastern Cape (Figure 176).

KARYOLOGY

The karyology of *Agapanthus* is minimally variable, with rare reports of deviation to the basic chromosome number, as well as the occasional presence of aneuploids, polyploids and B-chromosomes (supernumary chromosomes) in certain species.

Of the eight species (11 taxa) recognised in this work, chromosome counts are available for seven taxa (*A. africanus*, *A. campanulatus*, *A. caulescens*, *A. coddii*, *A. inapertus* subsp. *inapertus*, *A. inapertus* subsp. *intermedius* and *A. praecox*). Owing to the historical misapplication of the name *A. umbellatus* (=*A. africanus*) for the plant most commonly cultivated (*A. praecox*) it is probable that most material studied

cytologically by numerous researchers over many years was this species and not *A. africanus*. The karyotype of *Agapanthus* comprises chromosome pairs of different sizes, and the basic chromosome number is x = 15 (Darlington, 1933), with a reduction to x = 14 recorded in one collection of *A. inapertus* subsp. *intermedius* (Muzila & Spies, 2005), and an increase to x = 16 recorded in two collections of *A. praecox* (Riley & Mukerjee, 1962). The normal chromosome complement of 2n = 30 has been recorded for all the species investigated thus far (*A. africanus*, *A. campanulatus*, *A. caulescens*, *A. coddii*, *A. inapertus* and *A. praecox*) (Guignard, 1884; Belling, 1928; Darlington, 1933; Geitler, 1933; Stenar, 1933; Matsuura & Suto, 1935; Mookerjea, 1955; Lima-de-Faria & Sarvella, 1958; Sharma & Sharma, 1961; Riley & Mukerjee, 1960; Riley & Mukerjee, 1962; Sharma & Mukhopadhyay, 1963; Vijavalli & Mathew, 1990 and Muzila & Spies, 2005). Riley & Mukerjee (1962) recorded 2n = 32 for two collections of *A. praecox*, as did Nakano *et al.* (2003) for the cultivar *A. praecox* 'Royal Purple Select'. Stenar (1933) recorded 2n = 32 for *A. africanus*, however the plant may have been incorrectly identified and was probably *A. praecox*. In a study of genome size in *Agapanthus* (Zonneveld & Duncan, 2003), four triploids were found, including three in wild-collected specimens: *A. africanus* from the southern Cape Peninsula (*De Lange s.n.*, 253/95); *A. inapertus* subsp. *inapertus* of unrecorded origin (638/53), *A. inapertus* subsp. *intermedius* from the Blouberg in Limpopo (*Dyer & Codd 8765*; 873/54) and *A. inapertus* subsp. *pendulus* from Graskop in northern Mpumalanga (*Holland s.n.*, 552/43). Surprisingly, not a single polyploid was found in 140 *Agapanthus* cultivars investigated by Zonneveld (2004), however Nakano *et al.* (2003) reported that both diploid and tetraploid plants were regenerated from protoplasts of the cultivar *A. praecox* 'Royal Purple Select'.

In their chromosome study of *Agapanthus*, Riley & Mukerjee (1962) included a collection of *A. praecox* (identified there as *Agapanthus* sp.: 71/50) with 29 chromosomes as an aneuploid, as did Zonneveld & Duncan (2003) for a different collection of *A. praecox* (19/54), which had a high amount of nuclear DNA (26.57 pg). B-chromosomes were recorded by Riley & Mukerjee (1962) in *A. coddii* (identified there as *Agapanthus* sp.: 145/55) and in *A. praecox* (identified there as *A. orientalis*: 1/54), and by Muzila & Spies (2005) in *A. caulescens* (identified there as subsp. *angustifolius*), *A. inapertus* subsp. *intermedius* and *A. praecox*.

PHYTOCHEMISTRY AND MEDICINAL USE

PHYTOCHEMISTRY

The different chemistry of the Agapanthoideae and Amaryllidoideae is one of the major distinctions between the two subfamilies, the Agapanthoideae having various steroidal saponins, sapogenins and chalconoids (chalcones), but an absence of specialised amaryllid alkaloid compounds found in the Amaryllidoideae. Saponins, sapogenins and chalconoids are poisonous organic compounds found in the rhizome and roots of *Agapanthus*. The haemolytic sapogenin yuccagenin was first noted in *Agapanthus* by Wall *et al.* (1954), who isolated it in *A. inapertus* subsp. *pendulus* (*A. pendulus*), and the steroidal sapogenin agapanthagenin was first isolated by Stephen (1956) from various unidentified species of deciduous agapanthus from the former Transvaal province. Mathew (1970) isolated the steroidal saponin agapanthin from the evergreen *A. praecox*, as well as three sapogenins from this species: agapanthagenin, yuccagenin (in low concentration), and the new sapogenin, praecoxigenin. González *et al.* (1974) isolated two more new sapogenins, 7-dehydroagapanthagenin and 8(14)-dehydroagapanthagenin, and another new sapogenin 9(11)- dehydroagapanthagenin (González *et al.*, 1975) from plants identified as *A. africanus*, but which, in all likelihood, were *A. praecox*.

MEDICINAL USE

Numerous biological activities have been attributed to saponins in *Agapanthus*, including immunoregulatory and anti-inflammatory properties (Bruneton, 1995). Results of preliminary screening tests have indicated clear uterotonic activity (increases in the contraction of uterine muscles) in crude decoctions (Kaido *et al.*, 1994), and anti-inflammatory, anti-fungal, anti-bacterial and anti-tumour properties have been isolated in chalconoids (Kamara *et al.*, 2005).

In the eastern parts of South Africa, the roots and rhizome of *A. praecox* are widely used medicinally by various indigenous peoples, sometimes in combination with other plants, such as with the root of the reed *Typha capensis* (family Typhaceae) especially during pregnancy and childbirth, and in treatment of the newly born child (Watt & Breyer-Brandwijk, 1962;Veale *et al.*, 1992).

Pregnant Xhosa women take a decoction of the rootstock, orally or rectally, to assist in a difficult labour, and often during the final two months of pregnancy (Watt & Breyer-Brandwijk, 1962). An unidentified species of *Agapanthus* (probably *A. praecox*) forms part of 'Isicakathi', a medication widely used by Xhosa and Pondo women in the former Transkei region of the Eastern Cape as the first medicine given to the unborn baby. To ensure a healthy child, the pregnant mother starts using it six months before birth, until the time of delivery, by growing the plant in a large container of water, and consuming half a cup of the water in the morning and evening, with the belief that if the plant grows well, the unborn baby will be healthy, but if the plant dies, it is accepted that so too will the baby (Bolofo & Johnson, 1988). Consuming the water also has the objectives of ensuring that the child will not develop bowel ailments and that the placenta will be born without difficulty (Watt & Breyer-Brandwijk, 1962). The Xhosa also use the roots to make a paste with which to treat swollen

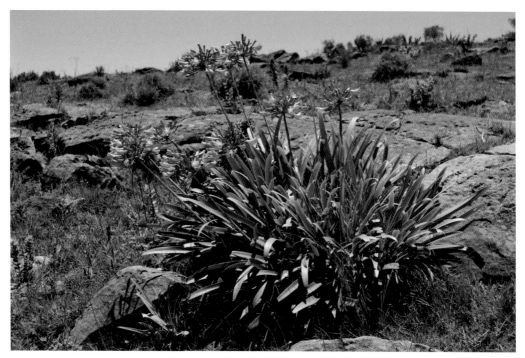

Figure 177. *Agapanthus praecox*, the most widely used species in traditional medicine, Khalinyanga, Eastern Cape. Image: Graham Duncan.

legs, and young Xhosa brides wear the roots as a necklace, which is said to ensure plentiful children and easy childbirth (Batten & Bokelmann, 1966) (Figure 177).

In southern KwaZulu-Natal, an infusion of the roots (probably of *A. praecox*) is used by the Zulus against various chest conditions including chest pain and tightness, and the emetic action is said to relieve chronic coughs and colds (Watt & Breyer-Brandwijk, 1962). The Zulus also use this species in combination with other plants during pregnancy to induce and augment labour (Veale *et al.*, 1992), as an aphrodisiac and daily hot infusion of the roots in cases of serious heart disease (Bryant, 1966), and in enemas given to young children for an ailment known as *inyoni* (Hutchings *et al.*, 1996) or 'sunken fontanel', a condition in which the soft spot on a baby's skull becomes more deeply set than usual, making it vulnerable to evil spirits. They also use root infusions as love charm emetics, as emetics against fear of thunder, and as a protective sprinkling charm around the home against thunder (Gerstner, 1938; Hulme, 1954). An infusion of the roots of *A. praecox* has potential in anticancer treatment (Koduru *et al.*, 2007), and the roots of this species are also used in combination with those of species of *Dianthus* (family Caryophyllaceae) as a fomentation in cases of severe abdominal pain, by being beaten up in cold water until it froths, and the whole body can also be washed with the liquid for relief from paralysis (Watt & Breyer-Brandwijk, 1962). In Limpopo, the rhizome of *A. inapertus* is used by Bapedi traditional healers in the treatment of tuberculosis, in which the rhizome is cooked for 10 minutes, and one cup of extract is taken orally three times per day (Semenya & Maroyi, 2013).

The South Sotho apply a lotion from the crushed roots of *A. campanulatus* to the newly-born child to ensure strength, and the crushed leaves are used to wash young babies (Phillips, 1917–1933; Jacot Guillarmod, 1971). In addition to its use in magic as a protective charm against lightning, unspecified parts of the *A. campanulatus* plant are used for various ailments in infants, including treatment of dry skin patches (cradle cap) on scalps (Hutchings *et al.*, 1996). In Eswatini, a concoction of the roots of *A. caulescens* (*A. nutans*) is taken orally for treatment of chronic penile ulcers (Amusan, 2009). *A. praecox* has been investigated for anti-mycobacterial activity against *Mycobacterium tuberculosis* (TB), in which extracts of the rhizome were found to be active against TB *in vitro*, and worthwhile of further analysis (Mokgethi, 2006).

The anti-inflammatory properties of *A. praecox* are useful for relief from sore or tired feet by placing leaves into shoes, or by wrapping feet with the leaves for half an hour. The strong, strap-shaped leaves also make useful bandages to keep wound dressings in place, and winding the leaves around the wrists is said to reduce fever (Roberts, 1990). In the Alice district of the Eastern Cape, the roots of *A. praecox* are boiled for 10 minutes, cooled, strained and given to sheep and goats in the morning by farmers, to treat diarrhoea (Dold & Cocks, 2001).

All species and hybrids of *Agapanthus* should be regarded as poisonous, especially the rhizome and roots, and the leaves, scapes and flowers to a lesser extent. *A. praecox* and its hybrids are commonly suspected of causing haemolytic poisoning in humans, especially in children (Watt & Breyer-Brandwijk, 1962; Popay *et al.*, 2010). Symptoms of human ingestion can include excessive salivation, local irritation to mucous membranes, gastrointestinal disturbance and diarrhoea. Contact with the sticky sap can result in severe ulceration and pain in the mouth, as well as a burning sensation to the skin and eyes (Veale *et al.*, 1992; Slaughter *et al.*, 2012). Eaten in quantity, agapanthus is potentially harmful to pets, causing gastrointestinal problems.

6. SPECIES RELATIONSHIPS

The species of *Agapanthus* have always presented a special problem in classification because of the paucity of unique characters with which to distinguish them. In addition, an extraordinarily high level of morphological plasticity exists within certain species, dependent upon environmental conditions and geographic location, especially within *A. campanulatus*, *A. caulescens*, *A. inapertus* and *A. praecox*. Among the few reasonably constant characters used in the only previous comprehensive classification attempt (Leighton, 1965), in which 10 species were recognised, was the presence of evergreen or deciduous leaves, and whether they were caulescent or not, and differences in perianth shape, length and orientation, and length of the perianth in relation to the perianth tube. Difficulty also sometimes exists in obtaining accurate dimensional information from herbarium specimens, as unless the flowers are pressed immediately upon collection, the tepals tend to wither and become reduced in size faster than the perianth tube, as noted by Leighton (1965).

With the exception of occasional triploids found in wild-collected accessions of *A. africanus*, *A. inapertus* subsp. *intermedius* and *A. inapertus* subsp. *pendulus* (Zonneveld & Duncan, 2003), the species of *Agapanthus* have the same diploid chromosome number (2n=2x=30), and are thus suitable for genome size investigation for taxonomic purposes, since differences in nuclear DNA content (2C) can, in some genera, be effective in delimiting infrageneric divisions (Ohri, 1998), and in indicating intraspecific (2C) variation. In a study aimed at delimiting the number of species in *Agapanthus* and investigating relationships between them, nuclear DNA content (2C) as measured in picograms (pg), using flow cytometry with propidium iodide (a DNA stain that intercalates in the double helix), as well as pollen colour and vitality, were used as novel criteria in conjunction with morphological traits, and geographical data. The results provided insight into the relationships between the species and showed that the nuclear DNA of the diploids distinguished two groups: a group of three deciduous species with a DNA content from 22.3–24.1 pg, and lilac pollen (comprising *A. campanulatus*, *A. caulescens* and *A. coddii*), and a group of three species with a DNA content of 25.2–31.6 pg, and brown, yellowish-brown or yellow pollen (comprising the evergreen *A. africanus* and *A. praecox*, and the deciduous *A. inapertus*), and the pollen vitality of the species ranged from 90 to 98% (Zonneveld & Duncan, 2003). Taxa with clearly different nuclear DNA amounts are considered good species, but this is not to say that those with very similar or identical amounts necessarily have to be considered as conspecific, since nuclear DNA amount should always be evaluated in combination with morphological data. The study found that several of the species recognised by Leighton, with restricted geographical ranges (i.e. *A. nutans*, *A. dyeri*, *A. comptonii* and *A. walshii*) fell within the distribution of widespread species, as did their nuclear DNA ranges, and, taken in conjunction with macromorphological traits, the number of species was reduced to six, with the recognition of a wide degree of variation within each of the six species recognised at that time (living material of the plant subsequently recognised as *A. pondoensis* was unavailable) (Zonneveld & Duncan, 2003). The deciduous *A. nutans*, with a nuclear DNA value of 23.38 pg, fell within the average DNA content range of the deciduous *A. caulescens* (23.18 pg) and was considered synonymous with *A. caulescens* (subsp. *gracilis*), differing morphologically from the latter only in the nodding orientation of its flowers. The deciduous *A. dyeri*, with a nuclear DNA value of 24.99–25.17 pg, fell within the average DNA content range of the deciduous *A.*

inapertus (25.16 pg) and was considered synonymous with *A. inapertus* subsp. *intermedius*, differing from the latter only in its shorter perianth tube, confirming previous speculation by Dyer (1966c). The evergreen *A. comptonii*, with a nuclear DNA value of 25.40–25.61 pg, fell within the average DNA content of *A. praecox* (25.46 pg) and was considered synonymous with *A. praecox* subsp. *minimus*, differing from the latter only in its sometimes longer perianth tube. The evergreen *A. walshii*, with the two accessions measured having a high DNA content of 31.44 pg and 31.83 pg, fell within the average DNA content range of the evergreen *A. africanus* (31.55 pg), but, because of its tubular or trumpet-shaped perianth, but otherwise almost identical leaves, was considered as a subspecies of the latter (Zonneveld & Duncan, 2003; Duncan, 2004; Duncan, 2005). In parts of their ranges, *A. africanus* and *A. walshii* sometimes occur within fairly close proximity, in discrete populations, but since no natural hybrids between the two have yet been recorded, the arrangement for the latter two taxa has been re-assessed and is not followed here, and *A. walshii* is returned to species level.

In a subsequent morphological study for the present work, encompassing a wider range of accessions from habitat, it became clear that morphological variation within *A. campanulatus*, *A. caulescens* and *A. praecox* is so extensive that none of the subspecific taxa previously recognised within these species can be upheld any longer, due to the presence of numerous intermediate forms between the subspecies. It also became apparent that *A. inapertus* subsp. *hollandii* is insufficiently distinct from subsp. *inapertus* to be recognised as a subspecies.

Agapanthus has an extraordinary propensity to hybridisation in cultivation, but this cannot currently be confirmed or discounted in the wild. However, hybridisation may have taken place between particular naturally occurring forms of the deciduous *A. inapertus* subsp. *inapertus* (previously recognised as forms of *A. inapertus* subsp. *hollandii*), and the evergreen *A. praecox*, which is widely grown in close proximity in local gardens in north-eastern Mpumalanga. These include the wild-collected plant suspected to be a hybrid, now known as *Agapanthus* 'Lydenburg' (*Beetge s.n.*, in BOL, collected at Alkmaar west of Mbombela (Nelspruit) (see pages 43–44) and another wild collection from Kaapsche Hoop, southwest of Mbombela (*Lavranos s.n.*, sub. NBG 839/82), whose hybridity seems to be confirmed by their relatively low pollen vitality and low nuclear DNA content, and by their semi-deciduous habit when grown in mild climates (Zonneveld & Duncan, 2003).

Kalendar *et al.* (2000) suggested that in dry, growth-limited environments, species adapt over evolutionary time, with an increase in DNA content, and a decrease in permanently wet conditions, which seems to be true for *A. africanus* and *A. walshii* that grow in hot, summer-dry habitats of the Western Cape. Although DNA content does not give direct clues about evolution, the following scenario might be envisioned for *Agapanthus*. From a supposed proto-agapanthus, *A. campanulatus* with the lowest DNA content (22.3 pg), and lilac pollen, arose. An increase in DNA content and the acquisition of an evergreen habit resulted in *A. praecox*, with 25.46 pg, and brown, yellowish-brown or yellow pollen. *A. campanulatus* spread north, with an increase in DNA content, resulting in *A. caulescens* with 23.5 pg and *A. coddii* with 24.1 pg, both with lilac pollen. *A. praecox* spread to the hot southwest, resulting in *A. africanus* and *A. walshii*, with 31.6 pg, and brown, yellowish-brown or yellow pollen. The remaining species, *A. inapertus*, which has brown, yellowish-brown or yellow pollen, and a similar DNA content (25.2 pg) to that of *A. praecox*, is deciduous. It could be derived from *A. campanulatus* via *A. caulescens*, with a change from lilac to brownish-yellow pollen and an increase in DNA content, or, alternatively, it could be derived from *A. praecox*, with a loss of its evergreen leaves. It may even be derived from both *A. praecox* and *A. campanulatus* or *A. caulescens*, a remnant of which may be the 'intermediate' *A. pondoensis* (for which nuclear DNA content is unknown) with its distinct, but much shorter dormant period from late autumn to mid-winter (Zonneveld & Duncan, 2003).

In their chromosome study of the genus *Agapanthus*, Sharma & Mukhopadhyay (1963) concluded that considering the widely varied habitats in which *Agapanthus* species occur, it is noteworthy that almost all taxa studied have 2n = 30, indicating that numerical alterations of chromosomes have played little role in speciation within the genus. According to Muzila & Spies (2005), the high basic chromosome number (x = 15) suggests a palaeoploid (ancient polyploid) origin for *Agapanthus*. This refers to the presence of more than two complete sets of chromosomes within the cells millions of years ago, with the reduction of the genomes to the present ploidy state after the polyploidisation event (Kahl, 2015).

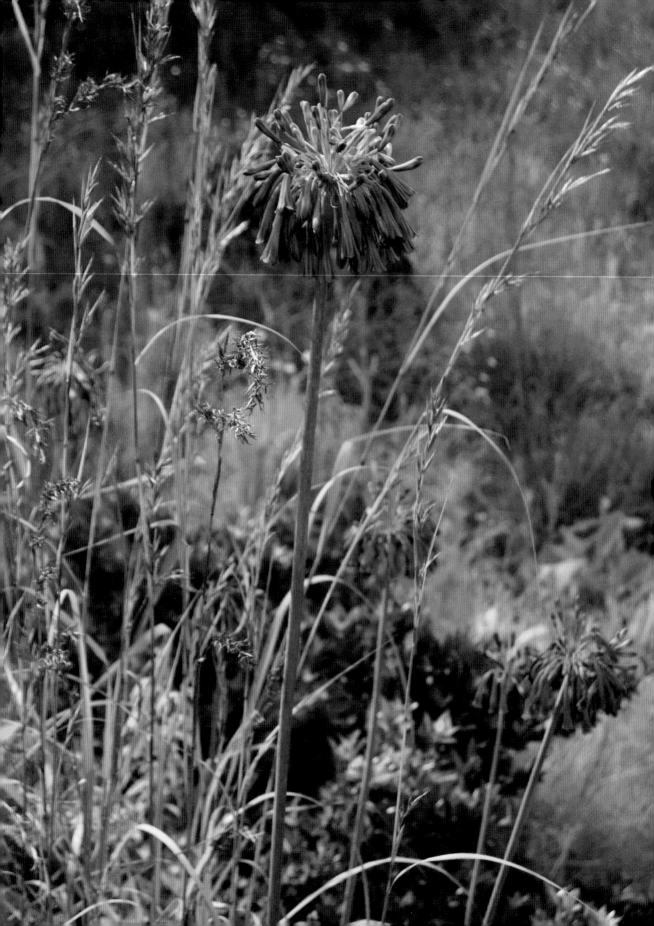

7. TAXONOMIC TREATMENT

The *Agapanthus* family (Agapanthaceae) is no longer considered distinct from the broader Amaryllidaceae (APG III, 2009; Chase *et al.*, 2009; APG IV, 2016; Christenhusz *et al.*, 2017). The current classification of *Agapanthus* follows:

Order Asparagales

Family Amaryllidaceae

Subfamily Agapanthoideae

Genus *Agapanthus*

The genus *Agapanthus* has occupied an uncertain taxonomic position for close to two centuries. Because of its (pseudo) umbellate inflorescence, the Agapanthaceae has often been regarded as a closely related, but separate family from the Amaryllidaceae, as they share a single evolutionary lineage (Fay & Chase, 1996). However, *Agapanthus* has important differences in other respects, including a superior ovary and the absence of amaryllid alkaloid compounds, which some authors have regarded as sufficient grounds upon which to warrant status in its own family.

Initially, *Agapanthus* was placed in subfamily Agapanthoideae of family Liliaceae by Stephan Endlicher (1836) in his *Genera Plantarum*, but subsequently the monogeneric family Agapanthaceae was established for it by Friedrich Voigt (1850). Bentham & Hooker (1883) placed it in tribe Allieae of the Liliaceae on account of its superior ovary, a position followed by Baker (1897), following which Lotsy (1911) returned it to Agapanthaceae, but Hutchinson (1934) transferred it to the Amaryllidaceae on account of the umbellate flower head, which he considered to be of greater taxonomic importance than the superior ovary in distinguishing the Liliaceae and Amaryllidaceae. Cronquist (1981) returned it to a broadly defined Liliaceae which included both the Alliaceae and Amaryllidaceae, and Dahlgren *et al.* (1985) placed it in the Alliaceae.

Based on DNA sequence analyses of the *rbcL* gene, and consideration of the distichous leaf arrangement and absence of characteristic onion- or garlic-smelling compounds typical of the Alliaceae, Fay & Chase (1996) showed that *Agapanthus*, Alliaceae and Amaryllidaceae form a monophyletic group, and that *Agapanthus* was sister to the rest of the Amaryllidaceae. They accepted that *Agapanthus* could be placed in its own family Agapanthaceae, but did not recommend this, in order to avoid a proliferation of family names, instead placing it in subfamily Agapanthoideae of the Amaryllidaceae, while taxa with inferior ovaries were treated as members of subfamily Amaryllidoideae, and the Alliaceae was recognised as subfamily Allioideae. Kubitzki (1998) preferred recognition of the Agapanthaceae, distinguishing it from the Amaryllidaceae by the presence of a superior ovary and steroidal saponins, and the absence of alkaloids. In a combined analysis of the plastid DNA sequences *rbcL* and trnl-F, *Agapanthus* was again indicated as the likely sister to the Amaryllidaceae, although

(opposite) *Agapanthus inapertus* subsp. *inapertus* near Rosehaugh, northen Mpumalanga. Image: Graham Duncan.

without strong support, and Agapanthaceae was once again recognised (Meerow *et al.*, 1999). A further study provided confirmation of fairly strong support for *Agapanthus*, the Amaryllidaceae and the Alliaceae representing a distinct lineage within the monocot order Asparagales (Fay *et al.*, 2000), however, using the same data, McPherson *et al.* (2004) found only moderate support. In a study by the Angiosperm Phylogeny Group, *Agapanthus* was regarded as the sole member of the 'bracketed' family Agapanthaceae, that could optionally be included in an enlarged family Alliaceae *sensu lato* encompassing Agapanthaceae, Alliaceae *sensu stricto* and Amaryllidaceae *sensu stricto* (APG II, 2003), but subsequently the name Amaryllidaceae was conserved for this enlarged family over the older name Alliaceae (Meerow *et al.*, 2007), and it changed from Alliaceae to Amaryllidaceae, but with the same circumscription. In additional studies, Pires *et al.* (2006) and Graham *et al.* (2006) found good support for *Agapanthus* as the sister group in a clade consisting of Alliaceae *sensu stricto* and the Amaryllidaceae.

The APG III system (2009) and Chase *et al.* (2009) subsequently confirmed recognition of the genus *Agapanthus* in subfamily Agapanthoideae of an enlarged family Amaryllidaceae, along with subfamily Amaryllidoideae and subfamily Allioideae. During the same year, Takhtajan (2009) followed the APG II system in recognising the 'bracketed' family Agapanthaceae, but finally the APG IV system (2016) and Christenhusz *et al.* (2017) upheld the genus in subfamily Agapanthoideae of the Amaryllidaceae, along with the subfamilies Allioideae and Amaryllidoideae.

Zonneveld & Duncan (2003) identified two groups of species according to genome size and pollen colour (one with a DNA content of 22.3–24.1 pg and lilac pollen, the other with a DNA content of 25.2–31.6 pg and brown, yellowish-brown or yellow pollen). Snoeijer (2004) referred to these two groups as published sectional names, as section *Lilacinipollini* Zonn. & G.D.Duncan and section *Ochraceipollini* Zonn. & G.D.Duncan, however neither of these sectional names were actually described in Zonneveld & Duncan (2003), and those published in Snoeijer (2004) are invalid, as no Latin diagnoses were provided, and no type material was indicated. Despite the existence of the two groups, I do not consider differences in DNA content and pollen colour to be the most convenient characters for the purpose of a major subdivision in a key to the taxa, and regard growth cycle (evergreen or deciduous) combined with the presence or absence of basal sheathing leaves as more useful characters.

SPECIES CONCEPTS

The species concepts adopted in this work are a combination of the morphological and the biological species concepts (Cronquist, 1978; Mayr, 1942). Taxonomic decisions have been made based on combinations of morphological discontinuities that can be distinguished, combined with the principle that a species is defined as groups of interbreeding natural populations that can produce viable, fertile offspring and are reproductively isolated from other such groups. In addition, nuclear DNA content (2C), as measured by flow cytometry, has been found to be a useful additional criterion in delimiting most of the species, taken in conjunction with morphology (Zonneveld & Duncan, 2003).

Due to extreme morphological variation within most of the species, it has been found expedient to dispense with almost all the subspecific taxa recognised by Leighton (1965), since these were not found to be easily discernible by morphological characters, due mainly to the presence of numerous intermediate forms, and overlapping populations. As a result, eight species are recognised, each defined by a unique combination of traits. The most variable species are *A. caulescens, A. campanulatus, A. praecox* and *A. inapertus*, and *A. coddii* is the most homogeneous species.

During the course of morphological research for the present work, the presence or absence of one or more basal sheathing leaves (see Figure 139 on page 124), not previously employed in classification of *Agapanthus*, was found to be useful for the purpose of substantiating a major division in the key (which correlates with deciduous and evergreen species) as an additional character in distinguishing between the five deciduous agapanthus (*A. campanulatus*, *A. caulescens*, *A. coddii*, *A. inapertus* and *A. pondoensis*) and the three evergreen species (*A. africanus*, *A. praecox* and *A. walshii*). Furthermore, pedicel orientation (more or less straight at anthesis, versus slightly, moderately or strongly downwardly curved at anthesis) was found to be useful as a major division within the deciduous taxa. The rank of subspecies is most often used for sets of populations that are isolated geographically and have relatively modest, and often overlapping, morphological differences (Davis & Heywood, 1973). In this work, the only species in which subspecies are recognised is *A. inapertus*. However, the four subspecies recognised here do not conform to one of the traditional requirements of subspecies (complete geographic isolation): subspecific rank seems to be the most appropriate manner in which to classify these plants, which clearly form four distinct entities; although populations sometimes occur within fairly close proximity, they are always isolated from one another.

AGAPANTHUS L'Hér., *Sertum Anglicum*: 17 (1789), nom. cons.; Leighton, *Journal of South African Botany* Suppl. 4: 15 (1965). Type species: *Agapanthus umbellatus* L'Hér. (=*Agapanthus africanus* (L.) Hoffmanns.).

SYNONYMY:

Tulbaghia Heist., *Beschreibung eines Neuen Geschlechts*: 15 (1755)*, nom. rej.*, non L. (1771).

Abumon Adans.*, Familles des Plantes* 2: 54 (1763). Type: *Abumon africanum* (L.) Britten (= *Agapanthus africanus* (L.) Hoffmanns.).

Mauhlia Dahl, *Observationes Botanicae*: 25 (1787). Type: *Mauhlia africana* (L.) Dahl (= *Agapanthus africanus* (L.) Hoffmanns.).

Evergreen or deciduous, winter- or summer-growing perennials, containing saponins, sapogenins, chalconoids and raphides. *Rhizome* narrowly to broadly cylindrical, branched or unbranched, sometimes with swollen apex (deciduous species), erect, suberect or spreading, persistent, hypogeal or partially epigeal, clump-forming; tissue white or cream-coloured; roots thick, fleshy, covered with a multiple velamen, branched or unbranched, arising from nodes. *Pseudostem* formed from sheathing leaf bases, short or long, narrow or broad, white, green, or purple-flushed; bulbous base prominent in deciduous species; old, dried, fibrous leaf remains surrounding leaf shoot bases prominent in evergreen species; basal sheathing leaves 1–9, lower portion tubular, tightly adhering, free portion strap-shaped or broadly linear, present only in deciduous species. *Leaves* 5–20, arising from one or more shoots, synanthous, strap-shaped, linear, lanceolate or oblanceolate, distichous, erect, suberect, arching or spreading, flat or slightly to deeply canaliculate, upper and/or lower surfaces glabrous or glossy, light to deep green, yellowish-green, glaucous or glaucous-green, thin-textured or leathery; venation parallel; midrib prominent on lower surface; margins flat or wavy, hyaline or ridged, sometimes purple in early growth phase; apices acute, subacute or obtuse. *Inflorescence* a pseudo-umbel, sparse to dense (3–100- or more-flowered), rarely developing pseudo-umbelulae, globose, subglobose or more or less campanulate; erect, suberect or reclining, held well above leaves, opening from outermost flowers towards centre; scape solid, slightly or strongly compressed, naked, rigid or somewhat flexible, erect, suberect or upwardly arching, light to deep green, glaucous or partially to fully purple-flushed, sometimes covered with powdery bloom, persistent; pedicels firm, erect,

suberect, spreading, downwardly oriented or arcuate, light to deep green, glaucous or partially to fully purple-flushed, persistent; spathe bracts 2, joined along two opposite margins in bud, membranous, deciduous, drying rapidly, usually splitting along one margin (rarely along both) prior to anthesis and dropping to ground; bracteoles 5–20, filiform, white, 10–20 mm long. *Perianth* zygomorphic, tubular, narrowly or widely funnel-shaped or trumpet-shaped, syntepalous, biseriate, hypogynous, unscented or slightly spicy-sweet scented, spreading, suberect, erect, cernuous or pendent, light to deep blue, bluish-white, violet, blackish-violet, deep magenta or bicoloured (anthocyanin pigment present), pure white or cream-coloured (anthocyanin pigment absent); tepals 6 (rarely 8, 12 or 18), subequal, fused basally into a short to long cylindrical tube containing nectar; outer surfaces with median ridge, inner surfaces grooved along same line; outer tepals lanceolate, apices obtuse or acute, often slightly hooded, thickened and uncinate or minutely apically bearded, narrower than inner tepals; inner tepals narrowly to broadly spathulate, apices obtuse or subacute, sometimes minutely apically bearded. *Stamens* 6, lower portion inserted along length of perianth tube; filaments slightly to strongly declinate, slightly or strongly unequal, included, shortly exserted or rarely well-exserted, light to deep blue, lilac or white; anthers 2-thecous, longitudinal, dorsifixed, versatile, introrse; pollen sulcate-reticulate, lilac, light to dark brown or brownish-yellow, rarely bright yellow. *Ovary* superior, ellipsoid or oblong, trilocular, syncarpic, light green or yellowish-green; septal nectaries present; ovules numerous, axile; style declinate or straight, hollow, included or slightly to well exserted, light to deep blue, lilac or white; stigma minutely capitate, white. Fruit a dry, papyraceous capsule, narrowly to widely ellipsoid, cernuous or pendent, apex acute, subacute or obtuse, loculicidally dehiscent. *Seeds* flat, ovate or oblong, winged opposite micropyle, shiny or matte black; phytomelan crust thin. *Basic chromosome number* x = 15, rarely 14, 16.

Agapanthus includes 8 species (11 taxa), confined mainly to the summer rainfall zone of South Africa in Limpopo, Gauteng, Mpumalanga, KwaZulu-Natal, Free State and Eastern Cape, and in summer rainfall Eswatini and Lesotho, and southern Mozambique, extending southwards and westwards to year-round and winter rainfall parts of Western and Eastern Cape, South Africa.

KEY TO THE TAXA

Note. The key refers to plants in their natural habitat; in cultivation, the high level of morphological plasticity within the taxa, when grown in differing conditions, can result in exaggerated features and dimensions.

1a Basal sheathing leaves absent; dried, old leaf remains usually present, plants evergreen; southern Cape Peninsula to south-eastern KwaZulu-Natal . 2

1b Basal sheathing leaves present; dried, old leaf remains usually absent, plants deciduous, summer-growing; central Eastern Cape to northern Limpopo. 4

2a Leaves soft-textured, rarely leathery, arching or suberect, extremely variable in width and length (150–650 × 7–50 mm); perianth widely or narrowly funnel-shaped, tepals thin-textured, light to deep blue, rarely ivory or white; pollen brown, yellowish-brown or bright yellow; among coastal scrub, along stream banks, forest margins, ledges, gorges and mountain slopes, associated with rocks; southern Cape to south-eastern KwaZulu-Natal, (west of Wilderness to Krantzkloof Nature Reserve, inland to Barkly Pass, Mortimer and north of Pearston) **3. *A. praecox***

2b Leaves leathery, erect or suberect, rarely spreading; tepals thick-textured, perianth widely or narrowly funnel-shaped, tubular or trumpet-shaped . 3

3a Perianth widely or narrowly funnel-shaped, spreading, suberect or slightly nodding, light to deep blue or deep violet blue, rarely light bluish-white or pure white; perianth tube 10–15 mm long; pollen yellowish-brown or bright yellow; rocky sandstone slopes and flats in fynbos; south-western Cape and southern Cape (southern Cape Peninsula to north-east of Riversdale) . . **1. *A. africanus***

3b Perianth tubular or trumpet-shaped, pendent or nodding, light to bright blue, rarely bicoloured or pure white; perianth tube 16–31 mm long; pollen light to dark brown; rocky sandstone slopes in fynbos; Elgin Valley .**2. *A. walshii***

4a Pedicels more or less straight at anthesis, spreading, suberect or erect, or oriented in all directions; perianth widely or narrowly funnel-shaped, produced in a globose or subglobose head; flowers nodding, spreading or suberect at anthesis. 5

4b Pedicels slightly, moderately or strongly downwardly curved at anthesis; perianth tubular, narrowly or widely funnel-shaped or trumpet-shaped, produced in a bell-shaped head; flowers nodding or pendent at anthesis; pollen brown, brownish-yellow or bright yellow 8

5a Perianth tube 5–10 mm long, rarely to 12 mm . 6

5b Perianth tube 15–25 mm long . 7

6a Tepals 10–20 mm long; perianth widely or narrowly funnel-shaped, light to bright blue or deep blue, rarely white; pollen lilac; leaves 6–25 mm wide, green or glaucous, apices subacute, produced in arching, erect or suberect fans; seepage areas among rocks in montane grassland in fertile black soil; eastern parts of Eastern Cape to south-eastern Limpopo (Komga to Shiluvani). **7. *A. campanulatus***

6b Tepals 25–28 mm long, light blue; perianth widely funnel-shaped; pollen lilac; leaves 30–55 mm wide, green, apices obtuse, rarely subacute, in erect or suberect fans; steep montane grassland slopes below cliffs; Waterberg, western Limpopo .**6. *A. coddii***

7a Perianth widely funnel-shaped, bright blue, deep blue or deep violet blue; perianth tube often with contrasting deeper blue or deeper violet base; inner tepals 6–8 mm wide; style strongly declinate; pollen lilac; leaves extremely variable in length and width (200–650 × 20–60 mm), glaucous or green, in erect or arching fans; plants dormant for 12 weeks in winter; grassland slopes and hillsides among rocks, beside waterfalls and on inaccessible ledges on dolerite, granite, sandstone and basalt; north-central and extreme north-eastern parts of Eastern Cape to northern and western Limpopo (north of Queenstown, north-west of Ngcobo, and from Bizana to the Soutpansberg and Waterberg). .**4. *A. caulescens***

7b Perianth narrowly funnel-shaped, light blue; perianth tube usually without contrasting deeper blue or deeper violet base; inner tepals 9–10 mm wide; style straight or slightly declinate; pollen yellowish-brown; leaves green, in spreading fans (220–300 × 18–25 (–28) mm); plants dormant for 4–6 weeks from late autumn to mid-winter; sheer sandstone cliffs and rocky river gorges; north-eastern part of Eastern Cape (east and south-east of Lusikisiki). **5. *A. pondoensis***

8a Style 11–13 mm long; inner tepals 10–15 mm long, 5–6 mm wide; perianth tube 10–15 mm long; perianth tubular, bright blue or navy blue, produced in small, dense heads; leaves bright green, in erect, narrow fans; rocky grassland flats, hills and mountain slopes; north-central to northern Mpumalanga (Machadodorp to Sabie)**8c. *A. inapertus* subsp. *parviflorus***

8b Style 18–32 mm long; inner tepals 15–24 mm long, 7–10 mm wide; perianth tube 10–32 mm long; perianth tubular or narrowly to widely funnel-shaped or trumpet-shaped 9

9a Perianth violet blue, deep blackish-violet or rarely deep magenta, tubular; perianth tube 15–20 mm long; tepals thick-textured (fleshy); leaves yellowish-green or glaucous-green, in spreading or suberect fans; among dolomite boulders, often in semi-shade within bushes and under trees; central and north-western to northern Mpumalanga (Belfast to Mariepskop) . **8d. *A. inapertus* subsp.** *pendulus*

9b Perianth light to deep blue or mauvish-blue, rarely white; tubular or narrowly to widely funnel-shaped or trumpet-shaped; tepals thin-textured . 10

10a Perianth tubular; light to bright blue, rarely white; perianth tube 16–32 mm long; leaves usually glaucous, in erect or suberect fans; plants up to 2.1 m high in flower; grassy flats, swamps, hills and mountain slopes; southern Mpumalanga to east-central Limpopo (Volksrust to Haenertsburg) . **8a. *A. inapertus* subsp.** *inapertus*

10b Perianth narrowly or widely funnel-shaped or trumpet-shaped; light to bright blue or mauvish-blue, rarely white; perianth tube 10–18 mm long; leaves glaucous or green, in arching, suberect or erect fans; plants up to 1.2 m high in flower; rocky grassland flats, hills, mountain slopes and plateaus, sometimes in seepage or beside streams; southern Mozambique, central Eswatini and Gauteng to the Soutpansberg, northern Limpopo (Namaacha, Manzini and Johannesburg to Blouberg and north of Makhado) **8b. *A. inapertus* subsp.** *intermedius*

THE SPECIES

1. AGAPANTHUS AFRICANUS

Agapanthus africanus (L.) Hoffmanns., *Verzeichniss der Pflanzenkulturen*: 35 (1824). *Crinum africanum* L., *Species Plantarum* 1: 292 (1753). *Mauhlia africana* (L.) Dahl, *Observationes Botanicae*: 26 (1787). *Crinum floridum* Salisb., *Prodromus stirpium in horto ad Chapel Allerton vigentium*: 228 (1796), nom. superfl. *Tulbaghia africana* (L.) Kuntze, *Revisio Generum Plantarum* 2: 718 (1891). *Abumon africanum* (L.) Britton, *Flora of Bermuda*: 72 (1918).

TYPE: South Africa, Cape, collector and precise locality unknown, *Herb. Linn.* 415.6 (LINN!, lectotype, designated by Leighton, *Journal of South African Botany*, suppl. vol. 4: 17, t. 2 (1965)).

SYNONYMY: *Tulbaghia heisteri* Fabr., *Enumeratio Methodica Plantarum Horti Medici Helmstadiensis* (ed. 2): 4 (1763). *Tulbaghia africana* (L.) Kuntze f. *heisteri* (Fabr.) Kuntze, *Revisio Generum Plantarum* 3(3): 317 (1898). Type: South Africa, Cape, collector and precise locality unknown, figure in C. Commelin, *Horti Medici Amstelodamensis Rariorum* 2: t. 67 (1701) (lectotype, designated here).

Agapanthus umbellatus L'Hér., *Sertum Anglicum*: 17 (1789). *Mauhlia umbellata* (L'Hér.) Thunb. ex Schult. & Schult.f. in Roemer, J.J. & Schultes, J.A., *Systema Vegetabilium* ed. 15 bis 7: 997 (1830). Type: South Africa, Cape, collector and precise locality unknown, figure in Breyne, *Prodromi Fasciculi Rariorum Plantarum*: 23, t. 10, fig. 1 (1739) (lectotype, designated here).

Mauhlia linearis Thunb., *Nova Genera Plantarum*: 111 (1792). Type: South Africa, Cape, precise locality unknown, *Thunberg s.n.* (UPS!, holo., microfiche no. 336/15).

Agapanthus minor G.Lodd., *The Botanical Cabinet* 1: t. 42 (1817). *Tulbaghia minor* (G.Lodd.) Kuntze, *Revisio Generum Plantarum* 2: 718 (1891). *Agapanthus umbellatus* L'Hér. var. *minor* (G.Lodd.) Baker, *Flora Capensis* 6: 403 (1897). *Tulbaghia africana* (L.) Kuntze f. *minor* (G.Lodd.) Kuntze, *Revisio Generum Plantarum* 3(3): 317 (1898). *Agapanthus africanus* (L.) Hoffmanns. var. *minor* (G.Lodd.)

Beauverd, *Bulletin de la Société Botanique de Genève* (ser. 2) 2: 197 (1910). Type: South Africa, Cape, collector and precise locality unknown, figure in C. Loddiges, *The Botanical Cabinet* 1: t. 42 (1817) (lectotype, designated here).

Agapanthus umbellatus L'Hér. var. *leichtlinii* Baker, *The Gardeners' Chronicle* 10 (new series): 428 (1878). *Agapanthus africanus* (L.) Hoffmanns. var. *leichtlinii* (Baker) Beauverd, *Bulletin de la Société Botanique de Genève* (ser. 2) 2: 198 (1910).

NAME. *africanus*: from Africa.

COMMON NAMES. Cape agapanthus, fynbos agapanthus, kleinbloulelie (Afrikaans).

DESCRIPTION. Evergreen, winter-growing perennial 200–750 mm high in flower, usually clump-forming, rarely solitary. *Rhizome* erect, 5–25 × 5–15 mm. *Pseudostem* 30–55 × 20–30 mm, erect, white, usually tightly surrounded by old, dried leaf remains, basal sheathing leaves absent. *Leaves* 5–20 per shoot, linear, 100–410 × 5–22 mm, slightly curved, leathery, deeply canaliculate, yellowish-green or light to bright green, produced in erect, suberect or arching fans; apices acute, margins entire. *Scape* erect or suberect, 140–700 × 4–7 mm, sturdy, green or purple-flushed, covered with a light grey waxy bloom; spathe bracts ovate, 20–35 × 20–25 mm, apices acute, light brownish-cream, sometimes

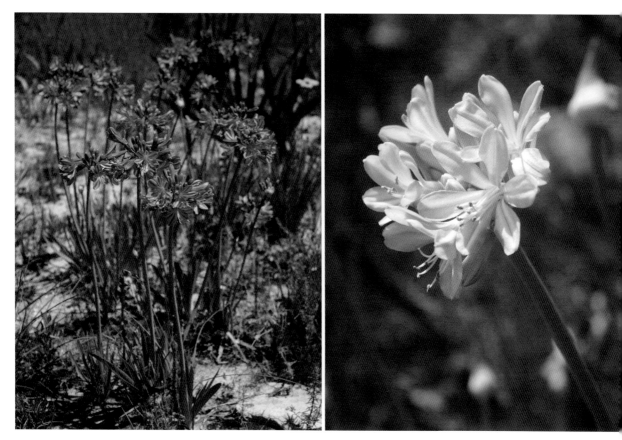

Figure 178 (left). The subglobose heads and sturdy scapes of *Agapanthus africanus*, Silvermine Nature Reserve. Image: Graham Duncan.

Figure 179 (right). A rare white form of *Agapanthus africanus*, Silvermine Nature Reserve. Image: Graham Duncan.

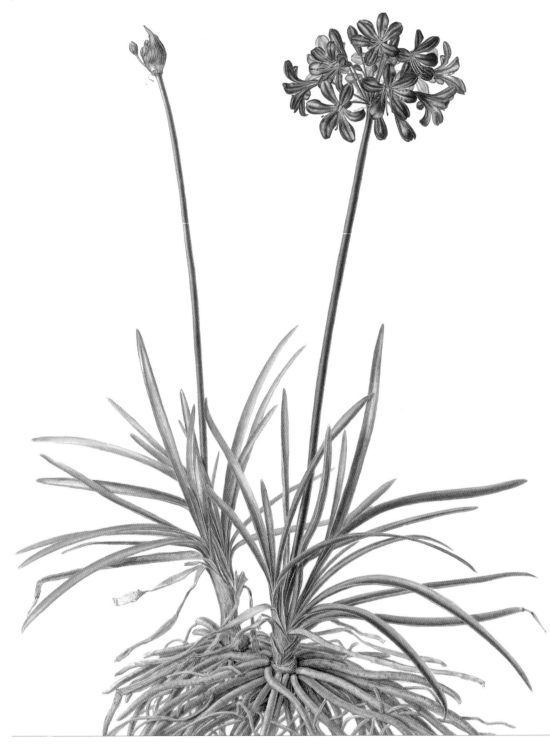

PLATE 3

Artist: Elbe Joubert

Watercolour painting of *Agapanthus africanus* from the Cape of Good Hope Nature Reserve, Western Cape (*de Lange s.n.*, NBG 253/95). Image 50% of life size.

flushed with blue at base, longitudinal veins brown. *Pseudo-umbel* globose or subglobose, 45–140 mm across, 3–60-flowered; pedicels erect or suberect in bud, suberect or sometimes spreading at anthesis, 10–45 mm long, light green or dull purple; bracteoles 6–12, filiform or narrowly lanceolate, 8–22 × 1–5 mm, dried at anthesis, creamy brown or translucent white, veins dull brown or light purple. *Perianth* narrowly or widely funnel-shaped (tepals radiate >15° up to 30° or more from longitudinal axis), light to deep blue or deep violet blue, light bluish-white or rarely pure white; spreading, suberect or slightly nodding; tepals fleshy, free to base or slightly overlapping in lower half, midrib prominent on lower surface; perianth tube cylindrical, 10–15 mm long, containing nectar; outer tepals oblanceolate, 16–25 × 6–7 mm, apices minutely bearded, midrib prominent on lower surface, margins flat or slightly undulate; inner tepals narrowly spathulate, 20–25 × 9–11 mm, margins entire or slightly undulate. *Stamens* declinate, included; filaments 12–17 mm long, light to deep blue or rarely white; anthers 1.2–1.4 mm long; pollen brown, yellowish-brown or bright yellow. *Ovary* narrowly ellipsoid, 8–10 × 3–4 mm, yellowish-green; style declinate, 12–20 mm long, light to deep blue or rarely white; stigma minutely capitate. *Capsule* ellipsoid, 20–30 × 7–10 mm. *Seeds* ovate or oblong, glossy or matte black, 3 × 3 mm; wing ovate, 4 × 3 mm. *Chromosome number:* 2n = 30 (Belling, 1928). Plate 3; Figures 102, 103, 122, 127–129, 178–184.

FLOWERING PERIOD. December to March, with a peak in January and February.

HISTORY. The early history of *Agapanthus* is essentially that of *A. africanus*, first described by Jakob Breyne in 1680, using the phrase name *Hyacinthus Africanus Tuberosus, Flore caeruleo umbellato*, or, 'The tuberous African Hyacinth with umbels of sky blue flowers'. Towards the end of the 17th century, the English botanist Leonard Plukenet published the first illustration of the species, a monochrome drawing, in part 3 of his *Phytographia* (Plukenet, 1692). The genus *Agapanthus* was established by the French amateur botanist Charles-Louis L'Héritier de Brutelle in 1789 when he described *A. umbellatus* (*A. africanus*), however this name also came to be used for other members of the genus including *A. praecox* and *A. campanulatus*, leading to considerable confusion. For further details, see History chapter (page 1).

DISTINGUISHING FEATURES AND AFFINITIES. *A. africanus* is recognised in flower by subglobose heads of widely or narrowly funnel-shaped, light to deep blue, deep violet blue, light bluish-white or sometimes pure white blooms, carried on suberect, light green or dull purple pedicels and sturdy scapes covered with a light grey or colourless waxy film (Figures 178, 179). The flowers are spreading or slightly nodding, with cylindrical perianth tubes 10–15 mm long and distinctly fleshy tepals (Figure 180) with oblanceolate outer tepals and narrowly spathulate inner tepals, with all the tepals free

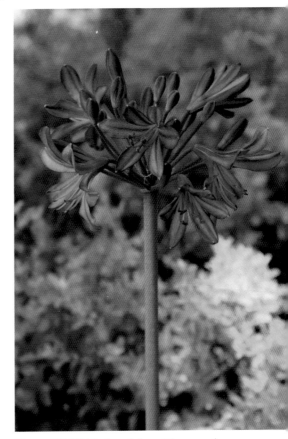

Figure 180. Widely funnel-shaped flowers and thick-textured tepals of *Agapanthus africanus*. Image: Graham Duncan.

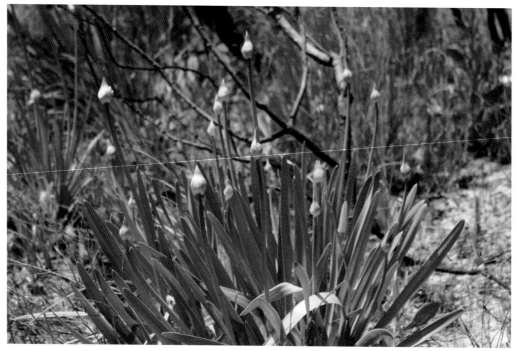

Figure 181. Fans of leathery leaves of *Agapanthus africanus*, Silvermine Nature Reserve, Cape Peninsula. Image: Graham Duncan.

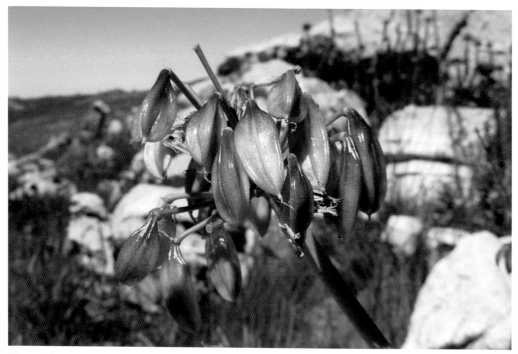

Figure 182. *Agapanthus africanus* glossy fruit, Overberg Mountains, southern Cape. Image: Cameron McMaster.

to the base, or slightly overlapping in the lower half. The style and stamens are included and declinate, and the anthers bear brown, yellowish-brown or bright yellow pollen. The distinctly leathery, strap-shaped leaves are borne in multiple erect, suberect or arching fans, with 5–20 leaves per fan, and are canaliculate with acute apices, and sometimes with purple-flushed leaf bases (Figure 181). The developing ellipsoid fruits have a distinctly glossy appearance (Figure 182). *A. africanus* appears most closely related to another fynbos endemic, *A. walshii*, which has very similar leathery leaves with acute apices, borne in erect, suberect or spreading fans, and thick-textured tepals. *A. walshii* differs in having pendent or cernuous, tubular- or trumpet-shaped flowers borne on slighty to strongly arching pedicels, with longer cylindrical perianth tubes 16–31 mm long, and overlapping, lanceolate outer and oblanceolate inner tepals. It also differs in having a more or less straight style and filaments, with the anthers protruding just beyond the tepal tips.

DISTRIBUTION, HABITAT AND LIFE CYCLE. *A. africanus* is native to the south-western and southern Cape, occurring from the southern and northern Cape Peninsula eastwards to the Boosmansbos Wilderness Area east of Barrydale and the Langeberg summit above the farm Witte Els Berg, north-east of Riversdale (Map 2). It is usually encountered in large colonies on steep, rocky, south-, west- and east-facing lower, middle and upper mountain and hill slopes, and on elevated flats, in a range of sandstone habitats including Peninsula Sandstone Fynbos, Kogelberg Sandstone Fynbos, Overberg Sandstone Fynbos and South Langeberg Sandstone Fynbos (Figures 183, 184). In the Cape of Good

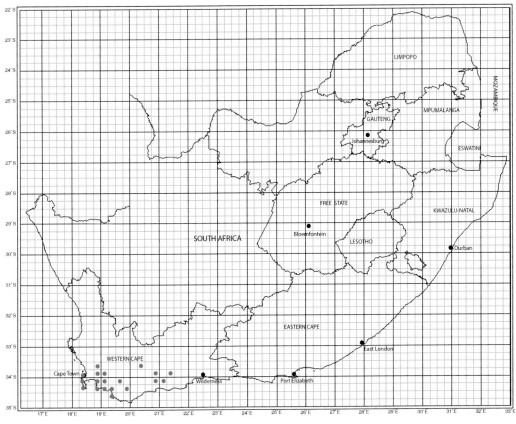

Map 2. Known distribution of *Agapanthus africanus*.

Figure 183. *Agapanthus africanus* en masse after fire in Overberg Sandstone Fynbos, Gansbaai. Image: Heiner Lutzeyer.

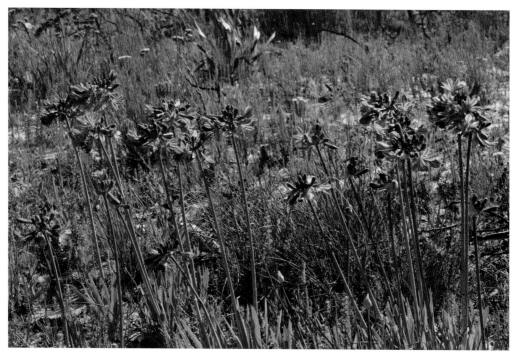

Figure 184. *Agapanthus africanus* after fire in Peninsula Sandstone Fynbos, Silvermine Nature Reserve. Image: Graham Duncan.

Hope Nature Reserve in the southern Cape Peninsula and at Gansbaai in the southern Cape, it ranges from close to sea level, and in the vicinity of Maclear's Beacon on Table Mountain, it reaches 1086 m. The plants inhabit sandstone rock crevices, depressions on rock sheets, open stony flats and rocky hill and mountain slopes, their thick, fleshy root mats securely anchoring the plants in extremely windy environments. They are strongly stimulated to profuse flowering following bush fires of the immediately preceding summer or autumn, but it is not a true pyrophyte, since sporadic flowering does takes place during interfire periods, although it is sometimes as low as 10% of mature plants. At Silvermine Nature Reserve in the southern Cape Peninsula it is frequently seen in flower in association with the evergreen geophyte *Watsonia tabularis* (Iridaceae).

CONSERVATION STATUS. *A. africanus* is not threatened, and is assessed as Least Concern, according to the SANBI Red List of South African Plants (version 2020.1) (Foden & Potter, 2005a).

NOTES. It is not precisely known what pollinates the funnel-shaped flowers of *A. africanus* in the wild, but it is likely to be solitary bees or long-proboscid flies. In pollination experiments carried out in cultivation at Kirstenbosch, flowers were found to be partially self-incompatible. In habitat, the seeds usually ripen from early to late March. Fresh seeds germinate readily within three weeks when sown directly after harvesting, and in ideal conditions, will often flower in as little as 30 months. Like those of *A. walshii*, their leathery leaves are much less susceptible to insect attack than the softer leaves of most other *Agapanthus* species, but they are subject to the fungus *Phomopsis agapanthi*, causing them to die back from the tips, especially in summer (Du Plessis & Duncan, 1989). *A. africanus* is half-hardy and decidedly requiring of protection in cold winter climates of the northern hemisphere, best grown in the cool greenhouse.

2. AGAPANTHUS WALSHII

Agapanthus walshii L.Bolus, *The Annals of the Bolus Herbarium* 3: 14 (1923).

TYPE: South Africa, Western Cape, Hottentots Holland Mountains in the vicinity of Steenbras railway station at about 1800 ft [±500 m], January 1918, *A.E. Walsh s.n.* [BOL 15675] (BOL!, holo.; K!, iso.).

SYNONYMY: *Agapanthus africanus* (L.) Hoffmanns. subsp. *walshii* (L.Bolus) Zonn. & G.D.Duncan, *Plant Systematics & Evolution* 241: 121 (2003). Type: as above.

NAME. *walshii*: after Albert Edward Walsh (1853–1930), English pharmaceutical chemist, who discovered this species and made the first scientific collection of the plants.

COMMON NAME. Walsh's agapanthus.

DESCRIPTION. Evergreen, winter-growing perennial 600–750 mm high in flower, solitary or clump-forming. *Rhizome* erect, 5–30 × 5–15 mm. *Pseudostem* erect, 30–110 × 15–30 mm, tightly surrounded by old, dried leaf remains, basal sheathing leaves absent. *Leaves* 6–14 per shoot, linear, 100–350 × 6–15 mm, distinctly coriaceous, stiffly erect or suberect, distichous or subdistichous, slightly canaliculate, light to deep green or yellowish-green, apices acute or subacute. *Scape* erect to suberect, 300–750 × 5–12 mm, sturdy, covered with a conspicuous, bluish-grey waxy bloom; spathe bracts ovate, 25–30 × 10–15 mm, creamy-green with conspicuous light to dark brown or green longitudinal veins, splitting longitudinally along one side, dropping off before full flowering stage. *Pseudo-umbel* campanulate, 8–30-flowered, 60–105 mm across; pedicels erect or suberect in bud, becoming arcuate at anthesis, dull bluish-green, 10–30 mm long; bracteoles filiform, 6–20 × 0.5–1.0 mm white, spirally twisted. *Perianth* tubular (tepals radiate up to 15° from longitudinal axis) or trumpet-shaped; tepals fleshy, light to deep blue throughout, or light to deep blue in lower half, shading to bluish-white above,

rarely pure white; median keels dark blue or greenish-white; perianth tube cylindrical, light to deep blue, bluish-white or pure white, 16–31 mm long; outer tepals lanceolate, 15–18 × 6–7 mm, apices acute, inner tepals oblanceolate, 15–18 × 8–9 mm, apices acute or obtuse. *Stamens* slightly declinate, included within perianth or rarely shortly exserted, filaments somewhat fleshy, subequal, 22–24 mm long, white in lower two thirds, shading to light blue in upper third, free portion arising in middle of perianth tube, lower portion decurrent along lower half of perianth tube; anthers oblong, pollen yellowish-brown (blue forms) or dark brown (white forms). *Ovary* narrowly ellipsoid, yellowish-green, 10–15 × 3–4 mm, style straight and fleshy, white, 21–25 mm long, included or rarely shortly exserted; stigma minutely capitate. *Capsule* ellipsoid, three-angled, cernuous or pendent, 25–45 × 10–12 mm, narrowed proximally with a distinct neck 5–8 mm long. *Seeds* ovate or obovate, 4 × 3 mm, wing ovate, 4 × 3 mm. Plate 4, front cover. Figures 85, 115, 154, 185–193.

FLOWERING PERIOD. Late December (sometimes from late November in cultivation) to early March, with a peak in January and February.

HISTORY. The earliest known record of *A. walshii* is that of Albert E. Walsh who collected several flowering specimens in January 1918 in the vicinity of Steenbras railway station at the southern foot of Sir Lowry's Pass, a short distance from the road that provides access over the Hottentots Holland Mountains east of Cape Town. Known as Hottentot's-Holland 'kloof' in the eighteenth and early nineteenth centuries, this road provided one of the most important routes from Cape Town to the interior, traversed by many prominent botanists and plant collectors of the time, who, remarkably, did not detect this taxon. Walsh's specimens were deposited at the Bolus Herbarium, University of Cape Town and at the Kew Herbarium, and the species was described by Louisa Bolus five years later in *The Annals of the Bolus Herbarium*, accompanied by a monochrome drawing by Mary Page, illustrating a single flower from the type collection (Bolus, 1923). The plant was subsequently recorded in the same area by the South African pharmacist and conservationist John Stanley Linley, who collected it in flower in January 1946, and his specimen is housed in the South African Museum collection (SAM 58398) at Kirstenbosch. By the time Frances Leighton's revision of the genus appeared in 1965, the species was only known from these two collections, and she was evidently unaware of the duplicate record of the type collection at Kew. Leighton noted that in flower colour and texture, the plant was similar to *A. africanus*, and she considered it to be a possible mutant of that species (Leighton, 1965).

In March 1969, John Rourke came across a small colony of plants in the eastern foothills of the Kogelberg Mountain range above Steenbras Dam, at an altitude of about 730 m. Flowering material of the typical blue form was later collected from this population and illustrated by Fay Anderson on plate 1675 of *The Flowering Plants of Africa* (Rourke, 1973). Subsequently, the plant was recorded in the lower Dwars Rivier Mountains within the Kogelberg Biosphere Reserve by Charlie Boucher in 1973, and in May 1977 a collection of five plants of a pure white form was made at Steenbras by G. Gerber, an official of the Cape Town City Council. These plants were found among blue-flowered forms and were cultivated in the nursery at Kirstenbosch (accession number 964/77), where they flowered in late November 1981 (Duncan, 1983).

In February 1982, Elsie Esterhuysen collected it in flower on a ridge above Rockview Dam near Elgin, SSE of the summit of Sir Lowry's Pass (*Esterhuysen* 35749 in BOL) at 730 m. A large colony, found on a steep, east-facing slope some distance to the east near Elgin, originally contained a wide range of blue forms as well as bicoloured and white-flowered plants. Elgin residents Peter and Barbara Knox-Shaw became aware of it during the late 1980s, and it flowered in profusion after an extensive fire there in January 1990. In late March 1990, seed was collected and sown at Kirstenbosch

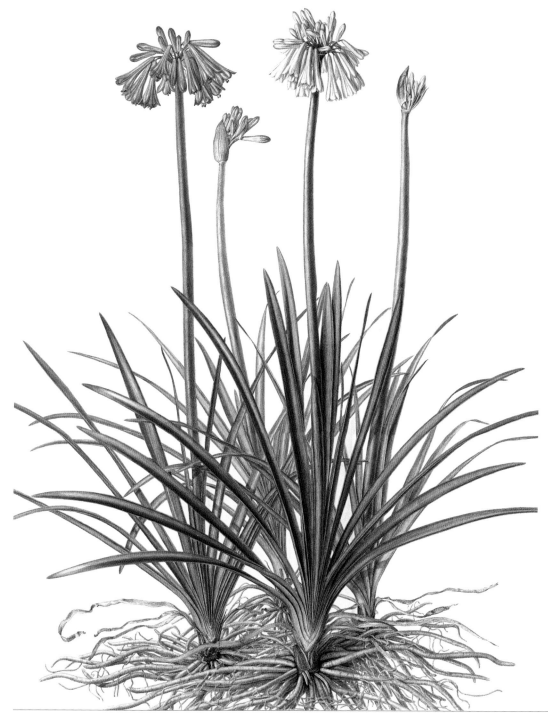

PLATE 4 Artist: Elbe Joubert

Watercolour painting of *Agapanthus walshii* from the Elgin Valley, Western Cape
(*Duncan 324*, NBG 69/93). Image 33% of life size.

(*Duncan 324*), which flowered three years later. Unfortunately, in the interim, the population has become subject to a rapidly expanding informal settlement, and has been totally overtaken by alien plants. During a search by the author in late 2018, not a single plant could be found (Plate 4).

In 2003, the results of a nuclear DNA study of *Agapanthus* suggested that, as postulated by Leighton (1965), *A. walshii* could be regarded as a mutant of *A. africanus*, and its taxonomic rank was altered to that of a subspecies, as *A. africanus* subsp. *walshii* (Zonneveld & Duncan, 2003; Duncan, 2004), however the plant is returned to species level in the present work. Thus far, natural hybrids between *A. walshii* and *A. africanus* have not been recorded. Zonneveld & Duncan (2003) found that *A. walshii* and *A. africanus* both have the same high nuclear DNA content between 31.25 and 31.83 pg, which is outside the range of all other *Agapanthus* species.

DISTINGUISHING FEATURES AND AFFINITIES. In a vegetative state, *A. walshii* is recognised by solitary or multiple fans of linear, usually erect or suberect, leathery, light to deep green or yellowish- green leaves, with acute or subacute apices. The erect or suberect scapes are covered with a prominent fine, bluish-grey powder, and bear few- to many-flowered heads of pendent or nodding, tubular or

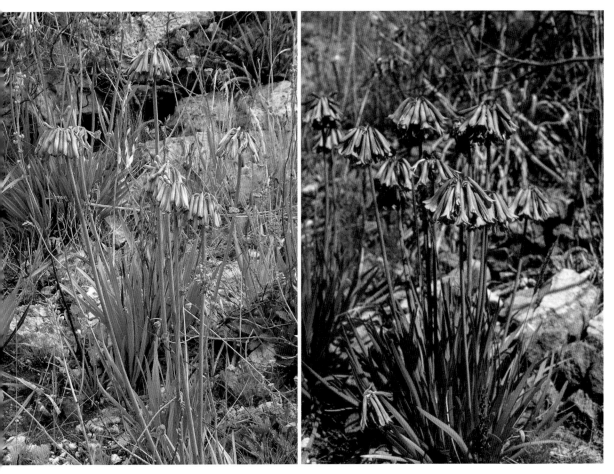

Figure 185 (left). *Agapanthus walshii* with tubular perianths, Elgin, Overberg. Image: Richard Jamieson.
Figure 186 (right). *Agapanthus walshii* with trumpet-shaped perianths, Elgin, Overberg. Image: Graham Duncan.

trumpet-shaped flowers, with the tepals spreading towards their apices, carried on slightly or strongly curved pedicels (Figures 185, 186). Perianth tube length varies considerably from 16–31 mm (Figures 187, 188). The lanceolate outer tepals and oblanceolate inner tepals are fleshy (thick-textured) and overlapping, and slightly or strongly flared towards the tips. Perianth tube and tepal colour vary in numerous shades of light to deep blue, or are rarely white, and in certain forms the perianth is bicoloured, in which the perianth tube is very light blue, with blue tepals. The stamens are slightly declinate and usually included, or rarely shortly exserted beyond the perianth, and pollen colour is yellowish-brown in blue forms, and dark brown in white forms. The ellipsoid capsules are cernuous or pendent, and narrowed proximally, forming a distinct neck 5–8 mm long (Figure 189).

The species appears most closely allied with *A. africanus*, which has very similar fans of leathery, yellowish-green or bright green, linear leaves with acute or subacute apices, thick-textured tepals, and scapes covered with a bluish-grey powder. *A. africanus* differs in having a narrowly or widely funnel-shaped perianth, with the tepals spreading from the mouth of the perianth tube, with somewhat shorter perianth tubes ranging from 10–15 mm long, oblanceolate outer tepals with subacute,

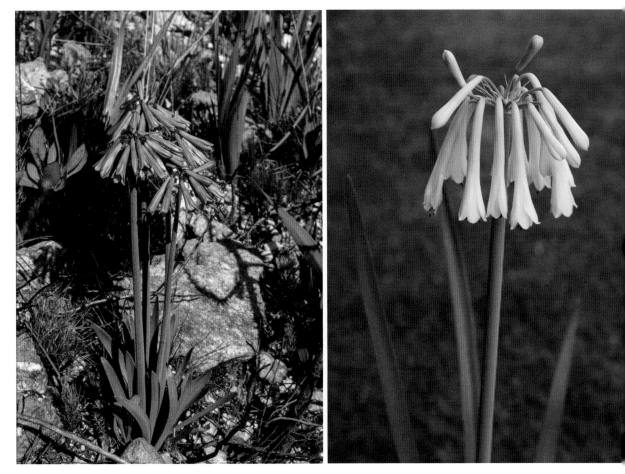

Figure 187 (left). A short-tubed, light blue form of *Agapanthus walshii*, Elgin, Overberg. Image: Barbara Knox-Shaw.
Figure 188 (right). A long-tubed, white form of *Agapanthus walshii*, from Steenbras, Overberg. Image: Graham Duncan.

minutely bearded apices, and spathulate inner tepals with obtuse, emarginate apices. The flowers are brighter or deeper blue or violet-blue, bluish-white or rarely white, and their orientation is spreading, suberect or slightly nodding, with their pedicels spreading or suberect. The spreading tepals of *A. africanus* are free or slightly overlapping at the base, and have slightly or moderately undulate margins, and the stamens have declinate orientation. Pollen colour in blue forms of *A. africanus* is brown, and white forms have bright yellow pollen. Both species share the same flowering time from late December to early March, with a peak period throughout January and early February, and occur mainly on east- and south-facing slopes, or in open aspects, on sharply drained, acid sandstone. *A. africanus* has a relatively wide distribution extending from the southern Cape Peninsula in the southwest, to the Boosmansbos Wilderness Area east of Barrydale, and the Langeberg north-east of Riversdale, whereas *A. walshii* has a highly restricted range in the Elgin Valley. Within the Kogelberg Biosphere Reserve, both taxa occur

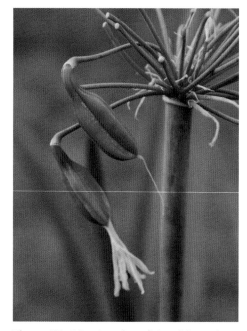

Figure 189. Ripening, glossy fruits of *Agapanthus walshii* (white form) in cultivation, showing distinct, proximal neck. Image: Graham Duncan.

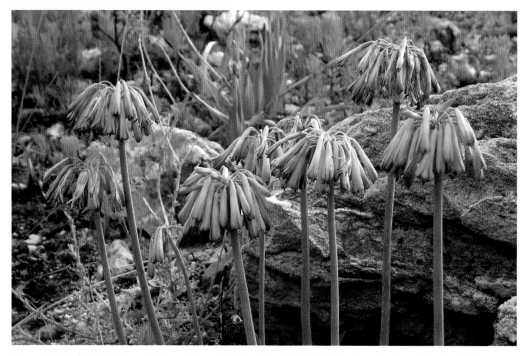

Figure 190. A light blue form of *Agapanthus walshii* flowering after fire in Overberg Sandstone Fynbos, Elgin. Image: Richard Jamieson.

within the 3418 BD grid, but in territorially isolated populations. *A. africanus* often forms large, spreading clumps sometimes comprising dozens of plants, but *A. walshii* often grows as solitary individuals or in much smaller clumps comprising up to six shoots.

DISTRIBUTION, HABITAT AND LIFE CYCLE. *Agapanthus walshii* is confined to the Elgin Valley just east of the Hottentots Holland Mountains, in the Overberg region of the southwestern Cape, from 600–730 m (Map 3). It occurs from Steenbras and the Kogelberg Biosphere Reserve in the west, to just west of Grabouw in the east, inhabiting windy environments on rocky east-, south- and west-facing sandstone slopes and ridges in acid sands in Kogelberg Sandstone Fynbos, and also occurs on elevated flats and gentle slopes (Figures 190, 191). The plants are encountered as scattered solitary individuals or in small to medium-sized clumps comprising up to

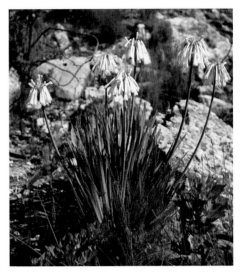

Figure 191. A white form of *Agapanthus walshii* flowering after fire in Overberg Sandstone Fynbos, Elgin. Image: Graham Duncan.

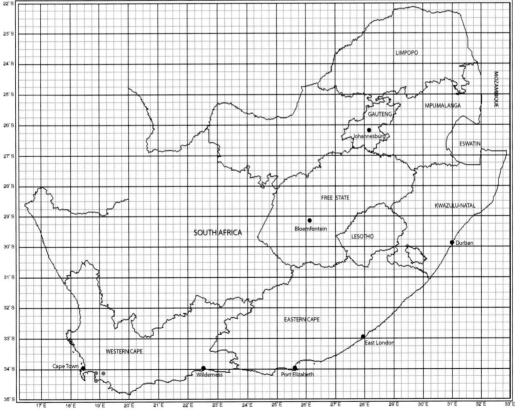

Map 3. Known distribution of *Agapanthus walshii*.

10 shoots, or sometimes in colonies comprising hundreds of plants, and in a rare instance a dense flowering clump with 16 scapes has been recorded (Peter Knox-Shaw, pers. comm.). Flowering mainly in January and February at the hottest and driest time of year, the plants survive by means of mats of extensive fleshy roots which lie within the relatively cooler environment beneath sandstone rock slabs and within rock fissures. Like *A. africanus*, it is strongly stimulated to profuse flowering following bush fires of the immediately preceding summer or autumn. This species is not a true pyrophyte though, since sporadic flowering does takes place during interfire periods (Duncan, 2004) (Figures 192, 193), although as few as 10% of mature plants may flower.

It is frequently seen flowering in association with fire-stimulated members of Iridaceae including the mauve- or purple-flowered *Thereianthus bracteolatus* (Lam.) G.J.Lewis and the bright orange *Watsonia schlechteri* L.Bolus, as well as the rhizomatous white Cape edelweiss, *Lanaria lanata* (L.) T.Durand & Schinz (Lanariaceae).

CONSERVATION STATUS. Endangered, as a result of habitat loss caused by informal settlement expansion, according to the SANBI Red List of South African Plants (version 2020.1) (Duncan &

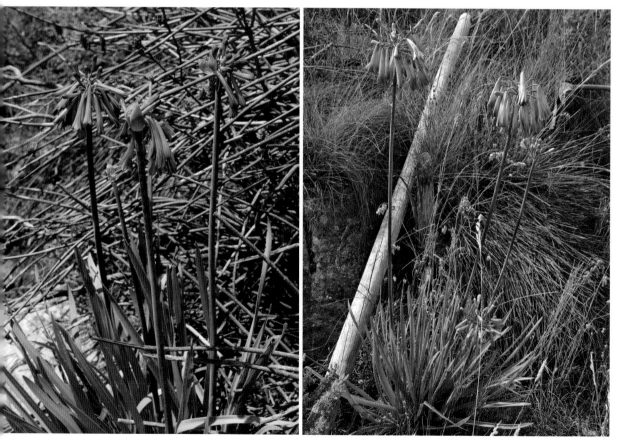

Figure 192 (left). A blue form of *Agapanthus walshii* flowering in thick, unburnt fynbos, Kogelberg Biosphere Reserve, Elgin, Overberg. Image: Graham Duncan.

Figure 193 (right). A bicoloured form of *Agapanthus walshii* flowering in unburnt fynbos, Kogelberg Biosphere Reserve, Elgin, Overberg. Image: Bennie Kruger.

Pillay, 2004). *A. walshii* is protected within the Kogelberg Biosphere Reserve, and on private farmland nearby, but the largest colony is under dire threat, due to a steadily encroaching informal settlement, and is ultimately doomed to extinction at this locality.

NOTES. The tubular or trumpet-shaped flowers of *A. walshii* are putatively pollinated by orange-breasted sunbirds. In addition to the ornamental attributes of the flowers, the sturdy scapes are covered with a most appealing bluish-grey waxy bloom. Unfortunately, it is the most difficult agapanthus to maintain in cultivation over the long term. It requires an extremely well-drained, acid sandy soil, and is usually best grown in deep containers placed where they will receive morning sun, or bright light throughout the day. The roots are highly susceptible to overwatering, requiring moisture mainly in winter, applied at widely separated intervals, and less in summer. Fresh seeds germinate readily within three weeks when sown directly after harvesting, and generally flower for the first time in their third year, under ideal conditions (Duncan, 2004). The leathery leaves are much less susceptible to insect attack than the softer leaves of most other species of *Agapanthus*, but they are subject to the fungus *Phomopsis agapanthi*, causing them to die back from the tips, especially in summer (Du Plessis & Duncan, 1989). *A. walshii* is half-hardy and decidedly requiring of protection in cold winter climates of the northern hemisphere, best grown in the cool greenhouse.

3. AGAPANTHUS PRAECOX

Agapanthus praecox Willd., *Enumeratio Plantarum Horti Regii Berolinensis*: 353 (1809). *Tulbaghia praecox* (Willd.) Kuntze, *Revisio Generum Plantarum* 2: 718 (1891). *Tulbaghia africana* (L.) Kuntze var. *praecox* (Willd.) Kuntze, *Revisio Generum Plantarum* 3(3): 317 (1898).

TYPE: South Africa, Cape, precise locality unknown, *C.L. Willdenow 6423* (B!, holo.).

SYNONYMY: *Agapanthus tuberosus* L. ex Redouté, *Les Liliacées* 1: t. 4 (1803), pro syn.

Agapanthus multiflorus Willd., *Enumeratio plantarum Horti Regii Berolinensis:* 353 (1809). *Agapanthus umbellatus* Willd. var. *multiflorus* (Willd.) Baker, *Flora Capensis* 6: 403 (1897).

Agapanthus giganteus Anon., *Wiener Illustrirte Garten-Zeitung* 5: 119 (1880). *Agapanthus umbellatus* L'Hér. var. *giganteus* (Anon.) L.H.Bailey, *The Standard Cyclopedia of Horticulture* 1: 229 (1914).

Agapanthus umbellatus L'Hér. var. *minimus* Ker Gawl., *The Botanical Register* 9: t. 699 (1823). *Agapanthus africanus* (L.) Hoffmanns. var. *minimus* (Ker Gawl.) Beauverd, *Bulletin de la Société Botanique de Genève* (ser. 2) 2: 198 (1910). *Agapanthus praecox* Willd. subsp. *minimus* (Ker Gawl.) F.M.Leight., *Journal of South African Botany* suppl. vol. 4: 22 (1965). Type: South Africa, Cape, collector and precise locality unknown, figure in *The Botanical Register* 9: t. 699 (1823), lectotype, designated by Duncan in *Bothalia* 35: 88 (2005).

Agapanthus umbellatus L'Hér. var. *maximus* Lindl., *Edwards's Botanical Register* 29(Misc.): t. 7 (1843). *Agapanthus africanus* (L.) Hoffmanns. var. *maximus* (Lindl.) T.Durand & Schinz, *Conspectus Florae Africae* 5: 355 (1893). Type: South Africa, Cape, collector and precise locality unknown, figure in *Edwards's Botanical Register* 29: t. 7 (1843) (lectotype, designated here).

Agapanthus longispathus F.M.Leight., *South African Gardening and Country Life* 24: 71, 82 (1934). Type: South Africa, Eastern Cape, Adelaide, 16 April 1928, *N.E. Meyer s.n.* sub. NBG 676/28 (BOL!, holo., iso.; NBG!, PRE!, iso.).

Agapanthus orientalis F.M.Leight., *Journal of South African Botany* 5: 57 (1939). *Agapanthus praecox* Willd. subsp. *orientalis* (F.M.Leight.) F.M.Leight., *Journal of South African Botany* suppl. vol. 4: 21 (1965). Type: South Africa, Eastern Cape, Port St Johns, coll. 1932, *N. Pillans 7198* (BOL!, holo.), synon. nov.

Agapanthus comptonii F.M.Leight. subsp. *comptonii, Journal of South African Botany*, suppl. vol. 4: 24, 27 (1965). Type: South Africa, Eastern Cape, Kaffir Drift, 25 February 1953, *R.H. Compton s.n.* sub. NBG 397/45 (BOL!, holo., iso.).

Agapanthus comptonii F.M.Leight. subsp. *longitubus* F.M.Leight., *Journal of South African Botany*, suppl. vol. 4: 27 (1965). Type: South Africa, Eastern Cape, Chalumna Causeway, 3 February 1953, *G.G. Smith s.n.* sub. NBG 135/45 (BOL!, holo.; NBG!, PRE!, iso.).

CULTIVARS: *Agapanthus umbellatus* L'Hér. var. *variegatus* G.Sinclair, *Miller's Dictionary of Gardening:* 89 (1834).

Agapanthus umbellatus L'Hér. *variegatus* (G.Sinclair) Hovey, Nursery Catalogue (Hovey & Co.) 1882: 16 (1882).

Agapanthus variegatus Steud., *Nomenclator Botanicus* (Steudel) 2(1): 33 (1840), pro syn.

Agapanthus umbellatus L'Hér. var. *flore-pleno* Van Geert, Nursery Catalogue (Auguste Van Geert) 76: 2 (1878).

A. umbellatus L'Hér. var. *flore-albo* Van Geert, Nursery Catalogue (Auguste Van Geert) 78: 4 (1879).

Agapanthus umbellatus L'Hér. *albus* Hovey, Nursery Catalogue (Hovey & Co.) 1882: 16 (1882).

Agapanthus umbellatus L'Hér. var. *excelsus* Ed. Otto, *Hamburger Garten-Blumenzeitung* 39: 282 (1883).

Agapanthus umbellatus L'Hér. var. *multiflorus* Ed. Otto, *Hamburger Garten-Blumenzeitung* 39: 282 (1883).

Agapanthus umbellatus L'Hér. var. *aureus* G.Nicholson, *Illustrated Dictionary of Gardening:* 36 (1884).

Agapanthus umbellatus L'Hér. var. *pallidus* L.H.Bailey, *The Standard Cyclopedia of Horticulture* 1: 230 (1914).

Agapanthus umbellatus L'Hér. var. *praecox* L.H.Bailey, *The Standard Cyclopedia of Horticulture* 1: 230 (1914).

Agapanthus umbellatus L'Hér. *albus* J.R.Duncan & V.C.Davies, Nursery Catalogue (Duncan & Davies) 1925: xiii (1925).

Agapanthus umbellatus L'Hér. *intermedius* J.R.Duncan & V.C.Davies, Nursery Catalogue (Duncan & Davies) 1925: xiii (1925).

Agapanthus umbellatus L'Hér. *maximus* J.R.Duncan & V.C.Davies, Nursery Catalogue (Duncan & Davies) 1925: xiii (1925).

Agapanthus umbellatus L'Hér. *maximus-albus* J.R.Duncan & V.C.Davies, Nursery Catalogue (Duncan & Davies) 1925: xiii (1925).

NAME. *praecox*: early, descriptive of the early appearance of the flowers in certain forms of this species.

COMMON NAMES. common agapanthus, blue lily, bloulelie (Afrikaans), agapant (Afrikaans), gewone agapant (Afrikaans), isicakathi (Xhosa), ubani (Zulu).

DESCRIPTION. Extremely variable evergreen, mainly summer-growing perennial 0.7–1.4 m high in flower, gracile or robust, strongly clump-forming. *Rhizome* horizontal, 50–220 × 15–50 mm. *Pseudostem* 30–200 × 12–50 mm, erect or suberect, light to deep green or glaucous, plain or purple-flushed; usually tightly surrounded by old, dried leaf remains, basal sheathing leaves absent. *Leaves* 6–20 per shoot, strap-shaped or oblanceolate, 150–650 × 7–50 mm, produced in arching or suberect fans, soft-textured or subcoriaceous, canaliculate, light to deep green or intensely glaucous; apices acute or subacute; margins entire, slightly to moderately cartilaginous, green or dull yellow. *Scape* suberect, 0.6–1.3 × 5–15 mm, moderately to strongly compressed, rigid or slightly lax, covered with a colourless or light grey waxy powder; spathe bracts ovate, 45–65 × 20–40 mm, translucent brownish-cream, longitudinal veins light brown. *Pseudo-umbel* globose or subglobose, 120–250 mm across, 15–120-flowered; bracteoles 8–20, filiform or narrowly lanceolate, 8–15 mm long, white; pedicels 35–90 mm long, radiating in all directions or suberect and spreading, more or less straight, firm or lax, green, glaucous or purple-flushed. *Perianth* narrowly or widely funnel-shaped (tepals radiate >15° up

to 30° or more from longitudinal axis); tepals light to bright blue or pastel-blue, rarely ivory or white, deeper-coloured median stripe on upper surface, median ridge prominent on lower surface, thin-textured, margins entire or slightly undulate; perianth tube cylindrical, 10–25 mm long, containing nectar; outer tepals lanceolate, 19–35 × 5–8 mm, apices acute or subacute; inner tepals broadly oblanceolate or narrowly spathulate, 20–36 × 7–12 mm, apices obtuse. *Stamens* declinate, included or shortly exserted, filaments light blue or white; outer filaments 15–35 mm long; inner filaments 14–27 mm long; anthers 2.0–3.5 mm long, pollen brown, yellowish-brown or bright yellow. *Ovary* ellipsoid, 7–17 × 2–4 mm, light green; style declinate, 11–34 mm long, white or light blue. *Capsule* ellipsoid, 27–40 × 5–12 mm, apices acute, subacute or obtuse. *Seed* obovate, 4–5 × 3–4 mm, black; wing more or less oblong, 6–8 × 3–4 mm. *Chromosome number:* 2n = 29; 30; 32; 32+2B (Riley & Mukerjee, 1962); 2n = 30; 30+0-2B (Muzila & Spies, 2005). Plates 5, 6; Figures 68–71, 84, 92, 98, 99, 101, 119, 120, 121, 126, 135, 137, 140, 141, 143, 145, 147, 152, 153, 155, 158–163, 175–177, 194–205.

FLOWERING PERIOD. December to April, with a peak from late December to late January.

HISTORY. Prior to the publication of *A. praecox* by Carl Ludwig von Willdenow in 1809, an illustration of the species had already appeared on plate 500 of *The Botanical Magazine*, erroneously under the name *A. umbellatus* L'Hér. (= *A. africanus*) (Curtis, 1800) (See Figure 4 on page 4). Because of the superficial similarity of *A. africanus* flowers to those of small forms of *A. praecox*, the misidentification of the figured plant (which is clearly *A. praecox*) and misapplication of the name *A. umbellatus*, led to untold confusion, which largely continues to the present. Numerous forms of *A. praecox* were brought into cultivation during the 19th century, most of which were published as varieties of *A. umbellatus*. Ker Gawler (1823) illustrated a small form of the species as *A. umbellatus* var. *minimus* on plate 699 of *The Botanical Register*, from material said to have been imported from an unrecorded location at the Cape. The plant had much smaller, light blue flowers and narrower leaves than other forms of *A. umbellatus* (*A. praecox*) already in cultivation in England, and the painting by M. Hart which accompanied it, compares well with forms of the plant from Knysna in the southern Cape. In 1843, John Lindley described a robust, evergreen agapanthus with large, blue flowers of unrecorded wild origin, as *A. umbellatus* var. *maximus* (*A. praecox*) in *Edwards's Botanical Register*, illustrated by Sarah Drake (Figure 194).

In 1934, Leighton described a different small form of *A. praecox* from Adelaide in the eastern Great Karoo as *A. longispathus*, and in 1939 she

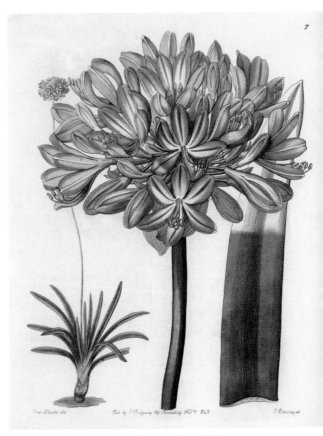

Figure 194. Engraved plate of *Agapanthus umbellatus* var. *maximus* (= *A. praecox*) by Sarah Drake, reproduced from *Edwards's Botanical Register*, plate 7, volume 29 (1843).

described robust plants from Port St Johns in the Eastern Cape as *A. orientalis*. During the course of her research towards a monograph, she came to the conclusion that *A. praecox* was an aggregate species, and that Ker Gawler's *A. umbellatus* var. *minimus*, and Lindley's *A. umbellatus* var. *maximus*, as well as her *A. longispathus* and *A. orientalis*, all represented morphological forms of the same species. Thus, she re-assessed *A. praecox* to comprise three taxa, subsp. *praecox*, subsp. *minimus* and subsp. *orientalis*, based on differences in perianth length, height and density of the inflorescence, and density of the plant clumps (Leighton, 1965). Two plates of a robust form of *A. praecox* (subsp. *orientalis*) by Cythna Letty were subsequently published in volume 37 of *The Flowering Plants of Africa*, one illustrating a life-size inflorescence, the other showing a leaf, details of the flowers, and monochrome drawings of the capsule and a reduced version of the whole plant, from material originally collected at Tsolo in the Transkei. Here, Dyer expressed the opinion that he would not find it surprising if the distinguishing characters between the three subspecies of *A. praecox*, as recognised by Leighton, were to 'break down on occasions', an opinion with which I concur (Dyer, 1966d).

DISTINGUISHING FEATURES AND AFFINITIES. In her key to the subspecies of *A. praecox*, Leighton (1965) distinguished subsp. *praecox* from subsp. *orientalis* and subsp. *minimus* by the length of its perianth (50 mm long or more), and those of subsp. *orientalis* and subsp. *minimus* (less than 50 mm long). She further distinguished subsp. *orientalis* from subsp. *minimus* by its dense flowerhead, by the plants forming dense clumps, and in having a scape usually 600 mm long or more in length, and subsp. *minimus* in its few- or many-flowered heads and smaller-sized plant, and not forming dense clumps, and having a slender scape usually less than 600 mm long. In her descriptions of the subspecies, she noted that subsp. *praecox* had 10–11 leaves per shoot, which were more or less erect, leathery, about 600 mm long and 30–40 mm wide, with subacute apices, with a many-flowered, stout scape 0.8–1.0 m high, with spreading pedicels often 100–120 mm long; a perianth 50–70 mm long, a perianth tube 20–26 mm long, with the tepals spreading, but not widely, with the outer tepals lanceolate and 7–8 mm wide, and the inner tepals oblanceolate with obtuse apices and 9–11 mm wide. She described subsp. *orientalis* as having up to 20 leaves per shoot, which were soft-textured and arcuate, with the perianth usually 40–45 mm long and the tepals spreading, with the outer tepals 60–80 mm wide, and the inner tepals 9–11 mm wide. Subsp. *minimus* she described as having 7–10 leaves per shoot and short and leathery, not soft-textured, often spreading horizontally, and 200–300 mm long and up to 25 mm wide. She described the scape as stiff, 400–600 mm high, bearing a few- to many-flowered head which was never dense, and with the perianth spreading widely, and 30–45 mm long, with the outer tepals lanceolate, 6–7 mm wide with subacute apices and appreciably narrower than the inner ones, which were obovate, and up to 12 mm wide, with the apices obtuse or emarginate, and the stamens shorter than the perianth (Plate 5).

While it is desirable to want to subdivide such a variable and widespread species, the characters used by Leighton are, unfortunately, ambiguous, as they don't form clearly discontinuous units, but rather, a continuum, and as a result, the subspecies cannot easily be distinguished due to the occurrence of numerous intermediate forms, and cannot be upheld. As examples, the perianth of subsp. *praecox* is sometimes less than 50 mm, as in plants occurring in the Longmore Forest Reserve near Hankey in the Eastern Cape, the leaves of subsp. *orientalis* are not always soft-textured and arcuate, but sometimes leathery and suberect, as in plants occurring on Barkly Pass and at Khalinyanga in the Eastern Cape (Figures 195, 196). Similarly, those of subsp. *minimus* are not always short and leathery, but often soft-textured and arcuate, as in plants occurring at Knysna in the southern Cape and Adelaide in the Eastern Cape. Furthermore, subsp. *minimus* does sometimes have leaves as wide as those of subsp. *orientalis*, such as forms occurring at Storms River mouth in the Eastern Cape (Plate 6), and subsp. *minimus* does sometimes form dense clumps at this locality, and at Knysna. In addition, McNeil (1972)

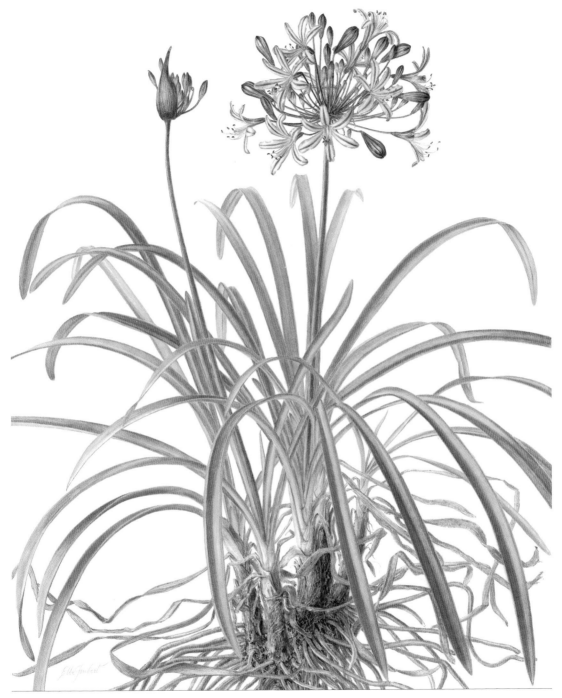

PLATE 5

Artist: Elbe Joubert

Watercolour painting of *Agapanthus praecox* 'Adelaide' from Adelaide, Eastern Cape
(*Meyer s.n.*, NBG 676/28). Image 40% of life size.

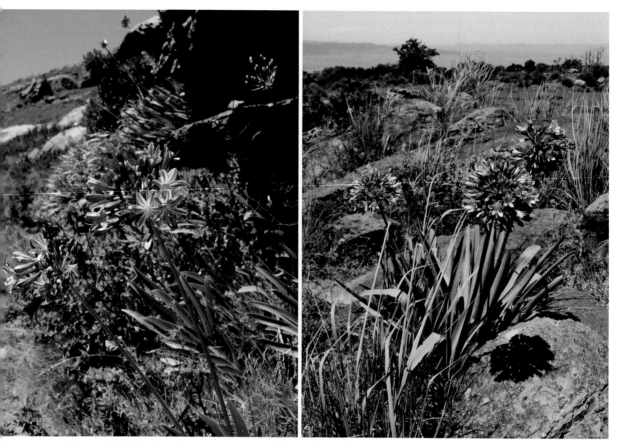

Figure 195 (left). *Agapanthus praecox* on a west-facing rocky sandstone slope, Barkly Pass, Eastern Cape. Image: Graham Duncan.

Figure 196 (right). Leathery, suberect leaves of *Agapanthus praecox*, Khalinyanga, Eastern Cape. Image: Graham Duncan.

reportedly observed all three subspecies occurring within the same population on the Katberg Pass in the Eastern Cape.

Leighton (1965) also described *A. comptonii*, a dwarf species comprising subsp. *comptonii* and subsp. *longitubus*, which she distinguished from one another by the perianth tube of subsp. *comptonii* being one third or less of the perianth length, and subsp. *longitubus* being more than one third and nearly half the length of the perianth. The flowers of *A. comptonii* subsp. *comptonii* strongly resemble certain forms of *A. praecox* subsp. *minimus*, as do its leaves, and except for its dwarf habit and longer perianth tube (20–25 mm long), flowers of *A. comptonii* subsp. *longitubus* resemble certain forms of *A. praecox* subsp. *orientalis*. In a study of genome size in *Agapanthus*, the nuclear DNA content obtained for *A. comptonii* subsp. *comptonii* and *A. comptonii* subsp. *longitubus* was shown to fall within the range of that of *A. praecox* subsp. *minimus*, and *A. comptonii* was placed in synonymy under *A. praecox* subsp. *minimus* (Zonneveld & Duncan, 2003; Duncan, 2005).

In a subsequent in-depth morphological investigation of perianth and leaf characters in *A. praecox* (including tepal and leaf length and width, perianth tube length, filament and style length and orientation, leaf length and width), I have not been able to find any characters that are reasonably constant for

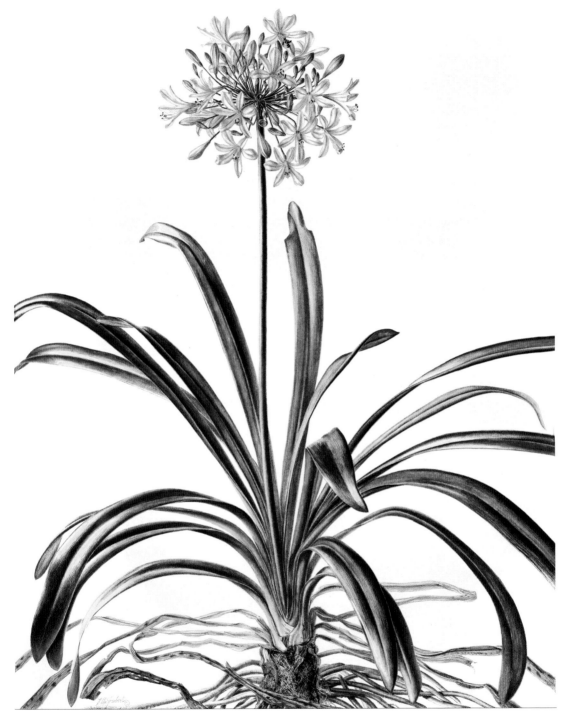

PLATE 6 Artist: Elbe Joubert

Watercolour painting of *Agapanthus praecox* 'Storms River', from Storms River mouth,
Eastern Cape (*Leighton 3106*; NBG 36/54). Image 25% of life size.

the purposes of subdivision, and have come to the conclusion that, due to extreme variation, the subspecies recognised by Leighton form a continuum rather than well-defined taxa, and can no longer be justified. *A. praecox* is thus regarded here as a single, extremely variable, aggregate species.

Agapanthus praecox is recognised in a vegetative state by arching or suberect fans of evergreen, strap-shaped or oblanceolate, channelled, light to deep green or intensely glaucous leaves with acute or subacute apices. Leaf length and width are extremely variable, and depending on wild location, vary from 150–650 mm long and 7–50 mm wide, and leaf colour is variable within some populations, for example plants occurring at Khalinyanga in the Eastern Cape have mainly glaucous, leaves but green-leaved clones also occur. Forms with glaucous leaves from relatively high altitude, such as from Barkly Pass in the Eastern Cape, are much more cold-tolerant than those with green leaves from lower altitude. Leaf width varies considerably within some populations, such as at Storms River in the Eastern Cape, where narrow-leaved plants predominate, but forms with leaves up to 30 mm wide also occur. The species has narrowly- or widely funnel-shaped flowers with included or shortly exserted, declinate stamens and a declinate style, and perianth size varies from small-flowered, light blue forms with short perianth tubes (10 mm long) and tepals (19–20 mm long) and narrow leaves (7–10 mm wide) at Storms River mouth (Figure 197) and Knysna in the southern Cape, to robust specimens with large, bright blue flowers, long perianth tubes (22–25 mm long) and broad leaves (30–50 mm wide) on Cambria Pass near Loerie in the southern Eastern Cape. Flower head shape and density varies from small, subglobose, relatively 'open' heads with 15–20 flowers near Wilderness and Knysna, to medium-sized, globose and dense heads comprising up to 70 flowers near Mtentu River in the Eastern Cape (Figure 198), and large, dense heads with 100 flowers or more near the mouth of the Umzimvubu River near Port St Johns. A pure white form is recorded from the latter locality, growing among

Figure 197. Light blue form of *Agapanthus praecox*, Storms River Mouth, Eastern Cape. Image: Graham Duncan.

Figure 198. Bright blue form of *Agapanthus praecox*, Mtentu, Eastern Cape. Image: Neil Crouch.

blue-flowered plants (*Leighton s.n.*, in PRE). A double-tepal form of *A. praecox* collected at Alice in the Eastern Cape (Kirstenbosch Garden accession number 447/53) (Figure 199), strongly resembles the cultivar *A. praecox* 'Flore Pleno', known in France since 1878. Pollen colour in light to deep blue-flowered forms of *A. praecox* is always brown or yellowish-brown, and in white forms it is bright yellow. The results of a study of genome size in *Agapanthus* indicated a relatively high nuclear DNA content (25.08–26.08 pg) for a range of *A. praecox* accessions mainly from wild collections (Zonneveld & Duncan, 2003; Duncan, 2005).

The flowers of certain small forms of *A. praecox* are superficially similar to those of *A. africanus*, which also has narrowly- or widely funnel-shaped flowers, declinate stamens and brown or bright yellow pollen, but the latter differs markedly in its leathery, deeply canaliculate leaves and thick-textured tepals, and the species has a substantially higher average nuclear DNA content of 31.6 pg. Forms of *A. praecox* with medium-sized flower heads are superficially similar

Figure 199. Double-tepal form of *Agapanthus praecox* from Alice, Eastern Cape, in cultivation, Kirstenbosch. Image: Graham Duncan.

to *A. pondoensis,* which has similar funnel-shaped flowers, and yellowish-brown pollen, the latter differing in its deciduous, summer-growing habit, prominent pseudostem with basal sheathing leaves, and somewhat narrower flowers, with straight or slightly declinate styles.

DISTRIBUTION, HABITAT AND GROWTH CYCLE. *A. praecox* has the third-widest distribution of all agapanthus after *A. caulescens* and *A. campanulatus,* extending from just west of Wilderness in the southern Cape, in an easterly direction to Krantzkloof Nature Reserve in southeastern KwaZulu-Natal, inland to Mortimer and north of Pearston in the western Eastern Cape, and to Barkly Pass in the northern part of this province (Map 4). It is always associated with rocky terrain, and frequents a wide range of habitats from just above sea level to 2010 m on Barkly Pass in the Eastern Cape. It favours niches between boulders along river mouths (Figure 200), semi-shaded conditions near waterfalls (Figure 201), coastal scrub of embankments (Figure 202), along stream banks and forested watercourses, on rocky outcrops on hill and mountain slopes (Figure 203), in gullies, on edges of gorge cliffs, inaccessible wet ledges and in crevices of steep rock faces, in forest clearings and along forest margins. It is often found in light to moderate shade on south-, south-east and east-facing rocky slopes, but also occurs in full sun, in both heavy and sandy soils, and in numerous vegetation types including Knysna Sand Fynbos, Southern Afrotemperate Forest, Transkei Coastal Belt, Camdebo Escarpment Thicket, Karoo Escarpment Grassland, Southern Drakensberg Highland Grassland, Tsomo Grassland and KwaZulu-Natal Coastal Belt.

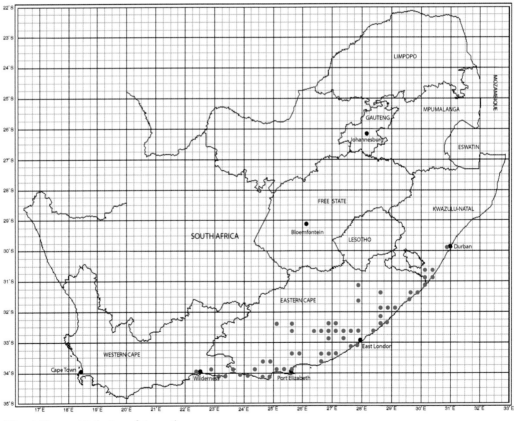

Map 4. Known dsitribution of *Agapanthus praecox.*

Figure 200. *Agapanthus praecox* among sandstone boulders, Mtentu River mouth, Eastern Cape. Image: Neil Crouch.

Figure 201. *Agapanthus praecox* in shaded riverine scrub, Mtentu River, Eastern Cape. Image: Neil Crouch.

Figure 202. Dwarf form of *Agapanthus praecox* along a coastal embankment, Knysna, southern Cape. Image: Fanie Avenant.

Agapanthus praecox is an evergreen species, producing new leaves in winter in the southern parts of its range, and in summer in inland and eastern parts. The species has a long flowering period in the wild from early summer to mid-autumn, but within populations, a remarkably low number of individuals produce flowers in any given year. In general, the earliest-flowering populations are those from the southern Cape which start in December, and the latest ones are in coastal parts of the Eastern Cape and KwaZulu-Natal, which flower from mid- to late autumn, and the peak flowering period is from late December to late January. Wind-dispersed seeds of this species from cultivation readily colonise roadsides along drainage lines in South Africa, such as along Sir Lowry's Pass in the Overberg, and robust plants occurring at Kaaimans River Mouth in the southern Cape are considered probable hybrids from gardens in the vicinity.

CONSERVATION STATUS. *A. praecox* is not threatened. The taxon previously recognised as *A. praecox* subsp. *praecox* was assessed as Least Concern, according to the SANBI Red List of South African Plants (version 2020.1) (Cholo & Kamundi, 2006), as were the taxa previously recognised as *A. praecox* subsp. *minimus* and *A. praecox* subsp. *orientalis* (Foden & Potter, 2005b; 2005c).

NOTES. In its natural habitat, *A. praecox* has multiple insect pollinators including nectar-feeding tabanid flies, at least three species of solitary bee, and numerous butterflies, including swallowtails. In cultivation at Kirstenbosch it is most often visited by Cape honeybees, and orange-breasted and southern double-collared sunbirds sometimes 'rob' nectar by piercing the base of the perianth tube. The most easily

cultivated of the evergreen agapanthus, *A. praecox* flowers well in full sun or light shade, and although it adapts to a wide range of soil types, it prefers a humus-rich, loamy soil. Once established, the thick root mats easily survive winter drought, but for best flowering results, should ideally receive at least monthly heavy watering in summer. In cultivation, certain wild-collected forms commence flowering much earlier than they do in the wild, such as 'Adelaide' from the Eastern Cape, which commences flowering at Kirstenbosch as early as the beginning of October. Coastal forms of *A. praecox* from the Western and Eastern Cape, and KwaZulu-Natal, can generally be regarded as half-hardy and requiring of protection in cold winter climates of the northern hemisphere, though inland forms from high-lying areas of the Eastern Cape are reasonably hardy.

A word of caution is essential with respect to the virtually indestructible nature of robust forms of *A. praecox* (especially those previously known as subsp. *orientalis*) when grown in temperate climates. It is often used in roadside plantings in South Africa, the Mediterranean, Australia, New Zealand and California, and has escaped into the wild from parks and gardens in numerous countries, including Australia, Ethiopia, Jamaica, Madeira, Mexico, New Zealand (Dawson *et al.*, 2018), Brazil (Duncan, 2003) and in the south-west of the United Kingdom. During the mid-1850s the philanthropist Augustus Smith introduced it in Tresco Abbey Garden which he founded in the Scilly Isles, whereupon it became naturalised across sand dunes of the islands by means of wind-dispersed seed (Taylor, 2008). Similarly, the plant gained a foothold in a seaside garden near St Austell, Cornwall where, despite being left to its own devices for ten years, growing in poor, stony shale soil, and subject to strong wind, it multiplied to such an extent that when seen flowering en masse on a cliff-top, it commanded a breath-taking sight (Lighton, 1973). Among numerous areas of invasion in New Zealand, where it is seriously impacting native ecosystems, it has become naturalised along the north coast of Coromandel Peninsula in North Island, easily withstanding salt wind and drought (Dawson & Ford, 2012) (Figures 204, 205).

Figure 203. *Agapanthus praecox* on a steep, north-east facing rocky slope, Khalinyanga, Eastern Cape. Image: Graham Duncan.

Figure 204. *Agapanthus praecox* naturalised on dunes, Opito Bay, Coromandel Peninsula, New Zealand.
Image: Trevor James.

Figure 205. Profuse flowering in *Agapanthus praecox* on dunes, Opito Bay, Coromandel Peninsula, New Zealand.
Image: Trevor James.

4. AGAPANTHUS CAULESCENS

Agapanthus caulescens Sprenger, *Gartenflora* 50: 21, 22, 281, t. 1487 (1901).

TYPE: South Africa, 'Transvaal Drakensberg', precise locality unknown, seeds collected by Dietrich, late 1890s, figure in *Gartenflora* 50, t. 1487 (1901) (lectotype, designated by Leighton (1965)).

SYNONYMY: *Agapanthus insignis* W.Bull, Nursery Catalogue (William Bull) 377: 1 (1904), synon. nov. *Agapanthus umbellatus* L'Hér. var. *insignis* (W.Bull.) L.H.Bailey, *The Standard Cyclopedia of Horticulture* 1: 230 (1914), synon. nov. Type: South Africa, collector and precise locality unknown, figure in Nursery Catalogue (William Bull) 377: page ii (1904) (lectotype, designated here).

Agapanthus gracilis F.M.Leight., *Journal of South African Botany* 11: 101 (1945). *Agapanthus caulescens* Spreng. subsp. *gracilis* (F.M.Leight.) F.M.Leight., *Journal of South African Botany*, suppl. vol. 4: 36 (1965), synon. nov. Type: South Africa, KwaZulu-Natal, top of Ubombo-Ingwavuma Mountain Range, February 1939, *J. Gerstner 3189* (BOL!, holo.; K!, NBG!, iso.).

Agapanthus caulescens Sprenger subsp. *angustifolius* F.M.Leight., *Journal of South African Botany*, suppl. vol. 4: 36 (1965), synon. nov. Type: Eswatini, near Mbabane, 5 miles (8 km) east of Forbes Reef, 22 January 1959, *S. Thompson s.n.* sub. NBG 686/54 (BOL!, holo.; NBG!, iso.).

Agapanthus nutans F.M.Leight., *Journal of South African Botany* suppl. vol. 4: 38 (1965). Type: South Africa, KwaZulu-Natal, Mooi River, *P. Cheape s.n.* sub. NBG 824/53 (BOL!, holo., iso; NBG!, iso.).

NAME. *caulescens*: descriptive of the distinctive pseudostem.

COMMON NAMES. stem agapanthus, hlakahla (Swazi).

DESCRIPTION. Extremely variable, deciduous, robust or gracile, summer-growing perennial, 0.6–1.50 m high in flower, clump-forming. *Rhizome* horizontal, 60–100 × 15–40 mm. *Pseudostem* 25–120 × 15–40 mm, erect or suberect, light green or glaucous, purple-flushed or plain, base bulbous; basal sheathing leaves 2–8, 20–60 × 10–40 mm, spreading or suberect, light to dark green or intensely glaucous. *Leaves* 8–13 per shoot, strap-shaped or lanceolate, 200–650 × 20–60 mm, produced in strongly arching, erect or suberect fans, soft-textured or subcoriaceous, canaliculate, light to bright green, dark green or intensely glaucous, sometimes weakly spirally twisted in upper part; apices obtuse, subacute or acute; margins entire or slightly undulate, slightly or moderately cartilaginous, dull yellow or glaucous. *Scape* erect or suberect, 0.6–1.0 m × 8–12 mm, slightly compressed, sturdy or gracile, covered with a light grey or green bloom. *Pseudo-umbel* subglobose, 110–260 mm across, 25–100-flowered; spathe bracts ovate, 35–60 × 18–30 mm, translucent brownish-cream, longitudinal veins light brown; bracteoles 10–20, filiform or narrowly lanceolate, 5–15 mm long, translucent white; pedicels 30–90 mm long, radiating, more or less straight, fairly lax, green or purple-flushed. *Perianth* widely funnel-shaped (tepals radiate >30° from longitudinal axis), spreading, suberect or nodding, bright blue, deep blue or deep violet blue; perianth tube tubular, 15–25 mm long, often deeper blue or deeper violet-blue towards base, containing nectar; tepals bright blue or violet-blue, median ridge prominent on lower surface, deep blue or deep violet-blue, margins entire or slightly undulate; outer tepals narrowly oblanceolate, 20–35 × 5–8 mm, apices acute; inner tepals narrowly spathulate or spathulate, 21–34 × 6–8 mm, apices obtuse. *Stamens* declinate, included; filaments 16–28 mm long, white in lower half, shading to light to deep lilac above; anthers 1.5–2.0 mm long; pollen lilac. *Ovary* narrowly ellipsoid, 7–9 × 2–3 mm; style strongly declinate, 17–28 mm long, light to deep lilac; stigma minutely capitate, white. *Capsule* ellipsoid, 18–35 × 6–11 mm, apices obtuse or subacute. *Seed* ovate, 4 × 3–4 mm, wing oblong, 6–7 × 4–5 mm. Chromosome number: 2n=30 + 0–2B (Muzila & Spies, 2005). Plate 7, Figures 88, 94, 117, 123, 206–214.

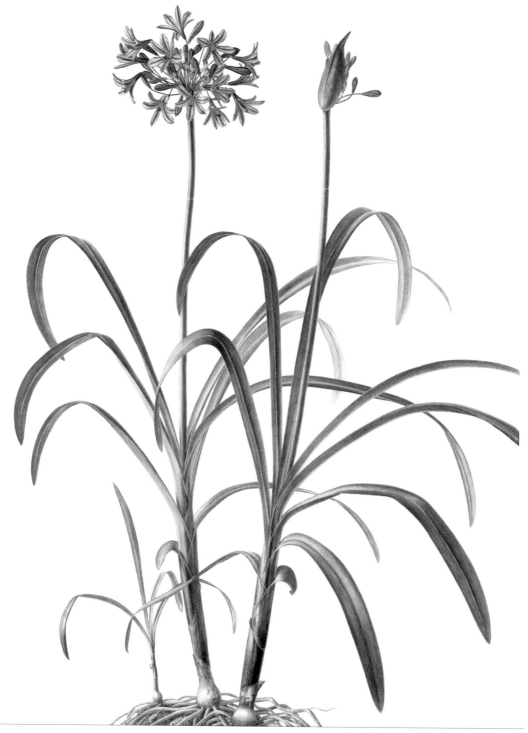

PLATE 7

Artist: Elbe Joubert

Watercolour painting of *Agapanthus caulescens* 'Politique' from Pietermaritzburg, KwaZulu-Natal (*Beard s.n.*, NBG 123/60). Image 25% of life size.

FLOWERING PERIOD. December to late February, with a peak in January.

HISTORY. The German botanist and horticulturist Carl Ludwig Sprenger (1846–1917) described *A. caulescens* from plants raised from seed collected by a friend, known only as Dietrich, in the late 1890s, which had been collected at an unspecified locality in the former 'Transvaal' Drakensberg, possibly in the current province of Limpopo. It was published in volume 50 of the German botanical magazine *Gartenflora* (Sprenger, 1901). The unsigned chromolithograph by Emil Laue accompanying Sprenger's text illustrates a coloured flower head in full bloom, a single broad leaf with an obtuse apex, as well as a reduced, monochrome sketch of a flowering plant with its distinctive caulescent pseudostem, and two offsets. A talented plantsman, Sprenger germinated the seeds, which flowered within three years in the summer of 1900 at the horticultural company Dammann & Co., which he owned in partnership at Villa de Biase in Vomero, Naples, in southwestern Italy. Although much of his prized plant collection was destroyed by volcanic ash following the eruption of Mt Vesuvius in April 1906, material of his *A. caulescens* is thought to have survived and been passed to the National Botanic Gardens at Glasnevin near Dublin, Ireland, and to the Royal Botanic Gardens, Kew. A plant of this collection was acquired by Frances Leighton at Kew, and grown at Kirstenbosch National Botanical Garden for many years (Leighton, 1965).

In 1903, an agapanthus sent from an unrecorded locality in South Africa flowered in the nursery of William Bull and Sons of Chelsea, London. It had lavender, funnel-shaped blooms produced on long, straight pedicels in a dense, hemispherical head atop a strong, tall scape. It was featured as *Agapanthus insignis* on page 67 of *The Garden* in July, 1903, accompanied by a monochrome photograph. The plant was subsequently offered for sale by William Bull and Sons in one of their 1904 catalogues, accompanied by a description and monochrome plate. The many-flowered inflorescence, and two very broad, arching leaves with distinctive ridged margins, compare well with large forms of *A. caulescens*, however this particular form does not appear to be in cultivation any longer.

Leighton (1945) described *Agapanthus gracilis* in volume 11 of the *Journal of South African Botany*, from type material collected in the Ubombo-Ingwavuma Mountain range in northern KwaZulu-Natal. She named it *gracilis* mainly on account of its slender, lax habit, and in her subsequent revision of *Agapanthus* she re-assessed it as a subspecies of *A. caulescens*. It was published alongside a watercolour painting by W.F. Barker of a plant from the type collection, made by the German botanist Jacob

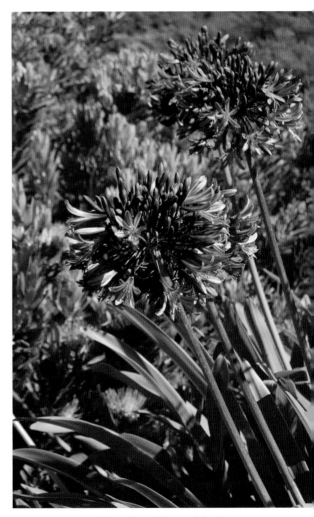

Figure 206. *Agapanthus caulescens* from Zululand, northern KwaZulu-Natal, in cultivation, Kirstenbosch.

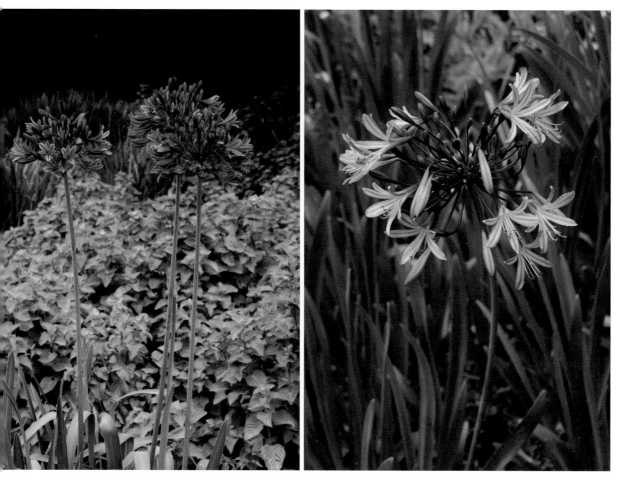

Figure 207 (left). *Agapanthus caulescens* 'Politique' from Pietermaritzburg, KwaZulu-Natal, in cultivation, Kirstenbosch. Image: Graham Duncan.

Figure 208 (right). *Agapanthus caulescens* from Mooi River, KwaZulu-Natal in cultivation, Kirstenbosch. Image: Graham Duncan.

Gerstner, in February 1939, on the Ubombo-Ingwavuma Mountains in northern KwaZulu-Natal (Leighton, 1965). Subsequently, a plant from the type collection, received from Kirstenbosch in 1956 and cultivated at Kew, was featured on plate 632 of *Curtis's Botanical Magazine* (new series) with an outstanding illustration by Margaret Stones (Hunt, 1972–1973). In 1965, Leighton described a new subspecies, *A. caulescens* subsp. *angustifolius,* mainly on account of its stiffly erect leaves, with acute or subacute apices (as compared with the typical subspecies), from type material collected by Miss S. Thompson at Forbes Reef near Mbabane, Eswatini. Leighton (1965) also described a new, deciduous species which she named *A. nutans* from KwaZulu-Natal and Limpopo, which was ultimately placed in synonymy under *A. caulescens* (subsp. *gracilis*) (Zonneveld & Duncan, 2003; Duncan, 2005). The cultivar *A. caulescens* 'Politique' is a selection from the wild from the farm 'Politique' near Pietermaritzburg, KwaZulu-Natal, with deep violet-blue, widely funnel-shaped blooms produced on sturdy, upright stems, with glaucous, upright leaves (Duncan, 1985; 1998) (Plate 7).

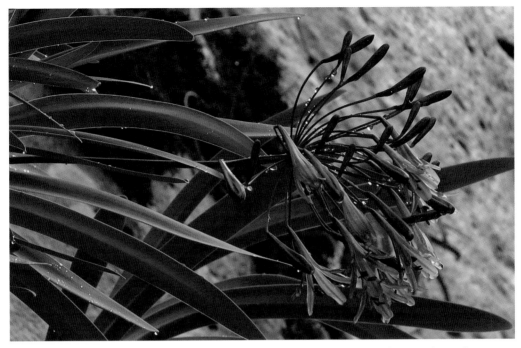

Figure 209. *Agapanthus caulescens* on a steep sandstone ledge, Royal Natal National Park, KwaZulu–Natal. Image: Neil Crouch.

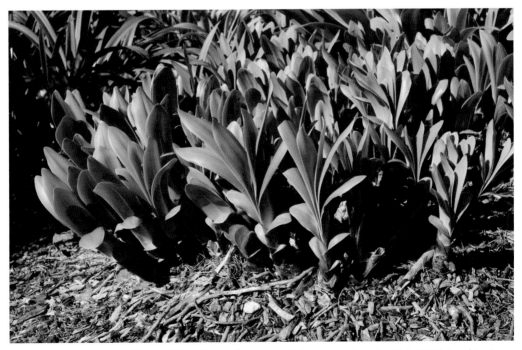

Figure 210. Emerging new leaves of *Agapanthus caulescens* from Zululand, northern KwaZulu–Natal, in cultivation, Kirstenbosch. Image: Graham Duncan.

DISTINGUISHING FEATURES AND AFFINITIES. *A. caulescens* is regarded here as an extremely variable, aggregate species, recognised by medium-sized to large, more or less subglobose heads (110–260 mm in diam.) of widely funnel-shaped, bright blue or violet-blue blooms, often with contrasting deep blue or deep violet-blue perianth tubes, and purple-flushed or green pedicels (Figures 206–209). Pedicel length varies greatly, sometimes reaching up to 90 mm long in the northern Drakensberg of western KwaZulul-Natal. The outer tepals are narrowly oblanceolate, and the inner tepals are spathulate, with the tepal margins entire or slightly undulate. The stamens and style are included and strongly declinate, with the filaments light to deep lilac in the upper half, and white in the lower half. The plant has a prominent, narrow or broad, light green or glaucous pseudostem which is flushed with purple or unmarked, with 2–8 basal sheathing leaves and a fan of 8–13 strap-shaped or lanceolate, light to bright green or glaucous leaves, with obtuse, subacute or acute apices, produced in arching, erect or suberect fans (Figure 210). Capsule size is extremely variable (18–35 × 6–11 mm) (Figure 211).

Leighton (1965) distinguished subsp. *angustifolius* and subsp. *gracilis* from subsp. *caulescens* mainly by their narrower leaves (30 mm wide or less, versus 40 mm wide or more), by their acute or subacute leaf apices (versus often obtuse) and by their smaller flowers. She further distinguished subsp. *angustifolius* by its more or less stiffly erect leaves, and by its tepals not recurving markedly toward the apex, and subsp. *gracilis* by its more slender, laxer habit, and flaccid leaves, and by its tepals recurving markedly toward the apex. Examination of living material and a wide range of herbarium records has revealed that the distinctions between the subspecies are blurred, with numerous intermediate forms. Subsp. *angustifolius* and subsp. *gracilis* cannot easily be set apart, since not all collections of subsp. *gracilis* have markedly recurved tepals, and the tepals in certain collections of subsp. *angustifolius* are markedly recurved. Furthermore, the supposedly more slender, laxer habit of subsp. *gracilis* is not constant across its distribution range. The leaves of subsp. *angustifolius* are not always more or less stiffly erect, and those of subsp. *gracilis* are not always flaccid. Although the leaf apices of subsp. *caulescens* are often obtuse, the leaves are not always much broader than those of subsp. *angustifolius* and subsp. *gracilis*. Although the perianth of subsp. *caulescens* is usually larger (perianth-tube 15–25 mm long; tepals 28–35 mm long) than those of both subspecies, this is not consistently the case, with perianth tubes and tepals of subsp. *angustifolius* varying from 15–20 mm long; tepals from 25–29 mm long, and those of subsp. *gracilis* varying from 15–20 mm long and 20–27 mm long, respectively. In addition, both subsp. *caulescens* (*Killick s.n.* in BOL) and subsp. *gracilis* (*Killick 2215* in BOL) are recorded from the same locality near Maqai Falls within the Royal Natal National Park in western KwaZulu-Natal.

Leighton (1965) described *A. nutans*, which she considered to be allied to *A. caulescens* (subsp. *gracilis*) and distinguished by its nodding perianth, with the perianth tube narrowed towards the throat, and the tepals spreading above the throat, but stated: 'I am aware that the sporadic occurrence of all those plants I have placed in *A. nutans* may very well mean that they are all mutants which arise from time to time, and I regard this as a grouping of like forms rather than a close-knit species'. The degree of recurving of the tepals does not seem an important difference, as those of *A. nutans* also show some degree of recurving. Likewise, the nodding orientation of the flowers does not seem distinctive, as both nodding and spreading flowers may occur within the same flowerhead, and perianth tube length (15–27 mm long) and tepal length (22–33 mm long) in *A. nutans* falls within the range for *A. caulescens*. Furthermore, both *A. nutans* and *A. caulescens* (subsp. *gracilis*) are recorded from Ingwavuma in the Ubombo Mountains of KwaZulu-Natal. The results of a nuclear DNA study found that *A. nutans* has a DNA amount of 23.38 pg which is within the range for *A. caulescens* (22.90-23–41 pg) and concluded that it be placed in synonymy under *A. caulescens* (subsp. *gracilis*) (Zonneveld &

Duncan, 2003; Duncan, 2005). In summary, as with the previously recognised taxa of *A. praecox*, those of *A. caulescens* form a continuum, with the existence of numerous intermediate forms between the taxonomic entities, and I can find no convincing reason for recognition of the subspecies.

A. caulescens is similar in appearance to *A. pondoensis* from Pondoland in the Eastern Cape, the latter having a distinct, often purple-flushed pseudostem, and a fan of distichous leaves with acute or subacute apices, but differs in its narrowly funnel-shaped, light blue perianth, wider inner tepals (9–10 mm), straight or slightly declinate styles, brown pollen and much shorter dormant period of four to six weeks from late autumn to mid-winter. *A. campanulatus* can also be confused with *A. caulescens* in its spreading or nodding, funnel-shaped flowers with declinate, included stamens and lilac pollen, and a prominent pseudostem bearing suberect or arching leaf fans. *A. campanulatus* differs in its smaller, more or less globose flower heads of smaller flowers, which are variable in shape (widely or narrowly

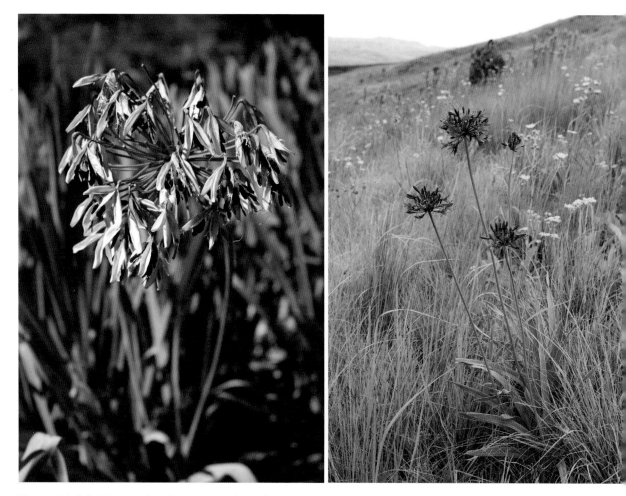

Figure 211 (left). Ripe capsules of *Agapanthus caulescens* from Mooi River, KwaZulu-Natal, in cultivation, Kirstenbosch. Image: Graham Duncan.

Figure 212 (right). *Agapanthus caulescens* in Midlands Mistbelt Grassland near Babanango, north-central KwaZulu-Natal. Image: Guy Upfold.

funnel-shaped) with shorter perianth tubes (5–10 mm long, rarely to 12 mm long) and shorter tepals (10–20 mm long), of which the outer tepals have rounded or subacute apices and the inner tepals have rounded apices, and it has a lower average nuclear DNA content (23.18 pg) (Zonneveld & Duncan, 2003). *A. campanulatus* has a slightly smaller distribution range, from the eastern part of the Eastern Cape to south-eastern Limpopo.

DISTRIBUTION, HABITAT AND GROWTH CYCLE. *A. caulescens* is the most widespread species, native to the eastern, north-eastern and northern summer rainfall parts of South Africa, and to Eswatini. It occurs in an arc from the central Eastern Cape to the Soutpansberg in northern Limpopo and the Waterberg, in the west of this province (Map 5). Robust, broad-leafed forms of this species have been recorded mostly in north-western Eswatini in the vicinity of Mbabane, and are also known from Mont-aux-Sources in western KwaZulu-Natal, near Nquthu in north-central KwaZulu-Natal, and near Ofcolaco in east-central Limpopo, occurring in colonies on hill and mountain slopes among rocks, beside waterfalls, and on ledges on dolerite, granite and basalt in KaNgwane Montane Grassland, Granite Lowveld, KwaZulu-Natal Highland Thornveld and uKhahlamba Basalt Grassland. Less vigorous forms with narrower leaves occur north of Queenstown in north-central Eastern Cape, and to the north-west of Ngcobo, as well as from Bizana in the extreme north-east of the Eastern Cape to the Ubombo-Ingwavuma Mountains and the Royal Natal National Park

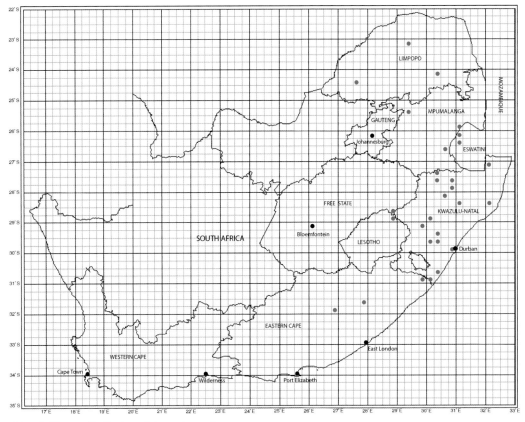

Map 5. Known distribution of *Agapanthus caulescens*.

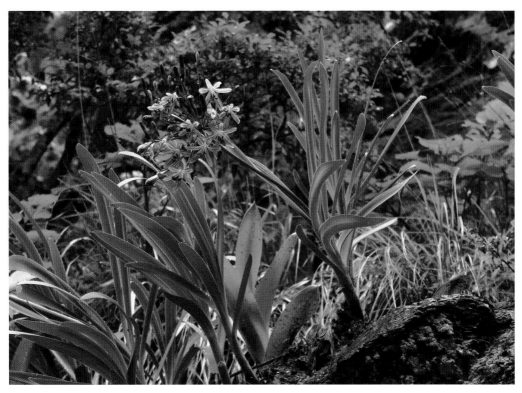

Figure 213. *Agapanthus caulescens* among grasses on a sandstone ledge, Royal Natal National Park, KwaZulu-Natal. Image: Neil Crouch.

in northern and western KwaZulu-Natal, respectively. They are also recorded from the vicinity of Mbabane in north-western Eswatini, the Soutpansberg and Waterberg in northern and western Limpopo, respectively, up to 2000 m. These plants inhabit a wide range of habitats including open grassland on moderate to steep, rocky mountain and hill slopes, shaded gullies and beneath cliffs, along wooded streams and sandstone ledges, often wedged between rock fissures on inaccessible sheer rockfaces, in marshy ground or in black, turfy soil. They occur as isolated clumps, in small groups or sometimes in dense stands, often on east- and south-east-facing slopes, in numerous vegetation types, including Drakensberg Foothill Moist Grassland, KaNgwane Montane Grassland, Midlands Mistbelt Grassland (Figure 212), Northern Drakensberg Highland Grassland, Paulpietersburg Moist Grassland, KwaZulu-Natal Highland Thornveld, Lebombo Summit Sourveld and Barberton Montane Grassland. In the Royal Natal National Park it occurs in association with the geophytes *Galtonia regalis* and *Merwilla plumbea*, and on the Waterberg in western Limpopo, it is found close to populations of *A. coddii,* but at lower altitude, at about 1500 m. *A. caulescens* is a summer-growing species which commences active growth in spring, flowers from mid- to late summer, and is dormant for approximately three to four months in winter.

CONSERVATION STATUS. The taxa previously recognised as subsp. *angustifolius* and subsp. *gracilis* were previously not considered to be threatened and assessed as Least Concern, according to the SANBI Red List of South African Plants (version 2020.1) (Foden & Potter, 2005d; Cholo, 2006); the taxon previously recognised as subsp. *caulescens* was not evaluated.

NOTES. Pollinator interactions in the wild are unknown for *A. caulescens*. In cultivation at Kirstenbosch, a robust, large-flowered form from Zululand in northern KwaZulu-Natal is visited mainly by the large, black, giant carpenter bee, and medium- and small-flowered forms are visited by Cape honey bees. Orange-breasted and Southern double-collared sunbirds have also been seen to 'rob' nectar by piercing the base of the perianth tube. Although occasionally grown as a garden plant in the UK, this outstanding and extremely variable species is poorly known in cultivation in South Africa, apart from botanic gardens and private collections. Large forms are recommended for planting in the front and centre of wide, mixed borders (Figure 214), and smaller forms are suited to rock garden pockets and large containers. They perform best in full sun in humus-rich soils, with regular, heavy watering in summer. *A. caulescens* can generally be regarded as half-hardy and requiring of protection in cold winter climates of the northern hemisphere, although forms from the northern Drakensberg are reasonably hardy.

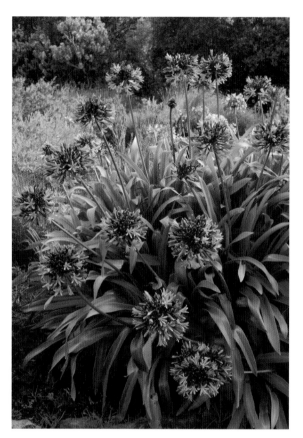

Figure 214. Robust form of *Agapanthus caulescens* from Zululand, northern KwaZulu-Natal, as a garden plant, Kirstenbosch. Image: Graham Duncan.

5. AGAPANTHUS PONDOENSIS

Agapanthus pondoensis F.M.Leight. ex G.D.Duncan, **sp. nov.**, differs from *Agapanthus caulescens* Sprenger in its narrowly funnel-shaped, light blue perianth, wider inner tepals (9–10 mm), straight or slightly declinate styles, brown pollen and much shorter dormant period of four to six weeks from late autumn to mid-winter.

TYPE: South Africa, Eastern Cape, 3129 (Port St Johns): Fraser Falls east of Lusikisiki, among sandstone boulders and on inaccessible cliffs and ledges of sheer rock faces (–BC), 9 January 1953; 8 December 1954 and 28 November 1956, *F.M. Leighton s.n.*, (BOL!, holo.; K!, NH!, PRE!, iso.).

NAME. *pondoensis*: after the Pondoland region in the north-eastern part of the Eastern Cape, where the type material was collected.

COMMON NAME. Pondoland agapanthus.

DESCRIPTION. Deciduous, summer-growing perennial 600–850 mm high in flower, clump-forming. *Rhizome* horizontal, 70–100 × 15–20 mm. *Pseudostem* 70–110 × 15–20 mm, suberect or erect, purple-flushed; base bulbous, up to 30 mm wide; basal sheathing leaves 2 or 3, free portion narrowly spathulate,

15–60 × 10–25 mm, bright green. *Leaves* 8–12 per shoot, broadly linear or narrowly oblanceolate, 220–300 × 18–25 (28) mm, strongly distichous, slightly curved, produced in arching or suberect fans, soft-textured, canaliculate, light to bright green; apices acute or subacute. *Scape* spreading, suberect or upwardly arching, rarely erect, slightly compressed, 450–650 × 6–8 mm, sturdy or gracile, bright green or purple-flushed. *Pseudo-umbel* subglobose, 160–200 mm across, 15–30-flowered; spathe-bracts ovate, 30–40 × 20–30 mm, papery at anthesis, translucent white, longitudinal veins purple; bracteoles 8–15, filiform, 8–20 × 1–2 mm, white; pedicels suberect or spreading, 40–60 mm long, green or brownish-purple. *Perianth* narrowly funnel-shaped (tepals radiate >15° up to 30° from longitudinal axis), light blue; perianth tube 15–25 mm long, containing nectar; tepals light blue, median stripe on upper surface deeper blue, median ridge on lower surface prominent, deeper blue; margins flat or slightly to strongly undulate, especially in upper half; outer tepals oblanceolate, 24–37 × 6–7 mm, apices acute or subacute; inner tepals narrowly spathulate or oblanceolate, 25–37 × 9–10 mm, apices obtuse. *Stamens* declinate, included or slightly exserted, white in lower half, shading to light blue above; outer filaments 23–38 mm long, inner filaments 20–33 mm long; anthers oblong, 2 × 1 mm, pollen yellowish-brown. *Ovary* narrowly ellipsoid, 12–14 × 2–4 mm, yellowish-green; style straight or slightly declinate, included, 21–39 mm long, white in lower half, shading to light blue above; stigma minutely capitate. *Capsule* ellipsoid, 22–30 × 8–11 mm, apex subacute. *Seed* more or less oblong, 4–5 × 3 mm, flat, black; wing papery, 4–5 × 4–5 mm, black. Plate 8; Figures 138, 148, 215–220.

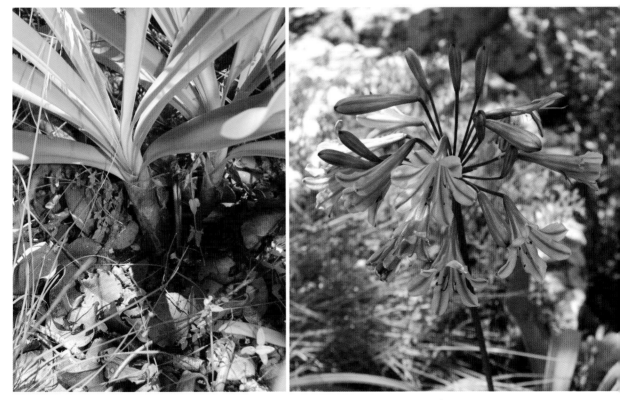

Figure 215 (left). Pseudostem of *Agapanthus pondoensis* near Fraser Falls, Eastern Cape. Image: Graham Duncan.
Figure 216 (right). *Agapanthus pondoensis* pseudo-umbel of narrowly funnel-shaped perianths near Fraser Falls, Eastern Cape. Image: Graham Duncan.

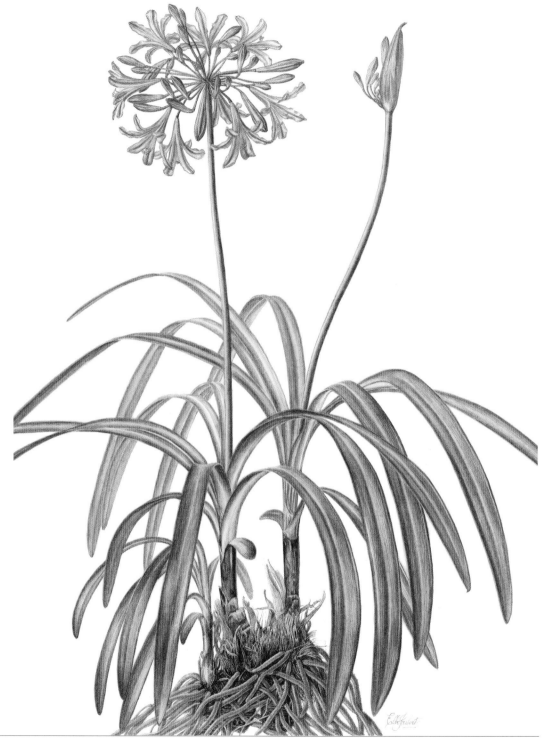

PLATE 8

Artist: Elbe Joubert

Watercolour painting of *Agapanthus pondoensis* from Mpopome near Magwa Falls, Eastern Cape (*van der Walt 811*, NBG 397/02). Image 33% of life size.

FLOWERING PERIOD. Early December to mid-January, with a peak from mid-December to early January.

HISTORY. Material of *A. pondoensis* was first recorded by F.M. Leighton on 9th January, 1953 at Magwa Falls south-east of Lusikisiki in the Pondoland region of the Eastern Cape (*Leighton s.n.*, NBG 1/53), and on the same day, she collected it at Fraser Falls east of Lusikisiki (*Leighton s.n.*, NBG 5/53), and the material was cultivated at Kirstenbosch. The following year on 8th December she made further collections at both localities, and on 28th November she made a further collection at Fraser Falls. In her monograph (Leighton, 1965) she noted that the plants from Fraser Falls were deciduous in cultivation, and that the new set of leaves emerged shortly after the plants had gone dormant. She considered the plants from Magwa Falls to be *A. praecox* (subsp. *orientalis*), and noted that those from Fraser Falls were not easily distinguishable from those of *A. praecox* (subsp. *orientalis*), except for their narrower shape and the somewhat different orientation of the tepals. She was reluctant to recognise

the latter as a new species, or as a subspecies or form of *A. praecox*, due to the fact that the plants were deciduous. Annotations to pressed material in the Bolus Herbarium indicate that Leighton had previously considered the plants from Fraser Falls to be a new species, to which she appended the manuscript name *A. pondoensis*, however she must subsequently have reconsidered her position, and the material remained filed under *A. praecox* (subsp. *orientalis*). In 2002, plants were collected by Kirstenbosch horticulturist LiesI van der Walt at Mpopome near Magwa Falls (Plate 8), and 16 years later I visited Magwa Falls and Fraser Falls in January 2018 to study the plants, and was later able to confirm the plants from both localities as the new species, *A. pondoensis*. Although not noted by Leighton, the plants from Magwa Falls are also deciduous.

DISTINGUISHING FEATURES AND AFFINITIES. *A. pondoensis* is a somewhat variable but distinctive, deciduous, summer-growing species. It has a prominent purple-flushed pseudostem with a bulbous base, 2 or 3 basal sheathing leaves, and a fan of distichous, broadly linear or narrowly oblanceolate, lax, green leaves with acute or subacute apices (Figure 215). The suberect or rarely erect, slightly compressed, green or purple-flushed scape bears a subglobose head (160–200 mm across) of narrowly funnel-shaped, light blue flowers borne on brownish-purple or green pedicels (Figure 216, 217). The

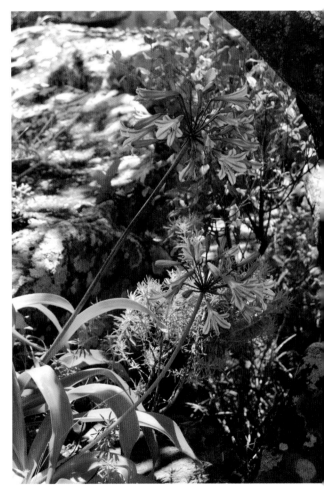

Figure 217. *Agapanthus pondoensis* among sandstone boulders near Fraser Falls, Eastern Cape. Image: Graham Duncan.

Figure 218 (left). *Agapanthus pondoensis* above cliff near Fraser Falls, Eastern Cape. Image: Graham Duncan.
Figure 219 (right). *Agapanthus pondoensis* on ledges of sheer cliff faces, Magwa Falls, Eastern Cape. Image: Graham Duncan.

stamens are declinate and included, with the outer filaments 5–6 mm longer than the inner ones, with yellowish-brown pollen, and the ovary has a straight or slightly declinate style. The species is variable in leaf width (18–30 mm wide) and in the length of the filaments (20–38 mm long) and style (21–39 mm long). It is most closely allied with *A. caulescens*, which differs in having flowers which are bright to deep blue or violet-blue and widely funnel-shaped (when fully open), usually with contrasting deeper blue perianth tube bases, narrower inner tepals (6–8 mm wide), strongly declinate styles and lilac pollen. *A. caulescens* has a more easterly and northerly distribution, centred in KwaZulu-Natal and Eswatini, with isolated records in the Eastern Cape, far to the west of those of *A. pondoensis*. It also has a longer flowering period extending to late February, and a much longer dormant period from late autumn until spring. The perianth in *A. pondoensis* is superficially similar to that of narrowly funnel-shaped forms of *A. praecox*, however the presence of a distinct pseudostem with prominent basal sheathing leaves, and a deciduous growth habit, easily distinguishes it from this species.

DISTRIBUTION, HABITAT AND LIFE CYCLE. *A. pondoensis* has a localised occurrence in the far north-eastern part of the Eastern Cape, in the vicinity of the Angel, Fraser and Magwa Falls to the east and southeast of Lusikisiki, in Pondoland-Ugu Sandstone Coastal Sourveld, in the Pondoland Centre of Endemism (Mucina & Rutherford, 2006; van Wyk & Smith, 2001) (Map 6). At the type locality east of Lusikisiki it grows in colonies among sandstone boulders and on inaccessible west-facing cliff edges of a rocky river gorge at an elevation of 405 m (Figure 218). Here it grows among grass tussocks, low scrub and small shrubs including *Asparagus densiflorus* and *Halleria lucida*. At Angel Falls it grows beside the waterfall on an east-facing rocky slope with *Strelitzia nicolai*, and at Magwa Falls to the southeast it occurs in small groups, in association with *Streptocarpus* and *Plectranthus* species, mainly in the upper part of a sheer, shaded, west-facing rock face behind the 144 m waterfall which drops abruptly into a narrow canyon (Figure 219). *A. pondoensis* is a distinctly summer-growing species, with a relatively short, but distinct dormant period. Leaves of the current growth season turn yellow and die back completely in late autumn (late May). New leaf shoots emerge four to six weeks later in mid-winter (early to mid-July), grow rapidly until early summer, and flowering takes place in mid-summer.

Map 6. Known distribution of *Agapanthus pondoensis*.

CONSERVATION STATUS. *A. pondoensis* has not yet been formally assessed. It occurs in largely inaccessible terrain, and although rare, is not threatened.

NOTES. Pollinators of this species are unrecorded, but are likely to include long-proboscid flies, solitary bees and butterflies. In their natural habitats, the tepals are eaten by blister beetles and nymphs of the green milkweed locust (*Phymateus viridipes*) (Figure 220). *A. pondoensis* adapts well to cultivation in containers and is also suited to rock garden pockets and mixed borders, and can be grown in full sun or light shade. It is noted for its short dormant period of four to six weeks from late autumn to mid-winter, and can generally be regarded as half-hardy and requiring of protection in cold winter climates of the northern hemisphere.

Figure 220. *Agapanthus pondoensis* flower buds and tepals are consumed by nymphs of the green milkweed locust (*Phymateus viridipes*) near Fraser Falls, Eastern Cape. Image: Graham Duncan.

6. AGAPANTHUS CODDII

Agapanthus coddii F.M.Leight., *Journal of South African Botany*, suppl. vol. 4: 36, 37 (1965).

TYPE: South Africa, Limpopo, Waterberg Mountain Range, Kransberg Mountain within Marakele National Park, at 1433 m, 27 January, 1960, *J. Erens & L.E. Codd 2081* sub. NBG 145/55 (PRE!, holo.; BOL!, NBG!, iso.).

NAME. *coddii*: in tribute to Dr Leslie E.W. Codd (1908–1999) who made the first scientific collection of plants with Jan Erens, in 1948.

COMMON NAMES. Codd's agapanthus; Waterberg agapanthus; Waterberg-bloulelie (Afrikaans).

DESCRIPTION. Deciduous, summer-growing perennial 0.8–1.3 m high in flower, strongly clump-forming. *Rhizome* horizontal, 30–60 × 18–25 mm. *Pseudostem* strongly caulescent, 120–180 × 25–30 mm, purple, or greenish-white flushed with purple, base bulbous; basal sheathing leaves 1–3, strap-shaped, 50–260 × 40–50 mm. *Leaves* 8–14, strap-shaped, 330–750 × 30–55 mm, arranged in an erect to suberect fan, upper portion sometimes falcate, lower portion deeply canaliculate, bright green, narrowing towards base, apices obtuse, rarely subacute, canaliculate. *Scape* erect, 0.6–1.5 m high, slightly compressed, bright green, stout. *Spathe bracts* ovate, 65–135 × 50 mm, green flushed with purple in bud stage, drying to light brown, prominent during early flowering stage. *Pseudo-umbel* globose, 30–50-flowered; pedicels light green, 55–59 mm long, radiating. *Perianth* widely funnel-shaped (tepals radiate 30° or more from longitudinal axis); tube cylindrical, 10–12 mm long, deep blue at base, shading to light blue above; outer tepals broadly oblanceolate, 25–28 × 9–11 mm, light blue with deep blue midrib on upper and lower surfaces, apices acute, margins slightly undulate or flat; inner tepals spathulate, 25–27 × 9–10 mm, light blue with deep blue midrib on upper and lower

surfaces; apices obtuse, margins slightly undulate or flat. *Stamens* declinate, included; filaments white, or white in lower half, light blue above; inner filaments 19–21 mm long, outer filaments 22–23 mm long; lower portion adnate to length of tube; anthers oblong, curved, centrifixed, pollen blackish-blue. *Ovary* narrowly obovoid, 6–7 × 3–5 mm, light green; style declinate, included, 17–21 mm long, white in lower half, light blue above. *Capsule* broadly ellipsoid, 20–30 × 13–17 mm, apex truncate. *Seed* obovate, 5–7 × 4–5 mm, flat, black; wing 7–9 × 4–5 mm, black. *Chromosome number* 2n=30 + 2B; *Codd 5920*: NBG 148/55 (Riley & Mukerjee, 1962). Plate 9; Figures 116, 221–226.

FLOWERING PERIOD. January to February, with a peak from mid- to late January.

HISTORY. The Dutch horticulturist and plant collector Jan Erens (1911–1982), and the botanist and Director of the former Botanical Research Institute in Pretoria, Dr L.E. Codd, collected this species for the first time in January 1948 (*Erens & Codd 2103*) along a stream bank in the Kransberg in the western portion of the Waterberg, northeast of Thabazimbi, in western Limpopo. They made several subsequent collections in the same area, and the type material was collected on 10 February 1955, and grown at the former Botanical Rsearch Institute in Pretoria. The holotype was pressed from this material on 27 January 1960, and is preserved in the National Herbarium (*Erens & Codd 2081*). Material from this collection, and others made by Erens and Codd were cultivated in the nursery at Kirstenbosch, and the collection with accession number 11/59 is still in cultivation there (Plate 9). It was illustrated in watercolour by Cythna Letty as an unnamed species of *Agapanthus* on plate 12 of *Wild Flowers of the Transvaal*, from a specimen collected at the type locality on the Kransberg (Letty *et al.*, 1962) and described as new by Frances Leighton in her revision of the genus (Leighton, 1965). The plant has since rarely been collected.

Figure 221. Emerging new leaves of *Agapanthus coddii* in cultivation, Kirstenbosch. Image: Graham Duncan.

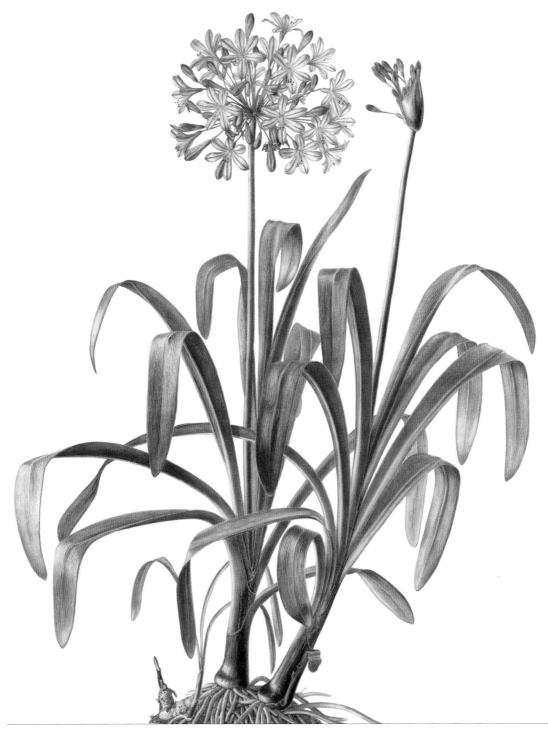

PLATE 9

Artist: Elbe Joubert

Watercolour painting of *Agapanthus coddii* from Kransberg, Waterberg, Limpopo
(*Codd 10396*, NBG 11/59). Image 25% of life size.

DISTINGUISHING FEATURES AND AFFINITIES. *A. coddii* is distinctive in the purple outer surfaces of its broad, 1–3 basal sheathing leaves (Figure 221) and erect or suberect fans of broad, strap-shaped, bright green leaves, borne on a prominent, purple-flushed pseudostem. The upper portion of the leaves is erect, suberect or falcate, with obtuse or subacute tips, and the lower portion is deeply canaliculate. The sturdy, erect scape grows to 1.3 m high, producing a rounded flower head of widely funnel-shaped, light blue flowers with darker blue tepal keels and margins, borne on long, radiating pedicels (Figure 222). The prominent spathe bracts are up to 135 mm long, green and flushed with purple in bud stage, drying to light brown at early flowering stage, before dropping off. The stamens are declinate and shorter than the tepals, and the anthers produce lilac pollen. The capsules are broadly ellipsoid and have obtuse apices (Figure 223). The species appears most closely allied to large forms of *A. caulescens* which have similar, prominent, purple-flushed pseudostems, broad leaves and widely funnel-shaped flowers with lilac pollen, but the latter differs in their broader pseudostem (up to

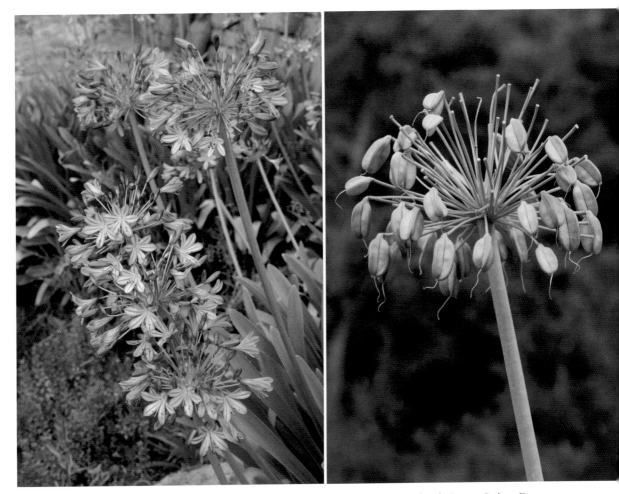

Figure 222 (left). Widely funnel-shaped perianths of *Agapanthus coddii* in cultivation, Kirstenbosch. Image: Graham Duncan.
Figure 223 (right). Ripening, ellipsoid capsules of *Agapanthus coddii* in cultivation, Kirstenbosch. Image: Graham Duncan.

40 mm wide) and leaves (35–60 mm wide) produced in arching fans, and in their more or less subglobose flower heads with bright blue flowers, and longer perianth tubes (15–25 mm long) with contrasting deep blue bases.

DISTRIBUTION, HABITAT AND GROWTH CYCLE. The species is known only from the western part of the Waterberg massif within the Waterberg Biosphere Reserve north-east of Thabazimbi, in the south-western part of Limpopo (Map 7). Within the Reserve, it is recorded from the farm Groothoek in the Kransberg area within the Marakele National Park, and from adjacent conservancies, growing in montane grassland in dense colonies, in Waterberg-Magaliesberg Summit Sourveld (Mucina & Rutherford, 2006). Its habitat is usually precipitous rocky slopes, in permanently moist seepage areas below cliffs in acidic loamy soil among grass tussocks, bracken, moss and scrub (Figure 224). The plants grow between sandstone rocks below south-facing cliffs, along stream banks and in wooded ravines, from 1430–2085 m (Figure 225). The plants follow a summer-growing cycle, the new leaf fans emerging in early summer, followed by rapid vegetative growth. Flower buds begin to appear in early January, and flowering takes place over a two month period at the hottest time of year in January and February. In late autumn the leaves start to turn yellow and the plants are completely dormant in winter.

CONSERVATION STATUS. Rare, but not threatened, according to the SANBI Red List of South African Plants (von Staden, 2004), due to the inaccessible nature of its habitat, and the protection it enjoys within the Marakele National Park and adjacent conservancies.

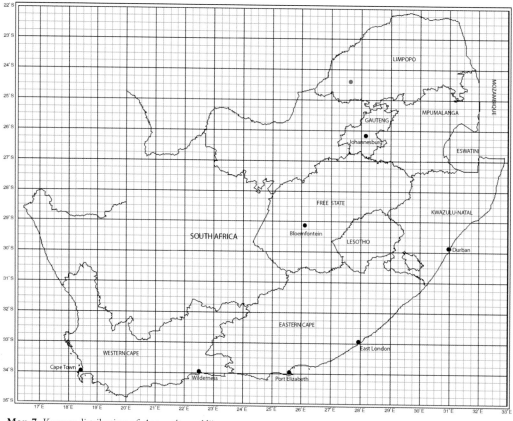

Map 7. Known distribution of *Agapanthus coddii*.

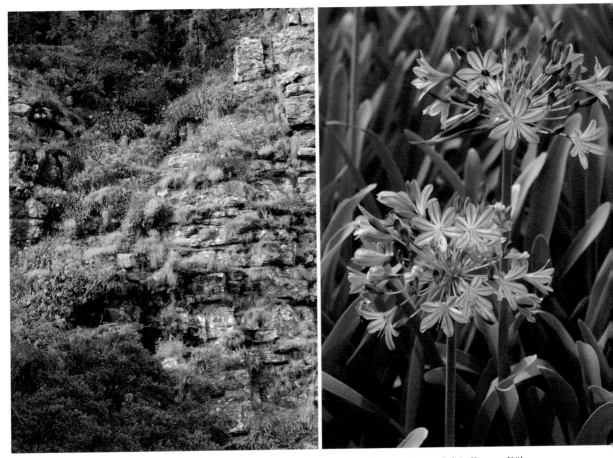

Figure 224 (left). Colony of *Agapanthus coddii* on steep rocky slopes, Waterberg, Limpopo. Image: Sylvie Kremer-Köhne.
Figure 225 (right). *Agapanthus coddii* grows at an elevation of 1430–2085 m. Image: Graham Duncan.

NOTES. Pollinator records in the wild are unknown for *A. coddii*, however these are likely to include long-proboscid flies and butterflies. It adapts remarkably well to cultivation in rich, loamy soils in full sun, with regular heavy watering in summer. In ideal conditions, this species produces up to 120 blooms per flower head and is an outstanding subject for massed landscape plantings, mixed borders and rock gardens (Figure 226). *A. coddii* can generally be regarded as half-hardy and requiring of protection in cold winter climates of the northern hemisphere.

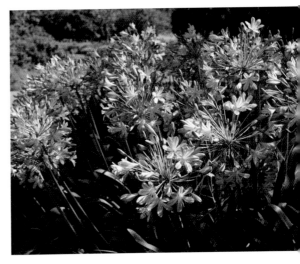

Figure 226 (right). *Agapanthus coddii* as a landscape subject, Kirstenbosch. Image: Graham Duncan.

7. AGAPANTHUS CAMPANULATUS

Agapanthus campanulatus F.M.Leight., *South African Gardening and Country Life* 24: 71, 82 (1934).

TYPE: South Africa, KwaZulu-Natal, Byrne Valley near Richmond, January 1932, *M. Beghin s.n.* sub. NBG 404/22, ex hort Kirstenbosch Nursery (BOL!, holo.; NBG!, PRE!, iso.).

SYNONYMY: *Agapanthus globosus* W.Bull, Nursery Catalogue (William Bull) 1899: 3 (1899) synon. nov. *Agapanthus umbellatus* L'Hér. var. *globosus* (W.Bull) Hort., *The Gardeners' Chronicle* (series 3, vol. 38, September 1905): 237 (1905) synon. nov. Type: South Africa, Orange River Colony [Free State], collector and precise locality unknown, figure in *The Gardeners' Chronicle* (series 3, vol. 38, September 1905): t. 89 (1905) (lectotype, designated here).
Agapanthus patens F.M.Leight., *Journal of South African Botany* 11: 99 (1945). *Agapanthus campanulatus* F.M.Leight. subsp. *patens* (F.M.Leight.) F.M.Leight., *Journal of South African Botany*, suppl. vol. 4: 33 (1965). Type: South Africa, Free State, Clocolan, October 1930, *A.F. Joubert s.n.* sub. NBG 1959/30, ex hort Kirstenbosch Nursery (BOL!, holo.; K!, NBG!, iso.).

CULTIVARS: *Agapanthus umbellatus* L'Hér. var. *mooreanus* G.Nicholson, *The Illustrated Dictionary of Gardening* 1: 36 (1884).
Agapanthus umbellatus L'Hér. *mooreanus* J.R.Duncan & V.C.Davies, Nursery Catalogue (Duncan & Davies) 1925: xiii (1925).
Agapanthus umbellatus L'Hér. var. *albidus* Besant, *Flora and Sylva* 1: 276 (1903).

NAME. *campanulatus*: descriptive of the bell-shaped flowers.

COMMON NAMES. agapanthus, bell agapanthus, small agapanthus, bloulelie (Afrikaans), lehlaha-hlaha (South Sotho), leta-laphofu (South Sotho), ugebeleweni (Xhosa), ubani (Zulu).

DESCRIPTION. Deciduous, summer-growing perennial 0.4–1.5 m high in flower, clump-forming. *Rhizome* horizontal, 60–150 × 12–20 mm. *Pseudostem* 60–100 × 10–15 mm, erect or suberect, light to bright green or light to deep purple-flushed, base bulbous; basal sheathing leaves 2 or 3, free portion narrowly to broadly ovate, 25–40 × 10–15 mm, light to deep green. *Leaves* 5–8 per shoot, narrowly to broadly linear, 250–410 × 6–25 mm, produced in arching, erect or suberect fans, soft- or firm-textured, canaliculate, light to bright green or glaucous; apices subacute. *Scape* erect or suberect, slightly compressed, 400–900 × 5–10 mm, sturdy or gracile, bright green or maroonish-brown flushed. *Pseudo-umbel* more or less globose, 65–160 mm across, 12–70-flowered; spathe-bracts ovate, 18–25 × 12–20 mm, papery at anthesis, translucent white, longitudinal veins purple; bracteoles filiform, 5–20 × 0.5–1.0 mm, white; pedicels erect, suberect or spreading, 22–70 mm long, green or glaucous. *Perianth* narrowly or widely funnel-shaped (tepals radiate >15° up to 30° or more from longitudinal axis), light to bright blue or deep blue, rarely white; perianth tube 5–10 mm long, rarely to 12 mm long, containing nectar; tepals light to bright blue, apices obtuse or subacute, median ridge deeper blue, prominent on lower surface; margins flat, rarely slightly undulate; outer tepals linear or oblanceolate, 10–20 × 5–8 mm; inner tepals narrowly spathulate or elliptic, 11–19 × 6–10 mm. *Stamens* slightly to strongly declinate, included, white in lower half, shading to light blue above; outer filaments 12–14 mm long, inner filaments 10–11 mm long; anthers oblong, 1.0 × 0.5 mm, pollen lilac. *Ovary* narrowly ellipsoid, 7–8 × 3–4 mm, yellowish-green; style slightly declinate, included, 7–15 mm long, white in lower half, shading to light blue above; stigma minutely capitate. *Capsule* ellipsoid, 15–25 × 11–14 mm, apex obtuse. *Seed* obovate, 4–5 × 3–4 mm, flat, black; wing 6–8 × 3–5 mm, papery, black. *Chromosome number* 2n=30 (Muzila & Spies, 2005; Riley & Mukerjee, 1962). Plate 10; Figures 91, 118, 121, 124, 151, 166–168, 227–233.

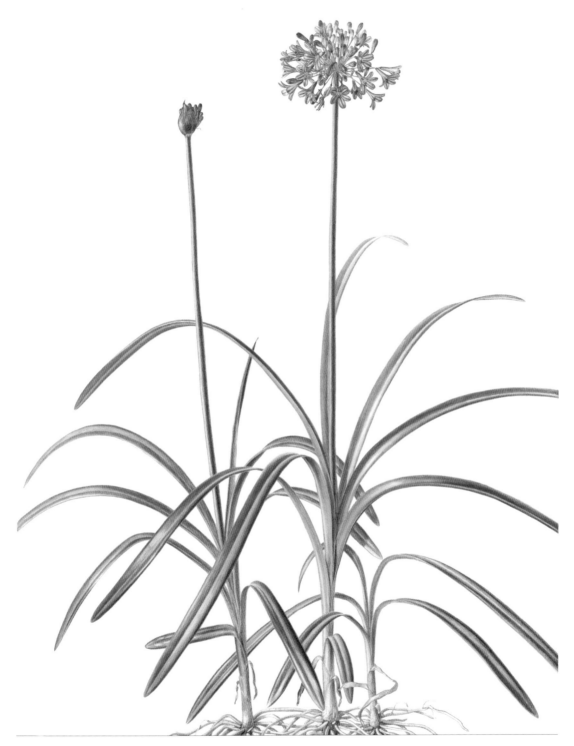

PLATE 10

Artist: Elbe Joubert

Watercolour painting of *Agapanthus campanulatus* 'Wolkberg' (*ex hort* Kirstenbosch, NBG 677/54). Image 25% of life size.

FLOWERING PERIOD. January to March, with a peak in January.

HISTORY. The type material upon which *A. campanulatus* is based, was collected in 1922 in the Byrne Valley near Richmond, to the west of Durban, and had already been in cultivation in the nursery at Kirstenbosch for 12 years before Leighton drew up her description of the species, published in the periodical *South African Gardening and Country Life* (Leighton, 1934) (Plate 10). In her monograph of *Agapanthus*, Leighton (1965) stated that the name *mooreanus* had been used for several hybrids of cultivated origin, among which she recognised a particular form which she regarded as a species and described as *A. campanulatus*. Prior to its formal description, *A. campanulatus* had already been in cultivation for more than half a century, from material cultivated at the Durban Botanic Gardens by its Curator, Wilhelm Keit. Keit had collected it in the early 1870s (supposedly in the eastern Free State, which, if correct, implied that it compared favourably with very cold-hardy material later described by Leighton as *A. patens*). In 1879 he sent material to Sir Frederick Moore, Director of the Royal Botanic Garden at Glasnevin, under the unpublished name, *A. mooreanus* (Nelson, 2016), and in 1884 the plant was included in *Nicholson's Dictionary of Gardening* as *A. umbellatus* var. *mooreanus*.

In 1899, a deciduous agapanthus which had been received from a correspondent in the Orange River Colony (Free State) in South Africa, flowered in the nursery of William Bull and Sons of Chelsea, London, and was described as *A. globosum* in their 1899 catalogue. It was exhibited at the Royal Horticultural Society in 1905, and described and illustrated by means of a monochrome

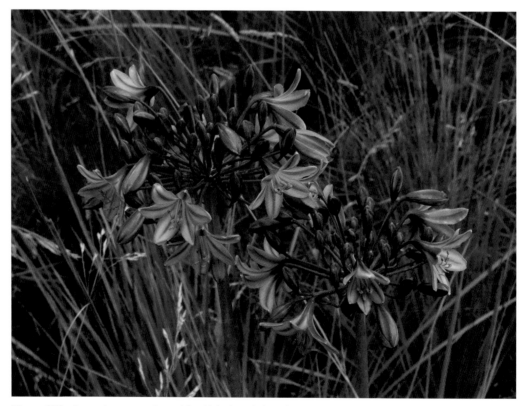

Figure 227. *Agapanthus campanulatus* with widely funnel-shaped perianths, Highmoor, Maloti-Drakensberg Park, western KwaZulu-Natal. Image: Neil Crouch.

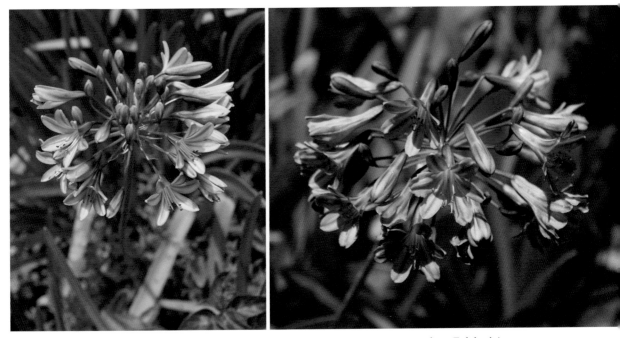

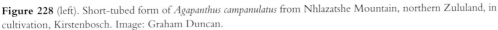

Figure 228 (left). Short-tubed form of *Agapanthus campanulatus* from Nhlazatshe Mountain, northern Zululand, in cultivation, Kirstenbosch. Image: Graham Duncan.
Figure 229 (right). Long-tubed form of *Agapanthus campanulatus*, in cultivation. Image: Graham Duncan.

drawing as *A. umbellatus globosus* in *The Gardeners' Chronicle* (vol. 38, series 3) in September 1905. The plant is deciduous and has a compact, very globular flower head of widely funnel-shaped, lilac-blue blooms with declinate stamens, produced atop long scapes, and the figure in *The Gardeners' Chronicle* compares favourably with *A. campanulatus* (subsp. *patens*). It is stated in the same article that when grown outdoors, the flower head has a less globular form.

Leighton later described *A. patens* in the *Journal of South African Botany*, from type material collected at Clocolan in the eastern Free State (Leighton, 1945). Having subsequently studied a wide range of specimens from KwaZulu-Natal, and noted that numerous intermediate forms existed between *A. campanulatus* and *A. patens*, she re-assessed the latter taxon as a subspecies of *A. campanulatus* in her revision of the genus published some 20 years later, on account of its more widely spreading or sometimes reflexed tepals. The tepals of subsp. *patens* were said to spread widely up to 90° from the longitudinal axis, as compared to those of subsp. *campanulatus* which were said to spread by up to ± 45°; subsp. *patens* was also said to have a 'relatively shorter' perianth tube, but length ranges for the latter were not provided (Leighton, 1965). A brief account of *A. campanulatus* subsp. *patens* appeared in *The Flowering Plants of Africa*, shortly after publication of Leighton's monograph, illustrated with a plate by Edith Burges, from material collected near Mamathes, Lesotho (Dyer, 1966a). The cultivar *A. campanulatus* 'Hardingsdale' is a selection from the wild from the farm Hardingsdale near Pietermaritzburg, KwaZulu-Natal, with bright blue, widely funnel-shaped blooms produced on sturdy, upright stems, with light green upright leaves (Duncan, 1985; 1998).

In a recent study of a population of *A. campanulatus* between Mooi River and Pietermaritzburg in south-central KwaZulu-Natal, and pressed material from PRE and NH, the 'relatively shorter'

perianth tube length used by Leighton to separate the two subspecies was found to be ambiguous; perianth tube length was found to overlap, and it does not form discrete units between the subspecies. In the same study, the degree of spreading of the tepals between the subspecies was found to be similarly variable and ambiguous, even within flowers of a single inflorescence. Thus, due to the ambiguous nature of both characters previously used to separate subsp. *campanulatus* and subsp. *patens*, the latter taxon was placed in synonymy (Singh & Baijnath, 2018), a decision with which I concur.

DISTINGUISHING FEATURES AND AFFINITIES. *Agapanthus campanulatus* is a variable species (both with regard to perianth shape and leaf width and colour), recognised in flower by small to medium-sized, more or less globose flower heads (65–160 mm across) of suberect, spreading or slightly cernuous, narrowly- or widely funnel-shaped, light to deep blue or rarely white flowers, with a deeper longitudinal, median stripe along the tepal inner surface (Figure 227). Perianth tube length varies from 5–10 mm long (rarely to 12 mm) (Figures 228, 229), the tepals have subacute apices, and the stamens are slightly to strongly declinate and subequal, with the outer filaments 2–3 mm longer than the inner ones. The flower heads are usually borne on long, slightly compressed, bright green or maroonish-brown-flushed scapes up to 900 mm high, and the fruiting head comprises ellipsoid capsules with obtuse apices (Figure 230). Each shoot has 5–8 light to bright green or glaucous, narrowly to broadly linear leaves (9–25 mm wide, 250–410 mm long), produced in arching, erect or suberect fans atop a green or maroonish-brown-flushed pseudostem 60–100 mm long. The species has an average nuclear DNA content of 22.34 pg (Zonneveld & Duncan, 2003). *A. campanulatus* appears most closely allied with *A. caulescens,* in particular with smaller forms (previously recognised

Figure 230 (left). A fruiting head of *Agapanthus campanulatus* in cultivation, Kirstenbosch. Image: Graham Duncan.
Figure 231 (right). *Agapanthus campanulatus* with purple scapes, Maclear, Eastern Cape. Image: Cameron McMaster.

as subsp. *gracilis*) which have a similar suberect, spreading or cernuous, widely funnel-shaped perianth with declinate, included stamens, lilac pollen, and a prominent pseudostem bearing erect, suberect or arching leaf fans. *A. caulescens* differs in its more or less subglobose flower heads, longer (15–20 mm long), contrastingly deeper blue perianth tubes, longer tepals (20–25 mm long) with acute outer tepal apices, and in its higher average nuclear DNA content (23.18 pg) (Zonneveld & Duncan, 2003).

DISTRIBUTION, HABITAT AND LIFE CYCLE. *Agapanthus campanulatus* is the second-most widely distributed species, after *A. caulescens*. It is concentrated in south-central and western KwaZulu Natal, western Lesotho and the eastern Free State, and extends to northern and southern KwaZulu-Natal, with outliers in the eastern and north-eastern Eastern Cape (Figure 231), southern Gauteng, northern Mpumalanga and south-eastern Limpopo (Map 8). The most southerly record is from Komga in the Eastern Cape, and the most northerly populations occur west of Shiluvane in the northern Drakensberg, in south-eastern Limpopo. The species favours summer-moist, east-, west-, north- and south-facing steep montane slopes and dolerite rocky outcrops in grassland, including Northern Drakensberg Highland Grassland, Ukhalamba Basalt Grassland, Eastern Free State Sandy Grassland, Mthatha Moist Grassland and Soweto Highveld Grassland. It is usually encountered in full sun along stream banks, on moist basalt cliffs, in floodplains and in seepage areas of gulleys and valleys, in humus-rich, black turfy soil, or sometimes wedged between quartzite or sandstone rocks (Figure

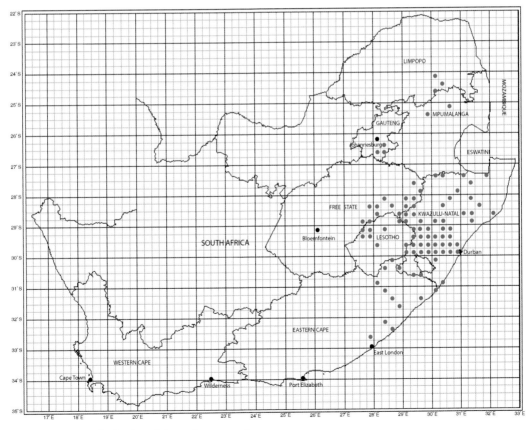

Map. 8. Known distribution of *Agapanthus campanulatus*.

Figure 232. *Agapanthus campanulatus* in black turf between boulders, Highmoor, Maloti-Drakensberg Park, western KwaZulu-Natal. Image: Neil Crouch.

Figure 233. *Agapanthus campanulatus* flowering en masse, Sani Pass, western KwaZulu-Natal. Image: Geoff Nichols.

232). Its habit is robust or gracile, always clump-forming, and it occurs in groups, or sometimes in vast colonies numbering thousands of plants (Figure 233). It is found from close to sea level, for example at Ramsgate in southern KwaZulu-Natal to over 3000 m on Thaba Putsoa in western Lesotho, which experiences some of the coldest temperatures in that country (as low as -20 °C), and at The Sentinel and Mont-aux-Sources in the northern Drakensberg in western KwaZulu-Natal, where winter temperatures can plummet to -15° C. The life cycle commences with the onset of spring and early summer rains, followed by rapid vegetative growth, flowering from midsummer to early autumn, seed dispersal from mid- to late autumn, and the leaf fans die back in late autumn in preparation for the cold, dry, winter dormant period.

CONSERVATION STATUS. *A. campanulatus* is not threatened, and is assessed as Least Concern, according to the SANBI Red List of South African Plants (Foden & Potter, 2005e; 2005f).

NOTES. In the wild, *A. campanulatus* is pollinated by multiple insects including tangle-veined and tabanid flies, and butterflies. In cultivation, honey bees are common pollinators, and the African humming-bird moth is an occasional visitor. Outstanding subjects for mixed borders in rich, loamy soils in full sun, best flowering performance is obtained from well established plants that have been left undisturbed for up to six years or more. Wild forms of *A. campanulatus* from high altitude terrain of Lesotho, KwaZulu-Natal and the Free State, as well as many of its hybrids, are among the hardiest of all agapanthus, and have played a pivotal role in the development of cold-hardy cultivars. They generally easily survive within the temperature range of -10 to -5°C during average winters in the UK.

8. AGAPANTHUS INAPERTUS

Agapanthus inapertus Beauverd, *Bulletin de la Société Botanique de Genève* (2nd series) 2: 179, 194 (1910).

TYPE: South Africa, Limpopo (Transvaal), Farm The Downs near Shiluvane (Shilouwane), originally collected 1903, *H.-A. Junod 4123* (G!, lectotype [barcode G004 18925], designated here; G!, isolectotype [barcode G004 18924], designated here).

NAME. *inapertus*: closed, descriptive of the narrow, tubular flowers of certain forms.

DESCRIPTION. Extremely variable, deciduous, summer-growing perennial 0.6–2.1 m high in flower, gracile or robust, clump-forming. *Rhizome* horizontal, 40–70 × 25–35 mm. *Pseudostem* erect, 30–220 × 15–30 mm, light green or glaucous, purple-flushed or plain, base bulbous; basal sheathing leaves 2–5, free portion obtuse, 10–80 × 15–35 mm, spreading or suberect, light green or glaucous. *Leaves* 5–12 per shoot, strap-shaped or narrowly oblanceolate, 25–70 × 12–45 mm, produced in arching, erect or suberect fans, tapered towards base and apex, distichous or spirally arranged, canaliculate, green, yellowish-green, glaucous green or glaucous; apices acute or subacute; margins flat and entire, or undulate and cartilaginous, green, glaucous or dull yellow. *Scape* erect, 0.30–1.90 m × 7–12 mm, slightly compressed, sturdy or gracile, green or glaucous, covered with a light grey or green bloom. *Pseudo-umbel* more or less campanulate, 60–120 mm across, 10–60-flowered; spathe bracts ovate, 30–40 × 20–25 mm, light brownish-green, longitudinal veins purple or green; bracteoles 8–12, linear or narrowly lanceolate, 10–15 mm long, translucent white; pedicels 20–55 mm long, slightly to strongly arching, lax, green or glaucous, sometimes purple-flushed. *Perianth* tubular (tepals radiate up to 15° from longitudinal axis) or narrowly or widely funnel-shaped (tepals radiate at an angle of >15° up to 30° from longitudinal axis), or trumpet-shaped; slightly curved, cernuous or pendent; tepals thin- or fleshy-textured, light to deep blue, mauvish-blue, navy blue, violet-blue or deep blackish-violet,

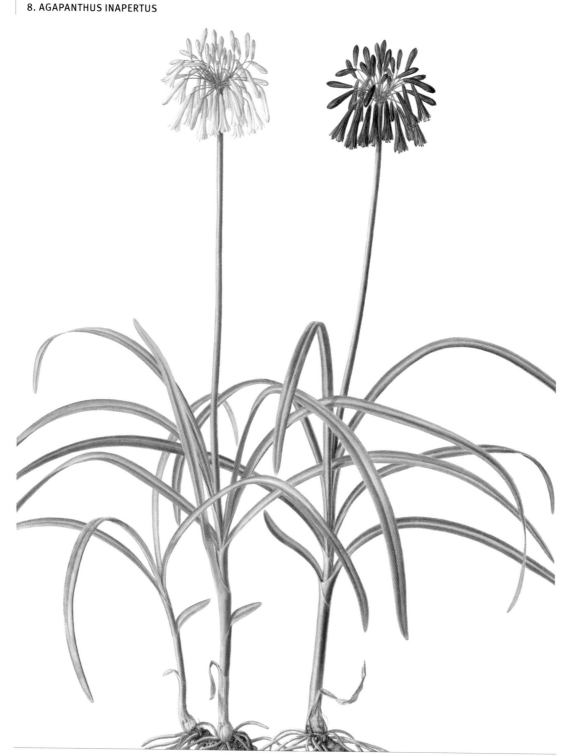

PLATE 11

Artist: Elbe Joubert

Watercolour painting of *Agapanthus inapertus* subsp. *inapertus* 'White' (*ex hort* Kirstenbosch, 690/83); and *Agapanthus inapertus* subsp. *inapertus* (blue form from Lochiel, Mpumalanga (*Thompson s.n.*, NBG 181/55)). Image 20% of life size.

rarely bluish-white or pure white, or with perianth tube magenta and tepals lilac-grey, with darker median stripe on inner surface; perianth tube cylindrical, 10–32 mm long, containing plentiful nectar; outer tepals linear or narrowly oblanceolate, 10–24 × 4–8 mm, apices acute; inner tepals oblanceolate or narrowly spathulate, 10–24 × 5–10 mm, apices obtuse. *Stamens* slightly declinate, included or shortly to well exserted; filaments 9–24 mm long, white throughout, or white in lower half, shading to light blue or light violet in upper half; anthers 1–2 mm long; pollen brown, brownish-yellow or yellow. *Ovary* narrowly ellipsoid, 10–15 × 3–4 mm, light green or light greenish-yellow; style straight or slightly declinate, 11–32 mm long, included or shortly exserted, rarely well-exserted, white throughout, or shading to light blue or light violet towards tip; stigma minutely capitate. *Capsule* narrowly to broadly ellipsoid, 20–40 × 6–16 mm, apex acute, subacute or obtuse. *Seed* obovate, 3–5 × 2–4 mm, flat, black; wing 3–9 × 4–5 mm, papery, black. *Chromosome number*: 2n = 30 (Sharma & Sharma, 1961; Riley & Mukerjee, 1962; Sharma & Mukhopadhyay, 1963). See also under *A. inapertus* subsp. *intermedius* below. Plates 11, 12.

FLOWERING PERIOD. Late December to mid-March, with a peak in January and February.

HISTORY. Henri-Alexandre Junod (1863–1934), the Swiss ethnographer and missionary of the Swiss Mission Romande, made the type collection of *A. inapertus* (subsp. *inapertus*) on the farm The Downs near the town of Shiluvane in east-central Limpopo in 1903. His material was sent to L'Herbier Boissier (the Boissier Herbarium) in Geneva, where it was grown, and flowered for the first time in September 1910, and the species was described and illustrated the same year by the Swiss botanist Gustave Beauverd (Beauverd, 1910) (Plate 11). Prior to Junod's record, *A. inapertus* had been known since at least 1898, when plants were sent to the German horticulturist Max Leichtlin in Baden-Baden, who in turn sent material to Messrs C.G. van Tubergen jun. of Haarlem in The Netherlands, under the unpublished name *A. weillighi* (Worsley, 1913) (see Figure 6). The material sent to Leichtlin was collected by the South African land surveyor and amateur botanist of German descent, Gideon R. von Wielligh (Van Vuuren, 2016), at an unrecorded location, probably along the border between Eswatini and Mozambique, in 1898. Von Wielligh, who had been Surveyor-General of the former Transvaal province, is recorded as having been in that vicinity in 1898 (Van Vuuren, 2016), but the name *Agapanthus weilligii* was only 'validly' published some 15 years later, described by the English nurseryman Henry B. May in *The Gardeners' Chronicle*, who reported it to be 'as hardy as *A. mooreanus*' (May, 1913). However, May erred in his spelling of the specific name *weilligii*, which should have been published as *wiellighii*. Leighton (1965) considered it to be synonymous with *A. inapertus* subsp. *pendulus*, but the tepals flare too widely to be subsp. *pendulus*, and it is more appropriately placed under subsp. *inapertus*. It was grown by the English horticulturist Arthington Worsley, who reported it to be hardy and strictly deciduous, withstanding severe drought in his garden in the south of England, and received an Award of Merit from the Royal Horticultural Society in August 1913 (Worsley, 1913).

During the early 1920s, Louisa Bolus described the deep violet-blue or blackish-violet *A. pendulus* in *The Annals of the Bolus Herbarium,* from living specimens collected at Lydenburg in northern Mpumalanga by A.S. Barnett, in April 1916. The type plants were recorded in flower at Kirstenbosch in February 1921, and a monochrome drawing showing a single flower with its pedicel was illustrated on Plate 3B of the article (Bolus, 1923) (Plate 12). Just over a decade later, Leighton described *A. hollandii* from Alkmaar near Nelspruit, Mpumalanga in *South African Gardening and Country Life,* from a collection made by F.H. Holland (Leighton, 1934). Following extensive fieldwork and observation of cultivated plants, Leighton subsequently came to the conclusion that *A. inapertus* was an aggregate species, which led her to re-assess *A. pendulus* and *A. hollandii* as subspecies of *A. inapertus*, and to describe two new taxa within the aggregate (subsp. *intermedius* and subsp. *parviflorus*) in her monograph,

and subsp. *inapertus* and subsp. *pendulus* were illustrated there in watercolour by W.F. Barker on plates 11 and 12 respectively (Leighton, 1965). Two watercolour plates by Cythna Letty, published in volume 37 of *The Flowering Plants of Africa*, depict *A. inapertus* subsp. *inapertus* collected by I.B. Pole Evans in the Polokwane (Pietersburg) district of central Limpopo, and *A. inapertus* subsp. *pendulus*, collected by G.W. Reynolds among boulders and under the protection of trees at the top of Kowyn's Pass, about 4 km from Graskop in northern Mpumalanga, respectively. The plates amply illustrate the long-tubed, light blue perianth of subsp. *inapertus*, with its relatively narrow leaves, and the deep violet blue perianth of subsp. *pendulus* with its distinctive broad, strap-shaped leaves (Dyer, 1966b, c). In 1993, *A. dyeri* (now a synonym of *A. inapertus* subsp. *intermedius*) was illustrated in watercolour by Gill Condy on plate 2062 of *The Flowering Plants of Africa*, from material collected on the Blouberg, Limpopo by S. Neser (Duncan, 1993).

DISTINGUISHING FEATURES AND AFFINITIES. *Agapanthus inapertus* is an aggregate species, regarded here as comprising four subspecies (subsp. *inapertus* (Figure 234), subsp. *intermedius* (Figure 235) subsp. *parviflorus* (Figure 236) and subsp. *pendulus* (Figure 237). It is recognised by more or less bell-shaped

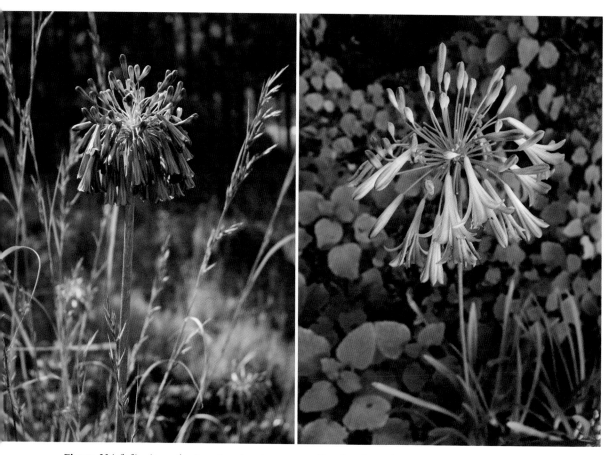

Figure 234 (left). *Agapanthus inapertus* subsp. *inapertus* near Rosehaugh, northern Mpumalanga. Image: Graham Duncan.
Figure 235 (right). *Agapanthus inapertus* subsp. *intermedius* from Namaacha, southern Mozambique, in cultivation, Kirstenbosch. Image: Graham Duncan.

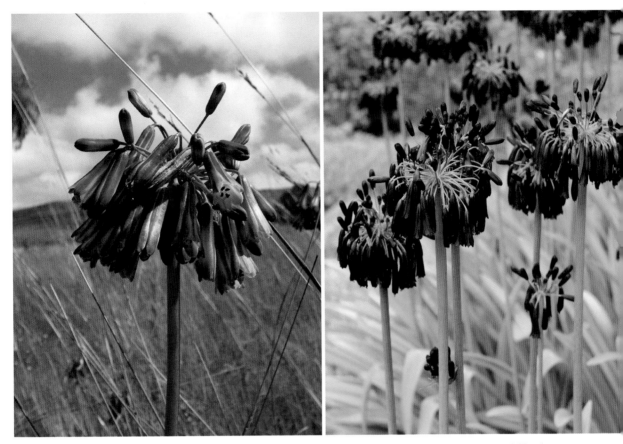

Figure 236 (left). *Agapanthus inapertus* subsp. *parviflorus* near Dullstroom, northern Mpumalanga. Image: Duncan McKenzie.
Figure 237 (right). *Agapanthus inapertus* subsp. *pendulus* 'Graskop' from Graskop, northern Mpumalanga, in cultivation, Kirstenbosch. Image: Graham Duncan.

heads of nodding or pendent, tubular, narrowly or widely funnel-shaped, or trumpet-shaped blooms, usually carried on strongly erect scapes. Identification is made easier by considering the collective features of each taxon (i.e. style length, inner tepal dimensions, tepal colour and texture, and to a lesser extent, perianth tube length, perianth shape, leaf orientation, shape and colour). The subsp. *parviflorus* and subsp. *pendulus* are the most easily recognisable taxa, but considerable variation exists within subsp. *inapertus* and subsp. *intermedius*.

During the bud stage, the pedicels of *A. inapertus* are erect or suberect, but their orientation changes to slightly, moderately or strongly downwardly curved at anthesis. Perianth tube length varies greatly from 10–32 mm long, the outer tepals are 10–24 mm long and 4–8 mm wide and linear or narrowly oblanceolate, with acute apices, and the inner tepals are 10–24 mm long and 5–10 mm wide and oblanceolate or narrowly spathulate, with obtuse apices. The degree of flaring of the tepals varies greatly from minimally flared (as in certain forms of subsp. *inapertus*, subsp. *parviflorus* and subsp. *pendulus*) to widely flared in certain forms of subsp. *intermedius*. The stamens are slightly declinate and usually included, but sometimes shortly to well exserted, and the style is straight or slightly declinate,

usually included or shortly exserted, and rarely well exserted. The flower heads are borne on erect, slightly compressed scapes. Each shoot has 5–12 yellowish-green, bright green or intensely glaucous, strap-shaped or narrowly oblanceolate leaves which are caniculate and tapered towards the base and apex, and are distichous or spirally arranged. They are produced in arching or suberect fans, and the base of the pseudostem is plain or lightly to heavily flushed with purple.

Considerable variation occurs in perianth colour within certain populations, for example in a population of subsp. *inapertus* near Graskop, deep blue forms predominate, but light blue, and bicoloured forms also occur (Figure 238). The pollen in taxa of *A. inapertus* is brown or brownish-yellow at anthesis, but pure white forms produce bright yellow pollen. The species has a nuclear DNA range of 24.95–25.17 pg (Zonneveld & Duncan, 2003). Capsules are narrowly to broadly ellipsoid (20–40 × 6–16 mm) with the apex acute, subacute or obtuse.

In her monograph, Leighton (1965) regarded the combination of features of cernuous flowers, relative length of the perianth tube with respect to the tepals, and the caulescent, deciduous leaves, as the salient features of *A. inapertus*, and recognised five subspecies, which she justified according to the degree of flaring of the tepals, the ratio between tepal length and tepal width, and the ratio between tepal length and perianth tube length. Regarding degree of tepal flaring, she did not specify actual degrees of difference, describing the differences vaguely as 'not spreading appreciably', 'spreading slightly' and 'spreading perceptibly'.

In 1965, Leighton described the new taxon *A. inapertus* subsp. *intermedius,* and in her key to the subspecies of *A. inapertus,* she stated it to differ from subsp. *inapertus*, subsp. *pendulus* and subsp.

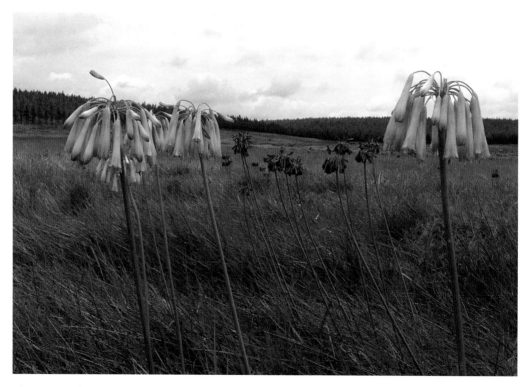

Figure 238. Colour variation in *Agapanthus inapertus* subsp. *inapertus* near Graskop, northern Mpumalanga. Image: Wessel Stoltz.

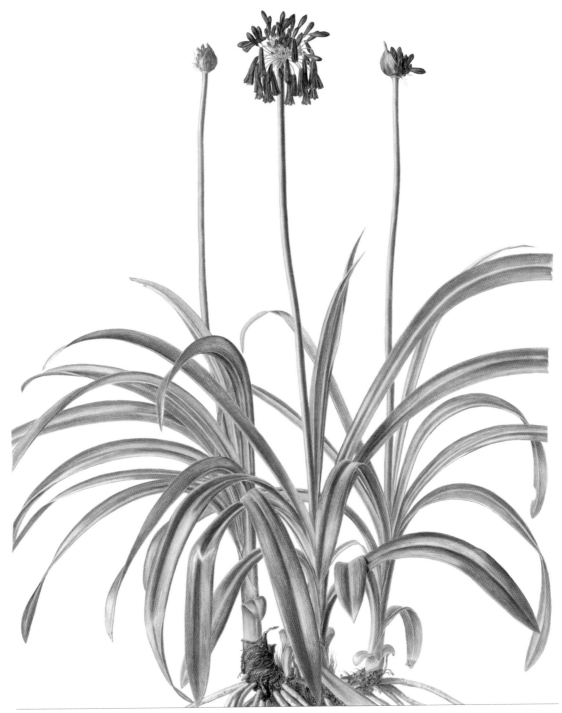

PLATE 12

Artist: Elbe Joubert

Watercolour painting of *Agapanthus inapertus* subsp. *pendulus* 'Graskop' from
Graskop, Mpumalanga (*Galpin s.n.*, NBG 2221/37). Image 25% of life size.

parviflorus by its tepals which 'spread perceptibly' and which are 'usually as long as the perianth tube'. However, in an explanatory paragraph beneath the Latin diagnosis, she contradicted herself by stating that the tepals of subsp. *intermedius* 'range from those which spread very little, to forms in which they spread appreciably', and she recognised four morphological forms, *Forma* α, with flowers 25–35 mm long and tepals which do not spread appreciably; *Forma* β, with flowers 40–45 mm long and segments which spread appreciably; *Forma* γ, with narrow leaves, few-flowered, lax inflorescences and widely spreading, but narrow perianth segments, and *Forma* δ, a very variable form with narrow flowers, in which the tube is about half the length of the perianth, or less. In order to clarify the ambiguity in Leighton's text, it has been necessary to re-circumscribe subsp. *intermedius* to comprise only those plants with narrowly or widely funnel-shaped, or trumpet-shaped flowers (i.e. those comprising her *Forma* β and *Forma* γ) in which the tepals radiate >15° or up to 30° or more from the longitudinal axis, and which have perianth tubes varying from 10–18 mm long, and to include all tubular-flowered forms (i.e. her *Forma* α and *Forma* δ) under subsp. *inapertus*.

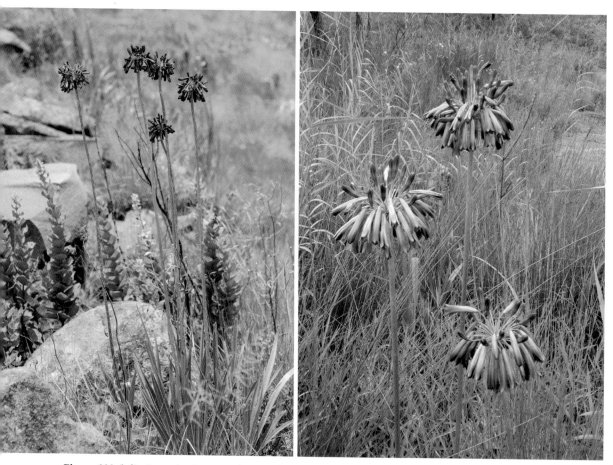

Figure 239 (left). *Agapanthus inapertus* subsp. *parviflorus* among boulders between Belfast and Dullstroom, central Mpumalanga. Image: Brian Schrire.

Figure 240 (right). *Agapanthus inapertus* subsp. *inapertus* in Lydenburg Montane Grassland near Waterval Boven, central Mpumalanga. Image: Duncan McKenzie.

Leighton (1965) described the new species *A. dyeri*, a plant at that time thought to occur only on the Blouberg Plateau in northern Limpopo, and at M'Ponduine, a mountain near Namaacha in southern Mozambique (Kativu, 2006). She considered *A. dyeri* to be 'very close' to *A. inapertus* subsp. *intermedius*, differing from it only in having a relatively short perianth tube. In a study of genome size, it was found that the nuclear DNA content of several collections of *A. dyeri,* including two from M'Ponduine (*Jamieson s.n.*), fell within the range of subsp. *intermedius.* The shorter perianth tube of *A. dyeri* does not seem an important difference, since it shows a gradation of sizes towards those of subsp. *intermedius*, and morphologically these collections compare very well with those of subsp. *intermedius*, and have a similar nuclear DNA content, and *A. dyeri* was placed in synonymy under subsp. *intermedius* (Zonneveld & Duncan, 2003; Duncan, 2005). R.A. Dyer himself questioned the authenticity of *A. dyeri* shortly after its publication, as follows: 'I am not so modest that I should wish to see *A. dyeri* relegated to synonymy, but I forsee the day when some worker will wish to know more precisely what its relationship is to *A. inapertus* subsp. *intermedius*, which is also recorded from the Blouberg Plateau, the type locality for *A. dyeri*' (Dyer, 1966c).

Having examined a range of living and pressed material, I have found no convincing way of recognising *A. inapertus* subsp. *hollandii*, a taxon which Leighton distinguished from subsp. *inapertus* and subsp. *pendulus* on account of its 'narrower perianth segments (tepals) which spread more widely and are narrower'. The tepals of subsp. *hollandii* are sometimes the same width as those of subsp. *inapertus*, and not consistently more widely spreading than subsp. *inapertus* and subsp. *pendulus*, and subsp. *hollandii* is here placed in synonymy under subsp. *inapertus*. Sealy (1940–1942) expressed a similar opinion regarding the possibility of *A. hollandii* being synonymous with *A. inapertus* subsp. *inapertus*. There is some doubt as to the purity of two collections of 'subsp. *hollandii*' from near Nelspruit, one made at Alkmaar (*Beetge s.n.*, NBG 461/440, see plate 2 on page 18), the other made at Kaapsche Hoop (*Lavranos s.n.*, NBG 839/82), whose nuclear DNA content (24.64 pg and 24.39 pg, respectively) falls outside the range for *A. inapertus*, and appears to indicate hybrid origin, and due to their relatively low pollen vitality. In the instance of the Alkmaar collection, the low pollen vitality may, however, also be the result of the plants having been vegetatively propagated for many years (Zonneveld & Duncan, 2003). During a recent visit to Alkmaar and Kaapsche Hoop in January 2018, no naturally occurring material of *A. inapertus* could be found, but *A. praecox* was seen to be commonly grown in local gardens, and could possibly be the other parent in question. At Kirstenbosch, a hybrid very similar in perianth shape and colour to the Beetge collection arises in garden beds from time to time, and the plants are more or less evergreen, indicating *A. praecox* as the probable other parent.

The tubular perianth of *A. inapertus* (subsp. *inapertus*) strongly resembles that of *A. walshii*, endemic to the Elgin Valley of the southwestern Cape. The perianth in both taxa is nodding or pendent, borne on arching pedicels, but *A. walshii* differs in having thick-textured tepals which are much shorter than the length of the perianth tube. Vegetatively, *A. walshii* differs in its evergreen habit, shorter and narrower, leathery leaves, produced in smaller fans, and shorter pseudostems, and it has a much higher nuclear DNA content range of 31.44–31.83 pg (Zonneveld & Duncan, 2003).

DISTRIBUTION, HABITAT AND LIFE CYCLE. *Agapanthus inapertus* is widely distributed in the northern and north-eastern summer rainfall parts of South Africa in Mpumalanga, Limpopo and Gauteng, and also occurs in Eswatini and southern Mozambique. The four subspecies recognised in this work do not conform to one of the traditional requirements of subspecies (geographic isolation), however subspecific rank seems to be the most appropriate manner in which to classify the plants, which do form four distinct entities; although populations sometimes occur within fairly close proximity, they

are always isolated from one another and there appears to be no evidence of natural hybridisation, except, possibly, where *A. praecox* has been grown in close proximity in local gardens. *A. inapertus* is encountered in a range of grassland habitats, often in dolomitic soils and in association with rocks or boulders (Figure 239), including high altitude grassy mountain slopes and flats (Figure 240), hills, seepage zones surrounding open grassveld (Figure 241), beneath trees in light shade, along forest margins, between mountain ridges, at the base of cliffs, and in gullies in dense undergrowth. Altitudinal range varies greatly from 600 m to 2300 m on De Berg Mountain north of Dullstroom in northern Mpumalanga. The plants follow a summer-growing, winter-dormant cycle, the new leaf shoots emerging in late spring and early summer, followed by rapid vegetative growth, flowering from mid- to late summer, seed dispersal in autumn, and dormancy in winter. Unusually, plants of subsp. *intermedius* from M'Ponduine northeast of Namaacha in southern Mozambique remain more or less evergreen when cultivated in Cape Town's temperate climate (Jamieson, pers. obs.). M'Ponduine has a warm and temperate climate, with high summer rainfall, receiving some rain (± 20 mm) even in the driest month of August. It is not precisely known whether or not the plants are deciduous in the wild, but if they are semi-evergreen or evergreen, it would be exceptional for this taxon. For further details, see under subspecies.

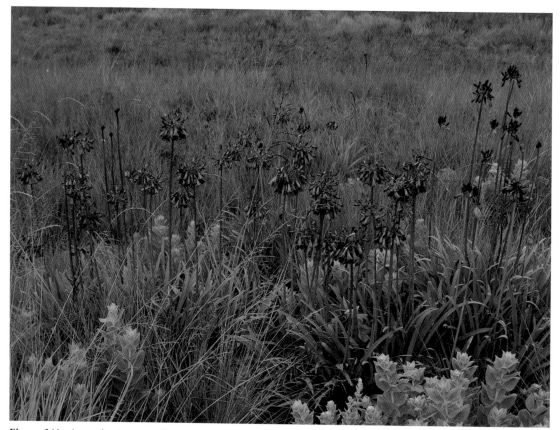

Figure 241. *Agapanthus inapertus* subsp. *intermedius* on grassy high-lying flats, Mauchsberg, north-central Mpumalanga. Image: Leigh Voigt.

Key to the subspecies

1a Style 11–13 mm long; inner tepals 10–15 mm long, 5–6 mm wide; perianth tube 10–15 mm long; perianth tubular, bright blue or navy blue, produced in small, dense heads; leaves bright green, in narrow, erect fans; rocky grassland flats, hills and mountain slopes; north-central to northern Mpumalanga (Machadodorp to Sabie) **8c. *A. inapertus* subsp. *parviflorus***

1b Style 18–32 mm long; inner tepals 15–24 mm long, 7–10 mm wide; perianth tube 10–32 mm long; perianth tubular, trumpet-shaped or narrowly or widely funnel-shaped 2

2a Tepals fleshy, violet blue or deep blackish-violet, rarely magenta and lilac-grey; perianth tubular; perianth tube 15–20 mm long; leaves yellowish-green or glaucous-green, in spreading or suberect fans; among dolomite boulders, often in semi-shade within bushes and under trees; central and north-western to northern Mpumalanga (Belfast to Mariepskop). .
. **8d. *A. inapertus* subsp. *pendulus***

2b Tepals thin-textured, light to deep blue or mauvish-blue, rarely white; perianth tubular, narrowly or widely funnel-shaped or trumpet-shaped . 3

3a Perianth tubular, light to bright blue, rarely bicoloured or white; perianth tube 16–32 mm long; leaves usually glaucous, in erect or suberect fans; plants up to 2 m high in flower; moist grassy flats, hills and mountain slopes; southern Mpumalanga to east-central Limpopo (Volksrust to Haenertsburg). **8a. *A. inapertus* subsp. *inapertus***

3b Perianth narrowly or widely funnel-shaped or trumpet-shaped; light to bright blue or mauvish-blue, rarely white; perianth tube 10–18 mm long; leaves glaucous or green, in arching or erect fans; plants up to 1.5 m high in flower; rocky grassland flats, hills, mountain slopes and plateaus, sometimes in seepage or beside streams; southern Mozambique, central Eswatini and Gauteng to Soutpansberg, northern Limpopo (Namaacha, Manzini and Johannesburg to Blouberg and north of Makhado). **8b. *A. inapertus* subsp. *intermedius***

a. subsp. **inapertus**

SYNONYMY: *Agapanthus wiellighii* H.B.May (sphalm. *weilligii*), *The Gardeners' Chronicle* series 3, 54: 125 (1913). *Agapanthus umbellatus* L'Hér. var. *wiellighii* (sphalm. *weillighii*) (H.B.May) L.H.Bailey, *The Standard Cyclopedia of Horticulture* 1: 230 (1914). Type: South Africa, precise locality unknown, collected ± 1898, *G.R. von Wielligh s.n.*, figure in *Curtis's Botanical Magazine* 163: t. 9621 (1940–1942) (lectotype, designated here).

Agapanthus hollandii F.M.Leight., *South African Gardening and Country Life* 24: 71, 82 (1934). *Agapanthus inapertus* Beauverd subsp. *hollandii* (F.M.Leight.) F.M.Leight., *Journal of South African Botany*, suppl. vol. 4: 42 (1965), synon. nov. Type: South Africa, Mpumalanga, Alkmaar west of Nelspruit, February 1932, *F.H. Holland s.n.* sub. NBG 173/29 (BOL!, holo.; NBG!, iso.).

Agapanthus inapertus Beauverd subsp. *intermedius* F.M.Leight. *forma* α, *Journal of South African Botany*, suppl. vol. 4: 45 (1965), synon. nov. Type: South Africa, Mpumalanga, near Palmford Station, January 1958, *G.W. Reynolds 7214* sub. NBG 260/54 (BOL!, holo., NBG!, iso.).

Agapanthus inapertus Beauverd subsp. *intermedius* F.M.Leight. *forma* δ, *Journal of South African Botany*, suppl. vol. 4: 46 (1965), synon. nov. Type: South Africa, Limpopo, Makapansgat, *B. Maguire 2674* sub. NBG 81/56 (BOL!, holo.).

COMMON NAMES. Drakensberg agapanthus, drooping agapanthus, bloulelie (Afrikaans), hlakahla (Swazi).

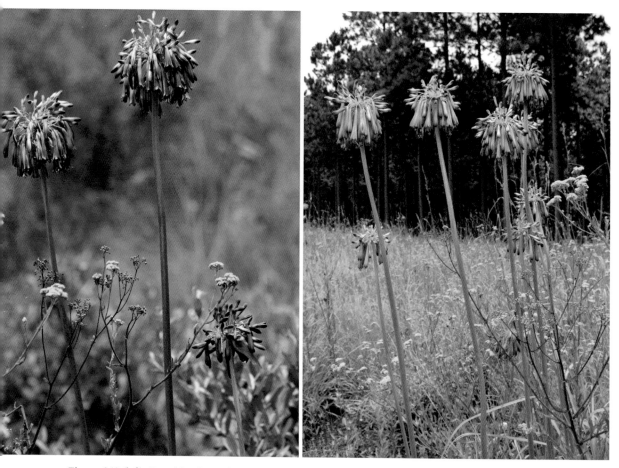

Figure 242 (left). Deep blue form of *Agapanthus inapertus* subsp. *inapertus* near Mac Mac Falls, northern Mpumalanga. Image: Graham Duncan.

Figure 243 (right). Light blue form of *Agapanthus inapertus* subsp. *inapertus* near Graskop, northern Mpumalanga. Image: Graham Duncan.

DESCRIPTION. *Plants* 0.8–2.1 m high in flower. *Pseudostem* 50–200 mm long. *Leaves* produced in erect or suberect fans, usually glaucous, rarely green. *Pseudo-umbel* 10–60-flowered. *Perianth* tubular (tepals radiate up to 15° from longitudinal axis), cernuous or pendent, light to deep blue, rarely white; perianth tube extremely variable in length, 16–32 mm long; outer tepals 13–24 × 5–7 mm; inner tepals 17–22 × 6–8 mm. *Filaments* 17–21 mm long, included or shortly to well-exserted. *Style* 20–32 mm long included or slightly exserted, rarely well exserted. *Capsule* ellipsoid, 25–40 × 8–12 mm, apex acute, subacute or obtuse. Plate 11. Figures 26, 27, 100, 125, 139, 144, 149, 156, 172, 173, 234, 238, 240, 242, 243.

FLOWERING PERIOD. December to March, with a peak in January and February.

DISTRIBUTION AND HABITAT. Populations of subsp. *inapertus* occur from Volksrust in southern Mpumalanga to just north of Haenertsburg in east-central Limpopo (Map 9). It is commonly encountered in the vicinity of Graskop in northern Mpumalanga, where certain forms of this taxon

are the tallest among all the subspecies of *A. inapertus*, and indeed of all agapanthus, with scapes reaching up to 2.1 m high in flower. The plants occur as isolated small to large clumps of the same clone, or sometimes in dense colonies numbering thousands of individuals comprising numerous clones, often in moist depressions along road verges, in swampy ground or heavily flooded flats, sometimes in slowly flowing water in thick grass, as well as on drier grassy hillsides and mountain slopes among rocks (Figures 242, 243). It is usually encountered in dolomitic soils, and occurs in several vegetation types including Granite Lowveld, Lydenburg Montane Grassland, Northern Escarpment Dolomite Grassland and Woodbush Granite Grassland.

CONSERVATION STATUS. The subsp. *inapertus* is not threatened, and is assessed as Least Concern, according to the Red List of South African Plants version 2020.1 (Foden & Potter, 2005g).

NOTES. Subsp. *inapertus* is putatively pollinated by sunbirds, although no actual records from the wild appear to exist. At Kirstenbosch, orange-breasted sunbirds and southern double-collared sunbirds regularly visit the flowers of both blue- and white-flowered forms, as do Cape honeybees. The striking, usually glaucous leaves and often very tall scapes, combined with considerable variation in blue tepal colouration makes this plant a highly appealing subject for the garden, whether planted among grasses in a meadow, or placed towards the centre or rear of mixed borders. White-flowered forms, with their intensely glaucous leaf fans, are equally outstanding horticultural subjects and have much potential

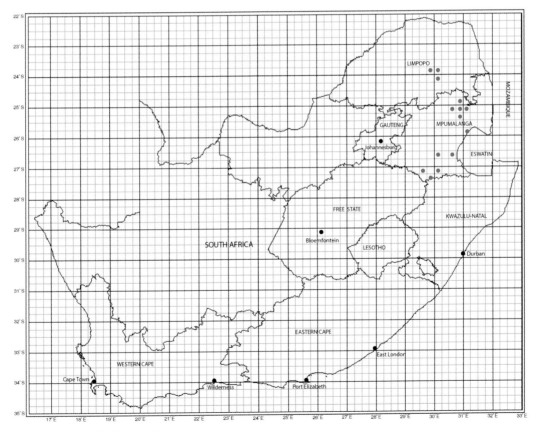

Map 9. Known distribution of *Agapanthus inapertus* subsp. *inapertus*.

as cut flowers (see Figure 100). Pre-requisites for success with this subspecies are humus-rich soils, plentiful moisture in summer, and full sun. The subsp. *inapertus* can generally be regarded as half-hardy and requiring of protection in cold winter climates of the northern hemisphere.

b. subsp. **intermedius** F.M.Leight., *Journal of South African Botany*, suppl. vol. 4: 45, 46 (1965).

TYPE: South Africa, Mpumalanga, 20 miles (32 km) south of Barberton, January 1945, *G.W. Reynolds s.n.* sub. NBG 42/43 (BOL!, holo., iso.) (= forma γ).

SYNONYMY: *Agapanthus inapertus* Beauv. subsp. *intermedius* forma β, *Journal of South African Botany*, suppl. vol. 4: 45 (1965). Type: South Africa, Mpumalanga, Farm 'The Brook' east of Carolina, 21 January, 1958, *L.E. Codd 9500* sub. NBG 81/56 (PRE, holo. (not found); BOL!, iso.).

Agapanthus dyeri F.M.Leight., *Journal of South African Botany*, suppl. vol. 4: 46 (1965). Type: South Africa, Limpopo, Blouberg (Blaauwberg), Mohlakeng Plateau, January 1955, *R.A. Dyer & L.E. Codd 8765* sub. NBG 873/54 (PRE!, holo.; NBG!, iso.).

NAME. *intermedius*: Leighton's subspecific name presumably refers to the intermediate length of the perianth, as compared with those of the short-flowered subsp. *parviflorus* and the long-flowered subsp. *inapertus*.

COMMON NAME. Dyer's agapanthus.

DESCRIPTION. *Plants* 0.6–1.2 m high in flower. *Pseudostem* 45–220 mm long. *Leaves* 20–45 mm wide, produced in arching or suberect fans, bright green, glaucous green or glaucous. *Pseudo-umbel* 15–60-flowered, sometimes forming pseudo-umbelulae. *Perianth* narrowly or widely funnel-shaped (tepals radiate at an angle of >15° up to 30° from longitudinal axis) or trumpet-shaped, cernuous,

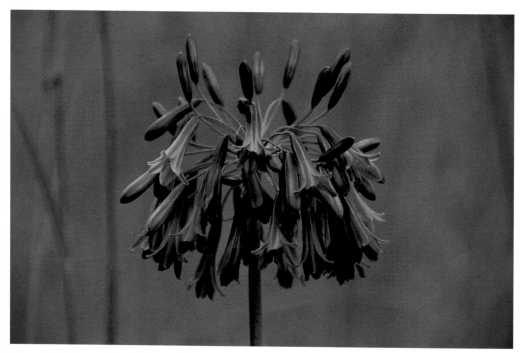

Figure 244. Trumpet-shaped blooms of *Agapanthus inapertus* subsp. *intermedius*, Verloren Vallei Nature Reserve, north-central Mpumalanga. Image: Leigh Voigt.

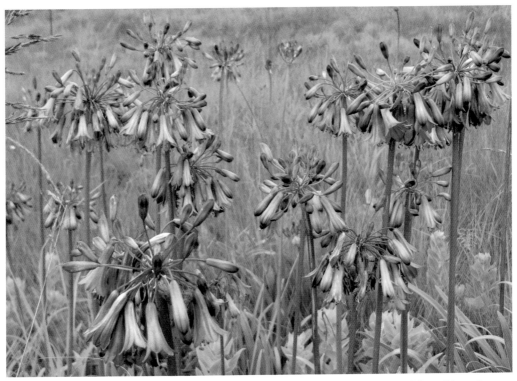

Figure 245. Narrowly funnel-shaped blooms of *Agapanthus inapertus* subsp. *intermedius*, Mauchsberg, Mpumalanga. Image: Leigh Voigt.

light to bright blue or mauvish-blue; perianth tube 10–18 mm long; outer tepals 20–25 × 7– 8 mm; inner tepals 18–24 × 7–10 mm. *Filaments* 20–22 mm long. *Style* 18–25 mm long, included or slightly exserted. *Capsule* narrowly to broadly ellipsoid, 20–27 × 8–16 mm, apex obtuse, subacute or acute. *Chromosome number*: 2n = 28 + 0–2B (Muzila & Spies, 2005). Figures 150, 235, 241, 244, 245.

FLOWERING PERIOD. Late December to mid-March, with a peak in January and February.

DISTRIBUTION AND HABITAT. Subsp. *intermedius* occurs from Namaacha in southern Mozambique, Manzini in central Eswatini and Johannesburg, Gauteng in the south of its range, to the Blouberg Plateau and to the north of Makhado (Louis Trichardt), in the western and northern Soutpansberg, respectively, in northern Limpopo (Map 10). The plants grow in small groups or in colonies, in a variety of habitats, usually in full sun or rarely in light shade, including summer-moist grassy flats among rocks or boulders in heavy, turfy soil, seepage grassland on quartzite rock faces, beside streams and on mountain plateaus, to just over 2000 m, such as on the Wolkberg in east-central Limpopo (Figures 244, 245). It occurs in numerous vegetation types including Soutpansberg Summit Sourveld, Southern Lebombo Bushveld, Wolkberg Dolomite Grassland, Northern Escarpment Dolomite Grassland and Lydenburg Montane Grassland.

CONSERVATION STATUS. The subsp. *intermedius* is not threatened, and is assessed as Least Concern, according to the Red List of South African Plants version 2020.1 (Pillay, 2004).

NOTES. The subsp. *intermedius* is probably visited by sunbirds and generalist insect pollinators. It adapts well to cultivation in rich, well-drained soils in full sun, and its varied, narrowly or widely

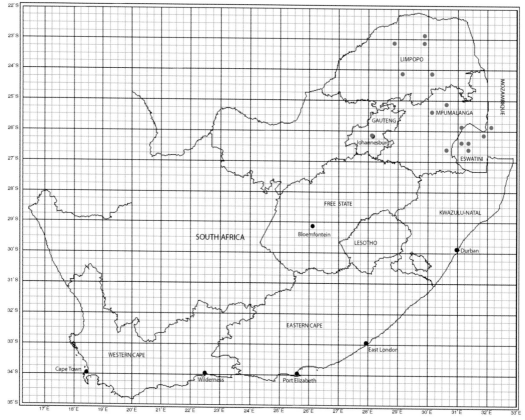

Map 10. Known distribution of *Agapanthus inapertus* subsp. *intermedius*.

funnel-shaped or trumpet-shaped blooms, in shades of light to deep blue or mauvish-blue, offer much potential for the mixed border, and for containers. The cultivar originally published as *A. inapertus* subsp. *intermedius* 'Wolkberg' in Duncan (1985, 1998) was identified as belonging to this taxon, but is correctly *A. campanulatus* 'Wolkberg' (see page 31). The subsp. *intermedius* can generally be regarded as half-hardy in cold winter climates of the northern hemisphere.

c. subsp. parviflorus F.M.Leight., *Journal of South African Botany*, suppl. vol. 4: 42 (1965).

TYPE: South Africa, Mpumalanga, 2 miles (3.2 km) south of Dullstroom, January 1955, *G.W. Reynolds 7217*, sub. NBG 261/54 (BOL!, holo.; NBG!, iso.).

NAME. *parviflorus*: descriptive of the relatively small, short flowers.

COMMON NAME. small-flowered agapanthus.

DESCRIPTION. *Plants* 0.8–1.8 m high in flower. *Pseudostem* 30–100 mm long. *Leaves* 10–20 mm wide, produced in erect or suberect fans, bright green. *Pseudo-umbel* 15–30-flowered. *Perianth* tubular (tepals radiate up to 15° from longitudinal axis), cernuous or pendent, bright blue or navy blue; perianth tube 10–15 mm long; outer tepals 10–15 × 4–5 mm; inner tepals 10–15 × 5–6 mm. *Filaments* 9–12 mm long. *Style* 11–13 mm long, included. *Capsule* narrowly ellipsoid, 23–30 × 6–8 mm, apex acute. *Seed* 3 × 2 mm. Figures 174, 236, 239, 246, 247.

FLOWERING PERIOD. January to February, with a peak in late January.

DISTRIBUTION, HABITAT AND GROWTH CYCLE. The subsp. *parviflorus* is distributed in north-central, northern and north-eastern Mpumalanga, from Machadodorp and Belfast in the south of its range, to Lydenburg and Sabie in the north, and White River to the north-east (Map 11). It occurs in several grassland and savanna vegetation types including Lydenburg Montane Grassland, Lydenburg Thornveld, Northern Escarpment Dolomite Grassland and Legogote Sour Bushveld. It is fairly common around Dullstroom, the highest town in South Africa (2100 m), where the type collection was made, and on De Berg Mountain at 2300 m, the highest point in Mpumalanga and one of the

Figure 246 (left). *Agapanthus inapertus* subsp. *parviflorus* in Lydenburg Montane Grassland near Dullstroom, north-central Mpumalanga. Image: Graham Duncan.

Figure 247 (right). *Agapanthus inapertus* subsp. *parviflorus* on moist grassy flats near Dullstroom, north-central Mpumalanga. Image: Duncan McKenzie.

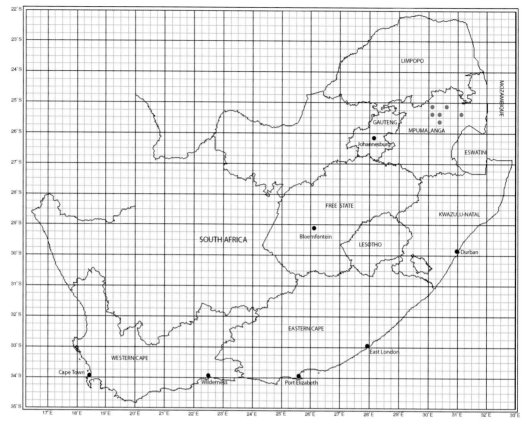

Map 11. Known distribution of *Agapanthus inapertus* subsp. *parviflorus*.

highest in South Africa. It is usually found in small groups on rocky hill slopes and flats among low scrub and grasses on outcrops of dolomite boulders (Figure 246), less frequently in large colonies among long grass on moist flats (Figure 247). To the north of Dullstroom it occurs on south-facing slopes among quartzite rocks and grasses near the town.

CONSERVATION STATUS. The subsp. *parviflorus* is not threatened, and is assessed as Least Concern, according to the Red List of South African Plants version 2020.1 (Foden & Potter, 2005h).

NOTES. The subsp. *parviflorus* is visited by the East African lowland honey bee *Apis mellifera* subsp. *scutellata* (family Apidae) and by the spotted blister beetle *Ceroctis capensis*. As with subsp. *inapertus* and subsp. *pendulus*, it is also putatively sunbird-pollinated, yet no documentary or photographic evidence of this appears to exist. Despite its relatively small flower heads and shorter perianths, the bright green, suberect leaves and often very long scapes bearing bright blue or navy-blue flowers make it an elegant addition to temperate gardens with warm summers and cool, dry winters, planted in wall-side borders, towards the rear of mixed borders, or in drifts. The subsp. *parviflorus* can generally be regarded as half-hardy in cold winter climates of the northern hemisphere.

d. subsp. **pendulus** (L.Bolus) F.M.Leight., *Journal of South African Botany*, suppl. vol. 4: 42 (1965). *Agapanthus pendulus* L.Bolus, *The Annals of the Bolus Herbarium* 3: 80 (1923).

TYPE: South Africa, Mpumalanga, Lydenburg, 24 April 1916, *A.S. Barnett s.n.*, NBG 1056/16 (BOL!, holo; K!, PRE, iso.).

NAME. *pendulus*: descriptive of the pendent orientation of the flowers.

COMMON NAME. Graskop agapanthus.

DESCRIPTION. *Plants* 0.6– 1.5 m high in flower. *Pseudostem* 30–100 mm long. Leaves up to 40 mm wide, produced in arching or suberect fans, yellowish-green or glaucous green, margins sometimes undulate and cartilaginous. *Pseudo-umbel* 15–45-flowered. *Perianth* tubular (tepals radiate up to 15° from longitudinal axis), cernuous or pendent, violet blue, deep blackish-violet or rarely with perianth tube magenta, tepals lilac-grey; perianth tube 15–20 mm long; outer tepals 12–21 × 7–8 mm; inner tepals 15–21 × 7–10 mm. Filaments 16–24 mm long. Style 18–22 mm long, included or slightly exserted. *Capsule* broadly ellipsoid, 22–27 × 11–16 mm, apex obtuse. Plate 12; Figures 28–30, 133, 237, 248, 249.

FLOWERING PERIOD. January to March, with a peak in February.

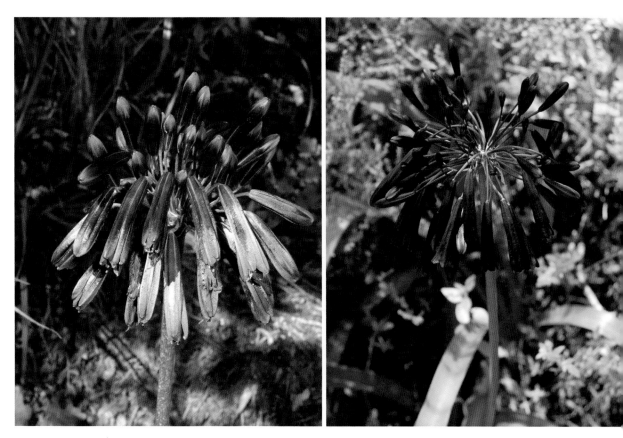

Figure 248 (left). Magenta form of *Agapanthus inapertus* subsp. *pendulus* near Mariepskop, northern Mpumalanga. Image: Neil Crouch.

Figure 249 (right). Violet-blue form of *Agapanthus inapertus* subsp. *pendulus* in dappled shade, Graskop, northern Mpumalanga. Image: Graham Duncan.

DISTRIBUTION AND HABITAT. In comparison with subsp. *inapertus* and subsp. *intermedius*, the subsp. *pendulus* has a relatively small distribution in central and northern Mpumalanga, from Belfast to Pilgrim's Rest, Graskop and near Mariepskop (Map 12). It occurs in Lydenburg Montane Grassland and Northern Escarpment Dolomite Grassland. It is most well-known from the vicinity of Graskop, where it often favours semi-shaded or even deeply shaded terrain among dolomite boulders beneath shrubs and trees, growing in humus-rich soils (Figures 248, 249).

CONSERVATION STATUS. The taxon is not threatened in the wild, and is assessed as Least Concern, according to the Red List of South African Plants version 2020.1 (Foden & Potter, 2005i). However, owing to its high horticultural value, numbers of plants have been illegally removed from the wild by collectors, and it is not nearly as plentiful as it used to be.

NOTES. The subsp. *pendulus* is putatively sunbird-pollinated, yet no illustrative records are known to exist from the wild. At Kirstenbosch, the flowers are regularly visited by orange-breasted sunbirds, as well as by Cape honeybees. An unusual form with undulate leaf margins (see Figure 142) as well as two other outstanding wild-collected forms, the cultivars 'Black Magic' (see Figure 29) and 'Graskop' (see Figure 30) have all been selected from the vicinity of Graskop. The subsp. *pendulus* is an outstanding garden plant for mixed borders in full sun. It can generally be regarded as half-hardy and requiring of protection in cold winter climates of the northern hemisphere, however it easily withstands moisture during the winter dormant period in temperate parts.

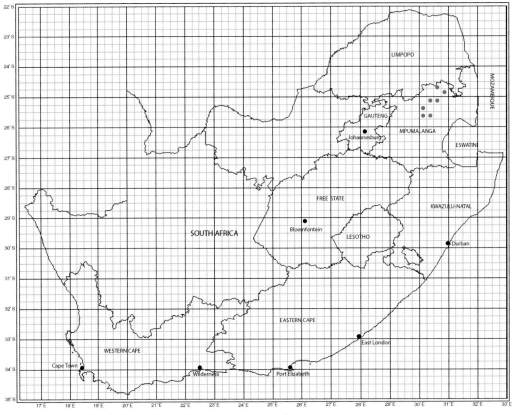

Map 12. Known distribution of *Agapanthus inapertus* subsp. *pendulus*.

INSUFFICIENTLY KNOWN NAMES
(including nomina nuda and nomina invalida)

Agapanthus maximus Hort., *Neerland's Plantentuin* 3: t. 40 (1867), nom. nud. No valid description was provided, and no material has been traced.

Agapanthus medius Lodd. ex Steud., *Nomenclator Botanicus* (Steudel) 2(1): 33 (1840), nom. nud. No description or figure was referred to, and no material has been traced.

Agapanthus umbellatus L'Hér. var. *saundersonianus* L.H.Bailey, *The Standard Cyclopedia of Horticulture* 1: 230 (1914), nom. nud. The description is too brief to form an opinion, no figure was provided and no material has been traced.

Agapanthus umbelliferus Poir., *Encyclopédie Méthodique* suppl. 1: 155 (1810), nom. nud. No description or figure was provided, and no material has been traced.

Section *Lilacinipollini* Zonn. & G.D.Duncan in W. Snoeijer, *Agapanthus*: 38 (2004), nom. inval. No Latin diagnosis was provided, and type material was not indicated.

Section *Ochraceipollini* Zonn. & G.D.Duncan in W. Snoeijer, *Agapanthus*: 39 (2004), nom. inval. No Latin diagnosis was provided, and type material was not indicated.

EXCLUDED TAXA

Agapanthus calyciflorus Banks & Sol. ex Hook.f. = *Fuchsia excorticata* (G.Forst.) L.f.

Agapanthus ensifolius (Thunb.) Willd. = *Lachenalia ensifolia* (Thunb.) J.C.Manning & Goldblatt

REFERENCES

Agardh, J.G. (1992). Alliaceae. In: Watson, L. & Dallwitz, M.J., *The Families of Flowering Plants.* http://www1.biologie.uni-hamburg.de/b-online/delta/angio/www/alliacea.htm. Accessed 27 November 2019.

AHDB Horticulture (2017). Biology and control of agapanthus gall midge. https://horticulture.ahdb.org.uk/sites/default/files/research_papers/HNS%20PO%20199_Grower%20Summary_2017.pdf. Accessed 11 December 2019.

Allemand, P., Pionnat, J.-C., Mallait, M. & Chapugier, Y. (2001). *L'agapanthe.* Association Nationale des Structures D'Experimentation et de Démonstration en Horticulture, Paris.

Allison, M. (2019). *The last Agapanthus. Amaryllids* 2019 part 2: 11–12.

Amusan, O.O.G. (2009). Some ethnoremedies used for HIV/AIDS and related disease in Swaziland. *The African Journal of Plant Science and Biotechnology* 3: 20–26.

Andrews, S. & Brickell, C. (1999). Does the true *Agapanthus africanus* 'Albus' exist in cultivation anymore? *The New Plantsman* 6(1): 31–34.

APG II (2003). An update of the Angiosperm Phylogeny Group classification for the orders and families of flowering plants: APG II. *Botanical Journal of the Linnean Society* 141: 399–436.

APG III (2009). An update of the Angiosperm Phylogeny Group classification for the orders and families of flowering plants: APG III. *Botanical Journal of the Linnean Society* 161(2): 105–121.

APG IV (2016). An update of the Angiosperm Phylogeny Group classification for the orders and families of flowering plants: APG IV. *Botanical Journal of the Linnean Society* 181: 1–20.

Bailey, L.H. (1914). *The Standard Cyclopedia of Horticulture* 1. The MacMillan Company, London.

Baker, J.G. (1897). XX. *Agapanthus*, L'Hérit. In: Thiselton-Dyer, W.T. (ed.), *Flora Capensis* VI Part 3: 402–403. L. Reeve & Co., London.

Baskaran, P. & Van Staden, J. (2013). Rapid in vitro micropropagation of *Agapanthus praecox. South African Journal of Botany* 86: 46–50.

Batten, A. & Bokelmann, H. (1966). *Wild Flowers of the Eastern Cape Province.* Books of Africa, Cape Town.

Beauverd, G. (1910). *Agapanthus inapertus* sp. nov. et revision des espèces et variétés du genre *Agapanthus. Bulletin de la Société Botanique de Genève* (series 2) 2: 194–198.

Belling, J. (1928). Contraction of chromosomes during maturation divisions in *Lilium* and other plants. *University of California Publications in Botany* 14: 335–343.

Bentham, G. & Hooker, J.D. (1883). Liliaceae, Tribus Allieae: *Agapanthus. Genera plantarum* 3(2): 798.

Bolofo, R.N. & Johnson, C.T. (1988). The identification of 'Isicakathi' and its medicinal use in Transkei. *Bothalia* 18: 125–130.

Bolus, H.M.L. (1923). Novitates Africanae. *The Annals of the Bolus Herbarium* 3: 14, 80.

Bond, J. (1978). *Agapanthus* trial. *The Garden* 103(8): 315–318.

Breyne, J. (1680). *Prodromus fasciculi rariorum plantarum.* Sumptibus auctoris, Danzig.

Breyne, J. (1739). *Prodromi fasciculi rariorum plantarum primus et secundus.* Sumptibus editoris, Danzig.

Brickell, C.D., Alexander, C., Cubey, J.J., David, J.C., Hoffman, M.H.A., Leslie, A.C., Malécot, V. & Xiaobai Jin (2016). *International Code of Nomenclature for Cultivated Plants* (9th edition). International Society for Horticultural Science, Leuven.

Bruneton, J. (1995). *Pharmacognosy, Phytochemistry, Medicinal Plants.* Intercept, Hampshire.

Bryant, A.T. (1966). Zulu medicine and medicine-men. *Annals of the Natal Government Museum* 2(1): 1–103.

Burge, G.K., Morgan, E.R., Seelye, J.F., Clark, G.E., McLachlan, A. & Eason, J.R. (2010). Prevention of floret abscission for *Agapanthus praecox* requires an adequate supply of carbohydrate to the developing florets. *South African Journal of Botany* 76: 30–36.

Carbutt, C. (2019). The Drakensberg Mountain Centre: A necessary revision of southern Africa's high elevation centre of plant endemism. *South African Journal of Botany* 124: 508–529.

Carrière, E.-A. (1882). Prolification et transformation des fleurs d'Agapanthe. *Revue Horticole* (1882): 155.

Chase, M.W., Reveal, J.L. & Fay, M.F. (2009). A subfamilial classification for the expanded asparagalean families Amaryllidaceae, Asparagaceae and Xanthorrhoeaceae. *Botanical Journal of the Linnean Society* 161(2): 132–136.

Cholo, F. (2006). *Agapanthus caulescens* Spreng. subsp. *gracilis* (F.M.Leight.) F.M.Leight. National Assessment: Red List of South African Plants version 2020.1. Accessed 11 July 2020.

Cholo, F. & Kamundi, D.A. (2006). *Agapanthus praecox* Willd. subsp. *praecox*. National Assessment: Red List of South African Plants version 2020.1. Accessed 11 July 2020.

Christenhusz, M.J.M., Fay, M.F. & Chase, M.W. (2017). *Plants of the World*. Kew Publishing, Kew.

Clark, V.R., Barker, N.P. & Mucina, L. (2009). The Sneeuberg: a new centre of floristic endemism on the Great Escarpment, South Africa. *South African Journal of Botany* 20: 2543–2561.

Conran, J.G. (2003-2004). Ultraviolet reflectance patterns in some Agapanthaceae, Alliaceae and Amaryllidaceae and their possible significance for pollination. *Herbertia* 58: 75–90.

Cronquist, A. (1978). Once again, what is a species? In: Knutson, L.V. (ed.), *Biosystematics in Agriculture*. Montlair, New Jersey.

Cronquist, A. (1981). *An Integrated System of Classification of Flowering Plants*. Columbia University Press, New York.

Cubey, J. (2020). *RHS Plant Finder 2020*. Royal Horticultural Society, Peterborough.

Curtis, W. (1800). *Agapanthus umbellatus*. *Curtis's Botanical Magazine* series 1, vol. 14: t. 500.

Dabee, V.P. (2013). Life cycle and host preferences in the Agapanthus borer (*Neuranethes spodopterodes*). BSc (Hons) thesis, University of Cape Town.

Dahlgren, R.M.T., Clifford, H.T. & Yeo, P.F. (1985). *The Families of the Monocotyledons: Structure, Evolution and Taxonomy*. Springer-Verlag, Berlin.

Darlington, C.D. (1933). Meiosis in *Agapanthus* and *Kniphofia*. *Cytologia* 4: 229–240.

Davis, P.H. & Heywood, V.H. (1973). *Principles of Angiosperm Taxonomy*. R.E. Krieger, New York.

Dawson, M.I. & Ford, K.A. (2012). Agapanthus in New Zealand. *New Zealand Garden Journal* 15(1): 2–18.

Dawson, M., Bodley, E., Stanley, R., Duncalf, I. & Morgan, E. (2018). Assessing fertility in horticultural selections of *Agapanthus*. Proceedings of the 2017 Annual Meeting of the International Plant Propagators' Society. *Acta Horticulturae* 1212: 41–62.

Dold, A.P. & Cocks, M.L. (2001). Traditional veterinary medicine in the Alice district of the Eastern Cape Province, South Africa. *South African Journal of Science* 97: 375–379.

Du Plessis, N.M. & Duncan, G.D. (1989). *Agapanthus. Bulbous plants of southern Africa*. Tafelberg Publishers, Cape Town.

Duncan, G.D. (1983). The white form of *Agapanthus walshii* L.Bol. *Veld & Flora* 69 (1): 21.

Duncan, G.D. (1985). *Agapanthus* species — their potential and the introduction of ten selected forms. *Veld & Flora* 71(4): 122–125.

Duncan, G.D. (1993). *Agapanthus dyeri*. *The Flowering Plants of Africa* 52 t. 2062.

Duncan, G.D. (1998). *Grow Agapanthus*. Kirstenbosch Gardening Series. National Botanical Institute, Cape Town.

Duncan, G.D. (2003). Some notes on *Agapanthus*. *The Plantsman New Series* 2: 174–178.

Duncan, G.D. (2004). *Agapanthus africanus* subsp. *walshii*. *Curtis's Botanical Magazine* 21(3): 205–214.

Duncan, G.D. (2005). Notes on African Plants. Agapanthaceae. Synonymy in *Agapanthus*. *Bothalia* 35: 87–89.

Duncan, G.D. (2010). *Agapanthus*. *Grow Bulbs*. Kirstenbosch Gardening Series. South African National Biodiversity Institute, Cape Town.

Duncan, G.D. & Pillay, D. (2004). *Agapanthus walshii* L.Bolus. National Assessment: Red List of South African Plants version 2020.1. Accessed 18 July 2020.

Duncan, J.R. & Davies, V.C. (1925). *General Catalogue of Choice Nursery Stock*. New Plymouth, New Zealand.

Dyer, R.A. (1966a). *Agapanthus campanulatus* subsp. *patens*. *The Flowering Plants of Africa* 37: t. 1478.

Dyer, R.A. (1966b). *Agapanthus inapertus* subsp. *inapertus*. *The Flowering Plants of Africa* 37: t. 1479.

Dyer, R.A. (1966c). *Agapanthus inapertus* subsp. *pendulus*. *The Flowering Plants of Africa* 37: t. 1480.

Dyer, R.A. (1966d). *Agapanthus praecox* subsp. *orientalis forma*. *The Flowering Plants of Africa* 37: t. 1476, t. 1477.

Edwards, D. & Leistner, O.A. (1971). A degree reference system for citing biological records in southern Africa. *Mitteilungen der Botanischen Staatssammlung München* 10: 501–509.

Endlicher, S. F.L. (1836). Agapantheae. *Genera Plantarum*: 141–142. Apud F. Beck, Vienna.

Fay, M.F. & Chase, M.W. (1996). Resurrection of Themidaceae for the *Brodiaea* alliance, and recircumscription of Alliaceae, Amaryllidaceae and Agapanthoideae. *Taxon* 45: 441–451.

Fay, M.F., Rudall, P.J., Sullivan, S., Stobart, K.L., De Bruijn, A.Y., Reeves, G., Qamaruz-Zaman *et al.* (2000). Phylogenetic studies of Asparagales based on four plastid DNA loci. In: *Monocots: Systematics and Evolution* (vol. 1). CSIRO, Collingwood.

Foden, W. & Potter, L. (2005a). *Agapanthus africanus* (L.) Hoffmanns. National Assessment: Red List of South African Plants version 2020.1. Accessed 5 July 2020.

Foden, W. & Potter, L. (2005b). *Agapanthus praecox* Willd. subsp. *minimus* (Lindl.) F.M.Leight. National Assessment: Red List of South African Plants version 2020.1. Accessed 5 July 2020.

Foden, W. & Potter, L. (2005c). *Agapanthus praecox* Willd. subsp. *orientalis* (F.M.Leight.) F.M.Leight. National Assessment: Red List of South African Plants version 2020.1. Accessed 5 July 2020.

Foden, W. & Potter, L. (2005d). *Agapanthus caulescens* Spreng.

subsp. *angustifolius* F.M.Leight. National Assessment: Red List of South African Plants version 2020.1. Accessed 5 July 2020.

Foden, W. & Potter, L. (2005e). *Agapanthus campanulatus* F.M.Leight. subsp. *campanulatus*. National Assessment: Red List of South African Plants version 2020.1. Accessed 5 July 2020.

Foden, W. & Potter, L. (2005f). *Agapanthus campanulatus* F.M. Leight. subsp. *patens* (F.M.Leight.) F.M.Leight. National Assessment: Red List of South African Plants version 2020.1. Accessed 5 July 2020.

Foden, W. & Potter, L. (2005g). *Agapanthus inapertus* Beauv. subsp. *inapertus*. National Assessment: Red List of South African Plants version 2020.1. Accessed 22 July 2020.

Foden, W. & Potter, L. (2005h). *Agapanthus inapertus* Beauv. subsp. *parviflorus* F.M.Leight. National Assessment: Red List of South African Plants version 2020.1. Accessed 22 July 2020.

Foden, W. & Potter, L. (2005i). *Agapanthus inapertus* Beauv. subsp. *pendulus* (L.Bolus) F.M.Leight. Red List of South African Plants version 2020.1. Accessed 22 July 2020.

Fogaça, L.A., Pedrotti, E.L. & Alves, A.C. (2016). Micropropagation of *Agapanthus umbellatus* var. *minor* by using two systems of multiplication. *Ciências Agrárias* 37: 2923–2932.

Fulcher, R.J. (2000). From Africa with love. *The Garden* (August), *Journal of the Royal Horticultural Society*: 592–597.

Fulcher, R.J. (2004). *Pine Cottage Plants Nursery Catalogue* (September 2004): 19.

Fulcher, R.J. (2018). In praise of *Agapanthus inapertus* — some observations on this species in the wild and in cultivation. *Amaryllids* (2018 part 2): 8–12.

Fulcher, R.J. (2019). RHS trial of *Agapanthus*. *The Plant Review* (September): 12–19.

Fulcher, R.J. & Fulcher, L. (2010). *Pine Cottage Plants Nursery Catalogue* (September 2010): 1–22.

Geitler, L. (1933). Das Verhalten der Chromozentren von *Agapanthus* während der Meiose. *Osterreichische Botanische Zeitschrift* 82: 277–282.

Gerstner, J. (1938). A preliminary checklist of Zulu names of plants with short notes. *Bantu Studies* 12(3): 215–236, (4): 321–342.

Gillissen, A.J.M. (1980). Sortiments onderzoek van het geslacht *Agapanthus* L'Héritier. Unpublished thesis, Department of Taxonomy of Cultivated Plants, Wageningen.

Gillissen, A.J.M. (1982). Aspecten uit onderzoek *Agapanthus* sortiment. *Vakblad voor Bloemisterij* 22: 48–51.

Goebel, K. (1933). *Organographie der Pflanzen*. 3. Teil: Samenpflanzen. G. Fischer, Jena.

González, G., Freire, R., Francicso, C.G., Salazar, J.A. & Suárez, E. (1974). 7-dehydroagapanthagenin and 8(14)-dehydroagapanthagenin, two new spirostan sapogenins from *Agapanthus africanus*. *Phytochemistry* 13: 627–632.

González, G., Francicso, C.G., Freire, R., Hernandez, R., R., Salazar, J.A. & Suárez, E. (1975). 9(11) dehydroagapanthagenin, a new spirostan sapogenin from *Agapanthus africanus*. *Phytochemistry* 14: 2259–2262.

Graham, S.W., Zgurski, J.M., McPherson, M.A., Cherniawsky, D.M., Saarela, J.M., Horne, E.S.C., Smith, S.Y. *et al.* (2006). Robust inference of monocot deep phylogeny using an expanded multigene plastid data set. In: *Monocots: Comparative Biology and Evolution* (vol. 1, excluding *Poales*). Rancho Santa Ana Botanical Garden, Claremont.

Guignard, L. (1884). Recherches sur la structure et la division du noyau cellulaire chez les vegetaux. *Annales des Sciences Naturelles Botanique*, sér. 17: 5–59.

Gunn, M. & Codd, L.E. (1981). *Botanical exploration of southern Africa*. A.A. Balkema, Rotterdam.

Hannibal, L.S. (1943). Mutations in amaryllids. *Herbertia* 10: 127–129.

Harris, K.M., Salisbury, A. & Jones, H. (2016). *Enigmadiplosis agapanthi*, a new genus and species of gall midge (Diptera, Cecidomyiidae) damaging Agapanthus flowers in England. *Cecidology* 31: 17–25.

Hickman, S. & Hickman, C. (2018). *Success with Agapanthus*. 2QT Ltd Publishing, Settle, North Yorkshire.

Hingston, A. (2006). Is the exotic bumblebee (*Bombus terrestris*) assisting the naturalization of *Agapanthus praecox* ssp. *orientalis* in Tasmania? *Ecological Management and Restoration* 7: 236–238.

Hoffmannsegg, J.C. (1824). *Agapanthus africanus. Verzeichniss der Pflanzenkulturen*: 035. Arnoldischen Buchhandlung, Dresden.

Hulme, M.M. (1954). *Wild flowers of Natal*. Shuter & Shooter, Pietermaritzburg.

Hunt, D.R. (1972-1973). *Agapanthus caulescens* subsp. *gracilis*. *Curtis's Botanical Magazine* (new series) 179: t. 632.

Hutchings, A., Scott, A.H., Lewis, G. & Cunningham, A. (1996). *Zulu Medicinal Plants — an inventory*. University of Natal Press, Pietermaritzburg.

Hutchinson, J. (1934). *The Families of Flowering Plants* Vol. 2: Monocotyledons. Clarendon Press, Oxford.

Jacot Guillarmod, A. (1971). *Flora of Lesotho*. Cramer, Lehre.

Jarvis, C. (2007). *Crinum africanum. Order out of Chaos*: 458. The Linnean Society of London in association with the Natural History Museum, London.

Jersáková, J., Jürgens, A., Šmilauer, P. & Johnson, S.D. (2012). The evolution of floral mimicry: identifying traits that visually attract pollinators. *Functional Ecology* 26(6): 1381–1389.

Johnson, S.D., Harris, L.F. & Proche, Ş. (2009). Pollination and breeding systems of selected wildflowers in a southern African grassland community. *South African Journal of Botany* 75(4): 630–645.

Kahl, G. (2015). *The dictionary of genomics, transcriptomics and proteomics.* John Wiley & Sons, New Jersey.

Kaido, T.L., Veale, D.J.H. & Havlik, I. (1994). The preliminary screening of plants used as traditional herbal remedies during pregnancy and labour. *South African Pharmacological Society, 28th annual congress, Cape Town,* 22–24 September 1994.

Kalendar, R., Tanskanen, J., Immonen, S., Nevo, E. & Schulman, A.H. (2000). Genome evolution of wild barley (*Hordeum spontaneum*) by Bare-1 retrotransposon dynamics in response to sharp microclimate divergence. *Proceedings of the National Academy of Sciences of the USA* 97: 6603–6607.

Kamara, B.I., Manong, D.T.L. & Brandt, E.V. (2005). Isolation and synthesis of a dimeric dihydrochalcone from *Agapanthus africanus. Phytochemistry* 66(10): 1126–1132.

Kativu, S. (2006). Agapanthaceae of the Flora Zambesiaca area. *Kirkia* 18(2): 171–173.

Ker Gawler, J. B. (1823). *Agapanthus umbellatus* var. *minimus. The Botanical Register* 9: t. 699.

Koduru, D., Grieson, S. & Afolayan, A.J. (2007). Ethnobotanical information of medicinal plants used for treatment of cancer in the Eastern Cape Province. *Current Science* 92: 97–99.

Kubitzki, K. (1998). Agapanthaceae. In: Kubitzki, K. (ed.): *The Families and Genera of Vascular Plants.* Vol. III: Flowering Plants, Monocoytledons: Lilianae (except Orchidaceae). 58–60. Springer-Verlag, Berlin.

Lawrence, G.H.M. (ed.) (1963). Charles Louis L'Héritier de Brutelle, *Sertum Anglicum.* Facsimile with Critical Studies and a Translation. Hunt Botanical Library, Pittsburgh.

Leighton, F.M. (1934). Plants — New and Noteworthy. *South African Gardening and Country Life* 24: 71, 82.

Leighton, F.M. (1939a). Some Changes in Nomenclature II. *Journal of South African Botany* 5: 55–58.

Leighton, F.M. (1939b). A brief review of the genus *Agapanthus. Herbertia* 6: 104–107.

Leighton, F.M. (1945). Plantae Novae Africanae. *Journal of South African Botany* 11: 99–101.

Leighton, F.M. (1965). The genus *Agapanthus* L'Héritier. *Journal of South African Botany,* supplementary vol. 4: 1–50.

Letty, C., Dyer, R.A., Verdoorn, I.C. & Codd, L.E. (1962). *Wild Flowers of the Transvaal:* t. 12. Wild Flowers of the Transvaal Book Fund, Pretoria.

L'Héritier de Brutelle, C.-L. (1789). *Agapanthus. Sertum Anglicum:* 17. P.F. Didot, Paris.

Lighton, C. (1973). *Cape Floral Kingdom:* 123–126. Juta & Company Ltd, Cape Town.

Lima-de-Faria, A. & Sarvella, P. (1958). The organization of telomeres in species of *Solanum, Salvia, Scilla, Secale, Agapanthus* and *Ornithogalum. Hereditas* 44: 337–346.

Lindley, J. (1843). *Agapanthus umbellatus* var. *maximus. Edwards's Botanical Register* 29: t. 7.

Linnaeus, C. (1753). *Crinum africanum. Species Plantarum* 1: 292. Laurentius Salvius, Stockholm.

Lotsy, J.P. (1911). Die Familie Agapanthaceae. *Vorträge über botanische Stam esgeschichte* 3: 732. Gustav Fischer, Jena.

Mathew, G.E.A. (1970). Steroidal saponins and sapogenins from *Agapanthus praecox.* PhD thesis, University of Cape Town.

Matsuura, H. & Suto, T. (1935). Contributions to the ideogram study in phanerogamous plants. 1. *Journal of the Faculty of Science, Hokkaido Imperial University*, series 5: 33–75.

May, H.B. (1913). *Agapanthus weilligii. The Gardeners' Chronicle* (August 16): 125.

Mayr, E. (1942). *Systematics and the Origin of Species.* Columbia University Press, New York.

McNeil, G. (1972). The Katberg *Agapanthus. Journal of the Royal Horticultural Society* 97: 534–536.

McPherson, M.A., Fay, M.F., Chase, M.W. & Graham, S.W. (2004). Parallel loss of a slowly evolving intron from two closely related families in Asparagales. *Systematic Botany* 29: 296–307.

Meerow, A.W., Fay, M.F., Guy, C.L., Li, Q.-B., Zaman, F.Q. & Chase, M.W. (1999). Systematics of Amaryllidaceae based on cladistic analyses of plastid rbcL and trnL-F sequence data. *American Journal of Botany* 86: 1325–1345.

Meerow, A.W., Reveal, J.L., Snijman, D.A. & Dutilh, J.H. (2007). (1793) Proposal to conserve the name Amaryllidaceae against Alliaceae, a "superconservation" proposal. *Taxon* 56(4): 1299–1300.

Miller, P. (1768). *The Gardeners Dictionary* (8th edition). Rivington, London.

Miller, P. (1834). *Miller's Dictionary of Gardening, Botany, and Agriculture.* Orr & Smith, London.

Mokgethi, T. (2006). The investigation of indigenous South African medicinal plants for activity against *Mycobacterium tuberculosis.* Ph.D thesis, University of Cape Town.

Moninckx, J. (1701). *Moninckx Atlas* vol. 4, t. 15. Amsterdam.

Mookerjea, A. (1955). Cytology of amaryllids as an aid to the understanding of evolution. *Caryologia* 7: 1–71.

Mori, G. & Sakanishi, Y. (1989). Effect of temperature on flowering of *Agapanthus africanus* Hoffmans. *Journal of the Japanese Society for Horticulturtal Science* 57(4): 685–689.

Mucina, L. & Rutherford, M.C. (2006). *The Vegetation of South Africa, Lesotho and Swaziland. Strelitzia* 19. South African National Biodiversity Institute, Pretoria.

Mukerjee, D. & Riley, H.P. (1961). The cytological behaviour of supernumary chromosomes in two species of

Agapanthus. Bulletin of the Association of Southeastern Biologists 8: 22.

Müller-Doblies, D. (1980). Notes on the inflorescence of *Agapanthus. Plant Life* 36: 72–76.

Muzila, M. & Spies, J.J. (2005). Agapanthaceae. Chromosome counts in the genus *Agapanthus. Bothalia* 35(1): 109–110.

Nakano, M., Tanaka, S., Oota, M., Ookawa, E., Suzuki, S. & Saito, H. (2003). Regeneration of diploid and tetraploid plants from callus-derived protoplasts of *Agapanthus praecox* subsp. *orientalis* (Leighton)Leighton. *Plant Cell Tissue and Organ Culture* 72(1): 63–69.

Nelson, E.C. (2016). Sources of plants for, and distribution of plants from, the Royal Dublin Society's Botanic Gardens, Glasnevin, 1795–1879: an annotated checklist. *Northern Ireland Heritage Gardens Trust Occasional Paper* no. 7: 1–94.

Nicholson, G. (1884). *Agapanthus. The Illustrated Dictionary of Gardening* 1: 35, 36. L. Upcott Gill, London.

Ohri, D. (1998). Genome size variation and plant systematics. *Annals of Botany* (London) 82 (Supplement A): 75–83.

Palmer, L. (1954). The genus *Agapanthus. Journal of the Royal Horticultural Society* 79(1): 25-28.

Palmer, L. (1956). *Agapanthus. Journal of the Royal Horticultural Society* 81(4): 163–166.

Palmer, L. (1967). Hardy *Agapanthus* as a plant for the outdoor garden. *Journal of the Royal Horticultural Society* 92 (8): 336–341.

Paxton, J. (1840). *A Pocket Botanical Dictionary.* J. Andrews, London.

Paxton, J. (1868). *Paxton's Botanical Dictionary.* Bradbury, Evans & Co., London.

Phillips, E.P. (1917–1933). A contribution to the flora of the Leribe Plateau and environs: with a discussion on the relationships of the floras of Basutoland, the Kalahari, and the south-eastern regions. *Annals of the South African Museum* 16: 300.

Phillips, E.P. (1920). *Agapanthus umbellatus. The Flowering Plants of South Africa* 1: 1.

Picker, M.D. & Krüger, M. (2013). Spread and impacts of the agapanthus borer (*Neuranethes spodopterodes* (Hampson, 1908), comb. nov.), a translocated native moth species (Lepidoptera: Noctuideae). *African Entomology* 21(1): 172–176.

Pionnat, J.C. & Favre, S. (2000). Détecion de virus dans des cultures de production et de collection d'agapanthes. *Phytoma* 529: 12–25.

Pillay, D. (2004). *Agapanthus inapertus* Beauv. subsp. *intermedius* F.M.Leight. National Assessment: Red List of South African Plants version 2020.1. Accessed 22 July 2020.

Pires, J.C., Maureira, I.G., Givnish, T.J., Sytsma, K.J., Seberg, O., Petersen, G., Davis, J.I., Stevenson, D.W., Rudall, P.J., Fay, M.F. & Chase, M.W. (2006). Phylogeny, genome size, and chromosome evolution of Asparagales. In: Columbus, J.T., Friar, E.A., Porter, J.M., Prince, L.M. & Simpson, M.G. (eds), *Monocots: comparative biology and evolution (excluding Poales).* Rancho Santa Ana Botanic Garden, California.

Plukenet, L. (1691–1692). *Leonardi Plukenetii Phytographia* part 3: t. 195, fig. 1. London.

Pole Evans, I.B. (1921). *Agapanthus umbellatus. The Flowering Plants of South Africa* 1: t. 1.

Popay, I., Champion, P. & James, T. (2010). *An illustrated guide to common weeds of New Zealand* (3rd ed.). New Zealand Plant Protection Society, Christchurch.

Reis, A.C., Franco, A.L., Campos, V.R., Souza, F.R., Zorzatto, C., Viccini, L.F. & Sousa, S.M. (2014). rDNA mapping, heterochromatin characterization and AT/GC content of *Agapanthus africanus* (L.) Hoffmanns (Agapanthaceae). *Anais da Academia Brasileira de Ciências* 88: 1727–1734.

Reimherr, P. (1983). *Agapanthus. Gaertnerboerse und Gartenweld* 83 (4): 89–92.

Riley, H.P. & Mukerjee, D. (1960). Chromosomes in *Agapanthus. Genetics* 45(8): 1008.

Riley, H.P. & Mukerjee, D. (1962). Chromosomes of some species of *Agapanthus. Cytologia* 27: 325–332.

Roberts, M. (1990). *Indigenous Healing Plants.* Southern Book Publishers, Halfway House.

Rourke, J.P. (1973). *Agapanthus walshii. The Flowering Plants of Africa* 42: t. 1675.

Royal Horticultural Society (2012). Royal Horticultural Society Hardiness ratings. https://www.rhs.org.uk/plants/pdfs/rhs-hardiness-rating.pdf. Accessed 20 July 2019.

Sealy, J.R. (1940-42). *Agapanthus inapertus. Curtis's Botanical Magazine* 163: t. 9621.

Seba, A. (1734). *Locupletissimi rerum naturalium thesauri accurata descriptio — Naaukeurige beschryving van het schatryke kabinet der voornaamste seldzaamheden der natuur.* Amsterdam.

Semenya, S.S. & Maroyi, A. (2013). Medicinal plants used for the treatment of tuberculosis by Bapedi traditional healers in three districts of the Limpopo Province, South Africa. *African Journal of Traditional, Complementary and Alternative Medicines* 10(2): 316–323.

Sharma, A.K. & Mukhopadhyay, S. (1963). Chromosome study in *Agapanthus* and the phylogeny of its species. *Caryologia* 16(1): 127–137.

Sharma, A.K. & Sharma, A. (1961). An investigation of the cytology of some species of Liliaceae. *Genetica Iberica* 13: 25–42.

Singh, Y. & Baijnath, H. (2018). *Agapanthus campanulatus. Curtis's Botanical Magazine* 35(2): 106–124.

Skelmersdale, C. (2019). *Agapanthus* on trial. *The Garden* (July 2019): 37–41.

Slaughter, R.J., Beasley, D.M.G., Lambie, B.S., Wilkins, G.T. & Schep, L.J. (2012). Poisonous plants in New Zealand: a review of those that are most commonly enquired about to the National Poisons Centre. *The New Zealand Medical Journal* 125: 87–118.

Snoeijer, W. (2004). *Agapanthus*. Timber Press in association with the Royal Boskoop Horticultural Society, Portland.

Sprenger, C. (1901). Neue und empfehlenswerte Pflanzen usw. *Agapanthus caulescens* n. sp. In: Wittmack, L. (ed.), *Gartenflora* 50: 21–22, 281, t. 1487.

Stafleu, F.A. (1963). L'Héritier de Brutelle: The Man and His Work. In: Lawrence, G.H.M. (ed.), Charles-Louis L'Héritier de Brutelle, *Sertum Anglicum 1788: Facsimile with Critical Studies and a Translation*. Hunt Botanical Library, Pittsburgh.

Stearn, W.T. (1992). *Botanical Latin* (fourth edition). David & Charles, Newton Abbot.

Stenar, H. (1933). Zur embryologie der *Agapanthus*-gruppe. *Botaniska Notiser* 1933: 520–530.

Stephen, T. (1956). Saponins and sapogenins. Part IV. Agapanthagenin, a new sapogenin from *Agapanthus* species. *Journal of the Chemical Society* 1956: 1167–1169.

Takhtajan, A. L. (2009). *Flowering Plants* (2nd edition). Springer Science and Business Media, Netherlands.

Taylor, P. (2008). *Gardens of Britain and Ireland*. Dorling Kindersley Ltd, London.

Traub, H.P. (1943). *Agapanthus* clone, Arthington Worsley. *Herbertia* 10: 132–135.

Van Dijk, H. (2004). *Agapanthus for Gardeners*. Timber Press, Portland & Cambridge.

Van Vuuren, H. (2016). *A Necklace of Springbok Ears*: 37. Sun Press, Stellenbosch.

Van Wilgen, B.W., Forsyth, G.G., de Klerk, H., *et al.* (2010). Fire management in Mediterranean-climate shrublands: a case study from the Cape fynbos, South Africa. *Journal of Applied Ecology* 47: 631–638.

Van Wyk, A.E. & Smith, G.F. (2001). *Regions of Floristic Endemism*. Umdaus Press, Pretoria.

Veale, D.J.H., Furman, K.I. & Oliver, D.W. (1992). South African traditional herbal medicines used during pregnancy and childbirth. *Journal of Ethnopharmacology* 36: 185–191.

Vijavalli, B. & Mathew, P.M. (1990). *Cytotaxonomy of the Liliaceae and allied Families*. Continental Publishers, Kerala.

Vogel, S. (1998). Floral Biology. In: K. Kubitzki (ed.), *The Families and Genera of Vascular Plants*. Vol. 3: Flowering Plants — Monocotyledons. Lilianae (except Orchidaceae). Springer Verlag, Berlin.

Voigt, F.S. (1850). Agapanthaceae. *Geschichte des Pflanzenreichs* 2: 440. Friedrich Maute, Jena.

Von Staden, L. (2004). *Agapanthus coddii* F.M.Leight. National Assessment: Red List of South African Plants version 2020.1. Accessed 22 July 2020.

Wall, M.E., Krider, M.M., Krewson, C.F., Eddy, C.R., Williaman, J.J., Corell, D.S. & Gentry, H.S. (1954). Steroidal sapogenins VII. Survey of plants for steroidal sapogenins and other constituents. *Journal of the American Pharmaceutical Association* (Scientific Edition) 43: 1–7.

Watt, J.M. & Breyer-Brandwijk, M.G. (1962). *The Medicinal and Poisonous Plants of Southern and Eastern Africa* (ed. 2). E. & S. Livingstone Ltd., Edinburgh.

Whitehead, V.B., Steiner, K.E. & Eardley, C.D. (2008). Oil collecting bees mostly of the summer rainfall area of southern Africa (Hymenoptera: Melittidae: *Rediviva*). *Journal of the Kansas Entomological Society* 81(2): 122–141.

Wijnands, D.O. (1983). *The botany of the Commelins*. A.A. Balkema, Rotterdam.

Willdenow, C.L. (1809). *Enumeratio Plantarum Horti Regii Berolinensis*: 353. Berlin.

Worsley, A. (1913). The genus *Agapanthus*, with a description of *A. inapertus*. *Journal of the Royal Horticultural Society* 39: 363–365.

Yaacob, J.S., Taha, R.M. & Mohajer, S. (2014). Organogenesis induction and acclimatization of African Blue Lily (*Agapanthus praecox* ssp. *minimus*). *International Journal of Agriculture and Biology* 16: 57–64.

Zhai, Y., Miglino, R. Sorrentino, R., Masenga, V., Alioto, D. & Pappu, H.R. (2014). First report of natural infection of *Agapanthus* sp. by Eggplant mottled dwarf virus (EMDV). *New Disease Reports* 29: 20.

Zonneveld, B.J.M. (2004). Genome size in species and cultivars of *Agapanthus* L'Hér. (Agapanthaceae). In: Snoeijer, W., *Agapanthus*: 20–36. Timber Press, Portland & Cambridge.

Zonneveld, B.J.M. & Duncan, G.D. (2003). Taxonomic implications of genome size and pollen colour and vitality for species of *Agapanthus* L'Héritier (Agapanthaceae). *Plant Systematics and Evolution* 241(1&2): 115–123.

GLOSSARY

adventitious: with reference to roots which arise directly from the rhizome

aggregate: a grouping of closely related taxa that are treated as members of a single species

aneuploid: having an abnormal number of chromosomes

anthesis: the flowering period, when the flower is fully open

axile placentation: ovules borne on the central axis

biseriate: arranged in two whorls

campanulate: bell-shaped

caulescent: having a distinct stem rising above ground

chalconoids (chalcones): plant-derived, polyphenolic compounds

chromosome: thread-like structure in the nucleus of a cell, containing a DNA molecule

dehisce/dehiscent: with reference to the splitting open of capsules or anthers

dorsifixed: with reference to the anther attached to the filament along its back

funiculus: a very thin, short stalk by which the ovule is attached to the ovary wall

glabrous: smooth

glaucous: greyish-green or bluish-grey, with reference to leaf or scape colour

gynoecium: the female reproductive parts of a flower

haemolytic: relating to the rupture or destruction of red blood cells

homogeneity: the quality of having a uniform composition and appearance

homogeneous: composed of similar elements, having a uniform quality

hypogynous: having the perianth and stamens attached below the gynoecium

gynoecium: the female reproductive parts of the flower, i.e. the ovary, style and stigma

inflorescence: the arrangement of flowers on the scape of a plant

infructescence: the fruiting stage of the inflorescence

introrse: turned inwards

karyology: the study of cell nuclei, especially with reference to the number and shape of chromosomes

karyotype: the number and appearance of chromosomes in the nucleus of a cell

locule/loculicidal: a compartment within the ovary

micropyle: a small opening in the outer coat of an ovule, through which the pollen tube penetrates

monophyletic: with reference to a group of organisms descended from a common evolutionary ancestor, and not shared with any other group

papyraceous: papery

phytomelan: black, organic material forming a crust-like covering in seeds, commonly found in members of the Order Asparagales

polyploid: cells containing more than two paired sets of chromosomes

pseudostem: a false stem, composed of tightly packed, overlapping leaf sheaths

pyrophyte: plants adapted to and stimulated by fire to regrow and flower

raphides: needle-shaped crystals that develop as metabolic by-products in cells, and are of toxicological importance

sapogenins: a crystalline substance derived from saponin

saponin: a toxic chemical compound with foaming characteristics

septal nectaries: specialised nectar-producing structures within an ovary

scape: the leafless peduncle bearing the flower head, which arises from the rhizome

steroidal: relating to fat-soluble chemical compounds

sulcate-reticulate: grooved or furrowed, with netted surface sculpturing, with reference to pollen surface sculpturing

syncarpic: consisting of several united fruits

taxon: a taxonomic unit of any rank, e.g. a species or subspecies

trilocular: divided into three compartments, with reference to the compartments in the ovary

uncinate: bent at the tip, like a hook

uterotonic: an agent used to induce contraction of the uterus

velamen: a spongy, multiple epidermis layer of dead cells

versatile: with reference to an anther turning about freely on the filament to which it is attached

INDEX OF SCIENTIFIC NAMES

Accepted *Agapanthus* names in **bold**, synonyms in *italic*, main entry pages and illustrations indicated by **bold** page numbers.

Abumon Adans. 151

Agapanthoideae 149

Agapanthus L'Hér. 151

 Section Lilacinipollini Zonn. & G.D.Duncan 150, 231

 Section Ochraceipollini Zonn. & G.D.Duncan 150, 231

 africanus (L.) Hoffmanns. **1**, **2**, 3, 5, 10, 11, 88, 90–92, **100**, 101, 103, 109, 111, **112**, 113–115, **116**–**118**, 119, 120, 122, 123, 126, 128–130, 132, 134, 140–142, 145, 146, 153, **154**–**161**, 162, 164–167, 171, 177

 subsp. *walshii* (L.Bolus) Zonn. & G.D.Duncan 161, 164

 var. *maximus* (Lindl.) T.Durand & Schinz 169

 var. *minimus* (Ker Gawl.) Beauverd 169

 calyciflorus Banks & Sol. ex Hook.f. 231

 campanulatus F.M.Leight. 5, 8–11, 13, 15, 20, 25, 91, **92**, 103, **109**, 110, 111, **112**, 113, **114**, 115, 117, 119, 122, 124, 128–130, **131**, 132,–134, 136, **137**, 138, 141, 142, 144–146, 150, 153, 178, 189, 190, **204**–**211**

 subsp. *campanulatus* 207, 208

 subsp. *patens* (F.M.Leight.) F.M.Leight. 9, 204, 207, 208

 caulescens Sprenger 7, 10, 11, 15, 94, 103, **108**, 109–111, **113**, 114, 115, 117, 119, 121, 122, 124, 126, 129, 132–134, 140–142, 144–146, 150, 153, 178, **183**–**192**, 196, 201

 subsp. *caulescens* 188

 subsp. *angustifolius* F.M.Leight. 183, 186, 188, 191

 subsp. *gracilis* (F.M.Leight.) F.M.Leight 9, 11, 183, 188, 191

 coddii F.M.Leight. 10, 11, 103, **107**, 108, 110, 111, 113, 122, 126, 129, 133, 134, 138, 141, 142, 145, 146, 150, 153, **198**–**203**

 comptonii F.M.Leight. 10, 11, 145, 146, 174

 subsp. *comptonii* 170, 174

 subsp. *longitubus* F.M.Leight. 170, 174

 dyeri F.M.Leight. 10, 11, 145, 219, 224

 ensifolius (Thunb.) Willd. 231

 giganteus Anon. 169

 globosus W.Bull 204

 gracilis F.M.Leight. 183, 185

 hollandii F.M.Leight 213, 221

 inapertus Beauverd 9–11, 13, 15, 20, 44, 68, 88, 103, 110, 111, 113–115, 117, 121, 122, 124, 128, 132, 133, 138, 139, 142, 144, 146, 150, **211**–**230**

 subsp. *hollandii* 8, 17, 146, 219

 subsp. **inapertus** 7, **8**, 110, 114, **115**, 121, 122, **124**, **127**,

128, 129, **130**, 132, 139–142, 146, **149**, 154, 213, **214**, 215, **216**, **218**, **221**–**224**, 228, 230

 subsp. **intermedius** F.M.Leight. 11, 109, 110, 126, 127, 129, **130**, 141, 142, 145, 146, 154, 213, **214**, 215, 216, 218, 219, **220**, 221, **224**–**226**, 230

 subsp. **parviflorus** F.M.Leight. 113, 129, 130, 132, 133, **140**, 153, 213, 214, **215**, **218**, 221, **226**–**228**

 subsp. **pendulus** (L.Bolus) F.M.Leight. 8, 97, 110, **119**, **126**, 129, 130, 133, 139, 140, 142, 145, 154, 213–216, 219, 221, 228, **229**–**230**

 inapertus Beauverd

 subsp. *hollandii* (F.M.Leight.) F.M.Leight. 221

 subsp. *intermedius* F.M.Leight. forma α 221

 subsp. *intermedius* F.M.Leight. forma δ 221

 subsp. *intermedius* F.M.Leight. forma β 224

 insignis W.Bull 183, 185

 longispathus F.M.Leight. 5, 8, 169, 172

 maximus Hort. 231

 medius Lodd. ex Steud. 231

 minor G.Lodd. 154

 mooreanus 13

 multiflorus Willd. 169

 nutans F.M.Leight. 10, 11, 144, 145, 183, 186, 188

 orientalis F.M.Leight. 25, 169, 172

 patens F.M.Leight 5, 9, 204

 pendulus 213

 pondoensis F.M.Leight. ex G.D.Duncan 108, 110, 111, 113, 119, 122, **123**, **129**, 132–134, 141, 145, 146, 153, 178, 189, **192**–**198**

 praecox Willd. **4**, **6**, 7, 9, **10**, 11, 13, 15, 17, 25, 44, 68, **87**, 88, 90, **93**, 97, **99**, 100, 101, **102**, 103, **104**, 105, **106**, **109**, 110, **111**, 112, 113, 115, **116**, 117, **118**, **119**, 120, 121, **123**, 124, **125**, **126**, **127**, **128**, 129, 130, **131**, 132, 133, **134**, **135**, **136**, **137**, 138, 140, **141**, 142, **143**, 144–146, 150, 152, **169**–**182**, 220

 subsp. *minimus* (Ker Gawl.) F.M.Leight 5, 8, 146, 169, 172, 174, 180

 subsp. *orientalis* (F.M.Leight.) F.M.Leight. 8, 88, 169, 172, 180, 181, 195

 subsp. *praecox* 172, 180

 tuberosus L. ex Redouté 169

 umbellatus L'Hér. 4, 5, 141, 154, 171

 var. *albidus* 13

 var. *albiflorus* 13

var. *giganteus* (Anon.) L.H.Bailey 169
var. *globosus* (W.Bull.) Hort. 204, 207
var. *insignis* (W.Bull.) L.H.Bailey 183
var. *leichtlinii* Baker 5, 155
var. *maximus* Lindl. 5, 97, 169, **171**, 172
var. *minimus* Ker Gawl. 5, 169, 171, 172
var. *minor* 5
var. *mooreanus* 13
var. *multiflorus* 5
var. *praecox* 5
var. *saundersonianus* L.H.Bailey 231
var. *variegatus* 13
umbellatus Willd. var. *multiflorus* (Willd.) Baker 169
umbelliferus Poir. 231
walshii L.Bolus 7, 8, 10, 11, 88, **89**, 90–92, 103, **107**, 111–
117, **118**, 119, 120, 122, 126, 128–130, **131**, 132,
133, 139–141, 145, 146, 153, **161–169**
weillighi 213
weilligii 7, 213, 221
wiellighii H.B.May 7, 213, 221
Asparagus densiflorus 197
Amaryllidaceae 149
Amegilla capensis 135
Anthobaphes violacea 139
Apis mellifera 136
subsp. capensis 135, 140
subsp. scutellata 140, 228
Asarkina africana 137, 138
Asparagales 149
Bacillus thuringiensis subsp. kurstaki 101, 103
Bombus hortorum 138
Bombus terrestris 138
Carex testacea 96
Ceroctis capensis 137, 138, 140, 228
Chalcomitra amethystina 139
Chasmanthe
aethiopica 96
bicolor 96
floribunda 96
Cinnyris
chalybeus 139
talatala 139
Colotis evippe 136
Cornu aspersum 105
Crinum africanum 3
Crocosmia 95
Danaus chrysippus 136
Dianthus 144
Diaphone eumela 103
Dictyphorus 118
Enigmadiplosis agapanthi 103

Eucomis
autumnalis 96
pallidiflora subsp. pole-evansii 96
Galtonia
candicans 96
regalis 191
Halleria lucida 197
Helicoverpa armigera **101**
Hemerocallis 95
Hyacinthus 1
Kedestes chaka 136
Kniphofia 95
Lanaria lanata 168
Macroglossum trochilus 136, 137
Mauhlia Dahl 151
Mauhlia linearis Thunb. 154
Merwilla plumbea 191
Metarhizium anisopliae 104
Mycobacterium tuberculosis 144
Mylothris agathina 136
Nectarinia famosa 139
Neuranethes spodopterodes **102**
Nomiodes 138
Pachycnema crassipes 138
Papilio
demodocus 136
nireus 136
Philoliche aethiopica 135
Phomopsis agapanthi **105**, 161
Phymateus viridipes 118, 198
Pieris brassicae 136
Plectranthus 197
Prosoeca ganglbaueri 137
Psilodera fasciata 135
Pyrgomorphidae 118
Rediviva colorata 140
Strelitzia nicolai 197
Streptocarpus 197
Thereianthus bracteolatus 168
Trichoderma asperellum 106
Trichogramma 103
Tulbaghia Heist. 3, 151
heisteri Fabr. 154
Typha capensis 143
Veltheimia bracteata 96
Watsonia
pillansii **96**
schlechteri 168
tabularis 161
Xylocopa caffra 134

INDEX OF CULTIVAR NAMES

Accepted *Agapanthus* cultivars in **bold**, synonyms in roman and illustrations indicated by **bold** page numbers.

Achillea
 'Terracotta' 95
 'Walther Funcke' 95
Allium
 'Gladiator' 96
 'Mt Everest' 95
Agapanthus
 'Adelaide' 73
 'African Skies' 57
 africanus 'Peter Pan' 72
 'Alan Street' 24
 'Albo-lilacinus' 13
 'Amsterdam' 24
 'Angela' 25
 'Aquamarine' 25
 'Arctic Star' 25
 'Ardernei' 25, 26
 'Ardernei Hybrid' 25
 'Argenteus Vittatus' 13, 75
 'Atlantic' 98
 'Aureovittatus' 13
 'Back in Black' 26
 'Ballerina' 57, 58
 'Balmoral' 26
 'Barnfield Blue' 58
 'Ben Hope' 27
 'Black Buddhist' 27
 'Black Magic' 38, 230
 'Black Pantha' 58, 59, 91
 'Black Panther' 59
 'Blue Boy' 59
 'Blue Flare' 19, 59
 'Blue Globe' 59
 'Blue Ice' 59, 60
 'Blue Jay' 60, 61
 'Blue Magic' 27
 'Blue Nile' 60
 'Blue Pixie' 61, 94
 'Blue Velvet' 27
 'Bray Valley' 27, 28
 'Bressingham Blue' 28, 94
 'Bressingham White' 29
 'Brody' 29

'Camilla' 30
campanulatus
 'Bressingham Blue' 28
 'Bressingham White' 29
 'Hardingsdale' 207
 'Navy Blue' 47
 'Oxford Blue' 30
 'Pinocchio' 49
 subsp. *campanulatus* 'Wendy' 31
 'Wendy' 31
 'Wolkberg' 31, 205, 226
'Casablanca' 98
'Castle of Mey' 31, 32
'Catharina' 31, 98
caulescens 'Politique' 32, 91, 184, 186
 subsp. *angustifolius* 'Politique' 32
'Celebration' 33
'Charlotte' 62, 90, 94
'Cloudy Days' 62
'Columba' 98
'Cornish Sky' 62, 94
'Croft's Pearl' 19, 63
'Dartmoor' 32, 33
'Devon Dawn' 63
'Dokter Brouwer' 33, 98
'Donau' 98
'Double Diamond' 63, 64, 94
'Duivenbrugge Blue' 33
'Eggesford Sky' 17, 34, 35
'Enigma' 63
'Ever White' 64
'Exmoor' 34
'Fireworks' 64, 65
'Flore Pleno' 75
'Flower of Love' 17, 34, 35
'Fragrant Glen' 20, 65
'Fragrant Snow' 20, 81
'Full Moon' 19, 22, 65
'Geagold' 66
'Gem' 34
'Glacier Stream' 98
'Glen Avon' 20, 65

'Gletsjer' 98
'Goldstrike' 66
'Gold Strike' 66
'Graskop' 39
'Hanneke' 66, 67
'Happy Blue' 35
'Headbourne Hybrid' 16
'Holbeach' 36
'Hole Park Blue' 62
'Hoyland Blue' 67
'Hoyland Chelsea Blue' 67
'Ice Blue Star' 36
inapertus 'Avalanche' 36
 'Graskop' 39
 'Purple Cloud'; 76
 subsp. *hollandii* 'Lydenburg' 43
 subsp. *intermedius* 'Wolkberg' 31
 subsp. **inapertus**
 blue form 212
 'Sky' 36, 37, 94, 139
 'White' 36, 37, 98, 132, 139, 212
 subsp. **intermedius**
 'August Bells' 37
 'Wolkberg' 226
 subsp. **pendulus**
 'All Gold' 38
 'Black Magic' 19, 38, 98
 'Graskop' 17, 38, 39, 96, 104, 215, 217, 230
 'White' 36
'Indigo Dreams' 39, 40
'Ink Spot' 40
'Inkspots' 40, 94
'Jacaranda' 68
'James' 68
'Jessica' 40, 41
'Jodie' 68
'Joni' 68, 69, 89
'Jonie' 68
'Jonny's White' 40
'Lady Grey' 15, 41
'Lapis Lazuli' 69

'Lavender Haze' 69, **70**
'Leicester' 41
'Lewis Palmer' 15
'Liam's Lilac' 41, **42**
'Lilac Time' 42
'Lilliput' 43, 94
'Loch Hope' 21, 43
'Lorna' **42**, 43
'Luly' 15, 43
'Lydenburg' **18**, 43, **45**, **92**
'Lyn Valley' 44
'Maria' 44
'Marianne' 44
'Marjorie' 44
'Marnie' 45
'Maureen' **45**, 46
'Megan's Mauve' **70**
'Midnight Star' **46**, 47, 94
'Monica' 70, **71**
'Monique' 47
'Mount Thomas' 75
'Mt Thomas' 75
'Navy Blue' 47
'Nicky' 47
'Nikki' 47
'Northern Star' 17, 20, **46**, 47
'Notfred' **48**
orientalis 'Albus' 74
'Pavlova' 71
'Peter Franklin' **71**, 94
'Peter Pan' 72
'Petite White' 48, 94
'Phantom' **72**
'Pinchbeck' 49
'Pinocchio' 49
'Polar Ice' 49
'Politique' 32
'Poppin Purple' 73
praecox
 'Adelaide' 17, **73**, **96**, **129**,
 138, **173**
 'Albiflorus' 13, **14**, **74**, **131**
 'Albus' 74
 'Argenteus Vittatus' **15**, 75
 'Blue Nile' 60
 'Flore Pleno' **13**, 75
 'Full Moon' 65
 'Mt. Thomas' 75, **132**
 'Royal Purple Select' 142
 'San Gabriel' 78
 'Selma Bock' 79

'Storms River' **76**, 94, 96, **97**,
 105, **175**
subsp. *minimus*
 'Adelaide' 73
 'Peter Pan' 72
 'Storms River' 76
 Tinkerbell' 83
subsp. *orientalis*
 'Albus' 74
 'Blue Nile' 60
 'Full Moon' 65
 'Mt. Thomas' 75
 'var. albiflorus' 74
 'Tinkerbell' 83
'Pretty Sandy' 52
'Prinses Marilène' 49
'Purple Cloud' 76, **77**
'Purple Delight' **77**
'Purple Emperor' 49
'Queen Mum' 77, **78**
'Queen of the Ocean' 98
'Quink Drops' **50**
'Regal Beauty' **78**
'Rhapsody in Blue' **50**, 51
'Rotterdam' 51
'Royal Blue' 51
'Royal Velvet' **51**
'Sandringham' 52
'Sandy' 52
'San Gabriel' 78, **79**
'Selma Bock' **19**, **79**, 134
'Septemberhemel' 52
'Silver Baby' **80**
'Silverbaby' 80
'Silver Lining' **80**
'Silver Mist' **81**
'Silver Moon' 48
'Snow Cloud' 20, **81**
'Snowcloud' 81
'Snow Crystal' **81**, **82**
'Snow Storm' 81
'Snowstorm' 81, **95**
'Stars and Stripes' 52, **53**
'Stéphanie Charm' 53
'Storm Cloud' 76
'Storms River' 76
'Strawberry Ice' 81, **82**
'Summer Days' 53
'Summer Delight' **54**
'Sunset Skies' **54**
'Sweet Surprise' 82

'Taw Valley' 55
'Tigerleaf' **83**
'Tinkerbell' **83**
'Twister' **55**
umbellatus
 albus 170
 'Bressingham Blue' 28
 intermedius 170
 maximus 170
 maximus-albus 170
 mooreanus 204
 var. *albidus* 204
 var. *albiflorus* 74
 var. *aureus* 170
 var. *excelsus* 170
 var. *flore-albo* 170
 var. *flore-pleno* 75, 170
 var. *mooreanus* 204
 var. *multiflorus* 170
 var. *pallidus* 170
 var. *praecox* 170
 var. *variegatus* 170
 variegatus 170
'Velvet Night' 39
'Volendam' 98
'Wembworthy' 55, **56**, **138**
'Wendy' 31
'White' 36
'White Century' **56**
'White Flash' 84, **95**
'White Heaven' **83**, **138**
'Windsor Grey' **56**
'Zambezi' **84**, 85
'Zigzag White' **85**
Crocosmia 'Lucifer' 95
Crocosmia 'Zeal Tan' 95
Echinops bannaticus 'Blue Glow' 96
Hemerocallis 'Bonanza' 95
Hydrangea paniculata 'Praecox' 96
Kniphofia 'Sunningdale Yellow' 95
Kniphofia 'Alkazar' 95

INDEX OF COMMON NAMES

Illustrations indicated by **bold** page numbers.

African agapanthus 13
African boll worm **101**
African blue lily 13
African humming-bird moth 136, **137**, 211
African hyacinth 2
African lily 13
African monarch butterfly **136**
Afrikaanse lelie 13
agapant (Afrikaans) 13, 170
agapanthus 204
agapanthus borer **102**
agapanthus fungus **105**
amethyst sunbird 139
bell agapanthus 204
blister beetles 198
bloulelie (Afrikaans) 13, 170, 204, 221
blue agapanthus 13
blue lily 13, 170
cabbage white 136
cacao yellow mosaic virus 106
Cape agapanthus 155
Cape edelweiss 168
Cape honey bee 140, 180, 192,
carpenter bee **134**
cherry spot moth **103**
citrus swallowtail 136
Codd's agapanthus 198
common agapanthus 170
common citrus swallowtail 136
common dotted border butterfly **136**
Drakensberg agapanthus 221
drooping agapanthus 221
Dyer's agapanthus 224
East African lowland honey bee 140
eggplant mottled dwarf virus 106
flower bee 138
flower of love 4
gall midge 103, **104**
garden bumblebee **138**
garden snail 105
gewone agapant (Afrikaans) 170
giant carpenter bee **134**, 192
Graskop agapanthus 229
green milkweed locust 118, **198**

hairy sedge 96
hlakahla (Swazi) 183, 221
honey bee **135**, 136, 211
impatiens necrotic spot virus **106**
isicakathi (Xhosa) 170
Kaapse lelie 13
large earth bumblebee **138**
large red-eyed fly **137**
lehlaha-hlaha (South Sotho) 204
leta-laphofu (South Sotho) 204
Lily of the Nile 13
long-proboscid bee **135**
long-proboscid fly 135, 161, 203
long-tongued tangle-veined fly **137**
lowland honey bee 228
malachite sunbird 139
mealybug 104
monkey beetle 138
orange-breasted sunbird **139**, 169, 180, 192, 223, 230
Pondoland agapanthus 192
red-eyed fly **137**, 138
red spider mite **104**
ringspot virus 106
Shaka's skipper butterfly 136
short-tongued, oil-collecting bee 140
small agapanthus 204
small-flowered agapanthus 226
snout beetle 105
solitary bee 161, 180
southern double-collared sunbird **139**, 180, 192, 223
spotted blister beetle **137**, **140**, 228
stem agapanthus 183
swallowtail butterfly 180
sweat bee 138
tabanid fly **135**, 180, 211
tangle-veined fly 211
thrips 105
tomato spotted wilt virus 106
ubani (Zulu) 170, 204
ugebeleweni (Xhosa) 204
Walsh's agapanthus 161
Waterberg agapanthus 198
Waterberg-bloulelie (Afrikaans) 198
white-bellied sunbird 139